KABUKI GREATS

Historical Period Dramas

歌舞伎名演目

時代物

Supervised by SHOCHIKU

監修 松竹株式会社

はじめに

　このたび、弊社の監修によりシリーズ「歌舞伎名演目」が出版される運びとなりました。
　現在でもしばしば上演されている人気演目のあらすじ、登場人物、みどころなどを数巻にわたり、写真とともに紹介する企画です。

　本書はその第一巻で、「時代物」の作品11演目を紹介します。
　「時代物」は、主に江戸時代より前の歴史的事件を題材にした演目のことで、広義には武士の社会で起こったお家騒動を題材とした演目も含まれます。歴史を題材にした歴史フィクションともいうべき内容で、波瀾万丈、時には荒唐無稽といわれる大胆な展開、誇張された演技や演出、衣裳や扮装など、いわゆる歌舞伎らしさに満ちた演目が数多くあります。
　この一巻でそのすべてを語りつくすことは到底できませんが、様式的な演目、ドラマチックな演目など魅力にあふれた演目を厳選いたしました。

　歌舞伎には古くから演者の芸を楽しむという側面があり、脚本や演出においてもストーリーの展開や整合性より、場面の美しさや面白さが優先されることもあります。そのため、あまり細かすぎるあらすじはかえってわかりにくくなるおそれもあり、また、舞台を見ればわかるような展開を羅列するだけの無味乾燥なものに陥ってしまうこともあります。
　そこで本書では、演目の魅力や内容を数行で表す、いわばキャッチコピー的な文章で演目のイメージを大づかみでつかんでいただくと同時に、簡潔なあらすじとコラム、写真などの多彩な切り口で、全体像を伝えることを主眼といたしました。

　歌舞伎の魅力は舞台にあり、書物ではなかなか伝えきることは難しいのですが、お読みになった後でその演目をご覧になった際、演技や舞台がよりお楽しみいただけるような実用にも役立つ一冊となるよう心がけました。
　本書が歌舞伎ご愛好の方々のご観劇のよき手引きとなることはもとより、本書で歌舞伎に初めて触れる方々が劇場に足をお運びいただくきっかけとなれば幸いでございます。

<div style="text-align: right;">松竹株式会社</div>

Foreword

We are pleased to present to you Famous Works of Kabuki: Jidai-mono, the first in a series of books about kabuki. Our editorial team has compiled synopses, character profiles, and highlight notes of some of the most oft-performed kabuki plays, accompanied by pictures to aid in understanding and visualization.

Jidai-mono introduces eleven period pieces of the kabuki theater. The term *jidai-mono* refers to plays based on historical events, often from the Edo Period of Japan (1603–1868). These plays deal with a broad range of topics and themes, including family disputes among samurai families. Though based on historical events, *jidai-mono* are fictionalized representations involving dramatic and sometimes absurd developments, exaggerated performance styles, and extravagant costumes—all signature elements of the kabuki theater.

It would be impossible to cover the entire repertoire of this rich genre in just one volume. Therefore, we have carefully selected only the most dramatic, impactful, and formally notable plays to discuss here.

In kabuki, the impact of the actors' performance is often the most important part of the show. This has been the case since ancient times, and some viewers may be surprised to hear that plot and consistency are sometimes considered secondary to the sheer beauty and impact of a scene. Because of this, some plays are actually more difficult to understand after reading a detailed synopsis. Indeed, what is meant to be a spectacular show may turn into a cut-and-dry series of events if more emphasis were placed on plot.

In editing this book, we regularly consulted with the writers concerning this aspect of the theater. We wanted to ensure that the charms of kabuki were conveyed in short and appealing language that doesn't require the reader to think too deeply. We only wish to convey the broad strokes of the plot in concise language while also offering photographs and highlight columns to help readers gain a balanced view of kabuki from different vantage points.

The delights of kabuki are something that can only be seen on the stage. Even so, we hope that our book may offer a practical understanding of the fundamentals of kabuki, allowing readers to enjoy this unique artform more fully.

This books meant not only to be a guide to kabuki lovers, but also an introduction to the theater for those who have never experienced it for themselves. It is our sincere hope that this book inspires newcomers to make their way to the theater and experience the fascinating world of kabuki for themselves.

<div align="right">SHOCHIKU Co., Ltd.</div>

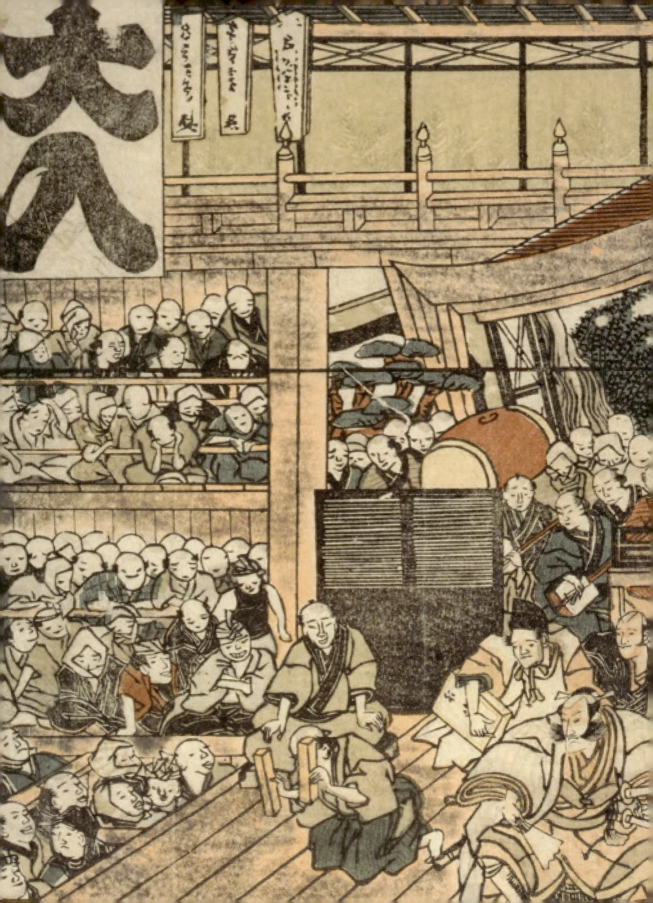

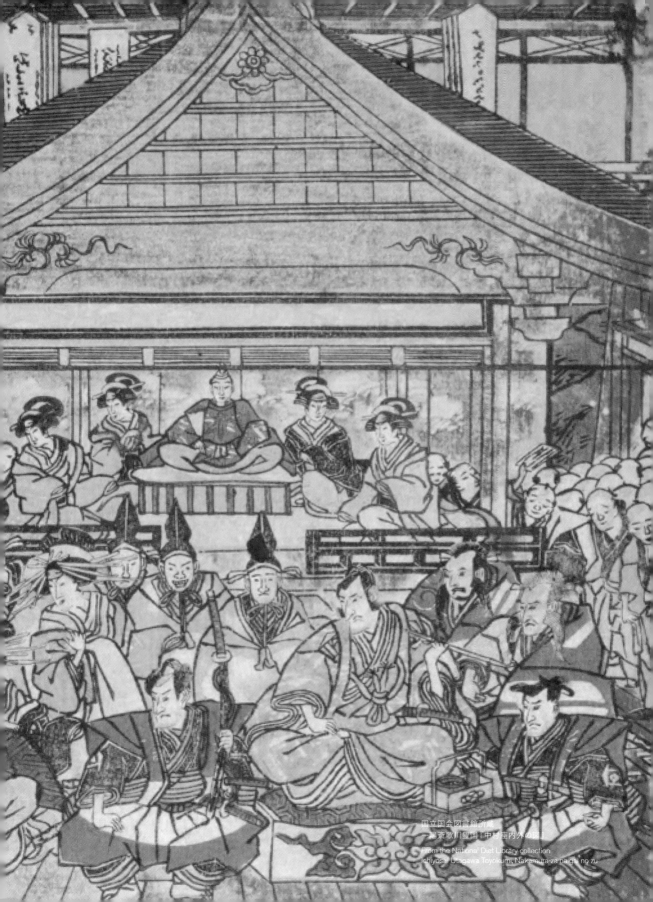

目次

01 **勧進帳** かんじんちょう
Kanjincho —— 10

02 **暫** しばらく
Just a Moment! —— 22

03 **鳴神** なるかみ
Narukami —— 34

04 **菅原伝授手習鑑** すがわらでんじゅてならいかがみ
Sugawara and
the Secrets of Calligraphy —— 42

05 **義経千本桜** よしつねせんぼんざくら
Yoshitsune and
the Thousand Cherry Trees —— 66

06 **仮名手本忠臣蔵** かなでほんちゅうしんぐら
Kanadehon Chushingura —— 92

Contents

07 伽羅先代萩 めいぼくせんだいはぎ
Meiboku Sendaihagi — 120

08 一谷嫩軍記 熊谷陣屋 いちのたにふたばぐんき くまがいじんや
Kumagai Jin'ya
— from Chronicle of the Battle of Ichi no Tani — 130

09 妹背山婦女庭訓 いもせやまおんなていきん
Imoseyama Onna Teikin — 140

10 祇園祭礼信仰記 金閣寺 ぎおんさいれいしんこうき きんかくじ
Kinkakuji
— from Gion Sairei Shinkoki — 154

11 寿曽我対面 ことぶきそがのたいめん
The Soga Confrontation — 166

12 付録
Appendix — 176

カバーイラストレーション：『菅原伝授手習鑑』「車引」梅王丸
Cover illsutration: *Sugawara and the Secrets of Calligraphy* "*The Carriage*" Umeomaru

KABUKI
PLAYS

演目紹介

Historical Period Dramas ——— 時代物

勧進帳
Kanjincho

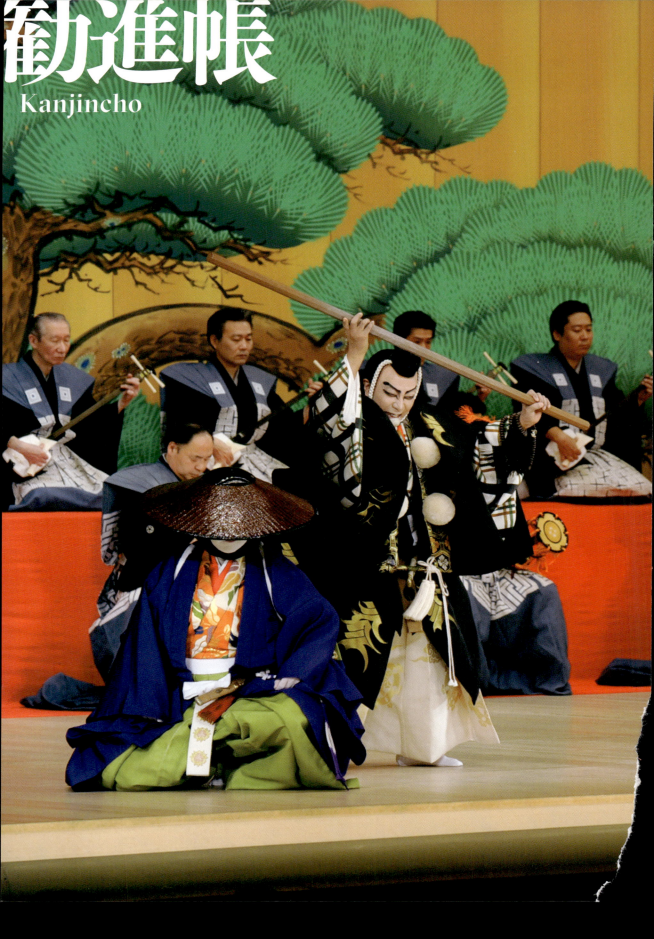

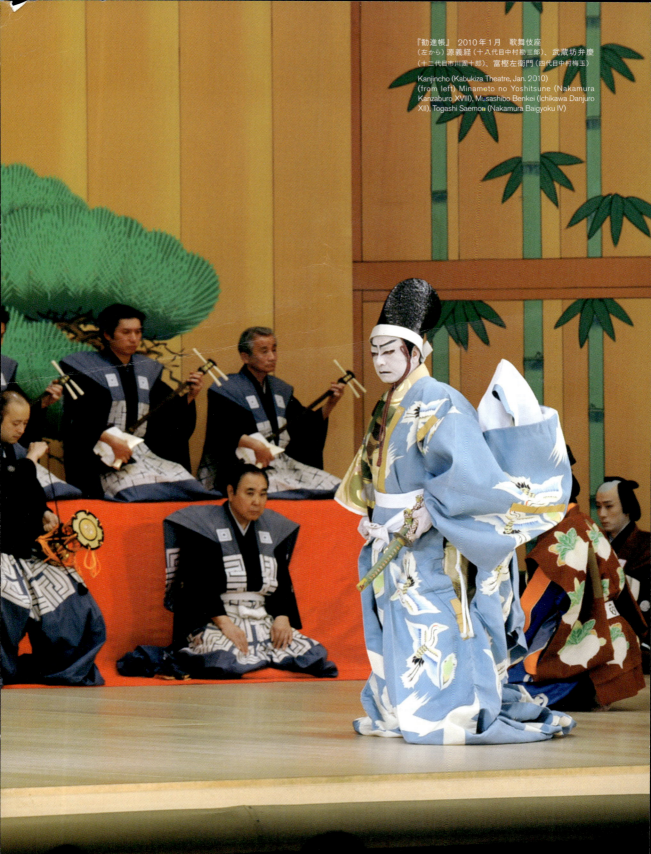

『勧進帳』 2010年1月 歌舞伎座
(左から) 源義経 (十八代目中村勘三郎)、武蔵坊弁慶
(十二代目市川團十郎)、富樫左衛門 (四代目中村梅玉)

Kanjincho (Kabukiza Theatre, Jan. 2010)
(from left) Minamoto no Yoshitsune (Nakamura Kanzaburo XVIII), Musashibo Benkei (Ichikawa Danjuro XII), Togashi Saemon (Nakamura Baigyoku IV)

数ある歌舞伎の演目のなかでも、不動の人気作

何があっても主君義経を守ろうとする武蔵坊弁慶の必死の思い。
激しい攻防の末、その思いに触れた関守富樫は……。
落魄（らくはく）の貴公子とそれを守る知仁勇備えた豪傑、情理わきまえた颯爽とした侍、
三人の男たちの魂がぶつかり合う一幕。

A Masterpiece Among Many Gems of the Kabuki Theater

Musashibo Benkei will do anything to protect his master.
Yet after a fierce battle, that resolve is tested by Togashi the barrier inspector…
Watch the fateful clash between three great souls:
A young aristocrat fallen on hard times; his servant, the hero and a man of wisdom, compassion and courage; and a gallant samurai moved to compassion.

源氏の武将源義経は、兄頼朝と手を携え、平家との戦いに勝利し、頼朝の政権樹立に大きな勲功を立てた。しかしその後はからずも不和となり、兄の追手を逃れ、各地をさすらっている。

義経は、少年のころに庇護を受けた奥州藤原氏を頼ることにし、わずかな家来とともに山伏に変装し、陸奥国平泉（現在の岩手県平泉町）に向かう。それを察知した頼朝は、一行詮議のため各地に関所を設けた。加賀国安宅（現在の石川県小松市）にも関所が設けられ、富樫左衛門が関守（関所の責任者）として守りを固めている。

そこに来かかった義経はじめ、亀井六郎、片岡八郎、駿河次郎、常陸坊海尊（ひたちぼうかいそん）らの四天王、そして武蔵坊弁慶の主従。行く先々に関所があっては奥州までは思いもよらぬと気弱になる義経。また、力づくで関所を突破しようとする亀井らをとどめ、弁慶は、義経に笠を深々とかぶり、強力（ごうりき・荷物持ち）に変装して後から目立たぬようについてくるよう求め、義経もそれに従うことにする。

関では、弁慶は東大寺再建の勧進（寄付を集めること）のための山伏と名乗った。当時東大寺など寺院の力は絶大であり、東大寺再建は勅命（天皇の命令）でもあったからだ。

しかし富樫は通行を許さない。義経が山伏に変装しているので、山伏は誰であろうと通行はならないというのだ。一

The Genji general Minamoto Yoshitsune has helped defeat the Heike and consolidate the political power of his older brother Yoritomo. Soon after, however, Yoshitsune finds himself out of favor with his brother, and wanders from region to region to escape Yoritomo's pursuit.

Yoshitsune decides to seek the help of the Northern Fujiwara who protected him as a boy. He and a small number of retainers disguise themselves as mountain monks and head for Mutsu Province (present-day Hiraizumi, Iwate Prefecture). Yoritomo, knowing his brother will attempt to seek refuge, sets up barriers throughout the land, including the Ataka Barrier in Kaga Province which Togashi Saemon is charged with protecting.

Yoshitsune, along with Benkei and four other retainers, make their appearance. Knowing of the barriers put up directly in their chosen path, Yoshitsune is losing hope of ever reaching Mutsu. The other retainers suggest pushing past the barrier with brute force, but Benkei has another plan. He disguises Yoshitsune in a large hat and the clothes of a servant, asking that his master follow along behind him to avoid suspicion. Yoshitsune agrees to this plan and does as Benkei says.

At the barrier, Benkei claims to be a mountain priest collecting alms to help in the reconstruction of Todaiji Temple. This temple was one of the most powerful of the time, and its reconstruction was sponsored by the emperor himself.

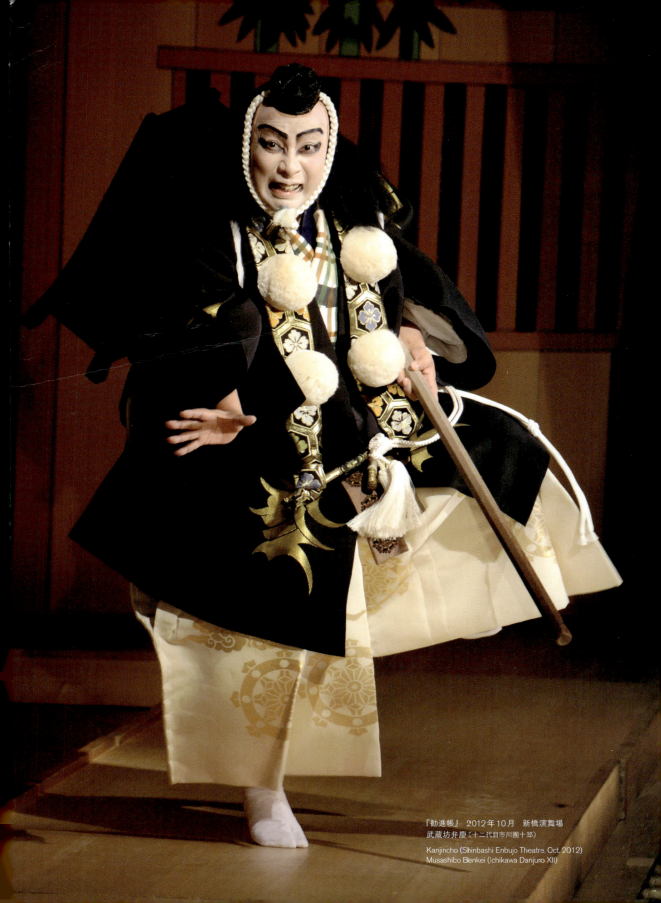

『勧進帳』 2012年10月 新橋演舞場
武蔵坊弁慶（十二代目市川團十郎）

Kanjincho (Shinbashi Enbujo Theatre, Oct. 2012)
Musashibo Benkei (Ichikawa Danjuro XII)

行は最後の勤めと称して祈りをはじめる。その姿を見た富樫は、ことによったら真の山伏かもしれないと思いなおし、「勧進帳」を読むように命じる。寄付の趣意を書いた「勧進帳」は、当然所持しているはずというのである。弁慶は勧進帳を持っていなかったが、笈(おい・荷物入れ)の内の巻物をひらき、即興で勧進帳を読みあげる。

なおも富樫は、山伏の装束などについて矢継ぎ早に問いかける。山伏の知識を試そうというのである。弁慶はもともと比叡山で学んだ僧。一つ一つに明快に答えていく。白熱した問答は、奥義の九字真言にまで至るが、弁慶は見事にこの場を切り抜ける。感心した富樫は、一行を真の山伏と認め、寄付の上、関所を通らせる。

その時、強力(実は義経)を、関所の番卒が見咎める。義経ではないのかというのである。すわやと殺気立つ四天王たちを抑え、取って返した弁慶は強力を叱りつける。わずかな笈を持って後から来るから怪しまれるのだ、それはお前が至らないからだ——弁慶は強力の杖を奪いとりさんざんに打ちのめす。家来が主君を杖で打つということはあり得ないことであるが、義経をあくまでも強力として扱い、この場を逃れようとする計略なのである。

しかし富樫らは許さない。四天王らと富樫らとのあわや一触即発の危機のなか、弁慶は荷物もろとも強力を置いていくか、さもなくば、この場で強力を打ち殺すと言って杖を振り上げた。義経を思う弁慶の必死の心に打たれた富樫は、すべての責任を自分の身に引き受ける覚悟で一行の通行を許す。

関所から離れ、一行はしばしの休息を取る。四天王は口々に弁慶のとっさの機転をほめるが、弁慶は計略とは言いながら主君を打ったことを泣いてわびる。その苦衷を察し、弁慶を優しくねぎらうとともに、自らの武運の拙さを嘆く義経。弁慶ら一行もこれまでの戦の日々を振り返り、ともに涙する。

そこに富樫の声がする。富樫は先ほどの無礼をわび、酒を持って追ってきたのである。弁慶は酒を飲み、舞を舞う。やがて義経らは隙を見てその場を立ち去る。最後に一人残った弁慶は、富樫の温情に感謝しつつ、義経らの後を追うのであった。

Togashi, however, refuses to let them pass, claiming that Yoshitsune is supposed to be disguising himself as a mountain priest. Benkei begins to pray, making Togashi believe he may actually be a priest. He asks Benkei to read from the donations record book which priests collecting alms would surely carry with them. Benkei, of course, does not possess such a book, so he takes a random scroll from his belongings and pretends to read.

Togashi then begins a long line of questions about the priests' robes to test their priestly knowledge. Benkei, a priest himself, is able to answer all these questions easily. Togashi's heated interrogation comes to an end when Benkei is able to answer about a secret text that only a priest would know. An impressed Togashi accepts that they are indeed priests and decides to let them pass.

Just then, however, another guard at the barrier recognizes the disguised Yoshitsune. The four other retainers in their party are ready to charge to their master's defense, but are stopped again by Benkei, who turns and begins to scold Yoshitsune. Taking Yoshitsune's walking stick from him, Benkei beats him harshly, claiming that it is because he carries so little of the load and drags his feet at the back of the group that he is suspected so. A servant beating his master is an unspeakable thing, but Benkei hopes thus to convince the guards that Yoshitsune is indeed a mere servant helping to carry their luggage.

Togashi and the other guards are unconvinced. Just as fighting is about to break out among the guards and Yoshitsune's retainers, Benkei raises the walking stick again, saying that, rather than leave his porter Yoshitsune and their luggage here, he will beat the porter to death. Togashi knows this is a ruse but is deeply moved by Benkei's devotion to his master. He decides to let them pass, taking full responsibility for the incident himself.

Yoshitsune's party moves some distance past the barrier and stops to rest. The other four retainers praise Benkei for his quick thinking, but Benkei cries and begs forgiveness for daring to beat his master. Yoshitsune consoles Benkei, thanking him and recalling his own military failings. They all then recall their past battles and cry together.

Togashi then appears before them, apologizing for his rudeness and offering some sake he brought along with him. Benkei drinks and begins to dance, giving Yoshitsune and the others an opportunity to get away. Benkei alone remains with Togashi, whom he thanks profusely for his kindness before following after his party.

作品の概要 / Overview

演目名 / Title

勧進帳 / Kanjincho

作者 / Writers

作詞＝三世並木五瓶
作曲＝四世杵屋六三郎

Lyrics by Namiki Gohei III
Music by Kineya Rokuzaburo IV

概要 / Overview

「歌舞伎十八番*」といわず、すべての歌舞伎演目の中でも不動の人気演目である。

天保11（1840）年3月　江戸・河原崎座において初演。作詞は三世並木五瓶、作曲は四世杵屋六三郎である。

現在の「歌舞伎十八番」のもととなっている、天保3（1832）年3月に制定公表された、「江戸市川流　歌舞妓狂言組十八番」にも『勧進帳』があるが、これは、初代團十郎が『星合十二段』で演じて以来、代々の團十郎が演じた、弁慶が勧進帳を読んで関所を通る内容の芝居のことを指しており、本作を指しているわけではない。

七代目團十郎は、本作を「歌舞妓十八番」と銘打ち上演したが、これまでの『勧進帳』の趣向・内容とは大きく異なっている。本作は能の『安宅』をもとに、講談や一中節などの先行作を取り入れた作品であり、「松羽目物（まつばめもの）*」のさきがけとされる。

なお、能『安宅』では弁慶一行は宗教の権威と武力で関所を押し通る。富樫が弁慶の心に打たれて義経と知って通行を許すという解釈は、近世に入ってからのものである。いずれにせよ本作の背景にあるのは「判官びいき*」の厚い心情である。

＊みどころの説明参照

One of the *Eighteen Great Kabuki Plays*, *Kanjincho* is set apart as one of the most popular and often performed plays of that group.

That play was first performed in January of 1840 at the Edo Kawarasaki-za Theater. The lyrics were written by Namiki Gohei III, and the music composed by Kineya Rokuzaburo IV.

The earlier *Eighteen Great Kabuki and Kyogen Plays* of the Edo Ichikawa School was the basis for the *Eighteen Great Kabuki Plays*. It also included a work titled *Kanjincho*, but this refers to a different play which depicts Benkei reading the fake donations record and passing through the barrier.

This Benkei was first played by Danjuro I, and he passed on his knowledge and skill in the role to his sons until Danjuro VII eventually played Benkei in this new version of *Kanjincho*. But this Benkei was quite different from what the previous Danjuro's had played. Based on the Noh play *Ataka*, *Kanjincho* was one of the first plays to borrow extensively from various other story-telling forms.

Furthermore, in *Ataka*, Benkei and his companions get through the barrier by force. The story of Togashi the guard letting them pass out of compassion is a modern retelling of the story. In all variations of the story, however, sympathy for the underdog is what pulls at the audience's heartstrings.

初演 / Premiere

天保11（1840）年3月　江戸・河原崎座

March 1840, Kawarasaki-za Theater, Edo

登場人物 / Characters

武蔵坊弁慶
むさしぼうべんけい

源義経を守護する側近中の側近として怪力勇壮の弁慶の存在はよく知られ、数々の逸話が古くから伝えられている。その集大成ともいえるのがこの『勧進帳』の弁慶である。豪快だけでなく、才覚知力に富み情も厚く、主君義経を無事に落ち延びさせるべくありとあらゆる手段を講じて関守の富樫と対峙する。忠臣の理想像にも見え、観客の関心と期待を一身に背負い感動を与える主人公である。

Musashibo Benkei

The superhuman strength and great heroism of Yoshitsune's right-hand man and bodyguard, Benkei, are widely known, and the Benkei that appears in Kanjincho is the crowning jewel among his dramatic depictions. He is not only brave, but exhibits sharp wits, wisdom, and incredible compassion in facing the guard Togashi and getting his master safely through the barrier. He is a paragon of dedication, the perfect protagonist who never disappoints his audience.

源義経
みなもとのよしつね

数々の武勇で知られた源氏の大将・源義経だが、兄・頼朝との不和により都を離れ奥州へ落ち延びようとしている。すでに従う者も少なく鎌倉方の追っ手を逃れるため山伏姿となり、特に義経は身分の低い荷物持ちの強力（ごうりき）に身をやつしている。しかし舞台に登場する義経は輝くばかりの神々しさと気品に溢れ、主君を杖で折檻したことを心から詫びる弁慶に、義経は温かい手を差し伸べる。

Minamoto no Yoshitsune

A decorated Minamoto general, Yoshitsune has fallen out of favor with his brother Yoritomo and now makes for a province far from the city with the few retainers he has left. His party are disguised as mountain priests to escape the suspicion of his brother's men who hunt him. Despite his disguise as a lowly porter, he is portrayed as a grand and elegant man who shows deep mercy on Benkei after being beaten by him.

亀井六郎・片岡八郎・駿河次郎
かめいろくろう・かたおかはちろう・するがのじろう

義経の家臣の中でも名を知られる忠臣たちで俗に「四天王」と呼ばれる。他の歌舞伎作品の中にもその名がしばしば登場するが、もう一人は伊勢三郎。この『勧進帳』には常陸坊海尊が登場するので、ここでは海尊を含めた四人で四天王が形成されている。舞台上で常に従者として存在し前面に出る活躍の場はあまり持たないが、その凛々しく毅然とした姿があってこそ義経一行が見事に形作られる。

Kamei Rokuro / Kataoka Hachiro / Suruga no Jiro

Commonly called "*Shitenno*" ("Four Heavenly Kings"), these are the most well-known and loyal of Yoshitsune's retainers. The fourth of this group, who sometimes appears in kabuki plays, is named Ise Yoshimori, though Kaison takes his place in *Kanjicho*. In this play, these characters do not take center stage, but the mere presence of the legendary four give Yoshitsune's retinue a grand presence.

富樫左衛門
とがしのさえもん

安宅関を守る関守。源頼朝の命令を忠実に守り勇気をもって任務に当たっている。義経、弁慶一行の山伏姿の者たちを一歩も引かぬ思いで詮議するが、一分の隙も見せない弁慶に一時は納得の態度も見せる。しかし怪しいとにらまれた義経を弁慶が厳しく折檻、富樫は次第に難しい判断を迫られてゆく。弁慶の力と知に屈したか情に動かされたか、関所を通した理由は様々複雑だが、ついに富樫は覚悟を決める。

Togashi no Saemon

The Ataka Barrier inspector, Togashi Saemon is dedicated to his duty to Minamoto Yoritomo. When Yoshitsune and Benkei's party arrive at the barrier, Togashi conducts a harsh interrogation but is satisfied with Benkei's flawless answers. He faces a difficult decision, however, when another guard recognizes Yoshitsune and Benkei proceeds to beat his master in an act to prove they are not lying. Togashi ultimately makes up his mind to let Benkei and the others pass, though his reasons are complex—he is at once impressed by Benkei's quick wits and also deeply moved by his undying devotion.

常陸坊海尊
ひたちぼうかいそん

義経の身近に仕える側近の一人で、武蔵坊弁慶と同様元は僧侶と思われる。義経に従う一行の中でもひときわ年かさで思慮分別に富み、安宅関を前にして勇ましい者たちが関所を踏み破らんと心もはやるところ、それを冷静に鎮める役割も演じる。『義経記』などで伝えられる人物ではあるが、その実在を含め詳細は不明、義経が没した後も永く生き延びたとされる説が巷間に伝えられる。

Hitachibo Kaison

One of Yoshitsune's retainers, he was once a priest like Benkei. He is a wise elder in Yoshitsune's party and plays the important role of stopping the other overzealous samurai from attempting to force their way through the barrier. *Gikeiki* ("The Chronicle of Yoshitsune") mentions him, but not much is actually known about him except that he supposedly lived some years after Yoshitsune died.

※登場人物の読み方は歌舞伎の慣例によっています。

みどころ
Highlights

1. 武蔵坊弁慶の衣裳 — Musashibo Benkei's Costume

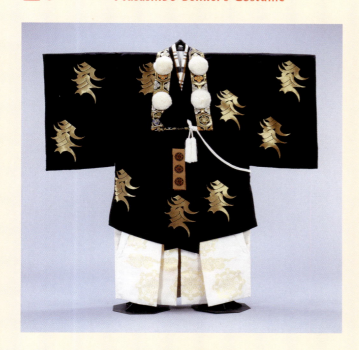

弁慶は山伏のいでたち。原作の能『安宅』の衣裳を参考に作られているが、あくまで歌舞伎独特のデザインである。翁格子の着物に、白地の大口袴、梵字を散らした水衣、紺地の篠懸（すずかけ）を首に下げている。

Benkei wears a mountain priests' garb. Though his costume is based on the Benkei costume from the noh play *Ataka*, the design has been altered to fit the kabuki theater. He wears a bold kimono with a checkered *okina-goshi* pattern over large trousers with a white dragon pattern and a *mizugoromo* robe with Sanskrit characters. Finally, draped from his neck is a navy-blue hemp robe called a *suzukake*.

2. 松羽目物 — Matsubame-mono

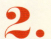

能楽を原作とする歌舞伎を「松羽目物（まつばめもの）」と呼ぶ。能舞台の鏡板を模した松を描いた背景以外に舞台装置はない。その最初の作品が『勧進帳』で、能の『安宅』を原作としている。『安宅』と大筋はほぼ同じで、弁慶が義経を打擲（ちょうちゃく）して守る展開も同じ。大きく異なるのは、『安宅』の関守は弁慶の威力に恐れをなして通すが、『勧進帳』の関守富樫は弁慶の心情に打たれ、義経と気づきながらも見逃す心をのぞかせるところだ。

Kabuki plays that are based on noh are called *matsubame-mono*. In such plays, there are no props or stage settings other than the pine tree background based on *kagami-ita* used in Noh plays. The first *matsubame-mono* was *Kanjincho*, based on the noh play *Ataka*. The Kabuki play largely follows the same plot as *Ataka*, even the scene in which Benkei beats Yoshitsune. The biggest change made is that in *Kanjincho* the barrier guard lets Benkei and his party pass due to his admiration of Benkei's devotion to Yoshitsune rather than fear of Benkei's strength. In the kabuki version, therefore, we see that the guard Togashi actually knows that Yoshitsune is in their party but lets them pass anyway.

3. 富樫左衛門の衣裳 — Togashi no Saemon's costume

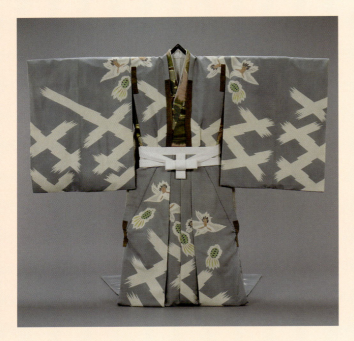

素襖と呼ばれる共布の上着と長大口袴を着けている。素襖は納戸色にまたは浅葱（あさぎ）で松皮菱に鶴と亀を散らした柄。下に着ている着物は革色と白茶の締切瓢箪巴柄の織物で、一行に疑いを持って片袖を脱ぎ刀を構えた時にちらりと見える。

The character wears what's called a *suou* (ceremonial dress of lower-class samurai), comprised of an upper robe and *hakama* trousers made of the same cloth. The *suou* is grayish blue with diamond-like shapes and images of cranes and turtles. The kimono worn underneath is the color of leather and white tea, with patterns of closed gourd-shaped *tomoe* (a comma-like swirl symbol). One can get a glimpse of this *tomoe* when the character, suspicious of those around him, takes off one sleeve and pulls out his sword.

4. 判官びいき — Hogan-biiki – Rooting for the Underdog

義経は都の保安にあたるため、検非違使（けびいし）・左衛門尉に任じられた。判官（ほうがん）にあたる位であったので、義経は九郎判官殿と通称された。兄によって滅ぼされた義経を哀れに思い、同情する心から「判官びいき」という言葉が生まれた。ここから弱いものに味方する心情を「判官びいき」と呼ぶようになった。歌舞伎に登場する義経は、優美で気品ある姿である。大軍を動かした武将だが、同情を集めるかよわいイメージだ。

Yoshitsune used to be a magistrate charged with keeping the peace in the capital, which is why he is also called Kuro Hogan (Magistrate Kuro). The term *hogan-biiki* ("sympathy for the magistrate") comes from the sense of sympathy the audience has for Yoshitsune after he falls out of favor with his brother. The word *hogan-biiki* is now used as a general term to express sympathy for the underdog. Yoshitsune appears as an elegant and genteel character in kabuki who is vulnerable and sympathetic despite his heroic war deeds as a general.

5. 勧進とは —— The Meaning of "Kanjin"

勧進とは寄付を募ること。勧進帳とは、その趣意書のこと。鎌倉幕府ができたころ、東大寺の大仏は平家によって焼き亡ぼされていた。重源という僧が再建を呼びかけ、その意を受けた山伏が全国を勧進して歩いたので、義経一行はその勧進の山伏という触れ込みで安宅の新関を通過しようとした。弁慶があり合わせの巻物を取り、勧進帳として朗々と読みあげたことから、「勧進帳を読む」とは、即興で話を作るたとえにもなった。

The word "kanjin" refers to collecting donations, and a kanjincho is the record book of donations collected. When the Kamakura Bakufu was established, the great Buddha statue (daibutsu) at Todaiji Temple had been burned down by the Taira clan. Because of this, a Buddhist monk named Chogen called upon his fellow priests to walk the country collecting donations to fund the statue's reconstruction. Yoshitsune and his party therefore attempt to pass through the Ataka Barrier on the pretense of collecting donations as Buddhist priests. The scene where Benkei pulls a fake scroll from their luggage and pretends to read it as the donations record is one of the highlights of the show which led to the phrase "kanjincho o yomu (reading the donations record book)," a figure of speech meaning to make something up.

6. 長唄が名曲 —— The Famous *Nagauta*

『勧進帳』の魅力のひとつは長唄が名曲であること。冒頭、富樫が静かに登場して名乗りを上げたあと、長唄が能の謡のように格調高く「旅の衣は篠懸の、旅の衣は篠懸の、露けき袖やしおるらん」と歌う。山道の草露で衣を濡らしながら山伏が進む様子から、月の美しい都を出て琵琶湖を渡ったことが美しく歌われて、弁慶たちの出になる。以後、変化に富んだ伴奏が続く。後半の弁慶の舞からは、また勇壮な曲調に戻って華やかに終わる。

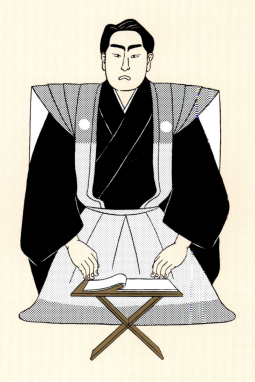

The famous *nagauta* melody is one of the charms of *Kanjincho*. After Togashi makes his entrance at the beginning of the play, the dignified *nagauta* song in the style of a noh chant begins. "*Suzukake*, a traveller's robe, *suzukake*, a traveller's robe, the sleeves are wet with dew." The words evoke the image of travellers walking a grassy mountain path damp with dew, and continues on to describe the travellers leaving the capital and passing over Biwako Lake. This is the cue for Benkei and the other protagonists to make their entrance. The accompaniment music continues in a constantly changing register that returns to a heroic mode from Benkei's dance in the latter half and finishes with a flourish at the end of the play.

7. 義経の都落ち —— Yoshitsune Fleeing the Capital

源平合戦で活躍し平家追討を成しとげながら、兄頼朝の不興を買った源義経の栄光と転落の物語は『平家物語』や『義経記』に伝えられている。義経は都落ちし、はじめ九州をめざしたが嵐に遭い、一時は吉野山に隠れる。やがて身なりを替えてひそかに奥州平泉の藤原氏を頼って、北を目指した。頼朝は義経捕縛のため、全国に新関を設けたという。安宅の新関は北陸道に設けられたといわれるが、詳細な場所は諸説ある。

The story of Minamoto Yoshitsune's fall is told in *The Tale of the Heike* and *The Chronicle of Yoshitsune*. When Yoshitsune is expelled from the capital he first heads for Kyushu but must hide at Mt. Yoshino due to a storm. After changing his clothes, Yoshitsune heads north to ask for help from the Fujiwara in Hiraizumi. At the time it is said that Yoritomo had established a new barrier called Ataka along the Hokurikudo route, and though there are many theories, no one truly knows where the barrier was located.

8. 弁慶の見得 —— Benkei's Mie Pose

見得は、にらみなどの表情を止め、体全体を大きく使ってストップモーションのように極まる歌舞伎の特徴的な演技である。『勧進帳』の弁慶も、劇中いくつかの見得をし、いずれも大きな山場になっている。それぞれに通称があり「天地人の見得」、「不動の見得」、「元禄見得」、「石投げの見得」などと呼ばれる。また、幕外の飛び六方の前にも、打ち上げの見得がある。見得は多く「ツケ」という効果音を伴うが、『勧進帳』では、ツケが入るのは「石投げの見得」と幕外のみである。

A mie is a dramatic pose struck by kabuki actors at the height of important scenes, used similarly to close-ups in movies. Benkei has many mie poses in Kanjincho, each of which occur at pivotal scenes in the show. Each mie has its own name, such as the "tenchijin no mie (heaven-earth-human mie)," "fudo no mie (immoveable mie)," "genroku-mie," and "ishinage no mie (stone-throwing mie)." Though there are many mie in Kanjincho, the ishinage no mie is the only one to be accompanied by the unique tsuke sound effect.

9. 歌舞伎十八番 —— Kabuki Juhachiban (Eighteen Great Kabuki Plays)

市川團十郎家の家の芸を十八番集めたもので、天保3年に七代目團十郎が制定した。8年後の『勧進帳』初演時に「歌舞伎十八番の内」と銘打ち評判になった。『不破』『鳴神』『暫』『不動』『嫐』『象引』『勧進帳』『助六』『外郎売』『押戻』『矢の根』『景清』『関羽』『七つ面』『毛抜』『解脱』『蛇柳』『鎌髭』である。人気作品が多いが、上演が絶えていた作品もあり、様々な復活が試みられている。

Eighteen plays chosen in 1832 by Ichikawa Danjuro VII, a legendary actor of the late Edo Period. He picked plays depicting bombastic *aragoto* characters dating as far back as his ancestor Danjuro I, and *Kanjincho* was one of the plays he chose. Danjuro VII himself created the current version of the play in 1840, but there were precedents performed by his predecessors, including noted performances by Danjuro I and Danjuro IV.

10. 歌舞伎の醍醐味 飛び六方
—— Flying *Roppo* Exit

花道は歌舞伎の大きな魅力のひとつ。客席の中をつらぬく花道は、舞台とは別の空間として使うこともできる。弁慶が安宅の関をあとにして花道にさしかかると、舞台の幕が引かれ、幕の下手側が少し奥に引き入れられる。もはや花道は、富樫たちから離れた街道筋である。一人立つ弁慶は、義経を無事にのがした安堵を見せ、神仏の加護に感謝し「飛び六方」というダイナミックな演技で、走り去っていく。

A *roppo* is an exaggerated stamping movement that is believed to have originated as religious protocol to exorcise spirits and demons. It can also be seen in folk arts, but in the case of kabuki, it is usually used in exaggerated *aragoto*-style shows for the entrance and exit of main characters. The flying *roppo* in *Kanjincho* is the show's final highlight, conveying the power of Benkei as he follows Yoshitsune. It uses the *hanamichi* that runs through the audience, bringing the action excitingly close to the spectator.

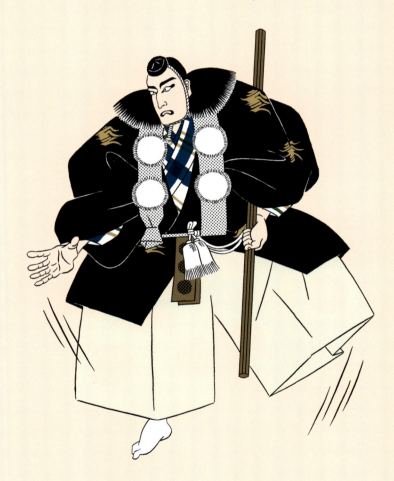

Shibaraku (Just a Moment!)

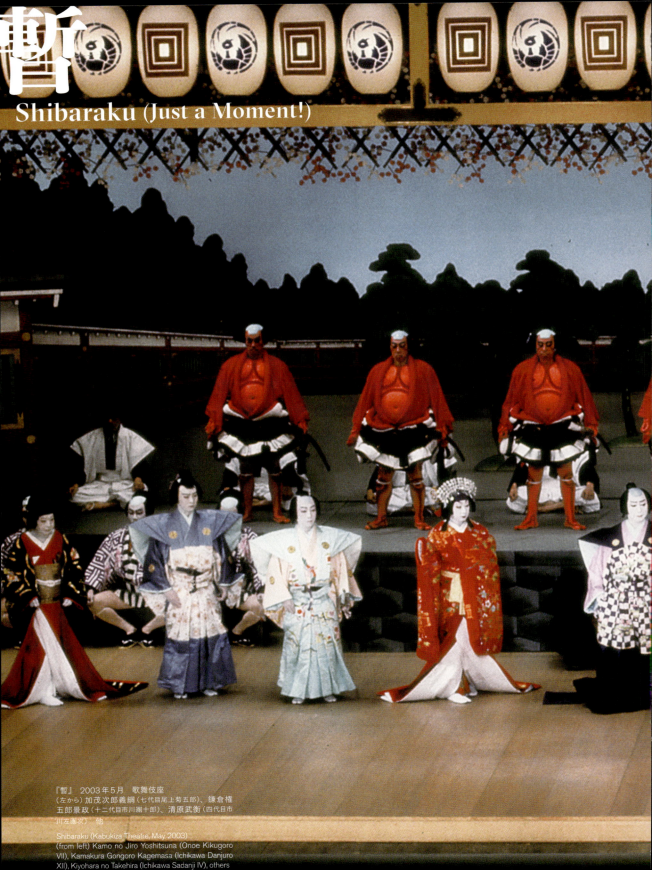

『暫』 2003年5月 歌舞伎座
(左から) 加茂次郎義綱 (七代目尾上菊五郎)、鎌倉権五郎景政 (十二代目市川團十郎)、清原武衡 (四代目市川左團次) 他

Shibaraku (Kabukiza Theatre, May 2003)
(from left) Kamo no Jiro Yoshitsuna (Onoe Kikugoro VII), Kamakura Gongoro Kagemasa (Ichikawa Danjuro XII), Kiyohara no Takehira (Ichikawa Sadanji IV), others

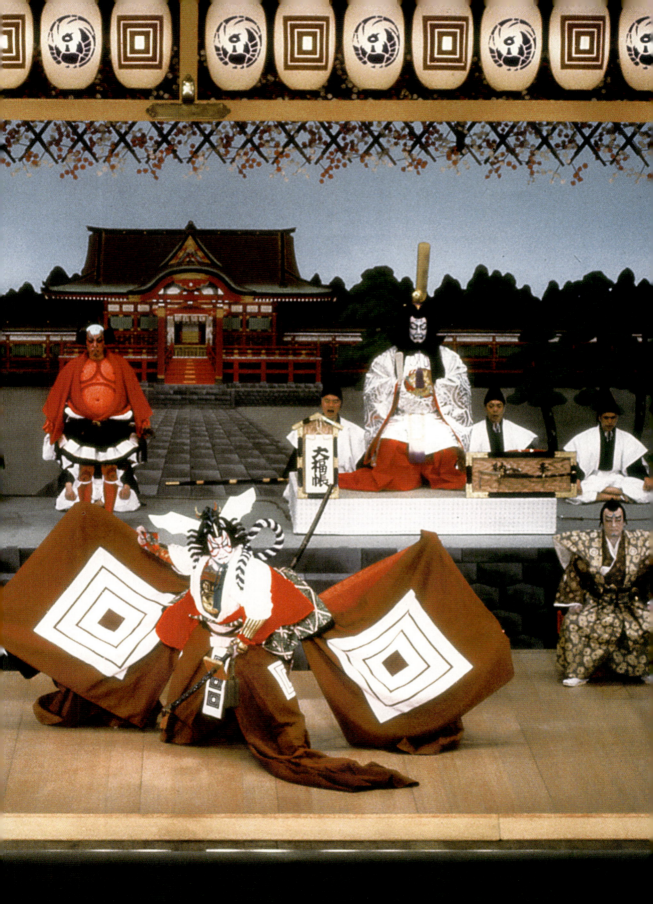

暫

あらすじ

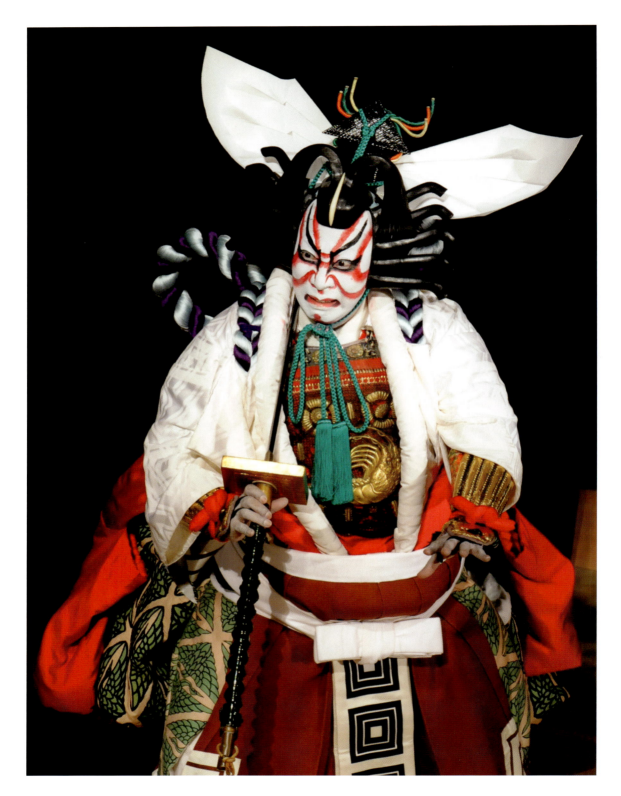

『暫』 2010年7月 新橋演舞場 鎌倉権五郎景政（十二代目市川團十郎）
Shibaraku, Jul. 2010 (Shinbashi Enbujo Theatre)　Kamakura Gongoro (Ichikawa Danjuro XII)

あらすじ / Synopsis

歌舞伎ならではの面白さが凝縮された一幕

「しばらく」と声をかけて登場するスーパーヒーロー。大きな体でしかも雄弁。
強くて頼りになる若者が、正義の力で悪人たちをやり込める。
連綿と演じつがれ、江戸の歌舞伎のエッセンスが今でも味わえる奇跡の演目。

A Scene that Encapsulates the Essence of Kabuki

The hero appears in the nick of time.
"Just a moment!" he shouts with eloquent authority.
The young yet strong protagonist defeats the villain with the power of righteousness.
"Shibaraku" is a scene that has been played since the Edo period and perfectly encapsulates the unique charm of the kabuki theater.

　後三年の役で勲功のあった清原武衡は、鎌倉鶴岡八幡宮において、自ら関白を名乗る儀式を執り行おうと企て、高位高官のみが許しを得て着ることができる、冠装束を着用している。

　そばに控えているのは、鹿島入道震斎、那須九郎妹照葉をはじめ、東金太郎、足柄左衛門、荏原八郎、埴生五郎ら、武衡に従う面々。そこには加茂次郎義綱と、許嫁の月岡息女桂の前をはじめとする人々が連行され引き据えられている。

　義綱をはじめ人々は武衡の装束に驚き、また義綱が奉納した大福帳の額を引き下ろし、代わりに雷丸（いかずちまる）という刀の額を掲げた非礼をただすが、武衡は聞き入れない。それどころか義綱に家来になるように迫るとともに、桂の前には自らになびくよう迫り、拒絶されると、成田五郎を呼び出し、全員の首をはねるよう命じる。

　家来たちが太刀を抜き、まさに首を切ろうとしたその時、「しばらく」という声がかかり、鎌倉権五郎景政という若者が現れる。武衡の家臣たちは権五郎を恐れ、この場から去らせようとするが、権五郎は、むしろ恐れげもなく武衡の近くまで歩を進め、許しのない装束の僭越（せんえつ）と、額を下ろした無礼を咎める。

　また、その代わりに奉納しようとしている雷丸は、実は偽

After distinguishing himself in the Gosannen War, Kiyohara Takehira plans a ceremony at the Kamakura Tsurugaoka Hachimangu Shrine to claim the position of chief advisor to the emperor. He wears a ceremonial garb and headdress that only the highest-ranking officials are allowed to wear.

Takehira has a large following of loyal supporters, including Kashima Nyudo Shinsai and Teruha. Kamo no Jiro Yoshitsuna and his fiancée Katsura no Mae, among other nobles of the imperial house, have been taken hostage by Takehira and his men.

Yoshitsune and the others, shocked to see Takehira's clothes, withdraw the money that Yoshitsune had previously donated and demand that Takehira return the sacred sword Ikazuchimaru. Takehira, however, ignores all of this and demands that Yoshitsuna become his servant and Katsura no Mae marry him. When they refuse these demands, Takehira calls Narita Goro to execute all of the hostages.

As Takehira's retainers draw their swords and prepare to execute the prisoners, the young Kamakura Gongoro Kagemasa appears with a shout: *"Shibaraku!"* Takehira recoils in fear of Gongoro and the valiant Gongoro steps forward, admonishing him for all of his wrongdoing.

It turns out that the sword Takehira was going to dedicate at the shrine is actually a counterfeit of Ikazuchimaru. Gongoro claims that this fake sword is cursed, and that Takemasa had orchestrated Yoshitsuna's

の刀で、呪詛の意味があること、さらに、義綱が勘当を受ける原因となった、印の紛失も武衡一味の仕業であろうと糾弾する。

　その時、武衡方と思われていた照葉が権五郎に声をかける。探している印は照葉が持っているというのである。実は照葉は武衡側に間者として入り込んでいたのである。さらに、近くに控えていた源義家（義綱の兄）の家臣小金丸行綱を呼び出し、本物の雷丸を差し出す。

　紛失していた印がもどり、真の宝剣雷丸を手に入れた義綱らは窮地を逃れる。

　権五郎はなおも襲い掛かる武衡の手下らを薙ぎ払うと、意気揚々と去っていくのだった。

disinheritance.

　At this moment, Teruha, who was supposedly working for Takehira, calls out to Gongoro. She had actually been spying on Takehira, and now has the seal that Yoshitsuna had lost, leading to his inheritance. She then calls on Koganemaru Yukitsuna to bring the real Ikazuchimaru.

　Yoshitsuna and the other imperials escape with the lost seal and sacred sword Ikazuchimaru. As Takehira's men attempt to stop them one last time, Gongoro mows them down and exits triumphantly.

作品の概要

演目名

暫

作者

不詳
（現行台本は福地桜痴による改訂）

概要

　「歌舞伎十八番」の中でも、古風な趣を残す演目である。
　超人的な力を持つ正義の味方が、悪人たちにより窮地に陥った善人たちを助ける、という『暫』の場面は、江戸歌舞伎では、毎年11月に上演される「顔見世狂言」で必ず挿入され、役名や演出もその都度替えられた。そのため様々な趣向の『暫』の場面が創作された。
　明治になり、九代目團十郎により「歌舞伎／十八番の内／暫」として、独立した演目として上演されるようになった。現行の上演は、明治28（1895）年11月東京・歌舞伎座において九代目團十郎が最後に上演した際の台本（福地桜痴改訂）と演出を受け継いでおり、掲載のあらすじは、現行台本によるものである。
　元禄10（1697）年1月　江戸・中村座において、初代市川團十郎が『参会名護屋』でこの趣向を演じたのが始まりとされる。

初演

元禄10（1697）年1月　江戸・中村座（『参会名護屋』）

Overview

Title

Shibaraku (Just a moment!)

Writers

Unknown
(present revised version by Fukuchi Ouchi)

Overview

　Among the *Eighteen Great Kabuki Plays*, *"Shibaraku"* retains many elements of the old style of kabuki. The superhuman hero who represents justice saves the victims from an evil villain—this is the essence of *"Shibaraku"* and was always included in the *"kaomise-kyogen"* performances held every November during the Edo Period. Characters names and production are often altered freely to suit the occasion, so there are many different varieties of *"Shibaraku."*
　From the Meiji Period, Danjuro IX began showing *"Shibaraku of the Great Eighteen Kabuki Plays"* as a standalone performance. The modern version of the scene is based on the script used for the final performance of *"Shibaraku"* by Danjuro IX in November 1895 at Tokyo's Kabuki-za. The synopsis given here is based on this script.
　"Shibaraku" is said to have originated from Ichikawa Danjuro I's performance of *Sankai Nagoya* at the Nakamura-za Theater in Edo (Tokyo) in January, 1697.

Premiere

January 1697, Nakamura-za Theatre, Edo (under the title *Sankei Nagoya*)

登場人物 / Characters

鎌倉権五郎景政
かまくらごんごろうかげまさ

江戸荒事の最も典型的な役で、荒唐無稽といえるほど強い主人公だが、前髪の付いた少年というのがお約束。正義の弱者たちが悪者どもに処罰されそうになった時、「しばら〜く〜！」と大声を上げて登場するので、「暫」がこの演目とこの役の通称となった。江戸時代は毎年11月の顔見世で必ず上演され、その都度役名が変わっていたが、明治28年の九代目團十郎の上演以降、この名前に統一されるようになった。

Kamakura Gongoro Kagemasa

This role is an archetype of the kabuki theater and particularly of the *aragoto* ("rough") style of play: the bombastic hero. The protagonist is meant to have seemingly absurd physical strength but is to be played by a young man with a very specific hairstyle including bangs. As the poor weak souls are to be punished by the antagonist, Gongoro appears in the nick of time, shouting "*Shibaraku!*" ("Just a moment!"). In the Edo Period, this piece was performed every year during the kaomise celebrations. For some time, the protagonist's name would change with each production, but *Shibaraku* was eventually standardized when Danjuro IX began playing the role in 1895.

清原武衡
きよはらのたけひら

舞台の中央に立ちはだかる巨悪。天下の乗っ取りを企み、高位高官の象徴たる冠装束を自ら身にまとって権力を主張している。公家悪と呼ばれる役柄で、顔には公家荒れという不気味な青い隈取が施されている。主人公の力強い演技を受ける役なので通称を「ウケ」と呼ぶが、その昔上演のたびごとに役名が変わっていたため、どの役かが特定できるよう、この演目特有のこういった通称が付けられている。

Kiyohara no Takehira

The villain who dominates center stage, Kiyohara no Takehira dons extravagant robes symbolic of the royal power he plans to usurp. This traditional *kugeaku* ("evil noble") role is characterized by a ghastly blue makeup. Because the roles in Shibaraku used to change so often, a special nickname was created for the villain. That name is *uke*, a term indicating that the villain will suffer the protagonist's power.

鹿島入道震斎
かしまにゅうどうしんさい

清原武衡に媚びへつらう坊主で、鯰（なまず）のひげを連想させる長く伸びたもみ上げにコミカルなその隈取、特徴的なその風貌から「鯰」と通称される。根っからの臆病者にもかかわらず鎌倉権五郎を追い払おうと恐る恐る向かってゆくが、ひと睨みされてだらしなく退散する。登場人物の中でもとりわけ滑稽な役で、役柄としては半道敵（はんどうがたき。半分道化の敵役）の部類に入る。

Kashima Nyudo Shinsai

An obsequious young priest with wispy sideburns reminiscent of a catfish, this role is commonly called *namazu*, the Japanese term for a catfish. A thoroughly cowardly character, he attempts to drive Gongoro away, only to retreat at a single glance from the enraged protagonist. A relatively comical character, this role falls under the *handogataki*, or the "half-comic antagonist."

加茂次郎義綱
かものじろうよしつな

清原武衡と対立する善人方の筆頭。重宝の印を紛失してお家存亡の危機、さらに武衡から家来になるよう要求され、許婚の桂の前も差し出せと脅されている。共にそれを拒絶すると今にも首を刎ねられそうな瀬戸際に立たされるが、あわやと思ったその時に鎌倉権五郎が現れて救われる。他にも数名の同胞（弱者）がいるが、上から大きな太刀を振りかざされているので「太刀下」と通称される。

Kamo no Jiro Yoshitsuna

The chief character among the characters abused by Takehira, Prince Yoshitsuna has lost his treasured seal and finds his house at the brink of ruin when Takehira appears, demanding that he become his retainer and submit his fiancé, the princess Katsura no Mae. Both the prince and princess refuse Takehira's demands, and are to be beheaded for their disobedience when Gongoro appears to save them. Yoshitsuna and Katsura have other companions (the *yowamono*), who are commonly called *tachishita* for the tachi swords they wear.

照葉
てるは

震斎の仲間でお神酒徳利のような存在、姿も妖しい「女鯰」と通称される。瓢箪（ひょうたん）が付いた梅の枝を担いでいるが、これは「瓢箪鯰」をもじった歌舞伎らしい洒落である。震斎に代わって権五郎のそばへ行き退散させようと試みるが、そこでのやり取りはまた一味違って観客を楽しませる。実は鎌倉権五郎の従妹で、スパイとして武衡側に入り込み、重宝と宝剣をまんまと盗み出す。

Teruha

A friend of Shinsai's, Teruha also has a rather fishy appearance, earning this character the popular name of *onnanamazu* ("female catfish"). She carries a plum branch with a gourd attached to it, a comic reference indicating her slippery character. After Shinsai's failed attempt, she goes after Gongoro which results in a rather entertaining fight. As it turns out, she is actually Gongoro's cousin, and has only been acting as a spy to steal back the sacred treasure and sword.

成田五郎義秀
なりたごろうよしひで

武衡側の従者で剛の者、いかにも下っ端の暴れ者を象徴するように「赤っ面」で大きな腹を突き出しているので、見た目の通り「腹出し」と通称される。その並外れてコミカルな姿は、いかにも歌舞伎の荒事らしい無類の大らかさを感じさせる。成田五郎は数人登場する腹出しの中でも筆頭格で、加茂義綱をはじめ「太刀下」の者たちを処刑する実行役として、呼び出されてから改めて登場する。

Narita Goro Yoshihide

Narita Goro is a great warrior on Takehira's side with vibrant red makeup and a great belly. This visage has earned this character the common name of *haradashi*, or "engorged belly." This utterly comical appearance is typical of kabuki, lending the piece a uniquely carefree mood. Narita Goro is the leader of the *haradashi* characters in Shibaraku and reappears as the executioner of Yoshitsuna and the other innocent *tachishita* characters.

小金丸行綱
こがねまるゆきつな

清原武衡に従う家来だが、実は善人方で照葉と同じくスパイとして潜り込んでいた少年。鎌倉権五郎が悪者一味を制圧した後、照葉が進み出て「預け申したその品を、急いでこれへ」と呼びだすと小金丸が刀を持って登場、その手にあるのは探し求めていた宝剣の雷丸。加茂義綱が見極めてみればまさしく本物、これでお家安泰と喜び、危機にさらされていた一同は悠然と引き上げてゆく。

Koganemaru Yukitsuna

The young man Yukitsuna appears on Takehira's side, but is actually a spy like Teruha. After Gongoro defeats the villains, Teruha comes forth and calls for Yukitsuna to bring out "that item I left in your keeping." Yukitsuna appears with a sword, which Yoshitsuna examines and confirms is actually the sacred sword *Ikazuchimaru*. With this his house can be restored, and so he and his companions make their joyous exit.

みどころ
Highlights

1. 鎌倉権五郎景政の衣裳
— Kamakura Gongoro Kagemasa's Costume

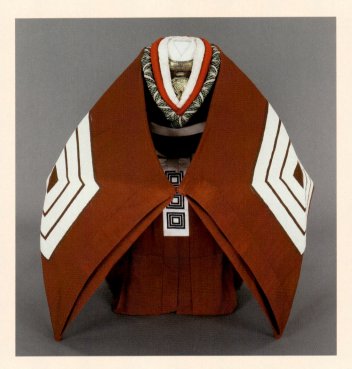

歌舞伎衣裳最大級の重さがある。黒地に松葉色柄入りの着物に、柿色の素襖大紋。袖には市川團十郎家の家紋三升が染め抜かれている。舞台いっぱいに袖を四角く拡げた大きな見得を観ると、邪気が払われると言われる。

Gongoro's costume is one of the most magnificent in kabuki. A black kimono with pine needle pattern over reddish-brown *suo-daimon* robes. The sleeves bear Ichikawa Danjuro's family crest. When Gongoro spreads his arms out in a grand *mie* pose, the sleeves seem to take up the whole stage as though to ward off all evil.

2. やっとことっちゃ、うんとこな
— A Heroic Shout

「歌舞伎十八番」は大らかな気分の良さが特徴で、そのひとつ『暫』は悪人退治がテーマ。赤い隈取の主人公鎌倉権五郎は正義の味方。悪人たちが善人たちを殺そうとするところに颯爽と現れ、「やっとことっちゃ、うんとこな」のかけ声もろとも、悪人たちをさぁっと退治、力強く問題を解決する。『毛抜』の粂寺弾正も天井に潜む悪者退治の時に、『助六由縁江戸桜』の助六も意休に近づく時に、このかけ声を発する。

Each of the *Eighteen Great Kabuki Plays* is known for their epic themes, and one of those is the grand defeat of the villain as seen in "*Shibaraku*." The bombastic hero Kamakura Gongoro in red *kumadori* makeup is the ultimate virtuous hero who gallantly jumps in just as the hostages are about to be killed. With a great shout of "*yattokotoccha, untokona*" (an amalgamation of various exclamations in Japanese), Gongoro immediately expels the villain and helps resolve the conflict of the play. Kumedera Danjo in the scene "*Kenuki*" can be seen shouting the same line. It is thought to be the dialect of Ichikawa Danjuro's ancestors who were from Koshu. This shout is reminiscent of the Warring States Period Takeda warriors.

3. 荒事～勢いのあるツラネ
—— Aragoto and the Vigorous Tsurane Monologue

初代市川團十郎が始めた正義のヒーロー大活躍の歌舞伎は、「荒事（あらごと）」と呼ばれる。関西で主流だった優しい美男が活躍するラブストーリーを「和事（わごと）」と呼んだのに対して生まれた言葉だという。「荒事」は少年の心で演じることが大切と言われる。「荒事」の遺伝子は現代の戦隊物のヒーローに伝わっているとも。花道にどっかり座った権五郎の、劇場中を圧倒するツラネと呼ばれる勢いある長せりふは聴きどころ。

The *aragoto* style that emphasizes the bombastic hero was started by Ichikawa Danjuro I. It was popular in the Kansai region, and the term *aragoto* came about as a contrast to the *wagoto* style which depicts the love story of a kind and dashing young man. It is said that *aragoto* roles must be played with a young man's mentality in mind, and that the style originates from the heroes of war stories. One of the most impactful moments of *Shibaraku* is watching Gongoro plunk down on the *hanamichi* and give a powerful *tsurane* monologue.

4. ウケ
—— Uke

舞台の上手奥に鎮座している悪人を、ウケと呼んでいる。正義の味方鎌倉権五郎の登場を受け止める役なので、「ウケ」である。貴族のような、仰々しい刺繍の付いた白い衣裳に青い隈取で髪は総髪。一見して巨悪とわかる扮装である。役名は清原武衡であるが、名前など客席はあまり気にして見ず、「ウケ」がなんだかんだ言うのを聞き流しながら、権五郎が花道の奥で発する「しばらく!」のかけ声を今か今かと待っている。

The villain who sits in the upper right hand of the stage is called *uke*, which derives from the verb "*ukeru*." This is a reference to the fact that the villain will suffer the punishment of the righteous hero Gongoro. The *uke* wears white robes with exaggerated embroidery called *shikami* as well as ghastly blue *kumadori* makeup and a knotted hairstyle. This costume is meant to indicate immediately to viewers that this is the villain of the story. Though this role takes on different names depending on the production, most viewers don't care much about this. Rather, the fun of the show is anticipating when the hero will shout "*shibaraku!*"

5. 昔は様々なヴァージョンがあった
—— The Various Versions of the Past

『暫』は、初代團十郎の「しばらく」と声かけするシーンがあった芝居を起源とする。顔見世狂言の一場面として『暫』を出すことが定番になったので、役名はその芝居の世界によって違っていた。なかには、主人公を女性にした『女暫』もある。勇壮なせりふが一転して女性らしい恥じらいを見せる場面が楽しい。明治28（1895）年に九代目團十郎が演じた折の台本が定着して以来、今では『暫』の主人公と言えば鎌倉権五郎景政となっている。

The origin "*Shibaraku*" is a scene performed by Danjuro I in which his character shouts, "*shibaraku*." After this, the play became a staple of the annual *kaomise* celebrations and underwent many alterations over the years. There is even a version called "*Onna Shibaraku*" in which the protagonist is a woman and the script is adjusted to make the hero more reserved and lady-like. The script used by Danjuro IX in 1895 has now become the standard, and Kamakura Gongoro Kagemasa is the hero of the official "*Shibaraku*."

6. 仁王襷（におうだすき）は力の象徴
―― Nio-dasuki Cords―a Symbol of Power

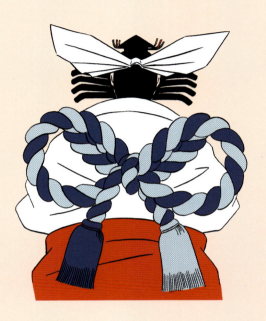

花道から舞台へ乗り込んだ権五郎が、衣裳を次々と肩脱ぎにすると、背中の紫と白を縒り合わせた極太の襷があらわになる。仁王襷である。古代には神を祭る際に行われていた。襷掛けは、袖の長い着物を着ていた時代には、袖を汚さないようにするために不可欠の実用の技だった。襷をピンと張らせた後ろ姿は権五郎の超人的な力を象徴している。

Gongoro enters from the *hanamichi*, pulls his kimono shoulders down, and uses exaggerated purple and white *tasuki* cords to tie back his sleeves. These cords are called *nio-dasuki*, and Gongoro's skilled students stand behind him and help him tie them, since their size makes it very difficult to tie by oneself. This magnificent scene is one you won't want to miss. *Tasuki* cords are traditionally used to tie back long kimono sleeves so as not to dirty them, and Gongoro's ability to tie them immediately is meant to evoke his superhuman strength.

7. 役者の名前でご挨拶
―― Breaking the Fourth Wall

花道に座った権五郎は、相手に出たなまず坊主を一撃でノックアウト。続いてピンチヒッターに立った女なまずは、巨大な扮装の権五郎にすり寄って、愛想を言う。「まあ、誰かと思ったら○○屋の〜さんじゃないの」というように、演者の屋号や名前で呼びかけるのだ。すかさず権五郎は、「誰かと思やあ、○○屋の姉え」などと返す。デコラティブな衣裳の古風な芝居に挟まれる、リアル楽屋落ちで、客席も大いに盛り上がる。

The gallant *Gongoro* defeats the catfish-like villain (*namazu-bozu*) in a single blow, after which the female catfish (*onna-namazu*) steps forth. This part of the scene shows the actors break character and address each other by their stage names. This banter among colleagues is a unique feature of kabuki that is quite entertaining to patrons of the theater.

8. 女なまずに、腹出し
—— *Onna-namazu* and *Haradashi*

悪の面々は派手なビジュアルで、それぞれニックネームがある。髪を尖らせ、筋肉隆々の胸元をさらけ出し仁王様のように立っている面々は通称「腹出し」。頭のてっぺんを剃り上げ、両耳ワキのもみあげを鯰（なまず）の髭のように垂らした人物は「なまず坊主」。瓢箪を肩に提げた赤い着物の女性が「女なまず」である。ただし、女なまずは実は権五郎の味方。下手側に縮こまって、今にも処刑されようとしている善人たちは「太刀下」とひとからげに呼ばれる。

The many villains in "*Shibaraku*" each have special nicknames referencing their eccentric physical appearance. The villain with tapered hair and bulky bodies is called *haradashi* for the way his bulging stomach protrudes. The character with a shaved head but sideburns that fall from the ears like a catfish are called *namazu-bozu*, and the woman in the red kimono who carries a gourd is called *onna-namazu*. Confusingly, *onna-namazu* is actually Gongoro's ally, and not a villain. The hostages huddled on the right side of the stage are called *tachi-shita*, a reference to their impending death at the hands of the villains.

9. 鹿島入道震斎の衣裳
—— Kashima Nyudo Shinsai's Costume

おどけた敵役の震斎は坊主頭で、両のもみあげを長く伸ばした姿が鯰に見える。衣裳の趣味もユーモラス。革色紬の着物は貝尽し柄で、裾を東絡げにして着る。共布の羽織は、赤い蛸の足が首から八方に延びた首抜き柄。

This jocular villain role, Kashima, is bald and has sideburns which give him the appearance of a catfish. The design of his costume is also humorous. The deep blue-green *tsumugi* (a soft thin cloth woven from silk) has a shell patterns and hems flipped up and pinched at the belt. The *haori* (short Japanese overgarment) is made of the same fabric with a red octopus leg pattern which extends out in all directions starting at the neck.

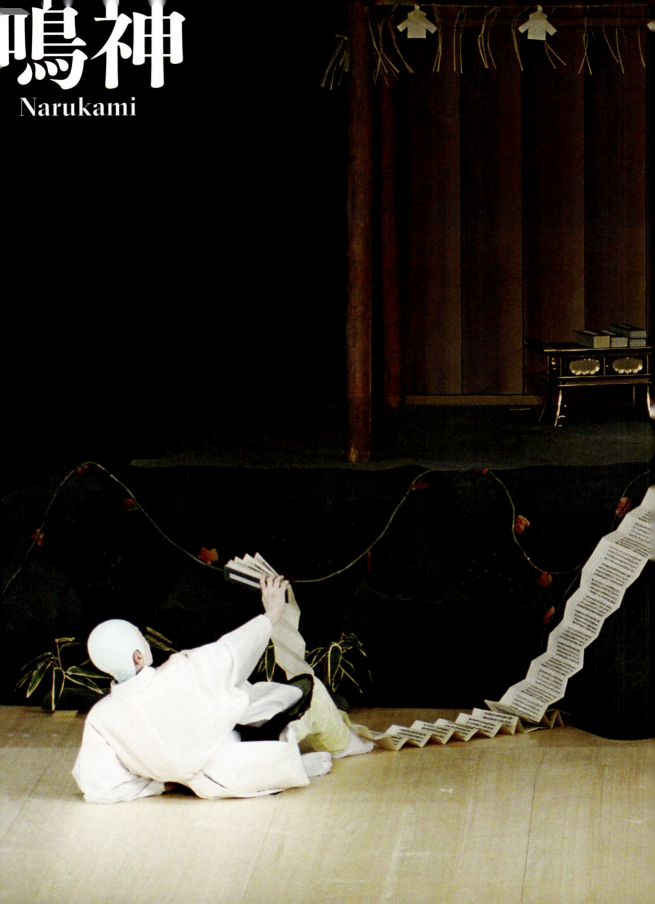

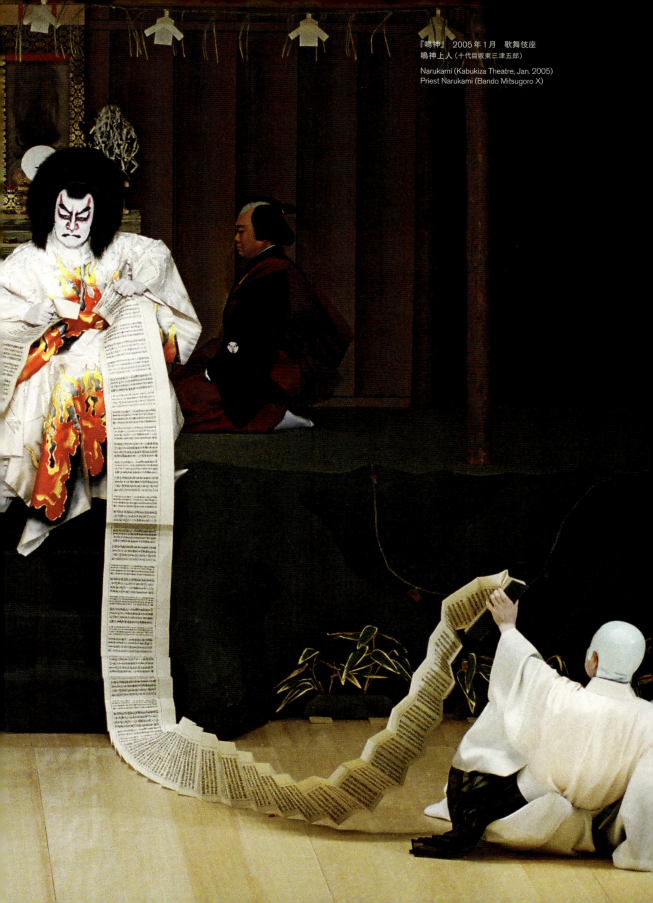

『鳴神』 2005年1月 歌舞伎座
鳴神上人（十代目坂東三津五郎）

Narukami (Kabukiza Theatre, Jan. 2005)
Priest Narukami (Bando Mitsugoro X)

鳴神

あらすじ / Synopsis

古今東西解説不要。
歌舞伎十八番の人気演目

古風な歌舞伎の様式の面白さに満ち満ちた作品で、
女方のせりふ術や荒事といった見どころの多い一幕。

A Title that Needs no Introduction
A Masterpiece Among
the 18 Great Kabuki Plays

A piece in the most traditional style of Kabuki
that showcases both the power of a beautiful woman's words
and the archetypical aragoto style of performance.

あらすじ

　平安時代のこと。自らの行法のおかげで皇子が誕生したのに、褒美の約束を守らない朝廷に怒った鳴神上人は、秘術を用いて龍神龍女を北山の滝壺に封じ込めた。雨を降らす龍を封じ込められ、それからというもの日照りが続き、干ばつで民は苦しんでいた。

　上人と弟子の白雲坊と黒雲坊が住まう北山の滝のほとりの庵に、一人の美しい女がやってくる。女は亡き夫の衣を滝の水ですすぎにきたと言い、問われるままに女が亡き夫との馴れ初めを話す。

　女の話に聞き入っていた上人は壇上から落ち気絶してしまう。すると女は滝の水をくんで口移しに鳴神に飲ませ、胸をさすって介抱する。気がついた上人は一角仙人が美女の色香に迷って通力を失った故事を思い出し、女を警戒する。

　女は上人の弟子になり出家したいと言い、上人の疑いを晴らす。弟子たちが出家の支度に山を下り、二人きりになると、女は癪を起こし苦しみだす。癪を抑えるため女の懐に手を入れ、初めて女に触れた上人は、次第に自分が押さえられなくなった挙句、自分と夫婦になるよう女に迫る。そして、祝言の杯と称して女がすすめるまま酒を飲み、戒律を破った上に酔いつぶれた上人は寝込んでしまう。

　その隙を窺い、女は滝のしめ縄を切る。酔った上人からし

Heian Japan. The priest Narukami, whose prayers led to the birth of the crown prince, bears a grudge against the imperial court for breaking their promise to him. He thus uses his powers to confine the dragon god of rain within a waterfall in the mountains to the north. With no more rain, there is a great drought and the people suffer greatly.

A beautiful woman appears at the hut in the mountains where the Narukami and his disciples live. She tells them that she has come to wash her late husband's robes at the waterfall. Narukami asks more about her husband, and the woman tells the story of how they fell in love.

Narukami listens intently to the story, and eventually faints, falling from the stage. Seeing this, the woman takes water from the waterfall, has Narukami drink it directly from her mouth, and gently caresses his chest to bring him to. When Narukami awakens he is wary of the woman, remembering a story of the sage Ikkaku who lost his powers due to the charms of a beautiful woman.

The woman claims she wishes to become Narukami's disciple, dispelling his suspicions. The other disciples leave to prepare for the rites of entering the priesthood, leaving Narukami and the woman alone. The woman then begins to shake violently, causing Narukami to reach into the chest of her robes to calm her. Having touched a woman for the first time, Narukami is unable to control himself and asks her to marry him. In celebration, the woman offers wine to the priest, who accepts, breaking his precepts and eventually falling asleep in a drunken stupor.

め縄を切ると雨が降ることを聞き出していたのだ。すると龍神は飛び去り、雷鳴がとどろき大雨が降ってくる。女は、雲の絶間姫という宮中第一といわれる美女で、成功すればかねて思いを寄せる男と夫婦になることができるとの条件で、鳴神上人を堕落破戒させるために朝廷からさしむけられたのだった。姫は鳴神を心ならずも騙したことをわび、ふもとへと逃げ去る。

駆けつけた弟子たちにより、自らが騙されたことを知った上人は、怒りのあまり恐ろしい姿になり、とめる弟子たちを投げ飛ばし、姫の後を追っていくのだった。

Slipping away, the woman cuts the cords binding the dragon god to the waterfall, having heard from the priest that this would cause the rains to fall again. The dragon god then flies away and with a roar of thunder, a great downpour of rain begins. As it turns out, the woman is actually the great beauty Princess Taema, sent by the court to seduce Narukami with the promise of marriage to the man she loves if she should succeed. Taema apologizes for brazenly deceiving Narukami and leaves the mountain.

As Narukami's disciples hasten back to the mountain, he realizes what has happened and becomes enraged. In a fit of rage, he grabs his disciples and hurls them away from himself, then hurries after the princess.

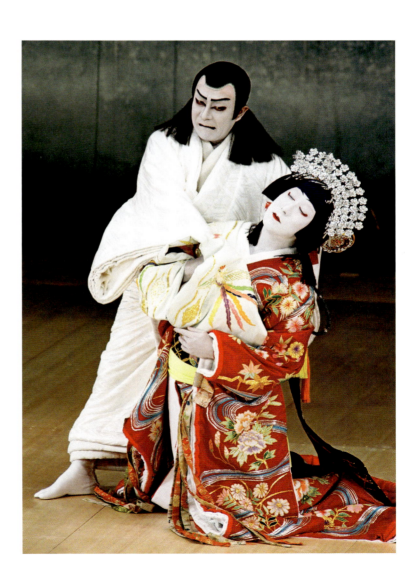

『鳴神』 2005年1月 歌舞伎座
(左から) 鳴神上人 (十代目坂東三津五郎)、雲の絶間姫 (五代目中村時蔵)

Narukami (Kabukiza Theatre, Jan. 2005 (from left) Priest Narukami (Bando Mitsugoro X), Princess Kumo no Taema (Nakamura Tokizo V)

鳴神

作品の概要 / Overview

演目名 / Title

鳴神

Narukami

作者 / Writers

安田蛙文・中田万助（『雷神不動北山桜』）

Yasuda Abun, Nakata Mansuke

概要 / Overview

「歌舞伎十八番」の一つ。高僧が美女の色香に迷い破戒し、荒事になるという内容を持つ演目は、初代團十郎がはじめたといわれるが不詳である。二代目團十郎も何度か上演し、寛保2（1742）年1月 大坂・佐渡嶋長五郎座の安田蛙文、中田万助合作の『雷神不動北山桜』でほぼ確定したといわれる。鳴神の部分は全五幕の内の四幕目に当たる。

その後様々に改訂を加えながら上演されたが、幕末に八代目團十郎が上演した後上演が絶えた。

現行の『歌舞伎十八番の内 鳴神』は、明治43（1910）年5月、明治座において二代目市川左團次が『雷神不動北山桜』などにより復活上演し、これがもととなっている。二代目左團次は、復活にあたり、幕末の台本ではなく、あえて古い時代の台本を選定し、演出も古風な歌舞伎の趣を取り入れた。

劇中にも出てくる一角仙人の説話は、インドに起源をもち、能にも取り入れられている。古今東西普遍的な内容に荒事の面白さを加えた、歌舞伎ならではの演目である。

登場人物が少なく、最後の立ち回りの人数を除けば、鳴神上人と絶間姫、それに白雲坊・黒雲坊が舞台を進行させていく。それだけに上人の前半の高僧ぶりと、後半一転しての荒事、絶間姫の仕方話では、女方の語り聞かせる芸など、演者の持ち味をたっぷりと楽しめる。

"Narukami" is one of the *Eighteen Great Kabuki Plays (kabuki juhachiban)*. Though unconfirmed, it is said that the story of the noble priest being seduced by the beautiful woman, thus falling from his lofty position, was started by Danjuro I. Danjuro II also played this story many times, and it was firmly established in the repertoire in 1742, with the premiere of *Narukami Fudo Kitayama Zakura*. "Narukami" is the 4th act of this 5-act play.

The play was performed many times after that, with minor alterations, but productions stopped after Danjuro VIII's production.

"Narukami" as played today was revived by Ichikawa Sadanji II in May 1910, who had the full play performed at the Meiji-za Theater. Sadanji II chose an old manuscript and made painstaking efforts to make it a traditional production that harkened back to kabuki's origins.

The story of the sage Ikkaku, which is referenced in "Narukami," is an ancient story of Indian origin that is also used in noh. The use of such time-honored, universal stories, juxtaposed with the aragoto style of Kabuki, is a truly unique feature of the Kabuki theatre.

"Narukami" features a very small cast. Excluding characters who appear at the end, it consists of only Narukami, his two disciples, and Taema. However, because of this, the audience is able to thoroughly enjoy the incredible skill required of performers in such a sparse play. The lofty priest who falls into vulgarity in the latter half, and the enticing words of the beautiful woman are truly a sight to behold.

初演 / Premiere

寛保2（1742）年1月 大坂・佐渡嶋長五郎座（『雷神不動北山桜』）

January 1742, Sadogashima Goro-za Theatre, Osaka (under the title *Narukami Fudo Kitayama Zakura*)

登場人物　　　　　　　　　　Characters

鳴神上人
なるかみしょうにん

気高く潔癖な高僧が美女の色香に迷って破戒堕落するという話は一角仙人や久米仙人といった伝説があり、この鳴神上人もそのあたりから材を得ている。上人は朝廷が約束を破ったため大いに怒り、世界中の龍神を滝壺の中に封じ込めて雨が降らぬようにしてしまった。しかし雲の絶間姫の妖艶な誘いに乗って酒を飲み、酔った隙に龍神を放たれてしまう。やがて怒りは頂点に達し荒々しい姿となる。

Priest Narukami
The character of Priest Narukami is inspired by the old tales of Ikkaku and Kume, noble and sage priests who were seduced by young women, broke their religious precepts, and thus fell into depravity. Narukami is angry at the court for breaking its promise to him, so he hides the dragon god of rain in a waterfall. However, he is later seduced by Princess Taema, drinks wine with her, and in his drunkenness lets her release the rain god from its captivity. In the end he becomes consumed by his burning rage and resorts to depraved violence.

白雲坊・黒雲坊
はくうんぼう・こくうんぼう

鳴神上人の弟子だが、気品と威厳があり真面目一方の鳴神上人とは打って変わった生臭坊主ぶりで、酒も飲めば魚肉も好み、色の世界に興味津々…。二人一対のキャラクターとして場をしばしば和ませ、道化の役割を軽妙に演じる。上人から使いを言い渡され、日の暮れかかったなかを出かけるが、後に残るはお師匠様と美女、その心配はやがて的中、戻った時には上人の変わり果てた姿が。

Hakuunbo & Kokuunbo
Hakuunbo and Kokuunbo are Narukami's disciples, but they are the complete opposite of their solemn master. They love alcohol, fish, meat, and many other delights of the secular world. This duo's antics lighten the mood of many scenes in "Narukami." Leaving their master alone with the beautiful Taema at twilight, the two are worried about their master, but they never expected the sorry state they would see him in when they returned.

早雲王子
はやくもおうじ

陽成帝の御代、百日も続いた干ばつで川も田畑も水が涸れ人々は困り果てている。先帝の弟・早雲王子はその混乱につけこんで帝を追いやり、自らが帝位につこうと企んでいる。また雲の絶間姫に横恋慕し、姫を我が物にしようと様々な策略を練っている。絶間姫と豊秀の婚礼の場で最後の悪あがきをするが、鳴神上人の悪霊に呪縛されてしまう。この人物は『鳴神』には登場しない。

Prince Hayakumo
The reign of Emperor Yozei. A drought lasting over 100 days has afflicted the land, and Prince Hayakumo, the previous emperor's younger brother, plans to take advantage of the resulting confusion to seize power for himself. He is also in love with Princess Taema and plots to make her his own. He makes one last attempt at Taema and Toyohide's wedding but is cursed by the angry spirit of Narukami. Prince Hayakumo, like Toyohide, does not appear in "Narukami."

雲の絶間姫
くものたえまひめ

雲の絶間姫は文屋豊秀と夫婦になりたいが、鳴神上人のところへ行って雨を降らせることができたなら夫婦になれるという約束から一人で赴くこととなった。人里離れた鳴神上人の元へやって来て巧みな作り話や色仕掛けで上人を誘惑し、ついには酒を飲ませて堕落させ、滝のしめ縄を切って大雨を降らせる。雲の絶間という名前は、鳴神すなわち雷が雲の間から落ちるといった洒落である。

Princess Kumo no Taema
Princess Taema is in love with Bun'ya no Toyohide, and she is offered his hand in marriage if she goes to Priest Narukami and brings rain back to the realm. She travels far from her home to reach Priest Narukami, and with her silver tongue and womanly charm, convinces him to drink wine, breaking his sacred precepts. Slipping away when the priest is drunk, Taema cuts the ropes confining the rain god and causes a great downpour of rain. Her full name, Kumo no Taema, is a play on words that suggests the image of lightning falling from between the clouds.

文屋豊秀
ぶんやのとよひで

この場には登場しない公家で、小野春道の息女・錦の前と許婚になっている。しかし、錦の前は髪の毛の逆立つ奇病になっているため、家臣の粂寺弾正が春道の館を訪ねるというのが前段の『毛抜』。一方雲の絶間姫は豊秀に惚れぬいているので、鳴神上人のところへ出かけて見事雨を降らすことができれば嫁入りが叶うということで決心した。その祝言の場に怒りに満ちた鳴神上人の霊が襲いかかる。

Bun'ya no Toyohide
Bun'ya no Toyohide does not actually appear in "Narukami." He is betrothed to the Ono no Harumichi's daughter, Nishiki no Mae. However, she has contracted a rare disease that causes her hair to stand on end, which has postponed the wedding. The previous act, "Kenuki," shows the retainer Kumedera Danjo visiting the Ono house to see Nishiki no Mae. Meanwhile, Princess Taema herself has fallen in love with Toyohide, and is determined to go to Priest Narukami and bring rain back to the realm in order to marry him. In the very midst of their nuptials, however, the enraged spirit of Narukami suddenly appears and attacks them.

みどころ
Highlights

1. 鳴神上人の衣裳（ぶっかえり）
—— Narukami's Bukkaeri Costume

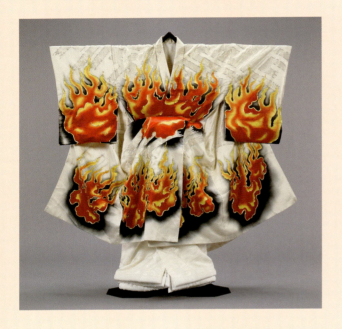

前半は白無地の着物で高潔な印象。だが女に裏切られたと知るや、全身に怒りの炎が立ち上る様を「ぶっかえり」と呼ばれる衣裳の手法で表現する。上着の肩の綴じ糸を抜き、一瞬で稲妻と火炎を刺繍した柄が現れるのだ。

At first glance, Narukami's plain white kimono gives a noble impression. However, when the character finds out he has been betrayed, violent flames symbolizing his anger spread across his whole body. This rapid change in costume is known as *bukkaeri*. In *Narukami*, a temporary binding thread on the jacket shoulder is pulled to reveal an embroidered flame and lightning pattern which represents Narukami's rage.

2. 天下に雨を降らせない
—— No Rain in the Realm

主人公鳴神上人は神通力を持っている。時の帝が上人とかわした約束を反故にしたので、怒った上人は法力で龍神たちを滝壺に閉じ込めてしまい、天下に雨が降らなくなった。田畑は干上がり、民の訴えに帝は苦慮しているというのが、このお話の背景。古来日本では、日照りが続くと帝をはじめ通力を持つ人々が雨乞い神事を行なってきた。舞台下手には滔々と水の流れる滝が見えているが、ここ以外に水がないことを想像して舞台を観てほしい。

The main character Priest Narukami possesses supernatural powers. Angered after the emperor reneges on a promise to him, Narukami uses his powers to confine the dragon gods in the basin of a waterfall. Because of this, there is a great drought, rice fields dry up, and the people starve. In ancient times, the emperor and other people possessing special powers would be charged with praying for rain in times of drought. In *Narukami*, the waterfall basin is located on the left side of the stage, and the audience is encouraged to imagine that there is no water anywhere else in the world of *Narukami*.

3. 天下一の美女のウソ
—— The Deception of a Beautiful Woman

鳴神上人のワザを破るため遣わされたのは、宮廷一の美

Princess Taema, the most beautiful woman at the imperial

女雲の絶間姫。色仕掛けで落とそうという企みである。実はこの姫はなかなか気の強い女性で、恋人の文屋豊秀との結婚を条件にこの作戦を引き受けた。恋の成就のためならどんなことも厭わない。豊秀には婚約者がいるのだが……。彼女がなりすますのは、夫と死に別れたばかりの女性。幸せの絶頂から突き落とされたという彼女の色っぽい思い出話に、上人はすっかり引き込まれる。

court, foils the schemes of Priest Narukami. An incredibly strong-willed woman, Taema uses her feminine charms to lead Narukami into secular depravity. She accepts this task with the promise of marrying her lover Toyohide whom she will do anything to have. Toyohide is already engaged, but his fiancée has a rare disease that has postponed their wedding. Taema, determined to marry him while she has the chance, pretends to have lost her lover to gain Narukami's sympathy and seduce him.

4. 「強い男が女に騙される」は世界の定番
—— The Strong Man Ruined by the Deceptive Woman

鳴神がどのようにして絶間姫に騙されるかが最大のみどころ。強い男が女に騙される物語は万国共通で普遍的。聖書の逸話から映画にもなった「サムソンとデリラ」では、美女デリラに酒を勧められ、酔った豪傑サムソンが、自分の力の秘密は髪の毛にあることを口走り、眠っている間にデリラに髪を切られて力を失う。「今昔物語集」などにある「久米の仙人」では、天空の雲に乗った仙人が下界の女性の足に見とれて通力を失い雲から落っこちてしまう。

Seeing how Princess Taema deceives Narukami is the greatest highlight of the show. The story of a charming woman deceiving a powerful man is a universal story found in many countries. Take the Bible's "Samson and Delilah," for example. Delilah gets Samson drunk and makes him reveal that his power comes from his hair. That night, Delilah cuts his hair, thus stripping him of his power. The noh play *Kume no Sennin* tells a similar story. The lofty sage residing in the clouds is beguiled by the legs of a woman from the secular world, and subsequently falls from his lofty heights.

5. 括り枕 (くくりまくら)
—— *Kukuri-makura* Pillows

長い修行生活を送っている鳴神上人は、女性を近づけたことがない。美女雲の絶間姫が突然苦しみだし、介抱しようとして胸元に手を入れ、何かまあるい柔らかいものが手に触れ、きょとんとして「なにやら括り枕のようなものの先に取っ手のようなものが」という。江戸時代の人は寝る時に結った髪が乱れないよう、枕を首に当てていた。括り枕もそのひとつ。細長い円筒形の布に、そば殻などを詰めてあり、両端がふっくらしている。

Priest Narukami has continued his ascetic religious practices for many long years, and has therefore never been near to a woman before. When the beautiful Princess Taema suddenly appears, he is taken aback. When she falls ill, it falls to Narukami to nurse Taema, which requires him to touch her. His hand slips into her robes and he notices something soft, "like a *kukuri-makura* with a knob attached to the end." In the Edo period, people slept by resting their necks on special pillows (*makura*) so as not to dishevel their hair. A *kukuri-makura* is one such pillow, which is filled with buckwheat hulls and drawn in at both ends.

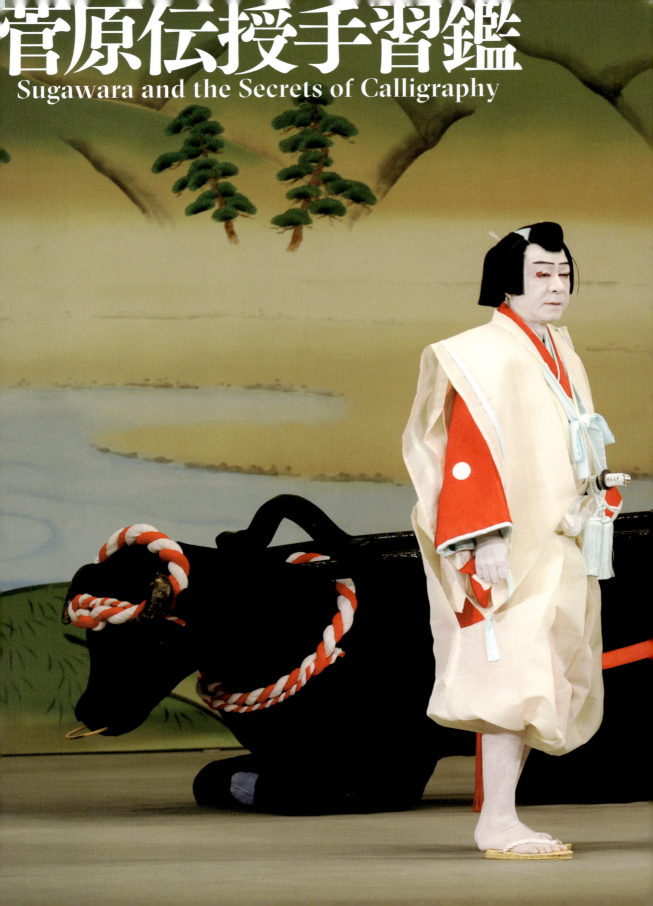

菅原伝授手習鑑
Sugawara and the Secrets of Calligraphy

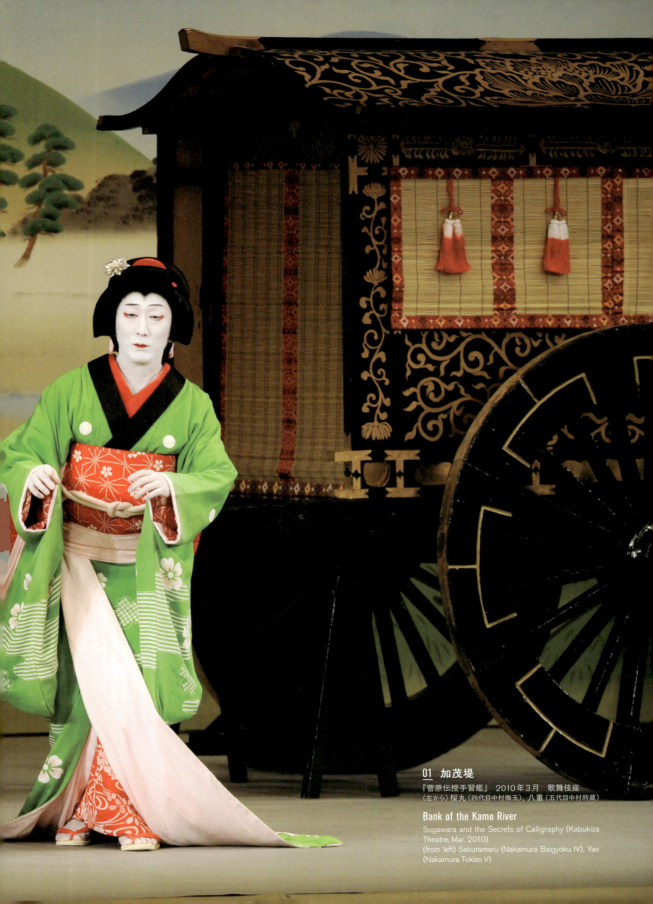

01 加茂堤

『菅原伝授手習鑑』 2010年3月 歌舞伎座
（左から）桜丸（四代目中村梅玉）、八重（五代目中村時蔵）

Bank of the Kamo River
Sugawara and the Secrets of Calligraphy (Kabukiza Theatre, Mar. 2010)
(from left) Sakuramaru (Nakamura Baigyoku IV), Yae (Nakamura Tokizo V)

あらすじ / Synopsis

恋人、親子、夫婦、兄弟、師弟。
すべてを引き裂き流れる歴史の怒涛

流人と家族の切ない別れ。老人の目の前で崩壊していく一家。
幼い弟子を殺すことを決意する師匠。
幼い恋を利用された二人、肉親を捨て孤独の道を歩む若者、自らの命を散らした者。
政治が、権力争いが、人々の人生を変えていく……。

The cruel currents of time that rend lover from lover, parent from child, master from student...

Exile forces a family to part painfully. A great house is on the verge of crumbling. A teacher must make the difficult decision of killing his own young student. Two lovers are used for political means, young men abandon their brothers, and one man takes his own life.
This is a story of how the government can drastically alter our lives...

01 加茂堤

帝の弟斎世親王に仕える舎人桜丸は、女房八重と言い合わせ、菅原道真(菅丞相)の養女苅屋姫と、親王との恋の仲立ちをするが、藤原時平の一味・三善清貫が、密通と騒ぎ立てる。

02 筆法伝授（菅原館奥殿）

菅丞相は、帝から優れた書の技法を弟子に伝えて残すように命ぜられ、精進潔斎して伝授すべき弟子を選定し、武部源蔵が呼び出される。源蔵は幼いころから丞相に仕え、書も学んでいたが、腰元だった戸浪との恋愛のため、丞相から勘当を受け、今は夫婦で寺子屋の師匠をしながら暮らしているのだった。

03 筆法伝授（菅原館学問所）

源蔵は、伝授より勘当を許してもらい、元の主従師弟に戻りたいと懇願するが、丞相は許さず、勘当と伝授は別であるとして、源蔵に筆法を授ける。そこに宮中からの急な呼び出し。丞相は装束を改め館をたつが、その際かぶっていた冠が

01 Bank of the Kamo River

Sakuramaru, who serves the emperor's brother Prince Tokiyo, and his wife Yae set up a meeting with Princess Kariya so that Tokiyo may profess his love to her. However, Fujiwara Shihei's friend Miyoshi no Kiyotsura helps to plot against them.

02 Transmission of the Secrets of Calligraphy (Sugawara Inner Palace)

Sugawara Michizane (Kan Shojo) is ordered to pass his secret calligraphy techniques on to a disciple, and so he chooses his former student, Takebe Genzo. Genzo learned from Shojo when he was very young, but was lost his inheritance after falling in love with the lady-in-waiting Tonami. Currently he teaches calligraphy at a rural temple school with his wife.

03 Secrets of Calligraphy (Sugawara Study)

Genzo asks to be reinstated as Shojo's retainer and student, but Shojo refuses, claiming that inheritance and transmission of secrets are separate matters. As he is teaching Genzo, Shojo is suddenly called to the palace. He changes his clothes, but his headpiece falls off as he leaves,

落ちる。不吉な予感とともに出仕する丞相。

04 筆法伝授（菅原館門外）

　果たして丞相は宮中で謀反の疑いをかけられた。斎世親王と養女の密会は道真の計画であるという。道真は知らぬことであり、敵対する藤原時平の悪計にはめられたのである。かくて道真は筑紫に流罪となる。冠が落ちたのはこの予兆だったのだ。

　道真に仕える舎人梅王丸は、道真の子菅秀才を武部源蔵に託す。

05 河内国道明寺

　筑紫へと流される丞相は、警護の役人判官代輝国の情けで、船の出航待ちの間、河内にある伯母覚寿の館に逗留している。覚寿は今回の事件の発端となった苅屋姫の実母。すべての原因となった娘を折檻するが、丞相の止める声がする。ところが、その声がしたひと間にあったのは、丞相が自ら彫り上げた木造のみであった。

　苅屋の姉立田の前は、宿禰太郎と夫婦である。太郎は父土師兵衛とともに丞相を偽の迎えで拉致し、暗殺することを企んでいたが、立田に立ち聞きされ、立田を斬殺する。

　ほどなく兵衛の偽の迎えが到着する。しかし輿に乗ったはずの丞相は、木像に代わっていた。

　やがて兵衛親子の悪計が露見し、太郎は覚寿によって成敗。丞相は、姫、覚寿との一世の別れを惜しみながら、筑紫へと旅立つ。

06 吉田社頭車引

　丞相に仕える梅王丸、斎世親王に仕える桜丸は三つ子の兄弟で、もう一人は松王丸といい、時平に仕えている。三つ子は天下泰平の瑞相という丞相の言葉で、三人がそれぞれの家に仕えたのだが、時平が斎世親王の恋を利用し、丞相を悪計にはめたため、兄弟は敵味方となってしまった。

　吉田神社に参詣する藤原時平の牛車に、梅王丸と桜丸が立ちふさがり、松王丸と争うが、牛車の中から現れた時平の威勢に、梅王丸・桜丸は圧倒されてしまう。兄弟双方、遺恨を残しつつ、父親の七十の賀の祝いまでは勝負は預け、とばかりに別れていく。

07 佐太村賀の祝

　佐太村の三つ子の親白太夫の家。白太夫はもと四郎九郎といっていた。三つ子が生まれた際丞相の口添えで三つ子は各家に仕えることができ、自らは佐太にある丞相の愛樹、梅・

an ill omen that leaves him unnerved.

04 Secrets of Calligraphy (Sugawara Palace Gate)

At the palace, Shojo is accused of plotting to seize power, claiming that he planned Tokiyo and Kariya's meeting. Unbeknownst to Shojo, this is part of his political rival Fujiwara Shihei's plot against him. Shojo is subsequently exiled to the distant Chikushi. His headpiece falling had truly been an omen of ill fortune.

Shojo's servant, Umeomaru, places Shojo's son Kan Shusai in the care of Genzo.

05 Domyoji in Kawachi Province

Shojo waits at his aunt Kakuju's residence in Kawachi Province for his escort to Chikushi, which is to take him by boat. Kakuju, Princess Kariya's mother, blames Kariya for Shojo's fate and beats her for it, but Shojo's voice is heard pleading with her to stop. Upon closer inspection however, it is not actually Shojo but a wooden statue of him.

Two men named Sukune Taro, husband of Kariya's sister Tatta no Mae, and Haji no Hyoe (Taro's father) have arranged a fake escort to pick up Shojo as part of an assassination attempt. Tatta overhears their plot, but the men kill her to keep her quiet. The fake escort arrives, but again it is not Shojo himself, but a wooden statue that boards the carriage. Kakuju discovers Taro and his father's plot and punishes Taro. Shojo is safe, but must now part from the princess and Kakuju and go to Chikushi.

06 The Carriage at Yoshida Shrine

This Act features triplets, each serving a different master. Umeomaru serves Shojo, Sakuramaru serves Prince Tokiyo, and Matsuomaru serves Shihei. It is Shojo's auspices that have allowed them each to serve different houses, but due to Shihei's plot against Shojo, the three brothers find themselves fighting against one another.

As Shihei's carriage approaches Yoshida Shrine, Umeomaru and Sakuramaru block its path, but are overpowered by Shihei's great power. The brothers part, unhappily halting their fight to be settled later at a celebration for their father's 70th birthday.

07 Celebration in Sata Village

The triplets' father, Shirokuro, lives in Sata Village. When his triplet sons were born, Shojo kindly recommended them to their respective houses, allowing them to make their living. Out of his deep gratitude toward Shojo, Shirokuro served as Shojo's retainer and was giving the task of looking after three trees (each echoing one of the three sons): plum, pine, and cherry. Shojo, hearing that Shirokuro would be turning 70, planned to change Shirokuro's name to Shiradayu and hold a celebration. Though Shojo is in exile, he intends to keep his promise to hold the celebration.

All three brothers and their wives attend the party, but Matsuomaru and Umeomaru are late, and as soon as they

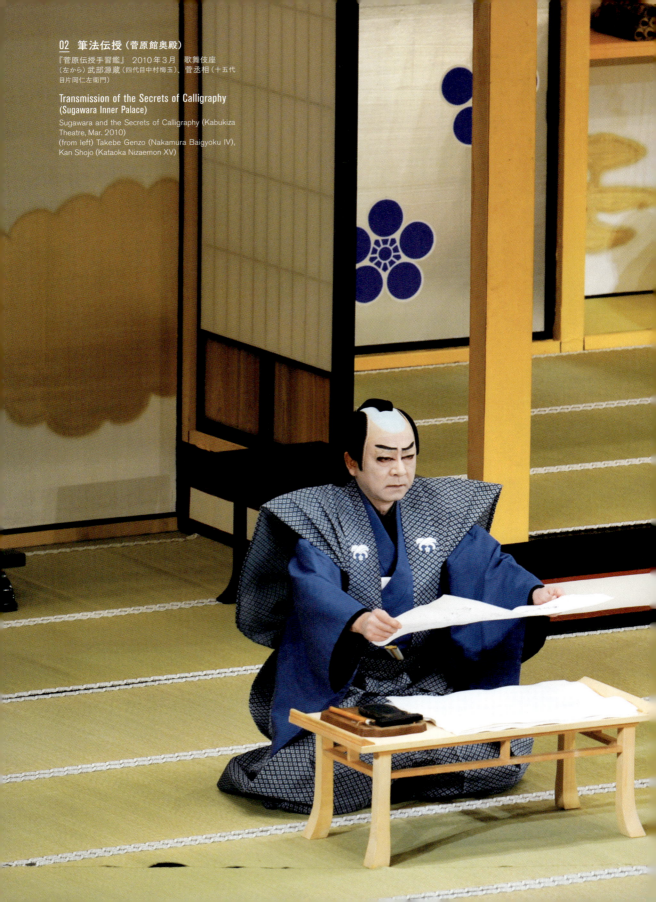

02 筆法伝授（菅原館奥殿）
『菅原伝授手習鑑』 2010年3月 歌舞伎座
（左から）武部源蔵（四代目中村梅玉）、菅丞相（十五代目片岡仁左衛門）

Transmission of the Secrets of Calligraphy (Sugawara Inner Palace)
Sugawara and the Secrets of Calligraphy (Kabukiza Theatre, Mar. 2010)
(from left) Takebe Genzo (Nakamura Baigyoku IV), Kan Shojo (Kataoka Nizaemon XV)

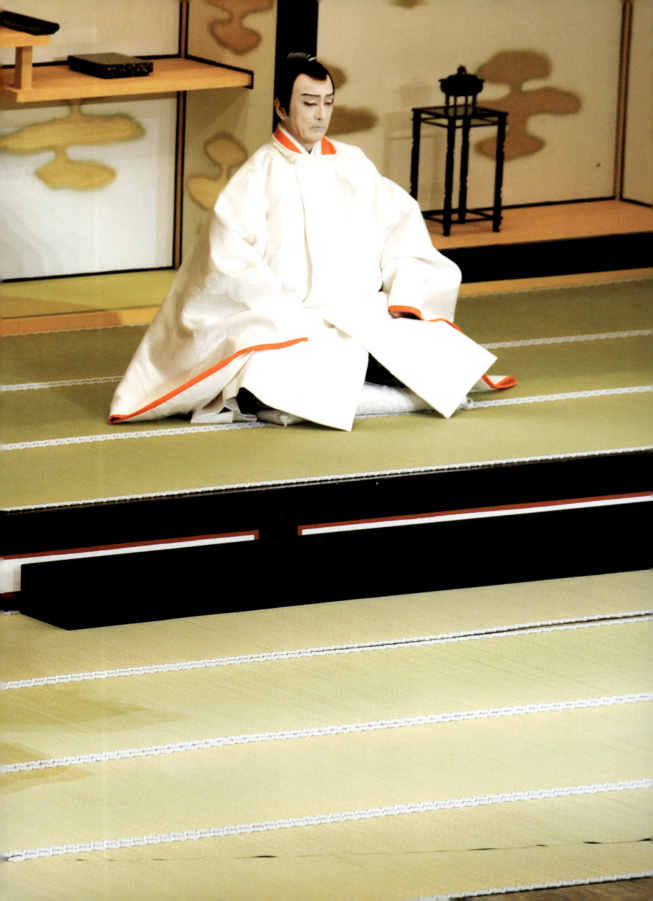

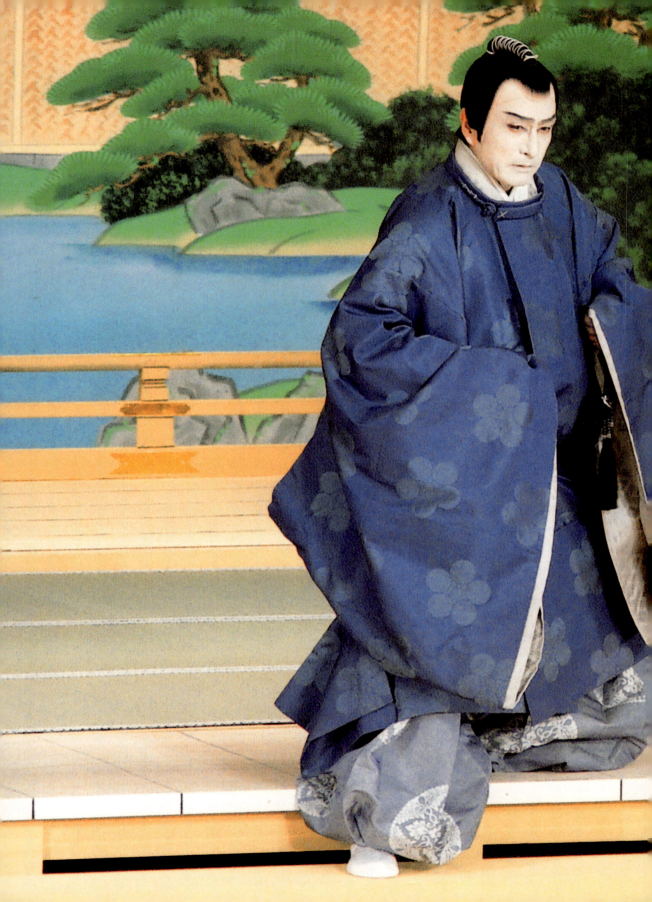

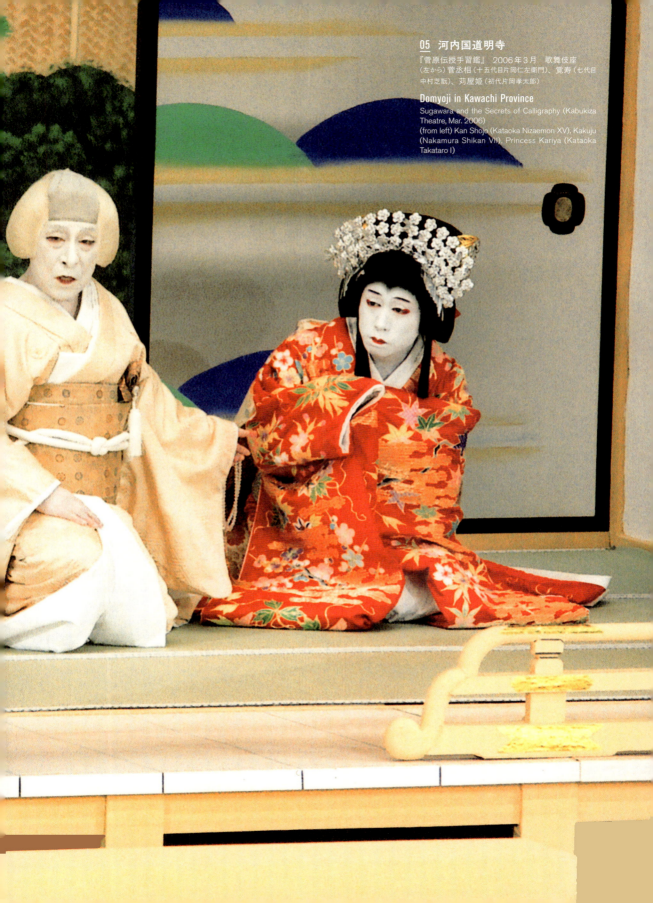

05 河内国道明寺

『菅原伝授手習鑑』 2006年3月 歌舞伎座
(左から)菅丞相(十五代目片岡仁左衛門)、覚寿(七代目中村芝翫)、苅屋姫(初代片岡孝太郎)

Domyoji in Kawachi Province
Sugawara and the Secrets of Calligraphy (Kabukiza Theatre, Mar. 2006)
(from left) Kan Shojo (Kataoka Nizaemon XV), Kakuju (Nakamura Shikan VII), Princess Kariya (Kataoka Takataro I)

06 吉田社頭車引

『菅原伝授手習鑑』 2015年3月　歌舞伎座
（左から）桜丸（五代目尾上菊之助）、藤原時平公（初代坂東彌十郎）、松王丸（七代目市川染五郎）、梅王丸（六代目片岡愛之助）

The Carriage at Yoshida Shrine
Sugawara and the Secrets of Calligraphy (Kabukiza Theatre, Mar. 2015)
(from left) Sakuramaru (Onoe Kikunosuke V), Fujiwara Shihei (Bando Yajuro I), Matsuomaru (Ichikawa Somegoro VII), Umeomaru (Kataoka Ainosuke VI)

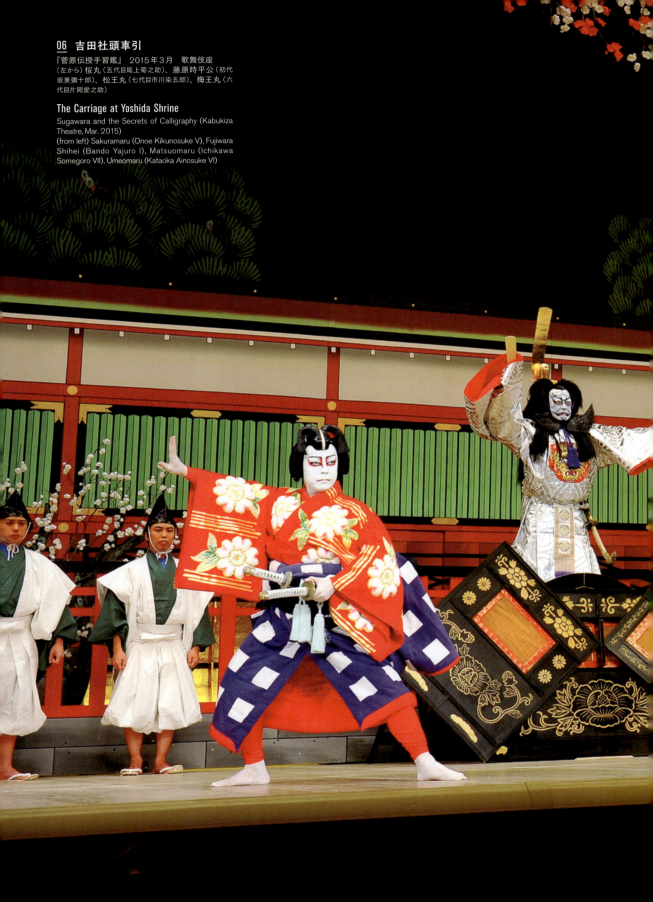

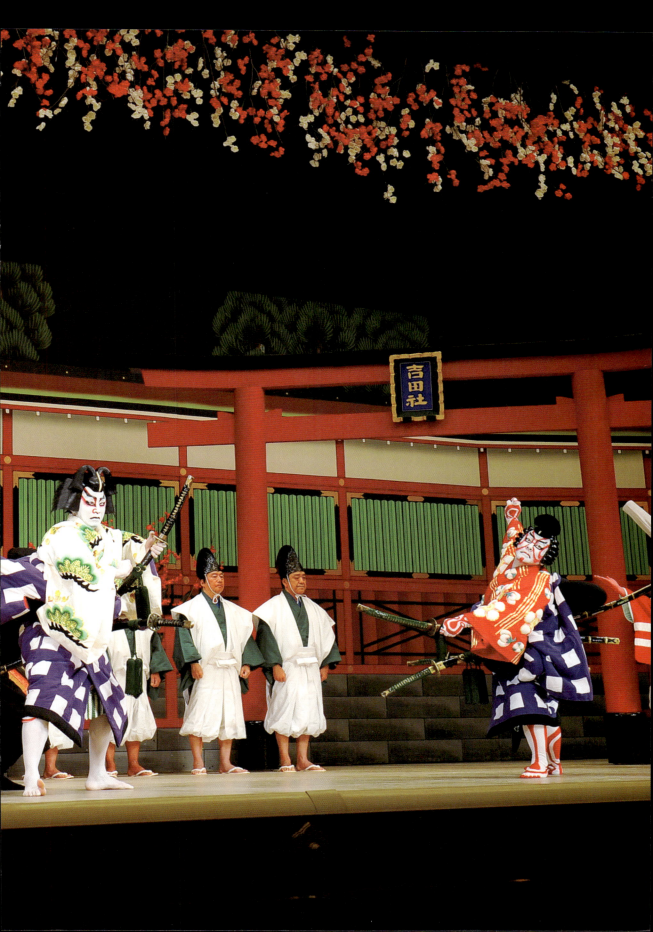

松・桜の世話する役を与えられ、丞相には深い恩を感じている。七十になることを聞いた丞相から、お祝いをすることと名を改めることをすすめられ、本日がその当日である。丞相流罪の時期ではあるが、丞相の言葉を守っているのである。

三つ子とその嫁たち、三組の夫婦そろって祝いをするはずだったが、嫁はそろったものの三つ子は来ない。松王丸・梅王丸は遅刻の上、来るなり喧嘩。あげくのはて、松王丸は勘当を願い出て親兄弟と縁を切り去っていく。梅王丸も父に追い立てられ、丞相の御台所園生の前、若君菅秀才の行方を捜し、守護するよう追い立てられる。

やがて奥から桜丸が現れる。桜丸は兄弟に先だち早くから家に来ていた。すべては自分の恋の仲立ちが原因と、自らの身を責めて自害する気でいるのだ。女房八重に別れを告げ、父の念仏の声とともに果てる桜丸。様子をうかがっていた梅王に後を託すと、白太夫は筑紫の丞相のもとへと向かう。

08　芹生の里寺子屋

都のはずれ、芹生の里にある武部源蔵夫婦の営む寺子屋。そこに菅秀才がかくまわれているが、それが時平に知られ、首を討つように命ぜられる。

窮地に陥った源蔵は首を討つことを承知するが、実は寺子＝生徒たちのうちだれかを身替わりに殺すつもりだった。寺子の中で今日寺入りしたばかりの小太郎が身替わりにふさわしいと思い定め、小太郎の首を討つ。

寺子屋へ乗り込んで来た時平方の役人たちの内、首の真贋を見分ける役は、菅秀才を見知っている松王丸。偽首を一目見た松王丸は、時平の腹心・春藤玄蕃に、菅秀才の首に間違いない、と言い放つ。

一安心した源蔵だがそこに小太郎の母が迎えにやってくる。母も斬ろうと刀を抜く源蔵に、母は我が子を身替わりの役に立ててくれたかと問い、用意していた経帷子（死者の装束）を見せる。そこに、倅はお役に立ったと言いつつ戻ってくる松王丸。実は小太郎は松王丸と千代の子。菅秀才の命を助けるために、松王丸夫婦が我が子を身替わりとして送り込んだのだった。松王丸も丞相に恩義を感じていたが、主人が敵対したため、やむなく時平に従っていたのだ。

松王丸は、すでに保護していた園生の前と菅秀才を引き合わせ、供をして苅屋姫のいる河内に落ち延びさせるのだった。

arrive the fighting begins. Eventually, Matsuo cuts ties with his family and leaves the celebration. Umeomaru is also driven out by his father, who points him in the direction of Shojo's wife and Shusai so that he might return to Shojo and serve him.

Sakuramaru finally appears, claiming that he is responsible for everything that has happened because he helped arrange Tokiyo and Kariya's meeting. Saying farewell to his wife Yae, Sakuramaru takes his life as his father intones a Buddhist chant. Shiradayu then leaves Matsuomaru, who had secretly been watching, and heads to Chikushi to see Shojo.

08 The School in Seryo Village

Takebe Genzo and his wife run a temple school in a rural village called Seryo. Shihei hears that Shojo's son Shusai is hidden there and orders him beheaded.

Genzo is deeply troubled to receive the order to behead Shusai, but decides to kill one of the students of the school rather than murder his former teacher's son. He makes up his mind and beheads a boy named Kotaro who has just entered the school.

Matsuomaru is chosen by Shihei to go to the school and inspect the head, since he knows Shusai. When Matsuo sees the false head, he tells Shihei's confidante Shundo Genba that it is indeed the head of Shusai.

Genzo is relieved for a moment, but soon Kotaro's mother comes to the school. He draws his sword, thinking he will have to kill her as well, but she shows the funeral garbs she has brought, and acknowledging that her son was able to be of use. Matsuomaru then returns and reveals that Kotaro is in fact his own son, and that he and his wife Chiyo sent their son to be a sacrifice to save Shusai's life. Because Shihei is his master, he had to follow his orders, but he also felt a great sense of duty toward Shojo, and thus helped save Shusai's life.

Matsuomaru, who had been looking after Shojo's wife and Shusai, now allows them to escape to Kawachi.

作品の概要

演目名

菅原伝授手習鑑

作者

竹田出雲・三好松洛・並木千柳

概要

延享3（1746）年8月　大坂・竹本座で初演された人形浄瑠璃の作品を歌舞伎に移したもの。原作浄瑠璃の作者は竹田出雲・三好松洛・並木千柳。歌舞伎では浄瑠璃初演の翌月、延享3（1746）年9月　京都・中村喜世三郎座で、翌年には江戸で上演されている。

義太夫狂言の三大名作のひとつに数えられ、三作のなかでは最初に上演された。

また、早くから歌舞伎化されたので、「車引」では荒事が取り入れられるなど、歌舞伎ならではの工夫が随所に加わっている。

原作浄瑠璃は全五段で、国立劇場がほぼ全場面を上演したときは2か月がかりであった。一日で通し狂言とする場合は、「加茂堤」「筆法伝授」「道明寺」「車引」「賀の祝」「寺子屋」を上演することが多く、あらすじもこの場を中心として説明してある。また、通しのほかにも各場面とも見取りでも上演される。

出雲・松洛・千柳の三人が、三様の親子の別れ（菅丞相と苅屋姫の生き別れ、白太夫と桜丸の死に別れ、松王丸と小太郎の首の別れ）を描き分けたといわれる。

初演

人形浄瑠璃―延享3（1746）年8月　大坂・竹本座
歌舞伎―延享3（1746）年9月　京都・中村喜世三郎座

Overview

Title

Sugawara and the Secrets of Calligraphy

Writers

Takeda Izumo, Miyoshi Shoraku, and Namiki Senryû

Overview

Sugawara and the Secrets of Calligraphy (Sugawara Denju Tenarai Kagami) was originally a bunraku play first performed in August 1746 at the Takemoto-za Theater in Osaka. The original bunraku was written by Takeda Izumo, Miyoshi Shoraku, and Namiki Senryu. The kabuki version of the play first debuted in September of 1746, a month after the bunraku debut, at Kyoto's Nakamura Kiyosaburo-za Theater.

Sugawara is one of the three masterpieces of gidayu-kyogen, and the first of the three to be performed. It also features many distinct features of kabuki, such as the aragoto style utilized in the carriage fight scene (*kuruma-biki*)

The play was originally in five acts and would take two months to perform at national theaters. To perform the entire play in only a single day (*toshi-kyogen*), it is common for only the six scenes summarized here to be performed. And of course, depending on the location, the play is often interpreted and played in other unique ways.

It is said that Izumo, Shoraku, and Senryu each contributed their own unique parting of parent and child to the play: Shojo's parting from Princess Kariya due to his exile, Shiradayu's parting from Sakuramaru who commits suicide, and Matsuomaru's parting from his son whom he sacrifices.

Premiere

Bunraku: August 1746, Takemoto-za Theatre, Osaka
Kabuki: September 1746, Nakamura Kiyosaburo-za Theatre, Kyoto

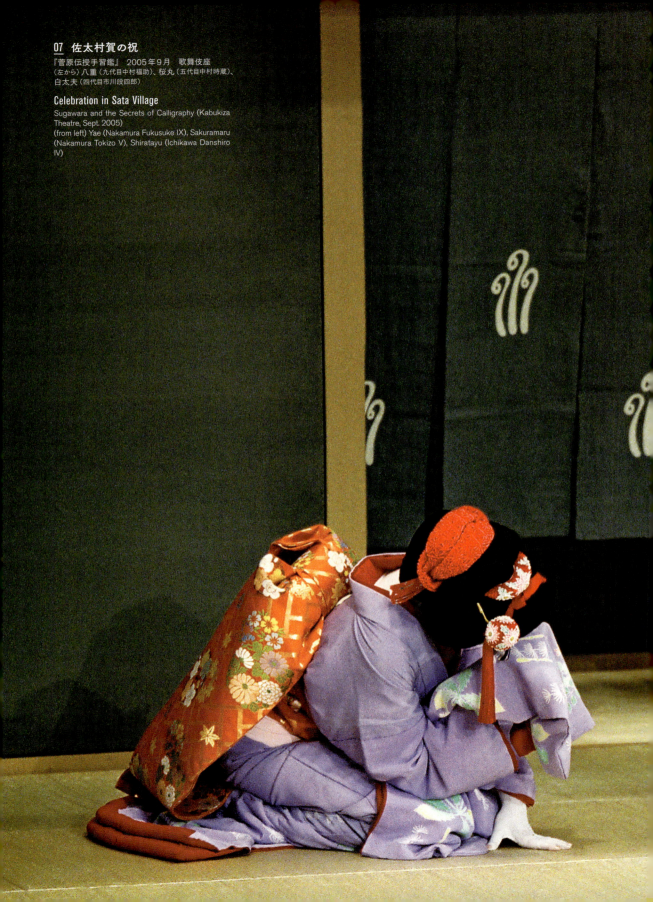

07 佐太村賀の祝

『菅原伝授手習鑑』 2005年9月 歌舞伎座
(左から) 八重（九代目中村福助)、桜丸（五代目中村時蔵)、
白太夫（四代目市川段四郎)

Celebration in Sata Village
Sugawara and the Secrets of Calligraphy (Kabukiza Theatre, Sept. 2005)
(from left) Yae (Nakamura Fukusuke IX), Sakuramaru (Nakamura Tokizo V), Shiratayu (Ichikawa Danshiro IV)

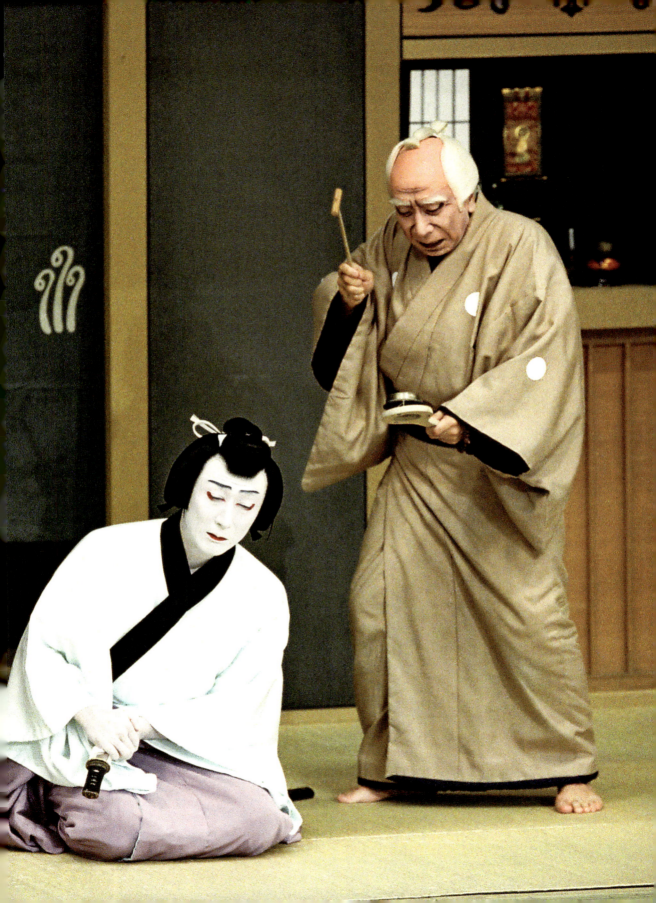

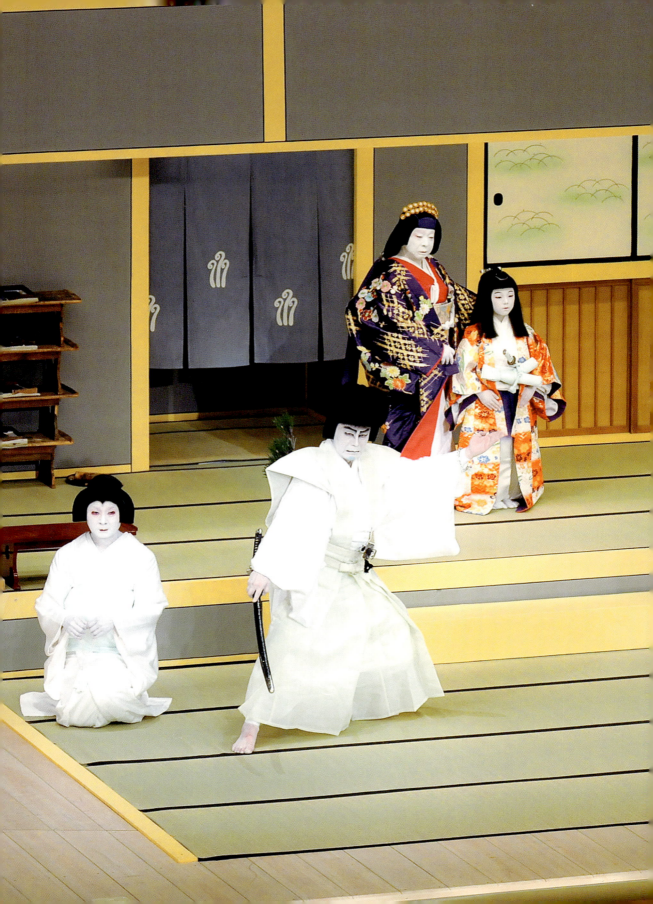

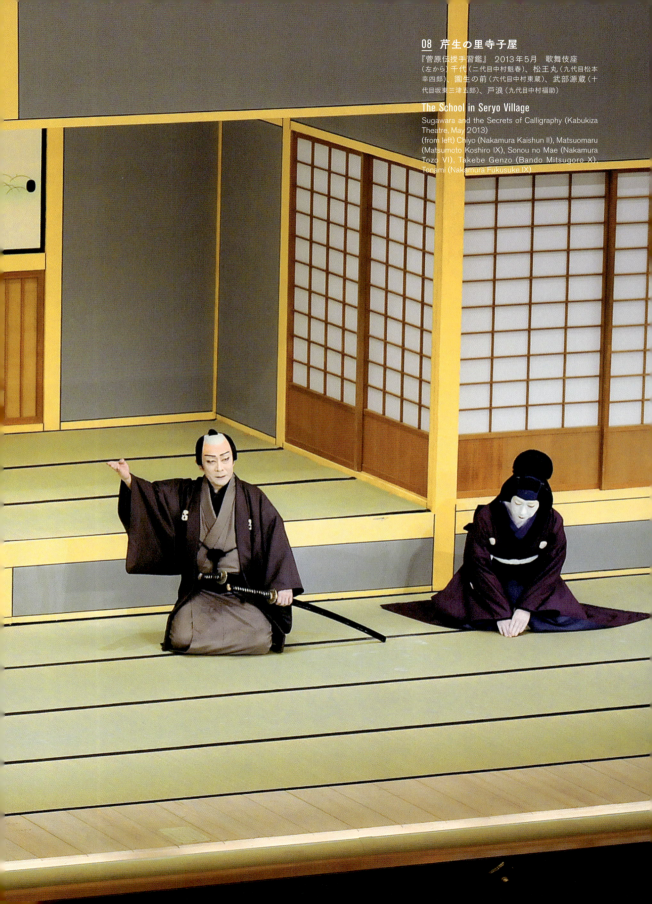

08 芹生の里寺子屋

『菅原伝授手習鑑』 2013年5月 歌舞伎座
（左から）千代（二代目中村魁春）、松王丸（九代目松本幸四郎）、園生の前（六代目中村東蔵）、武部源蔵（十代目坂東三津五郎）、戸浪（九代目中村福助）

The School in Seryo Village
Sugawara and the Secrets of Calligraphy (Kabukiza Theatre, May 2013)
(from left) Chiyo (Nakamura Kaishun II), Matsuomaru (Matsumoto Koshiro IX), Sonou no Mae (Nakamura Tozo VI), Takebe Genzo (Bando Mitsugoro X), Tonami (Nakamura Fukusuke IX)

登場人物 / Characters

菅丞相
かんしょうじょう

「学問の神様」として有名な菅原道真。「丞相」は律令制における大臣の唐風の呼称で、すなわち「菅大臣」。実際に菅原道真は右大臣、藤原時平が左大臣。菅丞相の養女・苅屋姫が斎世親王（帝の弟）と恋仲のため、娘を皇后にする野望を抱いていると時平に言い立てられ、謀反の罪で太（大）宰府へ流罪となる。後に丞相は時平こそ謀反の張本人と怒り、雷神と化して都に天変地異をもたらし時平一味に復讐する。

Kan Shojo

Sugawara Michizane, known as the "god of learning." "Shojo" is a title of the ritsuryo system, meaning "minister." Therefore, the name "Kan Shojo" which appears in *Sugawara* means "Minister Kan." Sugawara Michizane is minister of the right, and Fujiwara Shihei is minister of the left. Kan Shojo's adopted daughter Princess Kariya is in love with Tokiyo Shinno, causing Shihei to accuse him of attempting to take the imperial throne. Shojo is subsequently exiled to Dazaifu, but is later enraged to find that Shihei was the true plotter. In the end, Shojo turns into a thunder god, brings a great storm to Kyoto, and kills Shihei.

苅屋姫
かりやひめ

菅丞相の養女で、この物語すなわち菅丞相の太（大）宰府流罪という悲劇の発端を引き起こしてしまう。恋した相手・斎世親王が帝すなわち天皇の弟であったため、菅丞相が帝の地位を脅かしているという謀反の口実を与えてしまったのだ。実母で丞相の伯母・覚寿の館に身を寄せ、菅丞相にわずかながらの詫びと対面ができるが、ここでテーマのひとつ「菅丞相と苅屋姫、親子の生き別れ」が描かれる。

Princess Kariya

Kan Shojo's adopted daughter who inadvertently leads to his tragic banishment. Princess Kariya's lover Tokiyo Shinno is the emperor's younger brother, giving Shojo's political enemies reason to accuse him of plotting to take the throne. Kariya is able to see Kan Shojo once more at her mother Kakuju's home, and though she apologizes for her part in these tragic events, father and daughter must part nonetheless, one of the many motifs of parting seen throughout *Sugawara*.

梅王丸
うめおうまる

梅王丸、松王丸、桜丸は珍しい三つ子の兄弟。当然同い年であるが、梅王丸が長兄とされている。父は菅丞相に仕え、丞相の勧めで兄弟それぞれ別の主人の舎人（とねり＝警護や雑務に従事する身分の低い役職）となり、梅王丸は梅の花を愛する菅丞相に仕えている。力強い上に忠実で、危機が迫った時には丞相の子・菅秀才を救い出して源蔵に託し、また遠く筑紫まで赴いて忠義を尽くす。

Umeomaru

The triplets Umeomaru, Matsuomaru, and Sakuramaru are of course the same age, but Umeomaru is considered the eldest brother. His father serves Kan Shojo, and the triplets each serve as low-ranking servants to separate masters thanks to Shojo's auspices. The strong and faithful Umeomaru serves Shojo himself, and eventually saves his son Kan Shusai by putting him in the care of Genzo. Eventually he moves to Dazaifu where he continues to faithfully fulfill his duties.

斎世親王
ときよしんのう

病気となっている醍醐天皇の弟で、菅丞相の養女・苅屋姫とは恋仲である。しかし思うように逢うことが叶わぬ二人は帝の病気平癒の神事の日に、桜丸の手引きで加茂堤の牛車の中で密会をするが、噂をかぎつけた時平側の取り調べが迫ったため間一髪で逃れ、駆け落ちする。これが発端となって菅丞相に謀反の疑いが掛かり太（大）宰府へ追いやられることとなるが、事の重大さに二人はまだ気づかない。

Tokiyo Shinno

Tokiyo Shinno is the younger brother of the sick Emperor Daigo and lover of Princess Kariya, Kan Shojo's adopted daughter. The two lovers meet secretly on the day the Emperor recovers, but Shihei hears about it and has them followed. Tokiyo and Kariya escape their pursuers, but their meeting becomes the germ of suspicion that Kan Shojo is plotting to seize power, which eventually leads to his banishment to Dazaifu.

藤原時平
ふじわらのしへい

右大臣の菅丞相に対し、左大臣の地位にある。政敵である菅丞相を追い落とすために暗躍し、自らは帝に代わって天下を乗っ取ろうとする巨悪。歴史上の人物としては藤原時平（ふじわらのときひら）であるが、芝居の上では専ら時平公（しへいこう）と呼ばれる。「車引」の場では、行く手を阻む梅王丸と桜丸を凄まじい形相でにらみ、絶大な権力と何者も寄せ付けない特異な威圧感を見せつける。

Fujiwara no Shihei

As Minister of the Left, Tokihira is the political rival of Kan Shojo, the Minister of the Right. A *kyoaku* ("great villain") role, he accuses Kan Shojo of treason while secretly plotting to seize power himself. Based on the historical Fujiwara Tokihira, he is referred to as "Master Shihei" in *Sugawara*. In the "Carriage" scene, Umeomaru and Sakuramaru try to stop Shihei's carriage, but they are defeated by a single powerful glare. This is the overwhelming power and authority that Shihei's character possesses.

松王丸
まつおうまる

三兄弟の次兄で、皮肉なことにこの松王丸だけが敵側の藤原時平に仕えている。父ともども菅丞相に大恩ある身でありながら、今は時平公に仕えねばならないという微妙な立場が松王丸に様々なドラマをもたらす。作品上では次兄だが三兄弟の中で唯一の子持ちという点も含め、歌舞伎ではこの松王丸を長兄の心で演じるのが定型となっている。その子・小太郎は「寺子屋」の場で重要なカギとなる。

Matsuomaru

The second brother of the triplets, Matsuomaru is the only to play a villain on the side of Fujiwara Shihei. Though he owes a debt of gratitude to Kan Shojo, he serves Shihei, resulting in a deep internal conflict. Matsuomaru is the only of the triplets who has a child, and is played more as an eldest sibling. His son Kotaro fulfills a key role in the scene at the temple school.

桜丸
さくらまる

三兄弟の中の末っ子とされる。性格もその通り、勇壮で荒事的な二人の兄に対し、桜丸は各場面を和事の形で演じる。斎世親王に仕え「加茂堤」で親王と苅屋姫を手引きしたため、菅丞相を深い罪に追いやったことは自ら責めても責め切れない。すでに覚悟は決めているが、兄弟が顔を揃えて父の七十歳を祝う「賀の祝」までは生き永らえ、しかし桜の枝が折れたごとく、ついに運命の時を迎える。

Sakuramaru

The youngest of the triplets, Sakuramaru contrasts his rough *aragoto* brothers as a level-headed *wagoto* character. His actions in helping Tokiyo Shinno meet his lover Princess Kariya on the bank of the Kamo River eventually lead to Kan Shojo's exile, a fact which Sakuramaru blames himself for. He is determined to take his own life in penance, but waits until after his father's 70th birthday celebration.

源蔵女房戸浪
げんぞうにょうぼうとなみ

武部源蔵の妻。かつては源蔵と同じく菅丞相の家中で園生の前の腰元として仕えていたが、源蔵と共に家を追われ、以来芹生の里の寺子屋で貧しい生活を送っている。菅丞相からの呼び出しに源蔵と共に出掛け、園生の前とも対面するが今の我が身を恥じる。「寺子屋」の場では、菅秀才の首を討たねばならぬか、もしくは身替わりがいるか、その夫の苦悩を共に分かち共に嘆いて支え合う。

Tonami

Takebe Genzo's wife, Tonami used to serve Kan Shojo's house as Sonou no Mae's chambermaid. She and her husband were dismissed from their service and now live in poverty at a temple school in Seryo Village. Tonami accompanies her husband when he is summoned by Shojo, and is filled with shame as she stands before Sonou no Mae. She sympathizes with and supports her husband when he faces the difficult choice of whether to kill Shusai or find a substitute to save him.

覚寿
かくじゅ

菅丞相の伯母で、苅屋姫というのはこの覚寿の実の娘。菅丞相に預けたその姫は大きな過ちを犯し、覚寿の元へ身を寄せている。そこに太(大)宰府へ送られる途中の菅丞相が立ち寄るが、厳格な覚寿は心で哀れと思いながらも養い親への申し訳なさから姫を激しく打つ。さらに敵側が丞相をおびき出そうとするなかで姉娘の立田が殺され、その犯人と知れた娘婿を成敗し芯の通った強さを見せる。

Kakuju

Kan Shojo's aunt and Princess Kariya's mother, Kakuju suffers greatly in this play. After Kariya's fateful rendezvous with her lover which results in Shojo's exile, the strict Kakuju must severely punish her beloved daughter. Her eldest daughter Tatta's husband ends up siding with Shihei and killing Tatta, but Kakuju finds out the truth and avenges her daughter, showing the great strength of her character.

武部源蔵
たけべげんぞう

菅丞相の家臣で書道においても優れた弟子であったが、同じ家中の戸浪との不義により丞相から勘当と破門を受け、芹生の里で寺子屋を営んでいる。久々に丞相から呼び出され、筆法を伝授されるが、丞相の身に危険が迫り幼い菅秀才を預かる。やがて時平から、寺子屋に匿っている秀才の首を討って渡せと厳命され、苦慮の末新たに入門した品の良い子を身替わりにする決心をする。

Takebe Genzo

Genzo is a former calligraphy student and retainer to Kan Shusai. Though he was an excellent student, his illicit affair with Tonami led to the two being disinherited. They currently run a temple school in Seryo Village. When Genzo is called upon by Shojo to inherit his secret teachings, he finds that Shojo has been the victim of malicious rumors, and takes Shusai under his care to protect him from political enemies. Eventually, Shihei finds out where Shusai is and orders Genzo to murder him, but he chooses instead to kill an elegant young man who has just entered the school in Shusai's place.

左中弁希世
さちゅうべんまれよ

公家で、書の道においては菅丞相の古参の弟子である。丞相の優れた筆法の後継者は自分であると勝手に思い込んでいるが、素行も腕も悪く「筆法伝授」の重要な局面では俄かに呼び出された武部源蔵にその座を奪われる。そして菅丞相の立場が危うくなり流罪という話が聞こえてくると、即座に藤原時平に寝返ってしまう。後には、雷神となって襲ってきた丞相の怨念に取り殺されてしまう。

Sachuben Mareyo

Mareyo is Kan Shojo's senior calligraphy pupil, and believes he will be the one to receive the secret teachings. However, Shojo's deems both his skills and manners to be unworthy of such an honor, so he chooses Takebe Genzo instead in the "Secrets of Calligraphy" scene. Because of this, the resentful Mareyo betrays his master and sides with Fujiwara Shihei who exiles Shojo. In the end, he is killed by Shojo who takes the form of a thunder god and attacks the capital.

立田の前
たつたのまえ

覚寿の娘で、苅屋姫の姉。苅屋姫に同情し、母に内緒で苅屋と丞相を会わせようとする。また、夫の宿禰太郎とその父・土師兵衛が藤原時平の手先となり、菅丞相をおびき出して殺そうとするその計画を立ち聞きしてしまう。夫や舅の欲の深さは承知の上ながら貞女の立田は二人に思いとどまるよう諭すが、それが仇となってしまう。知られた上からはと立田は斬られて庭の池に沈められる。

Tatsuta no Mae

Kakuju's daughter and Kariya's older sister. She finds out that her husband Sukune Taro and his father Haji no Hyoe are cooperating with Fujiwara Shihei, but when she tries to convince them to stop she is killed and thrown in the courtyard pond. Before dying, however, she manages to bite off a piece of Taro's underwear, a clue which eventually proves his guilt.

宿禰太郎
すくねのたろう

立田の夫であるが欲が深く、父の土師兵衛と共に藤原時平に加担し、菅丞相をおびき出して殺そうとする。道明寺に逗留する菅丞相の迎えは夜明けで、刻限の合図は一番鶏の鳴き声。そこで早く鶏が鳴くよう細工をするが、そのやり取りを妻の立田に聞かれ、口封じのために殺してしまう。しかし殺す際に立田の口に押し込んだ下着の切れ端を覚寿に見破られ、覚寿の手で討ち取られる。

Sukune no Taro

Husband to the faithful Tatta no Mae, Sukune's deep avarice starkly contrasts his wife. He works with his father Haji no Hyoe to help Fujiwara Shihei. At Domyoji Temple, Shojo waits for the first rooster's call, the signal agreed upon for the ferry that is to take him to Dazaifu. However, Sukune and his father make the roosters cry prematurely in order to lure Shojo out to kill him. Though Tatta overhears these plans, Sukune kills her to keep her quiet, stuffing his underwear into her mouth. Tatta manages to bite off a piece of this underwear before dying. When Kakuju sees this, she knows that Sukune is guilty and kills him.

判官代輝国
はんがんだいてるくに

醍醐天皇、斎世親王の父にあたる宇多法皇に仕える武士で、菅丞相を筑紫まで送り届ける役目を担う。人情に厚い人物で、伯母である覚寿と暫しもの対面ができるようにと心を遣い、護送の途中とはいえ道明寺に一泊の逗留を許す。しかし我が名をかたる偽の迎えがやって来て菅丞相を連れ出そうとは思いもよらぬ事態。輝国は最後まで斎世親王と苅屋姫を守護し、藤原時平の成敗まで成し遂げる。

Hangandai Terukuni

A samurai in the service of the former Emperor Uda, who is the father of Emperor Daigo and Tokiyo Shinno. Terukuni is responsible for taking Kan Shojo to Dazaifu. He is a deeply compassionate man who allows Shojo to stay for one night at Domyoji Temple so that he can meet with his aunt Kakuju one last time before his exile. He is deeply troubled when a fake envoy comes to take Shojo away, but in the end he protects Tokiyo Shinno and Princess Kariya, and helps to defeats Fujiwara Shihei.

梅王丸女房春
うめおうまるにょうぼう はる

三兄弟の長兄・梅王丸の女房。白太夫の賀の祝いに梅・松・桜の三本の扇を持参し、白太夫も「子供が生先(おいさき)末広がり、氏神様にも頼んできましょう」と機嫌よく受け取る。自身も松王丸の千代、桜丸の八重という女房たちの要の役割か。「梅」という花は、桃、桜に先立って春を告げる花なので、梅王丸の女房の名が「春」。春は後に、北嵯峨に逃れた園生の前に付き添って忠を尽くす。

Haru

Haru is Umeomaru's wife who brings three fans representing the three brothers to Shiratayu's 70th birthday celebration. Shiratayu accepts these happily and says, "may my sons' futures spread before us like these fans." Haru means "spring," which resonates with her husband's name; *ume* or plum trees bloom before either peach or cherry, and those blossoms are therefore the first harbingers of spring. In the end, Haru flees with Sonou no Mae to Kitasaga where she remains her faithful servant.

土師兵衛
はじのひょうえ

宿禰太郎の父で、立田の母・覚寿とは義理の親同士ということになる。息子の太郎とともに藤原時平に加担し、菅丞相を殺そうと企む。歌舞伎でお家騒動など敵側の黒幕には親戚筋の悪者が絡むのが常套で、そういった奸智に長けた狡猾な悪人の役柄を叔父敵(おじがたき)と呼ぶが、この兵衛もそのひとつ。一方、宿禰太郎の方は少々小粒の悪党で安っぽく、端敵(はがたき)といったところ。

Haji no Hyoe

Haji no Hyoe is Sukune Taro's father, and therefore Tatta no Mae's father-in-law. Haji no Hyoe and his son join Fujiwara Shihei's plot and attempt to kill Kan Shojo. His role is an example of an *ojigataki* ("uncle villain"), the sly relative who pulls strings in the background for the villain. Hyoe's son Taro, on the other hand, is a relatively minor villain called *hagataki*.

白太夫
しらたゆう

三兄弟の父。元の名を四郎九郎といい、菅丞相に仕えてその領地佐太村の下屋敷を預かっている。屋敷の庭には丞相が愛する梅・松・桜の三本の木が植えられ、春の訪れを告げている。白太夫の名は七十歳の賀の祝いに際し丞相から与えられたものである。祝いの日は兄弟が揃うめでたい席となるはずだが桜丸は意を決して自害、ここで二つ目のテーマ「白太夫と桜丸、親子の死に別れ」となる。

Shiratayu

Father to the triplets, Shiratayu's former name was Shirokuro. He serves Kan Shojo, tending his villa in Sata Village. At this villa Shojo has three beloved trees that bloom in early spring and represent the three brothers: plum (*ume*), pine (*matsu*), and cherry (*sakura*). The name Shiratayu is given to him by Shojo on his 70th birthday. The day of his celebration is supposed to be an auspicious occasion with all three brothers in attendance, but Sakuramaru ends up killing himself in penance. The parting of father and son in this scene is yet another of the thematic partings that occur in *Sugawara*.

松王丸女房千代
まつおうまるにょうぼう ちよ

松王丸の女房。子供もあり三人の女房の内ではやや年かさの心。「松」という木は千年翠(せんねんのみどり)といわれる通り長寿の象徴なので、松王丸の女房の名は「千代」。「寺子屋」の場では子の小太郎を連れて寺入りをさせ、言い聞かせたはずの小太郎がぐずるのを毅然と諭す。再び戻った寺子屋で源蔵に斬り付けられるが身をかわし、現れた松王丸から「倅はお役に立ったわやい」と告げられる。

Chiyo

Wife of Matsuomaru, Chiyo has one son and is played as the elder among the three wives. The pine (*matsu*) tree is a symbol of long life, which is reflected in Chiyo's name which means "one thousand years." She leads her son Taro to the school in Seryo Village where he is to die. When he hesitates, she bravely admonishes him to fulfill his duty. When Chiyo appears at the school later, Genzo attempts to kill her, but Matsuomaru appears and declares, "it seems my son was of some use."

桜丸女房八重
さくらまるにょうぼう やえ

桜丸の女房で、まだうぶな娘らしさが残る。「加茂堤」で夫の桜丸と共に斎世親王と苅屋姫の逢瀬の手引きをし、逃げた二人を追う桜丸に代わり慣れぬ牛車を曳いてゆく。「賀の祝」では祝いの品として三方を持参するが、その三方に白太夫がのせてきた物は腹切刀。桜丸の女房は「八重桜」にちなみ、その名も「八重」。後に北嵯峨に隠匿する園生の前に付き添うが、時平の追っ手に討たれてしまう。

Yae
Sakuramaru's wife, Yae is the most naive of the wives. In the scene "Bank of the Kamo River," she and Sakuramaru help to arrange a rendezvous between the young lovers Tokiyo Shinno and Princess Kariya. In "Celebration in Sata Village," Yae brings three treasures as gifts, one of which is actually a dagger meant for Sakuramaru's seppuku. The name Yae echoes "*yae-zakura*" and therefore her husbands name. In the end she accompanies Sonou no Mae to Kitasaga, but is killed by Shihei who pursues them.

小太郎
こたろう

松王丸と千代の一子。母に手を引かれて源蔵が営む寺子屋に入門するが、その日は時平方から「菅秀才の首を討って渡せ」と厳されたる期限の日。源蔵は寺子の中に身替わりになる子がいるか思案するなか、今日寺入りした品の良い小太郎を見て身替わりの決断を固める。その小太郎は逃げも隠れもせずにっこりと笑って討たれたという。三つ目のテーマは「松王丸と小太郎、親子の首の別れ」となる。

Kotaro
Kotaro is Matsuomaru and Chiyo's son who is taken to Genzo's temple school. The day Chiyo enters him in the school, Genzo receives the order to kill Shusai. Genzo subsequently searches for a substitute to kill in Shusai's place, choosing Kotaro based on his genteel looks. Kotaro accepts his death with a meek smile, and his death is the third of the great partings depicted in *Sugawara*: the parting of father and son.

菅秀才
かんしゅうさい

菅丞相の子で、幼いながら聡明。菅丞相が武部源蔵に筆法を伝授した際、丞相謀反の詮議が入り、梅王丸が菅秀才を抱き上げて源蔵に後を託す。源蔵の寺子屋で我が子と偽って隠匿するが、やがて時平の知るところとなり、菅秀才の首を討って渡せと源蔵に命令が下る。首実検役の松王丸は「菅秀才の首に相違ない」と認めるが実は身替わり、一命をとりとめた秀才は母の園生の前と対面する。

Kan Shusai
Kan Shojo's young yet wise son who is entrusted to Genzo when Shojo is accused of attempting to seize power. Genzo claims that Shusai is actually his son, but Shihei learns of this and orders Genzo to kill Shusai. When Matsuomaru inspects the head presented by Genzo, he confirms that it is Shusai's, knowing it is actually Kotaro. Shusai is thus saved and is able to meet with his mother Sonou no Mae.

園生の前
そのうのまえ

菅丞相の奥方で、すなわち菅秀才の母。菅丞相流罪の後は春、八重と共に北嵯峨に隠れ住んでいたが、時平の追っ手がやって来て八重は討たれ、園生の前は山伏姿の者に危ういところを救われる。源蔵の寺子屋で松王丸の子・小太郎が菅秀才の身替わりとなり、園生の前は我が子と久々の対面が叶うが、北嵯峨から園生の前を救い出した山伏姿の人物はなんと、時平に仕えていたはずの松王丸だった。

Sonou no Mae
Kan Shojo's wife and Shusai's mother, Sonou no Mae escapes to Kitasaga with Haru and Yae after Shojo is exiled, but Shihei pursues them and murders Yae. Sonou no Mae is then saved by a mountain priest. Later when she is reunited with her son, it turns out this priest was actually Matsuomaru, who went against his master Shihei to save both Shusai and Sonou no Mae.

みどころ
Highlights

1. 「寺子屋」松王丸の衣裳
—— Matsuomaru's Costume in "The School in Seryo Village"

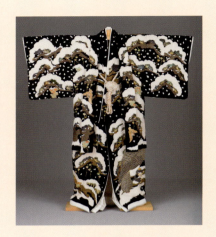

黒繻子の雪持松の柄の着物と羽織、裾には鷹の縫い取り。菊五郎系の演者は地が銀鼠色の衣裳を着る。松王丸は、のちに本心を明かす場面では黒無地の着物に袴姿、最後の息子を供養をする場面では白の喪服姿になる。

Matsuomaru wears a black satin kimono and haori jacket with a snowy pine motif and a falcon pattern embroidered along the hem. This costume is in the style of Danjuro, with a grey base in the style of Kikugoro. When Matsuomaru shows his true intentions, he wears a black kimono over *hakama* pants, and finally white mourning robes as he memorializes his son.

2. 菅原道真公と天神様
—— Sugawara Michizane and the God Tenjin

菅原道真（845-903年）は平安時代の学者で政治家。右大臣であったが、政敵藤原時平によって失脚、太（大）宰府に左遷されて没した。しかし没後天変地異が続き、朝廷は道真の名誉を回復。やがて北野天満宮をはじめ各地に天満宮が建立され、道真公は天満天神として祀られた。天神様は学問の神様として江戸時代にも大変人気を集めた。『菅原伝授手習鑑』では大臣を表す丞相を付け、菅丞相（かんしょうじょう）と呼び表している。

Sugawara Michizane (875–903) was a scholar and statesman of the Heian Period (794–1185) of Japan. Though he was once Minister of the Right, Michizane lost his position and was exiled to Dazaifu by Fujiwara Tokihira. Though he died there, the natural disasters that afflicted the capital after he died were interpreted as the work of the enraged spirit of the exiled Michizane. His reputation was thus restored posthumously, and Tenmangu shrines were erected throughout the country to praise Michizane as Tenshin, the god of learning. Tenshin became incredibly popular in the Edo Period, and is referred to as Kan Shojo in *Sugawara and the Secrets of Calligraphy*, a name that refers to his status as Minister of the Right.

3. 三つ子の話題で、三つの別れ
—— Three Partings Reflecting the Three Triplets

昔は三つ子が無事に育つということは極めて珍しかった。初演前、生まれた三つ子が宮中の牛飼いになったニュースを聞いた芝居の作者たちは、それに絡めて三つの「親に別れる物語」を構想したと伝わっている。その頃芝居の台本は責任者の立作者（たてさくしゃ）が筋を通し、数人が場面を分担して書いた。二段目「道明寺」が道真と苅屋姫の別れ、三段目「賀の祝」が白太夫と桜丸の別れ、四段目「寺子屋」が松王丸と小太郎の別れだ。

The safe birth of triplets was an incredibly rare occurrence in the past. It is said that the writers of *Sugawara* heard the news of a set of triplets who became cow herders for the imperial palace and were inspired to write a story depicting three partings of parent and child. The plays of the day were first outlined by the head writer (*tateyakusha*), and then different scenes were assigned to different dramatists to write. "Domyoji Temple" in Act II depicts the parting of Michizane and Princess Kariya, "Celebration in Sata Village" in Act III depicts the parting of Shiratayu and Sakuramaru, and finally, Act IV's "School in Seryo Village" depicts the parting of Matsuomaru and Kotaro.

4. 桜丸の後悔 —— Sakuramaru's Regret

斎世親王の舎人となった桜丸は女房の八重と協力し、親王と道真の娘苅屋姫とのひそかな逢瀬を取り持った。結婚して幸せな桜丸は、親王の恋心がよくわかったのだ。しかし二人の恋は、斎世親王を帝にしようという道真謀反の企みとされ、道真の太（大）宰府流罪に発展してしまった。桜丸の後悔は果てしなく深い。親白太夫の七十の賀の祝のあと、父親に自分の罪を告白し、妻に黙って自ら腹を切る。歌舞伎でもっとも悲痛な切腹場面のひとつ。

Tokyo Shinno's servant Sakuramaru plans with his wife Yae to help Tokiyo and Michizane's daughter Princess Kariya to meet in secret. The happily married Sakuramaru understands Tokiyo's feelings for Kariya, but political enemies interpret this affair as an attempt to make Tokiyo Emperor. Michizane is subsequently exiled to Dazaifu, and Sakuramaru bitterly regrets his actions. At his father Shiratayu's 70th birthday celebration, Sakuramaru confesses his sins and commits seppuku, unbeknownst to his wife. This is one of the most powerful seppuku scenes in kabuki.

5. 妻の嘆き、夫の涙 —— A Lamenting Wife, a Tearful Husband

「寺子屋」は最も人気のある場面。山里で夫婦で寺子屋をいとなむ源蔵と戸浪には子供がない。匿っていた恩師道真の一子菅秀才の首を討てと迫られ、寺子の誰かを身替わりに殺す決心をする。二人の嘆きは「せまじきものは宮仕え」という言葉で語られる。人に仕える勤めは、辛いことが多いのでするものじゃないというほどの意味だが、ここは忠節のために殺人者になろうという局面である。妻は静かに嘆き、夫は目に浮かぶ涙を振り払う。

The "School in Seryo Village" scene is the most popular scene in Sugawara. Genzo and Tonami who run the school have no children, so they are at a loss when told to kill Kan Shusai, the son of Genzo's teacher. They decide to find a substitute to kill in Shusai's place. The two famously lament that it is better to avoid a life of servitude, yet they intend to become murderers to remain faithful to their former teacher. Tonami laments their fate while her husband Genzo fights back tears.

6. 人形が身替わりに　太（大）宰府 —— A Statue in Michizane's Stead

大阪府にある道明寺は、太（大）宰府へ流される道真が伯母と別れを惜しんだ地として名高い。道真が自ら形見として刻んだ木造の自像がその地に残っている。江戸時代、近隣の寺子屋では学問の神天神様ゆかりの道明寺詣でを遠足のように楽しんだとか。劇中、刺客が偽の輿で迎えに来ると、道真は静かな足取りで輿に乗る。これが実は木像が身替わりに乗ったので、本物は館に残った。寺に残る木像がその昔道真の命を助けた、というのが本作の趣向。

Domyoji Temple in Osaka is well-known as the place where Michizane parted ways with his aunt on his way to Dazaifu where he was exiled. He left at the temple a wooden statue he carved himself, and during the Edo Period students of the local temple school often took field trips to the temple, known for its association with Tenshin (Michizane, the god of learning). In the play, a fake envoy comes to pick Michizane up, but it is actually Michizane's wooden statue that boards the ferry, saving the real Michizane who remained in the temple. The actual wooden statue at Domyoji was the inspiration for this part of the play.

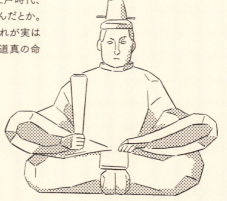

7. 舎人（とねり）のしごと
—— Toneri Servants

梅王丸は右大臣菅原道真の舎人（とねり）、松王丸は左大臣藤原時平（しへい）の舎人、桜丸は帝の弟宮の舎人。舎人は幼い頃から主人の貴人の傍にいつも供として仕え、身辺の世話や時には恋文の使いなどをすることもあった。名前に「丸」が付くのは元服前を意味し、三つ子は皆前髪を剃っていない。が、三人とも妻帯者で、松王丸には子供もいる。ちなみに東京都足立区の地名舎人は、一説には馬飼いの舎人が住んだことに由来するとか。

Each of the triplets serves as a *toneri* servant. Umeomaru works for Sugawara Michizane, Matsuomaru for Fujiwara Shihei, and Sakuramaru for the emperor's younger brother. *Toneri* serve nobles from a young age and attend to their personal care, including, at times, receiving and sending love letters. The suffix "-maru" attached to each of the triplets' names indicates a boy who has not yet come of age. Although each of the triplets has a wife, and Matsuomaru even has a son, they each nonetheless wear boyish bangs indicative of youth. Some readers may be familiar with the Toneri district in Tokyo. One theory claims that this derives from the fact that cattle-herding *toneri* once lived in that area.

8. 三つ子が2：1で争う「車引」
—— The "Carriage" Scene: the Triplets' 2-to-1 Fight

三つ子の父白太夫は菅原道真の別荘の番人で、三つ子の名付け親は道真である。しかし政変によって、悲しいことに梅王丸・桜丸と、松王丸は立場が対立してしまう。「車引」では三つ子は同じ格子柄の着物を着ているが、上着を脱ぐと梅王丸が赤の襦袢、桜丸も赤の襦袢。しかし政敵時平の舎人松王丸の襦袢は白地なのである。松王丸は道真に恩があるが、忠義も守らねばならない。三人の立場が色彩としても表現される歌舞伎の演出である（三つ子として三人赤の襦袢を着る演出もある）。

The triplets' father Shiratayu tends to Sugawara Michizane's villa, and it was Michizane himself who named the triplets. Tragically, however, Umeomaru and Sakuramaru are on the opposite side of a political coup to their brother Matsuomaru. In the "Carriage" scene all three triplets are wearing a similar grid-patterned kimono, but when they remove their jackets it is revealed that Umeomaru and Sakuramaru are wearing red shirts while Matsuomaru's shirt is white. Though Matsuomaru owes Michizane a great debt of gratitude, he must remain loyal to his master. Their confrontation is a particularly colorful scene among the many masterpieces of the kabuki theater.

9. 松王丸の孤独
—— The Isolation of Matsuomaru

劇中「梅は飛び 桜は枯るる 世の中に 何とて松の つれなかるらん」という歌が出てくる。菅原道真の歌と伝えられ、飛梅・飛松伝説と深くかかわっている。この歌を作者は巧みに織り込んだ。すなわち太（大）宰府に赴いた梅王丸の事が「梅は飛び」、切腹した桜丸のことが「桜は枯るる」、さらに、どうして松王だけがつれないことがあろうか、いやそのようなことはない。という三つ子を思いやる菅丞相の歌とした。この歌が世間に誤って広がり、松王丸だけが菅丞相につれない、不忠であると言われ、松王丸の孤独を深めることになった。

"The plum flies and the cherry wilts, but why is the pine so cold?" These lyrics appear in *Sugawara and the Secrets of Calligraphy* and belong to a song said to have been written by Sugawara Michizane himself. They have to do with the legend of the flying plum/pine, and each tree referenced refers to one of the triplets. The song asks why Matsuomaru alone is indifferent to his father's fate while the other two brothers suffer (Umeomaru is sent to Dazaifu to attend his father while Sakuramaru kills himself in penance). The song emphasizes Matsuomaru's faithlessness and further isolates him in the play.

10. 飛び梅伝説
—— The Legend of the Flying Plum

菅原道真が太(大)宰府に旅立つ折、愛していた庭の梅の木を見て「東風吹かば 匂いおこせよ 梅の花 あるじなしとて 春な忘れそ」と歌を詠んだという。梅は一夜にして筑紫へ飛んでいったと言われる。『菅原伝授手習鑑』の梅王丸は、名にふさわしく太(大)宰府の道真公のもとへ向かう。歌舞伎では上演はまれだが、本作の「天拝山」には、時平の陰謀を知った太宰府の道真が温厚な性格を一変させ、怒りの形相で雷となり都へと飛びさる場面がある。

When Michizane was exiled to Dazaifu, he gazes at his beloved plum tree and composes a poem: "When the wind blows from the east, send the fragrance of your blossoms upon it. Though your master is gone, don't forget to bloom in spring." There is a legend that this plum tree later flew (*tobiume*) all the way to Chikushi in one night. In *Sugawara and the Secrets of Calligraphy*, the loyal Umeomaru is true to his name, leaving for Dazaifu with Michizane. There is also a reversal of this imagery in a rarely performed scene called "Mt. Tenpai." Michizane, enraged to hear of Shihei's evil schemes, takes the form of a thunder god and flies all the way to the capital to exact vengeance.

11. よだれくり
—— Yodarekuri

「寺子屋」は、子供たちだけで手習いをするにぎやかな場面で始まる。なかでも体格のいい15歳の子がやんちゃで、顔に墨を付けチャンバラをしている。「涎(よだれ)くり与太郎」と呼ばれる道化役で、子役ではなく若手の俳優が演じることになっている。習字の心得を述べる菅秀才と好対照の役どころだ。実は「よだれ」は「商売は牛のよだれ」という諺もあるように、牛に付き物だ。牛は道真公の乗物で、天満宮には必ず牛の像がある。

The "School in Seryo Village" scene begins with an energetic boy of 15 wearing black makeup playing at sword fighting. His name is Yodarekuri Yotaro, and though he is a comic *dokeyaku* role, he is not usually played by a *koyaku* actor, but rather a *wakate* actor. Yotaro is a direct contrast to Shusai, who is quite talented in calligraphy. The term *yodare* (meaning "drool") echoes an old saying that "business is like a cow's drool," which refers to the hope that business should continue on like the long dripping drool of a cow. Because of this, cow imagery is a necessity to this role, and we see cows pulling Michizane's carriage and at the Tenmangu Shrine.

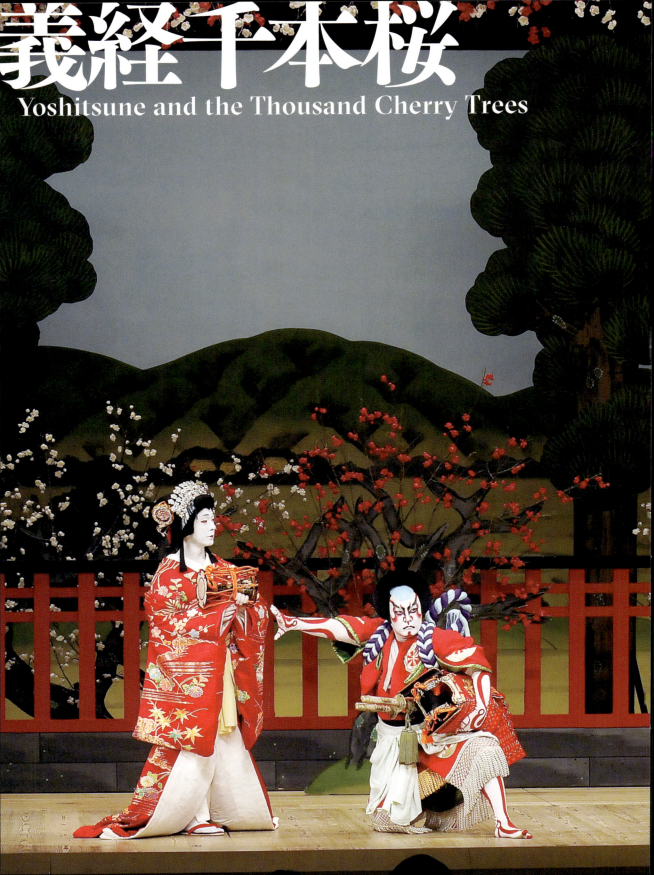

義経千本桜
Yoshitsune and the Thousand Cherry Trees

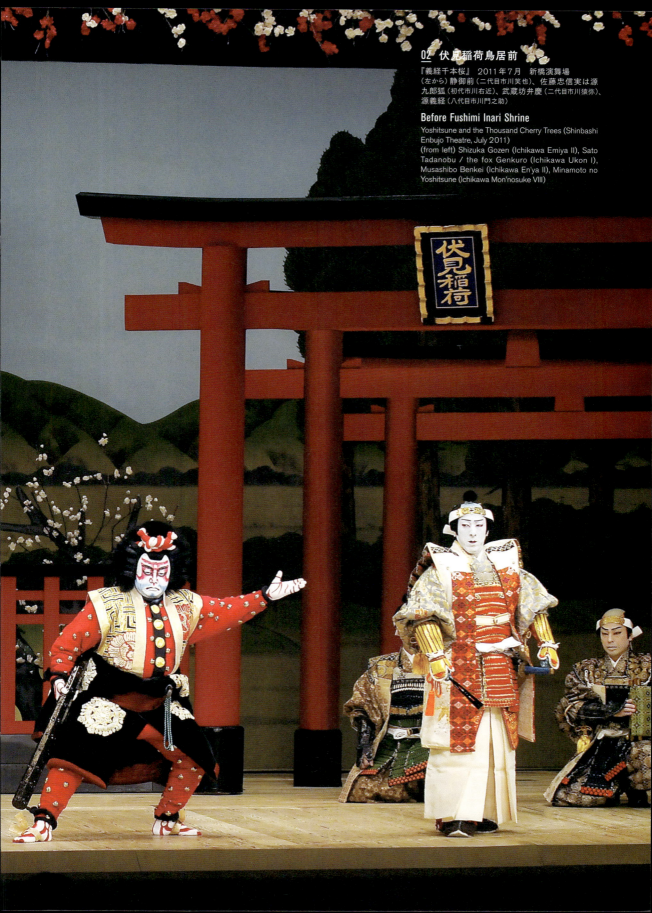

02 伏見稲荷鳥居前

『義経千本桜』 2011年7月 新橋演舞場
(左から) 静御前(二代目市川笑也)、佐藤忠信実は源九郎狐(初代市川右近)、武蔵坊弁慶(二代目市川猿弥)、源義経(八代目市川門之助)

Before Fushimi Inari Shrine
Yoshitsune and the Thousand Cherry Trees (Shinbashi Enbujo Theatre, July 2011)
(from left) Shizuka Gozen (Ichikawa Emiya II), Sato Tadanobu / the fox Genkuro (Ichikawa Ukon I), Musashibo Benkei (Ichikawa En'ya II), Minamoto no Yoshitsune (Ichikawa Mon'nosuke VIII)

あらすじ / Synopsis

死んだはずの武将が生きていた——
フィクションが描き出すもう一つの歴史

源氏と平家の戦い後の、誰も知らない裏の歴史。
勝者だった義経も今や落魄の身。
それでも彼を敵と狙うもの、身替わりで助かるもの、善も悪も因果の連鎖。
親族骨肉の修羅の明け暮れの人間たち、それを縫って語られる獣の真情。

The generals who were supposed to have perished in the war—
The alternate history of the theater.

An alternate history nobody speaks of.
The victorious Minamoto general Yoshitsune has fallen out of favor...
This is the story of his former enemies from the war, those who sacrifice themselves for him, the karmic bonds that transcend good and evil,
and the tragic story of a spirit beast whose family's blood was shed long ago.

01 堀川御所

　義経の京の住まい堀川御所に、鎌倉からの使者川越太郎が訪れ、討ち死にしたはずの平知盛・平維盛・平教経の首が偽首だったこと、また頼朝を討てとの意を込めた初音の鼓を後白河院より受け取ったこと、平家の娘である卿の君を義経が娶ったことを質す。頼朝への謀反があるのではないかと疑われているのだ。義経は、偽首は、大将の死を世に知らせることで残党の決起を防ぐ計略であり、初音の鼓は自ら打たない（討たない）と心に決めている。また卿の君は実は川越太郎の娘であると答える。卿の君は嫌疑を晴らすため自害し、川越太郎は涙ながらに介錯する。

　そこに鎌倉の討手が攻め寄せる。あくまで恭順を貫こうとする義経だが、武蔵坊弁慶が戦闘を始めてしまう。これでは卿の君の自害とその心遣いも水の泡。義経はわずかな供を連れ館から脱出する。

02 伏見稲荷鳥居前

　一行が伏見稲荷までやってくると、静御前、続いて弁慶が

01 The Horikawa Residence

　A messenger from Kamakura named Kawagoe Taro visits Yoshitsune at his Kyoto residence, Horikawa. They discuss how the Taira generals Tomomori, Koremori, and Noritsune, who were thought to have died in the war, are still alive. They also discuss the significance of the sacred drum called Hatsune which was given to Yoshitsune by Emperor Goshirakawa, and how Yoshitsune came to be married to Kyo no Kimi, a daughter of the Taira clan. It turns out that there are rumors of an attempt at Yoritomo's life, and the drum is thought to have a secret meaning: "strike" Yoritomo as you would a drum. Yoshitsune explains that the heads of the generals were falsified to prevent an uprising of surviving Taira members, and that he had no intention of "striking" Hatsune himself. Furthermore, Yoshitsune says that Kyo no Kimi is actually Kawagoe Taro's daughter, and to prove this, she commits suicide before his very eyes. In tears, Kawagoe Taro finishes the job Kyo no Kimi started by beheading her.

　At that moment, warriors from Kamakura suddenly attack. Though Yoshitsune intends to prove his allegiance to Yoritomo, his retainer Musashibo Benkei has already begun fighting with the enemy forces, and Kyo no Kimi's sacrifice is utterly wasted. Yoshitsune escapes with what little of his retinue remains.

追いつく。義経は弁慶を激しく叱責するが、静のとりなしもあり供に加わることになる。静も同道を願うが、逃避行に女性は連れて行けないと許されない。義経は初音の鼓を形見として静に与え去る。

残された静が鎌倉方に引っ立てられようとするところへ、母の病で里帰りをしていた佐藤忠信が現れ、静を救う。立ち戻った義経は静を助けた功により、忠信に「源九郎」の我が名と鎧を与え、静の供を命じた。

03　渡海屋

九州を目指す義経一行が逗留している、摂津国大物の廻船問屋・渡海屋。鎌倉の武士・相模五郎らが来て、無理難題の末、義経らのいる店の奥に踏み込もうとするが、主人の銀平に追い返される。

義経一行は銀平と女房お柳のすすめるまま雨の中、船に乗り込む。ところが銀平は実は討ち死にしたはずの平知盛であり、娘のお安は安徳天皇、女房のお柳は安徳帝の乳母典侍局であった。平家の再興を狙う知盛は義経一行を襲撃しようと、わざと悪天候に船出したのである。知盛は白装束に白糸威しの鎧を着て幽霊に身をやつし、同じく舟幽霊に扮した手勢を率いて出かけていく。

上首尾を待つ安徳帝と典侍局のもとに、相模五郎が駆けつける。最前の銀平とのやりとりは義経を信頼させる計略で、実は知盛の家臣であった。五郎は知盛方劣勢を告げる。義経はすでに知盛の襲撃を察知していたのである。続いて入江丹蔵が、味方は討ち死に、知盛は行方知れずと注進し、入水して果てた。局は自害の覚悟を極め、安徳帝を抱き上げ海に身を投げようとするが、義経の家臣にとらえられてしまう。

04　大物浦

大物の浜辺では知盛が最後の力をふりしぼって戦っていた。そこに帝を保護し局を伴った義経一行が現れる。あくまでも義経に立ち向かおうとする知盛だったが、義経のことを仇に思うなという帝の言葉や、局の自害に猛々しい心も折れてしまう。

そして安徳帝が西海に漂い、この世の地獄のような戦に苦しんだのも、知盛らの父・清盛に原因があり、その報いを受けたのだと悟る。義経に帝を託した知盛は、碇を重りに海に身を投げて果てるのだった。

05　下市村椎の木

平維盛の御台所若葉の内侍と、若君六代は、維盛が生きて

02　Before Fushimi Inari Shrine

Yoshitsune and his retinue arrive at Fushimi Inari Shrine, followed by Yoshitsune's concubine Shizuka Gozen and Benkei. Though Yoshitsune scolds Benkei for his actions, Shizuka Gozen helps convince him to forgive Benkei. Shizuka wishes to go with them, but they refuse to take a woman on such a dangerous journey. Leaving the drum Hatsune with her, they leave Shizuka at the shrine.

Shizuka, who has been left behind, is nearly kidnapped by men from Kamakura, but Sato Tadanobu, who is visiting his ill mother, appears to save her. Yoshitsune returns and thanks Tadanobu for saving Shizuka by bestowing the name Genkuro and a suit of armor. He then commands Tadanobu to accompany Shizuka.

03　Tokaiya: the Shipping House

On their way to Kyushu, Yoshitsune and his retinue stop to rest at Tokaiya, a shipping business in Daimotsu Bay in Settsu Province. Sagami Goro, a warrior sent from Kamakura, arrives and makes ridiculous demands, eventually trying to enter Tokaiya where Yoshitsune is hidden. The owner, Ginpei, however, throws him out.

Ginpei and his wife Oryu have prepared a boat for Yoshitsune, and they insist on departing even though it's raining. It is revealed that Ginpei is actually the Taira general Tomomori who is thought to have died in the war. His daughter is in fact Emperor Antoku, and his wife the nurse Suke no Tubone. Tomomori intends to kill Yoshitsune, which is why he had them depart in the rain. He and his men depart dressed in white robes to appear as ghosts.

Goro returns to where Tsubone has been left alone, and it is revealed that he actually works for Tomomori. His actions before were meant to gain the trust of Yoshitsune. The plan has not worked, however, as Yoshitsune already knew about Tomomori's plot. Goro reports of Tomomori's defeat. Next, Irie Tanzo reports the fall of his comrades and that Tomomori was nowhere to be found before jumping off the boat to his death. Tsubone is determined to commit suicide, taking Emperor Antoku with her, but she is stopped by one of Yoshitsune's retainers.

04　Daimotsu Bay

Tomomori had his final battle at Daimotsu Bay. Yoshitsune does not wish to hurt the emperor or Tsubone, and Emperor Antoku himself warns Tomomori not to consider Yoshitsune an enemy. Even so, Tomomori chooses to fight, and Tsubone commits suicide after his loss, making this a truly heartbreaking scene.

Tomomori now realizes that his father Kiyomori was the cause of Emperor Antoku's suffering during and after the war, and that he is being punished for this. Leaving the Emperor in Yoshitsune's hands, he ties himself to an anchor and jumps into the sea.

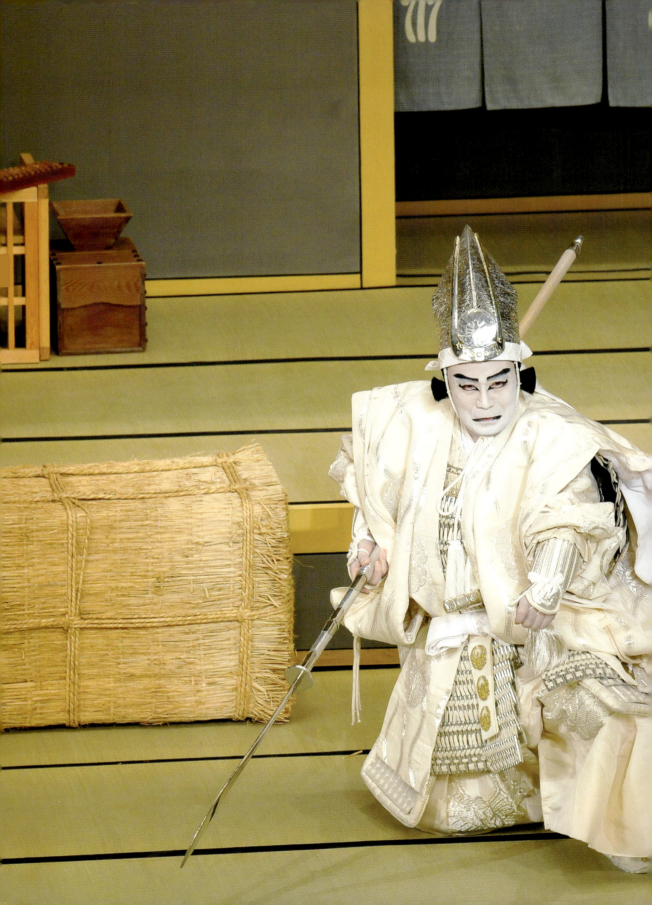

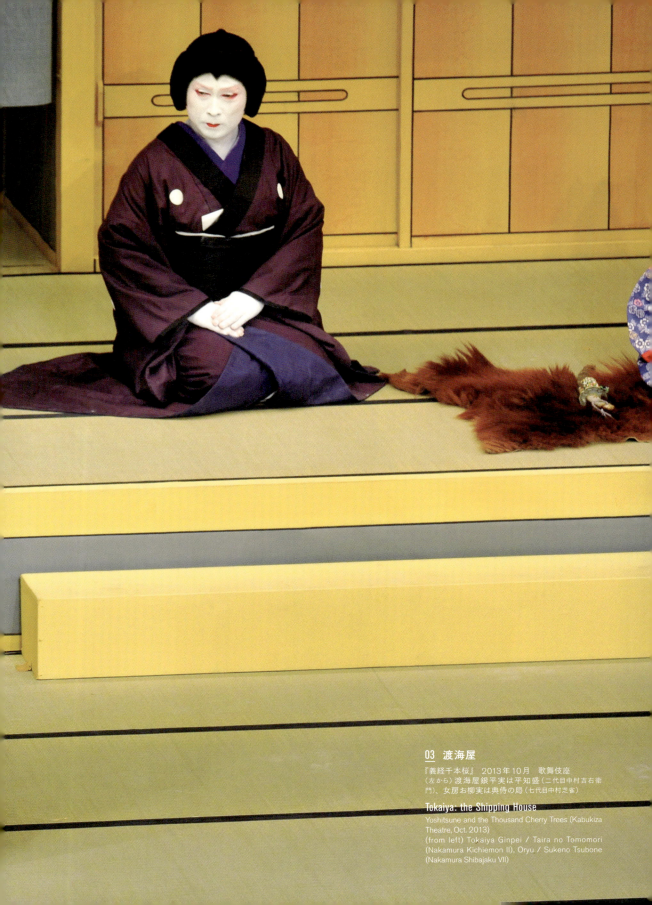

03 渡海屋

『義経千本桜』 2013年10月 歌舞伎座
(左から) 渡海屋銀平実は平知盛 (二代目中村吉右衛門)、女房お柳実は典侍の局 (七代目中村芝雀)

Tokaiya: the Shipping House
Yoshitsune and the Thousand Cherry Trees (Kabukiza Theatre, Oct. 2013)
(from left) Tokaiya Ginpei / Taira no Tomomori (Nakamura Kichiemon II), Oryu / Sukeno Tsubone (Nakamura Shibajaku VII)

04 大物浦
『義経千本桜』 2013年10月 歌舞伎座
渡海屋銀平実は平知盛（二代目中村吉右衛門）

Daimotsu Bay
Yoshitsune and the Thousand Cherry Trees (Kabukiza Theatre, Oct. 2013)
Tokaiya Ginpei / Taira no Tomomori (Nakamura Kichiemon II)

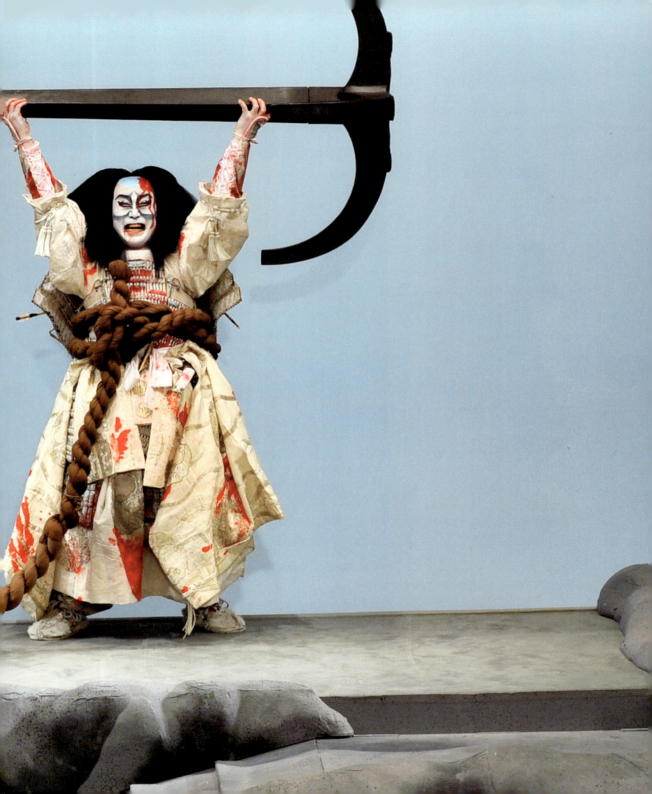

いるとのうわさを聞き、高野山へと向かっていた。供をするのは若侍主馬小金吾のみ。一行は、吉野下市村で、男に騙され金をとられてしまう。

男はこの近在で釣瓶鮓屋（つるべすしや）を営む弥左衛門のせがれで、いがみの権太と呼ばれている悪党。女房小せんは、子どもの善太のためにも悪事を改めてくれと意見するが、権太は耳も貸さない。

06　下市村竹藪小金吾討死

若葉の内侍と六代は、追手に襲われるが、小金吾の働きで逃げることができた。しかし深手を負った小金吾は息絶えた。そこへ弥左衛門が通りがかり、小金吾の首を切り落とし持ち去るのだった。

07　下市村釣瓶鮓屋

釣瓶鮓屋の弥左衛門には、権太のほかに娘のお里がいる。お里は下男の弥助と祝言をあげることになっていた。そこへ、権太が父の目を盗んでやってきて、母から三貫目の金をだましとるが、間もなく父が帰ることを察知した権太は空の鮓桶に金を隠し、自らは家の奥に身をひそめる。

弥左衛門は小金吾の首を鮓桶の一つに隠し、迎えに出た弥助を上座に座らせる。弥助は実は、鎌倉方の詮議の的・平維盛で、弥左衛門が匿っていたのである。弥左衛門は、その昔、維盛の父平重盛に、死に値する大罪を不問とされて命を助けられたことがあり、その恩義で維盛を助けたのだ。

そこへお里が出てくる。布団を敷き、お里は先に寝るが、維盛は妻子を思うと気も晴れない。そこに宿を乞う女の声。若葉の内侍と六代であった。思わぬ再会に驚きながらも維盛は二人を招き入れ話をする。その話を聞き、弥助の素性を知ったお里は、身分違いの恋を嘆くのだった。

そこに鎌倉の武士梶原景時が詮議に来るとの知らせ。お里は維盛たちを立ち退かせるが、物陰で事の次第を聞いていた権太が、維盛たちを捕まえて褒美にありつくのだと飛び出してくる。権太は、先ほど母からだまし取った金を隠しておいたはずの鮓桶を持ち、維盛たちのあとを追ってゆく。

乗り込んで来た梶原から維盛を差し出せと迫られた弥左衛門は、維盛はもう首にしてあると梶原に告げ、鮓桶を差し出そうとする。先程の首を身替わりにするつもりなのだが、その桶に権太が隠した金が入っていると思った権太の母が阻む。二人が争ううち、維盛たちを捕らえたという権太の声が響く。

05　The Beech Tree in Shimoichi Village

Taira no Koremori's wife Wakaba no Naishi and her son Rokudai are travelling to Mt. Koya, searching for Koremori who is rumored to be alive. They are accompanied only by their retainer Shume Kokingo and fall victim to a thief in Shimoichi Village.

The man who stole their money is Gonta, the son of Yazaemon who runs Tsurube Sushi. His wife Kosen pleads with him to stop swindling for the sake of their son, but Gonta refuses to listen.

06　Shimoichi Village: Kokingo's Battle

Naishi and Rokudai are chased, but escape thanks to Kokingo, who suffered deep wounds and perished in the fight. Yazaemon comes by his corpse and decides to cut off his head and return to town with it.

07　Shimoichi Village: Tsurube Sushi

Gonta's mother and sister, Osato, are back at Tsurube Sushi, where Osato has been promised to the manservant Yasuke. Gonta comes and tricks his mother into giving him money behind his father's back, but just then Yazaemon returns. Gonta quickly hides the money in an empty Sushi container and hides himself in the back of the shop.

Yazaemon hides Kokingo's head in another sushi container, and sits Yasuke down at the seat of honor. As it turns out, Yasuke is actually Taira no Koremori. Yazaemon was once saved by Koremori's father Shigemori, who pardoned him for a severe crime that would have cost him his life. It is due to Yazaemon's debt of gratitude to Shigemori that he is protecting Koremori.

Osato and Koremori, who have just been married, lie in bed together. Osato falls asleep first, but Koremori, thinking of his actual wife and son cannot fall asleep. He hears a woman's voice outside the house and realizes it's Naishi and Rokudai. Koremori welcomes them in and introduces them, and Osato laments falling in love with a noble whose social status is much higher than her own.

Kajiwara Kagetoki, a soldier from Kamakura, appears at the house to investigate the whereabouts of Koremori. Osato helps Koremori and his family escape, but Gonta, who was hidden in the house, hears about what is happening. To capture Koremori for his own personal gain, he takes the sushi container with his hidden money and chases after them.

Kajiwara demands that Yazaemon procure Koremori, but Yazaemon claims that he has already killed Koremori and has his head. He goes to get the container where he has hidden Kokingo's head, but is stopped by his wife, who is afraid he will find the money she gave to Gonta. As they are fighting, Koremori appears, announcing that he has captured Koremori and his family.

権太は縛りあげた内侍と六代、鮓桶に入れた維盛の首を差し出した。梶原は首を実検し、褒美として頼朝の陣羽織を与えて去る。怒った弥左衛門は権太に刀を突き立てるが、権太は苦しい息の下から、首は父親の持って帰った首であり、内侍と六代と見せかけたのは、自分の女房と子供だと明かす。父と維盛の話を聞き、改心した権太は、鮓桶を間違えて持ち出したのを幸いに、首と身替わりを差し出したと語る。そして維盛たちを呼び出すのだった。

維盛が頼朝の陣羽織を裂こうとすると、中に袈裟と数珠が縫いこまれていた。頼朝は少年のころ重盛らの嘆願により命が助かったことがあり、その恩を思い、維盛を出家させ、命を助けるという謎をかけたのであった。梶原は首が身代わりであることを知っていたのだ。改心しての芝居も水泡に帰した権太の死を悼みつつ、出家した維盛は高野山に、内侍と六代は弥左衛門が供をして高尾の文覚上人のもとに旅立っていく。

08 道行初音旅

静御前は義経が吉野にいるらしいとの噂を聞き、忠信とともに吉野に向かう。初音の鼓を打つと、忠信がどこからともなく現れるのだった。旅の憂さをはらすために、忠信は、兄の佐藤継信が、義経の身替わりに平教経の矢に当たり討ち死にしたことなどを物語る。

09 川連法眼館

義経は吉野山にある川連法眼(かわつらほうげん)の館に身を寄せていた。そこに佐藤忠信がやってくるが、静御前を伴っていない。忠信は故郷から今着いたばかりで、静御前のことは知らないという。義経はこれを聞き自分を裏切り鎌倉に静を渡したのに違いないと怒る。その時、また佐藤忠信が、静御前を伴って参着したとの知らせがくる。

静御前が初音の鼓を持って義経たちの前に現れた。義経は静に、供をしてきた忠信についてたずねる。供の忠信はいつの間にかいなくなり、目の前にいる忠信は違うようだという静。その忠信は道中、初音の鼓を打つと現れたと聞いた義経は、静に忠信を詮議するよう命じる。

静が初音の鼓を打つと供をしていた忠信が現れた。鼓の音に聞き入る様子だったが、問い詰められた末、ついにその正体を白状した。この忠信は実は狐の化身であった。桓武天皇の御代。雨乞いのために千年生きながらえてきた夫婦の狐の皮で鼓を作った。それが初音の鼓で、自分はその鼓にされた狐の子だというのである。親を恋い慕っていた子狐は、初音の鼓が義経に下されたのを知り、鼓に付き添っていた。伏見稲荷で佐藤忠信に化けて静の危機を救い、源九郎という名

Gonta hands over Naishi and Rokudai, who have been tied up, and produces the head that was hidden in the sushi container. Kajiwara inspects the head, and, satisfied, gives Gonta a coat that once belonged to Yoritomo. After Kajiwara leaves, Yazaemon flies into a rage and attacks Gonta, but Gonta explains that the head he gave was in fact Kokingo's head which Yazaemon had hidden. The two prisoners he gave to Kajiwara, too, were actually his own son and wife. Having had a change of heart after hearing about his father and Koremori, Gonta decided to use the head from the container he mistakenly took and his own wife and son as substitutes to appease Kajiwara.

Koremori then appears at Gonta's summons and examines the robe Gonta received. Ripping it open, he finds monk's robes and prayer beads. It turns out Yoritomo, too, was saved by Shigemori when he was a boy, and intended to save Koremori as a repayment of this debt. Kajiwara, then, must have known all along that the head was a fake. Though he has finally changed his ways, Gonta kills himself, and Koremori heads to Mt. Koya as a monk. Yazaemon accompanies Naishi and Rokudai to the priest Mongaku in Takao.

08 Michiyuki

Shizuka Gozen travels to Yoshino, hearing that Yoshitsune is there. Along the way, she plays the Hatsune drum, causing Tadanobu to suddenly appear. To take their mind off the difficult journey, Tadanobu talks about how his brother Tsugunobu died fighting Taira no Noritsune in Yoshitsune's place.

09 The Kawatsura Hogen Residence

Yoshitsune is staying at the priest Kawatsura Hogen's place in Yoshino. Tadanobu appears there, but Shizuka is not with him. He says that he has just arrived from his hometown, and that he doesn't know where Shizuka is. Yoshitsune is furious, believing Tadanobu betrayed him and turned Shizuka in to the shogun. Just then, however, he hears that Tadanobu has arrived with Shizuka.

Shizuka appears before Yoshitsune with the drum Hatsune. Asking about Tadanobu, Shizuka says that he has suddenly disappeared, and that the Tadanobu who stands before her now is not the same person. Hearing about how Tadanobu appeared after playing the Hatsune drum, Yoshitsune tells Shizuka to interrogate this strange Tadanobu.

Shizuka once again summons Tadanobu by playing the drum. Though Tadanobu is initially entranced by the sound of the drum, Shizuka questions him and eventually finds out that he is in fact a fox in disguise. The fox spirit explains that Hatsune was made using the skin of a fox couple who had lived for a thousand years. The drum was made during the reign of Emperor Kanmu to help bring rain to the realm. The fox who had disguised itself as Tadanobu is actually the child of the foxes whose skin was used to make Hatsune. He saved Shizuka at Fushimi Inari Shrine, receiving the name

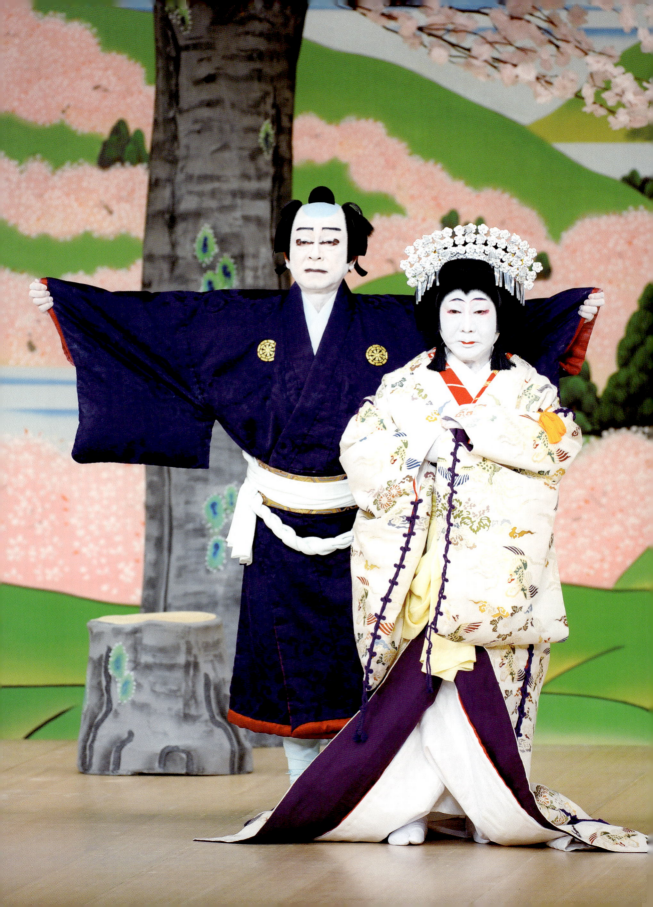

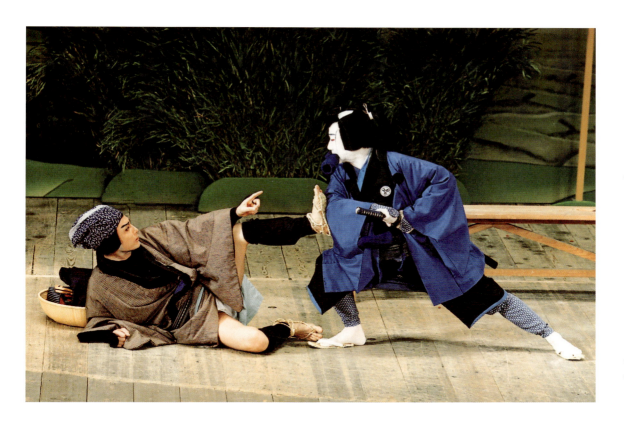

05 下市村椎の木
『義経千本桜』 2007年3月 歌舞伎座
(左から) いがみの権太 (十五代目片岡仁左衛門)、主馬小金吾 (三代目中村扇雀)

The Beech Tree in Shimoichi Village
Yoshitsune and the Thousand Cherry Trees (Kabukiza Theatre, Mar. 2007)
(from left) Igami no Gonta (Kataoka Nizaemon XV), Shume no Kokingo (Nakamura Senjaku III)

08 道行初音旅
『義経千本桜』 2014年10月 歌舞伎座
(左から) 佐藤忠信実は源九郎狐 (四代目中村梅玉)、静御前 (四代目坂田藤十郎)

Michiyuki
Yoshitsune and the Thousand Cherry Trees (Kabukiza Theatre, Oct. 2014)
(from left) Sato Tadanobu / the fox Genkuro (Nakamura Baigyoku IV), Shizuka Gozen (Sakata Tojuro IV)

義経千本桜

あらすじ

06 下市村竹藪小金吾討死
『義経千本桜』 2016年6月 歌舞伎座
主馬小金吾（二代目尾上松也）

Shimoichi Village: Kokingo's Battle
Yoshitsune and the Thousand Cherry Trees (Kabukiza Theatre, June 2016)
Shume no Kokingo (Onoe Matsuya II)

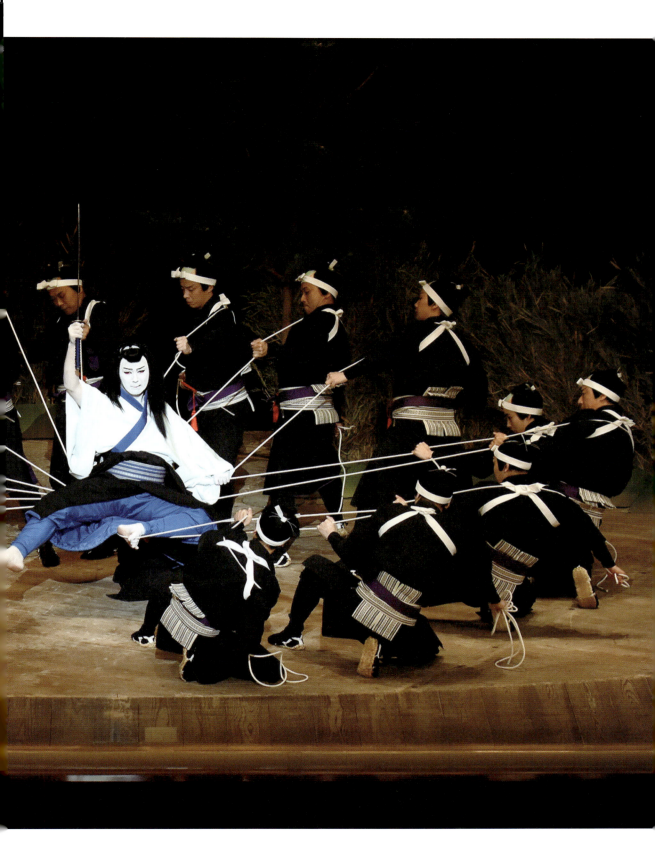

07 下市村釣瓶鮓屋

『義経千本桜』 2014年11月 歌舞伎座
(左から) 若葉の内侍 (二代目市村萬次郎)、弥助実は平維盛 (五代目中村時蔵)、鮓屋弥左衛門 (四代目市川左團次)、いがみの権太 (七代目尾上菊五郎) 他

Shimoichi Village: Tsurube Sushi
Yoshitsune and the Thousand Cherry Trees (Kabukiza Theatre, Nov. 2014)
(from left) Wakaba no Naishi (Ichimura Manjiro II), Yasuke / Taira no Koremori (Nakamura Tokizo V), Yazaemon (Ichikawa Sadanji IV), Igami no Gonta (Onoe Kikugoro VII), others

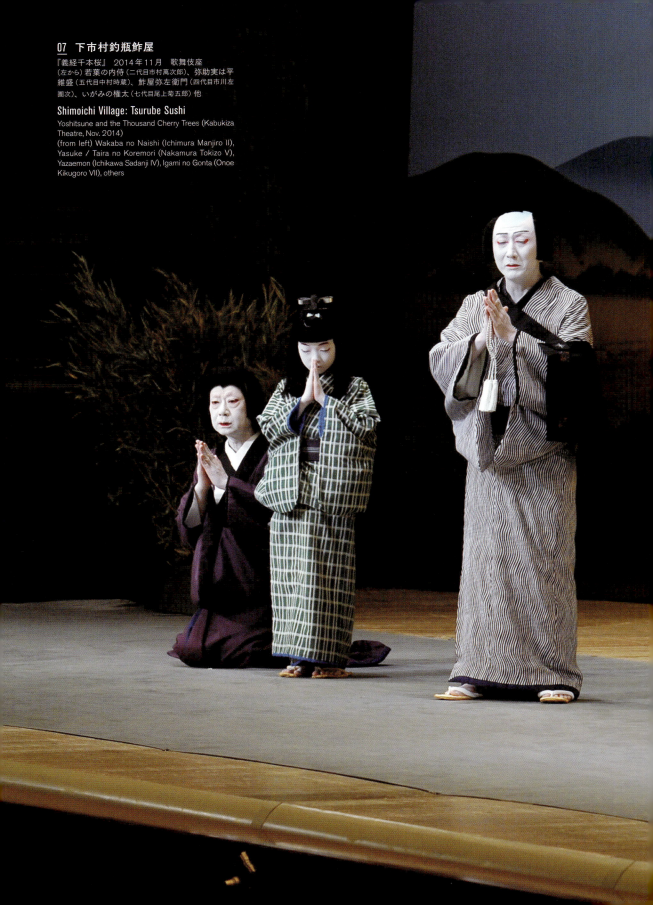

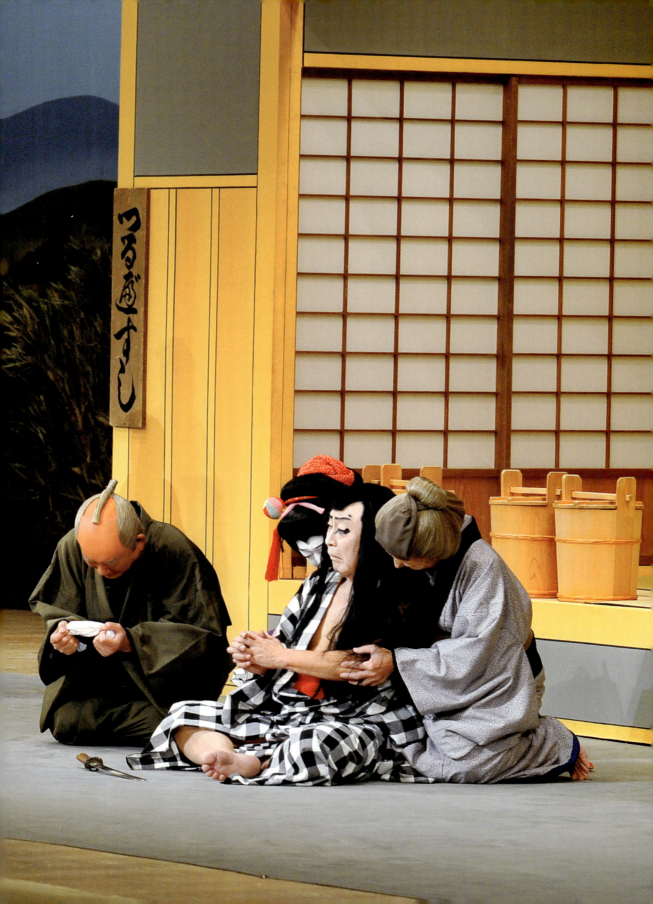

義経千本桜

あらすじ

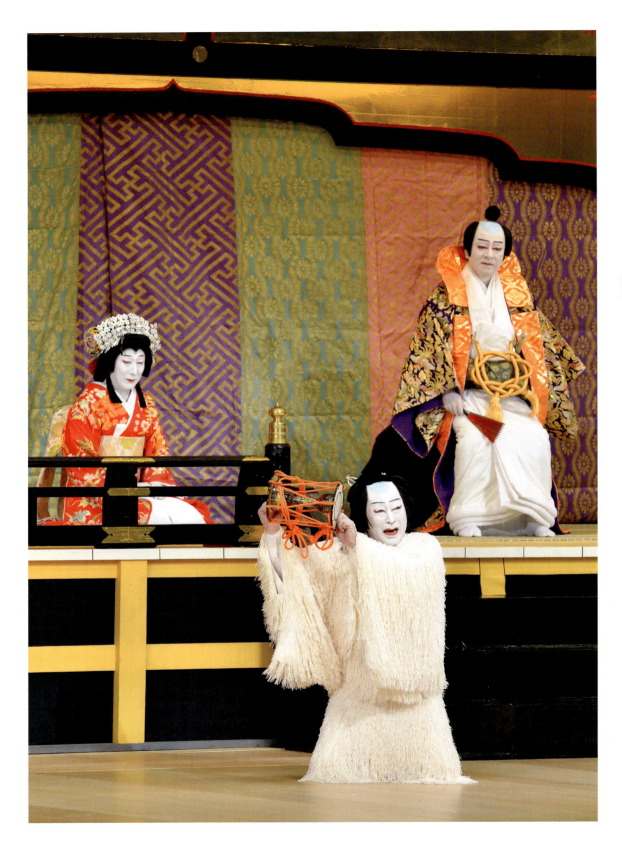

まで賜った。しかし本物の忠信にこれ以上迷惑はかけられない、と狐は姿を消してしまう。

　義経は、自分は幼くして父義朝と死に別れ、その後兄頼朝に仕えたが、憎まれ追われる身の上となった。自分と源九郎狐の肉親の縁が薄いのは、前世の業であろうかと嘆く。そして再び姿を現した源九郎狐に初音の鼓を与えた。源九郎狐は喜び、かつ吉野の僧兵が館を襲おうとしていることを知らせ、鼓とともに姿を消すのであった。

10　川連法眼館奥庭

　衣の下に鎧を着込み、薙刀を持った僧・横川覚範が現れるが、この覚範こそ平教経。教経は佐藤忠信、源九郎狐、義経一行らと対峙する。

Genkuro, in order to follow the drum made from his beloved parents. In the end, however, the fox disappears, saying that he mustn't cause any more trouble for the real Tadanobu.

　Yoshitsune recalls the early death of his own father, and how he once served his brother Yoritomo only to be hunted by him now. He muses that his fate and that of the fox Genkuro who was also separated from his parents, must be karmic retribution from a former life. Genkuro appears once more and Yoshitsune gives him Hatsune. Genkuro is elated, and before leaving he warns Yoshitsune that the warrior monks in Yoshino are planning to attack Kawatsura Hogen's home where he is currently staying.

10　Kawatsura Hogen Inner Courtyard

　Yokokawa Kakuhan appears and it is revealed that he is in fact Taira no Noritsune, the third of the Taira generals thought to be dead. A fight ensues between him and Yoshitsune's retinue, including Tadanobu and Genkuro.

09　川連法眼館
『義経千本桜』 2013 年 10 月　歌舞伎座
（左から）静御前（五代目中村時蔵）、佐藤忠信実は源九郎狐（七代目尾上菊五郎）、源義経（四代目中村梅玉）

The Kawatsura Hogen Residence
Yoshitsune and the Thousand Cherry Trees (Kabukiza Theatre, Oct. 2013)
(from left) Shizuka Gozen (Nakamura Tokizo V), Sato Tadanobu / the fox Genkuro (Onoe Kikugoro VII), Minamoto no Yoshitsune (Nakamura Baigyoku IV)

作品の概要

Overview

演目名 / **Title**

義経千本桜

Yoshitsune and the Thousand Cherry Trees

作者 / **Writers**

竹田出雲・三好松洛・並木千柳

Takeda Izumo, Miyoshi Shôraku, Namiki Senryu

概要 / **Overview**

　延享4（1747）年11月　大坂・竹本座で初演された人形浄瑠璃の作品を歌舞伎に移したもの。原作浄瑠璃の作者は竹田出雲・三好松洛・並木千柳。歌舞伎では浄瑠璃初演の翌々月、延享5（1748）年1月　伊勢の芝居、同年5月江戸・中村座で上演されている。

　義太夫狂言の三大名作のひとつに数えられる。原作浄瑠璃は全五段で、国立劇場がほぼ全場面を上演したときは2か月がかりであった。一日で通し狂言とする場合は、原作の順にこだわらず、「鳥居前」「渡海屋・大物浦」「道行初音旅」「椎の木・小金吾討死・すし屋」「川連館」の順で上演されることもある。また、通しのほかにも各場面とも見取りでも上演され、近年では、「鳥居前」「道行」「川連館」の、狐忠信に関わる場面を組み合わせて上演もされる。

　また「堀川御所」の後に弁慶が荒事を見せる演出もある。あらすじは上記各場面と、次に上演頻度の高い「堀川御所」を加え、教経の登場する「奥庭」は確定した台本がないので、あらましをしるした。

　Yoshitsune and the Thousand Cherry Trees was first performed as a Bunraku play in November, 1747 at Takemoto-za Theater in Osaka, and later adapted to kabuki. The original bunraku play was written by Takeda Izumo, Miyoshi Shoraku, and Namiki Senryu, and the first kabuki performance was held in January of 1748, two months after the bunraku debut.

　One of the three masterpieces of idayu-kyogen, Yoshitsune consists of five acts and would take two months to perform at national theaters. When performed on a single day, the following scenes are often shown: "Before the Shrine Gate," "Tokaiya / Daimotsu Bay," "The Beech Tree / Kokingo's Battle / The Sushi Shop," and "The Kawatsura Residence." They are played in this order, though it is not the original order of the full play. Of course, the play is also interpreted and played in other unique ways depending on the location. In recent years, performing all of the scenes dealing with the fox spirit disguised as Tadanobu ("Before the Shrine Gate," "Michiyuki," and "The Kawatsura Residence") has become quite popular. The scene after "The Horikawa Residence" is also very popular. Above we have included summaries of each scene, including the "Horikawa Residence Scene." We have also included a summary of the "Inner Courtyard" scene in which Noritsune appears, since there is no fixed script for this scene.

初演 / **Premiere**

人形浄瑠璃—延享4（1747）年11月　大坂・竹本座
歌舞伎—延享5（1748）年1月　伊勢の芝居
　　　　同年5月　江戸・中村座

Bunraku: November 1747, Takemoto-za Theatre, Osaka
Kabuki: January 1748, Ise; May 1748, Nakamura-za Theatre, Edo

登場人物 / Characters

源義経
みなもとのよしつね

いうまでもなく歴史的にも名高い源氏の大将で、兄・頼朝に疎まれ都を落ち悲劇の結末を迎える。この演目『義経千本桜』はその名を冠しているが、義経自身が活躍するというよりは、義経の周辺で様々な登場人物がドラマを展開してゆく。伏見稲荷鳥居前で愛妾の静御前と別れた義経は、武蔵坊弁慶や四天王と呼ばれる側近たちを従えて大物浦そして吉野へと旅を続け、平家の能登守教経と対峙する。

Minamoto no Yoshitsune

The historical Yoshitsune is famous as a decorated Minamoto general who fell out of favor with his brother and was forced to flee the capital. In *Yoshitsune and the Thousand Cherry Trees*, Yoshitsune is not the one who drives the plot. Rather, various characters around Yoshitsune push the story forward. After parting with his concubine Shizuka Gozen, Yoshitsune travels with Musashibo Benkei and his four samurai (known as *shitennno*) to Daimotsu Bay and Yoshino, where they eventually confront the Taira warrior Notonokami Noritsune.

佐藤忠信 実は 源九郎狐
さとうただのぶ じつは げんくろうぎつね

佐藤忠信は武勇優れた義経の家臣。義経と別れて一人きりとなった静御前の前にこの忠信が現れ、立ち戻った義経の許しを得て静と旅をする。しかし川連法眼館には別の忠信がすでに到着していた。実は先に来ていたのが本物の忠信、旅をしてきた忠信は静が持つ初音の鼓の皮となった狐の子、親狐を慕うあまり人の姿となって付き添っていたのである。義経から鼓を賜った狐は喜んで飛び去ってゆく。

Sato Tadanobu / the fox Genkuro

Sato Tadanobu is a capable samurai serving Yoshitsune. When Yoshitsune leaves Shizuka Gozen, Tadanobu appears to save her and eventually receives permission from Yoshitsune to travel together with her. Yoshitsune, however, finds another Tadanobu at the Kawatsura Hogen Residence. It turns out this is the real Tadanobu, while the Tadanobu who has been travelling with Shizuka is a fox spirit who is the child of the foxes whose skin was used to make the sacred drum Hatsune. The fox Genkuro leaves after happily receiving Hatsune from Yoshitsune.

渡海屋銀平 実は 平知盛
とかいやぎんぺい じつは たいらのとももり

海に面した廻船問屋・渡海屋の主人銀平は天気と船の日和を見る名人。ここには義経一行が逗留し西国への船出を待っているが、今が頃合いと悪天候にもかかわらず出航を促す。実はこの銀平こそ壇ノ浦で死んだはずの平知盛。身をやつして義経へ報復の機会を狙い、いま再び挑むがすでに義経に見抜かれて劣勢となり、大物浦で瀕死となった知盛は碇を重りに海へと身を投じて劇的な最期を見せる。

Tokaiya Ginpei / Taira no Tomomori

Ginpei is the proprietor of a shipping business next to a harbor. He prepares a boat for Yoshitsune to take to the west, and insists on their leaving despite the bad weather. In fact, Ginpei is the Taira general Tomomori who was thought to have died at the battle of Dan no Ura. He has been lying in wait for an opportunity to take revenge against Yoshitsune, but Yoshitsune sees through his disguise. Outnumbered by Yoshitsune's men at Daimotsu Bay, Tomomori meets a tragic end when he attaches himself to an anchor and drowns himself in the water.

静御前
しずかごぜん

源義経の愛妾で、都落ちする義経からは同行を許されず、初音の鼓を預けられて残される。追っ手がやって来て危うくなるところへ義経の家臣・佐藤忠信が現れ、心強い警護役を得た静は共に旅を続けてゆく。主従でありながら似合いのカップルにも見えるほのぼのとした二人旅。やがて義経が匿われている吉野の川連法眼館に到着するが、静はそこで初めて同行してきた忠信の正体を知る。

Shizuka Gozen

Shizuka is Yoshitsune's concubine but is denied when she asks to accompany Yoshitsune into exile. She is attacked after taking custody of the sacred drum Hatsune, but Sato Tadanobu appears to save her. Because of this, he accompanies her as a bodyguard, though at times they look like a couple to the audience. It isn't until the stunning scene at the Kawatsura Hogen Residence that Shizuka finally learns the true identity of her travel companion.

武蔵坊弁慶
むさしぼうべんけい

武蔵坊弁慶は源義経の家臣の中でもとりわけ剛力怪力で知られるが、序段にあたる「堀川御所」では、鎌倉(頼朝)方に包囲されるも兄との争いを避けようとする義経の思いをよそに、弁慶は相手の土佐坊を討ち取ってしまい、ある意味義経を窮地に追い込んでしまった。そして都を落ちる義経に伴い、大物浦では平知盛との最後の戦い、さらに吉野へと旅を続け忠実に義経を守り続けてゆく。

Musashibo Benkei

Benkei is well-known as one of Yoshitsune's strongest and most loyal retainers. In the "Horikawa Residence" scene, Benkei ignores his master's wish to avoid fighting and flee, killing Yoritomo's agent who has come for Yoshitsune. This leaves Yoshitsune no choice but to flee the capital, as there is no chance of restoring his reputation. Benkei protects Yoshitsune at the battle with Taira general Tomomori at Daimotsu Bay, and continues to travel and serve him faithfully as they travel to Yoshino and beyond.

女房お柳 実は 典侍局
にょうぼうおりゅう じつは すけのつぼね

渡海屋銀平の女房お柳は義経相手に主人の自慢話を並べるが、実は安徳帝の乳母典侍局。主人から武将へと変身した平知盛を送り出し、海上の戦況を見つめるが次第に形勢は悪くなるばかり。安徳帝に「波の底にも都がある」と諭し入水しようとするところ、駆け付けた義経勢に留められる。知盛は奮戦の末の瀕死、安徳帝が義経に庇護されることを確かめると、典侍局はもはやこれまでと自害する。

Nyobo Oryu / Suke no Tsubone

Suke no Tsubone of the Taira clan is disguised as Oryu, Ginpei's wife, and Ginpei is actually the Taira general Tomomori. Though they house and entertain Yoshitsune, they secretly plan to kill him. Tsubone is dismayed to see the battle between Tomomori and Yoshitsune gradually develop in Yoshitsune's favor, and finally attempts to commit suicide together with Emperor Antoku. She is stopped by Yoshitsune, but commits suicide herself after Yoshitsune promises that he will protect the emperor.

義経千本桜

登場人物

娘お安 実は 安徳帝
むすめおやす じつは あんとくてい

渡海屋の娘・お安が寝ているところ、たまたまその上をまたいだ武蔵坊弁慶の足が俄にしびれるが、不思議な力を秘めたこの娘こそ実は安徳帝。知盛の戦いもみるみる風前の灯となり、平家の女性たちは次々と入水するが、典侍局に抱かれた安徳帝は間一髪で義経に救われる。ついに敗戦を余儀なくされた知盛に向かい、安徳帝はこれまでの知盛の介抱をねぎらい、今は義経の情けと告げる。

Musume Oyasu / Emperor Antoku

Emperor Antoku is disguised as Ginpei's daughter Oyasu. Antoku has a mysterious power that manifests itself when Benkei steps over the sleeping Oyasu/Antoku, causing his legs to go numb. As Tomomori loses his battle with Yoshitsune, Suke no Tsubone takes hold of Emperor Antoku and attempts to commit suicide, but Yoshitsune stops them in the nick of time. As Tomomori is about to die, Emperor Antoku thanks him for his service and acknowledges Yoshitsune's compassion.

いがみの権太
いがみのごんた

釣瓶鮓屋の息子の権太郎だが、人を脅したり金を巻き上げたり、あまりに素行が悪く嫌われ者で「いがみの権太」と呼ばれている。鮓屋に奉公している弥助を平維盛とにらんだ権太は、鎌倉方に突き出せば金になると、維盛の首のほか奥方と若君まで生け捕って梶原平三に渡す。実は首は偽物、身替わりに立てたのは自分の妻子だが、この憎まれ者が改心したとわかったのは命の切れる直前だった。

Igami no Gonta

Tsurube's son Gontaro is a rascal who threatens and robs people of their money. His reputation has earned him the nickname "Igami no Gonta," or "depraved Gonta." He finds out that Yasuke, who is working at his father's sushi restaurant, is actually Koremori. Knowing he might receive an award, he beheads Koremori and takes his wife and son hostage, handing them to Kajiwara Kagetoki. Afterwards it is revealed that the head of Koremori he presented was actually a fake, and that the hostages were actually Gonta's own wife and child. It isn't until just before he kills himself that the audience sees his compassionate side.

若葉の内侍
わかばのないし

平維盛の妻で、維盛との間には六代君という子がある。維盛の居所を求めて若き家来の小金吾と共に旅を続けているのだが、長旅のひと時、ちょうど下市村の茶店にさしかかり休息していると、やって来たのはいがみの権太。木の実拾いにかこつけて近付いてきた権太は、荷物の取り違えをタネに思いもよらぬゆすりを働く。しかし鎌倉方に追われる親子が、この権太に救われることになろうとは。

Wakaba no Naishi

Wakaba no Naishi is Taira Koremori's wife, and has one child with him, named Rokudai. She travels with Rokudai and her young retainer Kokingo in search of Koremori, but are robbed by Gonta when they stop for rest at the teahouse in Shimoichi Village. This makes it all the more surprising when Naishi and her son are saved by the very same Gonta.

相模五郎 と 入江丹蔵
さがみのごろう と いりえたんぞう

渡海屋へやって来た鎌倉方の傍若無人な二人の武士、相模五郎と入江丹蔵。義経詮議のため今すぐ船を出せ、もしくは船を注文した奥の侍をここへ出せと無理難題。そこへ戻って来た主人銀平に追い出されるが、その時の悪態が「鰯（いわし）ておけば飯蛸（いいだこ）思い、鮫々（さめざめ）の鮫鱇（あんこう）雑言」と魚づくし。実はこの二人は平知盛側近の家臣で、義経たちを信用させる計略。

Sagami no Goro and Irie Tanzo

Arrogant samurai in the service of Yoritomo who come to Ginpei's shipping house and demand that either a boat or that the samurai hidden in his house come out. They are after Yoshitsune whom Ginpei is harboring, but Ginpei comes and drives them away. This show, however, is merely an act to make Yoshitsune trust Ginpei. From the beginning, Goro and Tanzo are both working for Tomomori, who is disguised as Ginpei.

女房小せん
にょうぼうこせん

いがみの権太の女房。ささやかな茶店を営んでなかなかの働き者、権太との間には善太という無垢な倅もいる。権太が店先で客にゆすりを働いたり、善太に博打を教えたりと手を焼くことばかりだが、時には親子水入らずの温かみを感じさせる瞬間もある。この茶店にやって来たのはこのあたりでは見かけぬ高貴な奥方と若君、そして凛々しい若侍。やがて予期せぬ因縁がわが身にふりかかる。

Nyobo Kosen

Gonta's hardworking wife who runs a teahouse. Kosen has a single son named Zenta. Though Gonta spends his time bothering customers and teaching his son gambling, he can be kind when no one else is around. In the end, Kosen and her son end up caught up in the affairs of a group of nobles who come to the teahouse.

主馬小金吾
しゅめのこきんご

平維盛の家来で、まだ前髪立ちの若衆。若葉の内侍、六代君に伴って維盛を探しに高野山を目指すが、下市村で追っ手に囲まれ、目覚ましく奮戦するも多勢に無勢で深手を負う。駆け寄った若葉の内侍と六代君に早々の落ち入りを促し、自分はやがて息絶えてゆく。そこに通りかかったのは鮓屋の弥左衛門、むごたらしいその姿に驚くが、何やら思い当たることがある様子で刀を取る。

Shume no Kokingo

Kokingo is one of Taira general Koremori's retainers, a young man with who wears bangs. He travels with Wakaba no Naishi and her son Rokudai in search of Koremori, but suffers a fatal wound in Shimoichi Village when they are attacked. After telling Naishi and Rokudai to flee to safety, Kokingo dies and is found by Yazaemon, the proprietor of a sushi restaurant. Yazaemon is surprised to find his body there, but cuts his head off. Apparently, he has some plot in mind.

すし屋弥左衛門
すしや やざえもん

下市村の釣瓶鮓屋の主人で、いがみの権太はここの倅。平維盛の父・重盛には大きな恩があり、熊野で出会った維盛を店に奉公させ弥助と名乗らせている。それを知っているのは女房のみ。しかし維盛がいるということが鎌倉方に知られ、首を討って渡せとの厳しい申し渡しを受ける。そこで弥左衛門が思いついた小金吾の首、それは店先に並べてある鮓桶の中にあるはずだが。

Sushiya Yazaemon

Yazaemon is the proprietor of the Tsurube Sushi Shop and father of Igami no Gonta. He is descended from the Taira clan and is deeply indebted to Koremori's father, Shigemori. After finding Koremori in Kumano, Yazaemon disguises him as a worker at his shop named Yasuke, telling no one but his wife. Despite this, word reaches Yoritomo that Koremori is at Yazaemon's shop and he is subsequently ordered to kill Koremori and present his head to the authorities. Yazaemon decides to use Kokingo's head which he had left hidden in a sushi container, but things don't go as smoothly as he had hoped.

お里
おさと

弥左衛門の娘で、権太の妹。兄とは打って変わった可憐な娘である。かねてより店に奉公の弥助に心を寄せて、祝言を上げて夫婦になることを夢見るばかり。顔を赤らめて今宵こそと思う時、弥助には妻子のある身と打ち明けられ、さらにその妻子の思わぬ来訪。ようやく事情を察したお里は三人を急いで逃がすが、しかし権太が現れ、お里が止めるのも聞かず三人を縛って渡すと走ってゆく。

Osato

Yazaemon's daughter and Gonta's sister, Osato is a young and charming girl who is nothing like her brother. She falls in love with Yasuke and dreams of marrying him, but just when she thinks her dreams may come true, she finds out that Yasuke already has a wife and child. When the family is reunited, Osato helps them escape, but Gonta chases after them in hopes of turning them into the authorities.

川連法眼
かわつらほうげん

川連法眼は吉野山一帯の僧たちをまとめる検校職の立場にあり、義経が幼少で鞍馬山にいた頃からの縁を大切に、今は義経を館の中に匿っている。しかし大勢いる山の衆徒たちがいずれが鎌倉方か義経方か、はたまた川連法眼は誠に義経に恩を着せる所存か、互いに疑心暗鬼の様相である。ここへ家臣の佐藤忠信が現れ懐かしき対面となるが、京を去る時静御前を預かったことは知らぬという。

Kawatsura Hogen

Kawatsura Hogen is a disciplinarian of the Buddhist monks on Mt. Yoshino who knew Yoshitsune when he was a child. His sympathy for Yoshitsune lead him to shelter him in his own home, but the air is full of suspicion as to whether any of the monks are loyal to Yoritomo and whether Kawatsura is sincere in his sympathy toward Yoshitsune. Sato Tadanobu, Yoshitsune's retainer, eventually arrives at the residence but says he knows nothing about where Shizuka Gozen is even though she was in his charge.

弥助 実は 平維盛
やすけ じつは たいらのこれもり

源氏に討ち取られたと思われた平維盛だが、幸いにも鮓屋の弥左衛門に巡り合い身をやつして店に奉公し、由緒ある弥助の名を名乗っている。この店の娘お里に心を寄せられ困惑するが、そこへ偶然にも一夜の宿をと訪ねてきたのは妻・若葉の内侍と子の六代君。追っ手も迫る中、親子手を携えて急ぎその場を逃げてゆくが、間もなくやってくるのは梶原平三の詮議。しかし意外な人物に救われる。

Yasuke / Taira no Koremori

Believed dead at the hands of the Minamoto clan, Koremori is alive and well, disguised as a lowly worker named Yasuke at Yazaemon's sushi shop. He is unsettled at the affection Osato shows toward him until his wife Wakaba no Naishi and son Rokudai appear at the shop one day. Shortly after their arrival, however, Yoritomo's men come searching for them, forcing them to flee. Kajiwara Kagetoki chases after them, but they are finally saved by the most unlikely person.

梶原平三景時
かじわらへいぞうかげとき

源頼朝の家臣。頼朝の命令を受けて維盛が潜伏している釣瓶鮓屋を取り調べ、維盛、若葉の内侍、六代君を捕らえる任務を負っている。権太が抱えてきた維盛の首を相違ないと認め、縛られた妻子を連れてゆくが、褒美として権太に与えたのは頼朝の陣羽織。その中には袈裟と念珠があり、維盛に出家を勧めるという謎。頼朝はその昔、平重盛に命を救われた恩があり、そもそも維盛を助ける所存だった。

Kajiwara Heizo Kagetoki

Yoritomo's retainer Kagetoki who is charged with investigating rumors that Yoshitsune is hiding at the Tsurube Sushi Shop. Gonta presents Koremori's head as well as Koremori's wife and son whom he has captured. Knowing that they are substitutes presented in order to save Koremori and his family, Kagetoki nonetheless accepts them and gives Gonta a coat as a reward. Inside the coat are a monk's stole and rosary, meant as a secret message that Koremori should enter the priesthood. It turns out that Yoritomo was saved by Koremori's father Shigemori in the past and has saved Koremori as an act of gratitude toward his father.

横川覚範 実は 能登守教経
よかわのかくはん じつは のとのかみのりつね

川連館の奥庭に立ちはだかるのは衆徒の大将・横川覚範、実は平家の能登守教経。「八島の合戦で討ち漏らし、今ここで勝負」と、義経、忠信、四天王たちが取り囲む。実はこの『義経千本桜』は、討ち取られたと思われた平家の三人の武将、すなわち知盛・維盛・教経が実は生きていて再び源氏に挑むというテーマが根底にあり、「大物浦」の知盛、「すし屋」の維盛、そしてこの場の教経でそれが完結する。

Yokawa no Kakuhan / Notonokami Noritsune

Yokawa Kakuhan confronts Yoshitsune and his men in the inner courtyard of the Kawatsura residence. "Though I failed to kill you at the battle of Yajima, I will not fail this time." It turns out that he is actually Notonokami Noritsune of the Taira clan, the third of the Taira generals thought to have died in the war. The three Taira generals' renewed attempt to challenge the Minamoto clan is a major theme in *Yoshitsune and the Thousand Cherry Trees*. Tomomori's chapter is covered in "Daimotsu Bay," Koremori's in "The Sushi Shop," and finally, Noritsune's chapter is concluded in the "Inner Courtyard" scene.

みどころ
Highlights

1. 千年年経る狐の子
—— The Thousand-year-old Fox

義経（よしつね）は、（ぎつね）とも読める。ここから千本桜の狐の物語が構想されたとも言われ、狐は義経の影武者のように現れて物語を彩る。発端にあたる大序で、義経は後白河法皇から宮中の宝物「初音の鼓」を賜る。これは齢（よわい）千年の雄狐雌狐の夫婦の皮でできた鼓。「鼓を打つ」になぞらえて、法皇は「頼朝を討て」と義経に暗に伝えるのだ。兄への思慕厚い義経は鼓を賜っても打たねばよいと考えて、これを受け取る。

The kanji for the name Yoshitsune can also be read as "gitsune," and it is said that this is where the idea of having a fox (*kitsune* in Japanese) in *Yoshitsune and the Thousand Cherry Trees* came from. The fox acts behind the scenes to drive the plot, and his presence is connected to the sacred drum Hatsune which the retired emperor Goshirakawa bestows upon Yoshitsune in the "Great Preface." This drum was made using the skin of two foxes who were married and had lived for a thousand years. In giving the drum to Yoshitsune, Goshirakawa is suggesting that Yoshitsune "strike" his brother as he would the drum, thus killing him. Yoshitsune accepts the drum, but has no intention of killing his beloved brother.

2. 能の「船弁慶」
—— The Noh Play *Funa Benkei*

『平家物語』は、平知盛は壇ノ浦合戦の敗北を知ると、「見るべきほどのことは見つ」と叫び鎧二領を身に添えて海に沈んだと伝える。平家を滅ぼした義経が西国を目指して船出すると嵐に遭うが、これは知盛の怨霊の仕業であるとも。能『船弁慶』では義経は子方が演じる。静御前と別れて船出した義経一行の前に、黒髪を乱した蒼白の面の知盛の怨霊が現れるが、弁慶が祈り伏せる。『義経千本桜』は実は生きていた知盛が怨霊に化けたと逆転させた。

The Tale of the Heike tells the story of Taira no Tomomori who is defeated at the battle of Dan no Ura and throws himself into the sea while clasping two heavy suits of armor. Afterward when Yoshitsune of the triumphant Minamoto clan is heading to the western country by boat, he is met by a storm said to be the angry of Tomomori. This story is depicted in the noh play *Funa Benkei*, in which Yoshitsuna is played by a *kokata* (child) actor. In this play, Yoshitsuna parts with Shizuka Gozen and sets sail with his men, only to be met by the angry spirit of Tomomori, played with ghastly pale skin and disheveled black hair. He is eventually warded off by the gallant Benkei. In *Yoshitsune and the Thousand Cherry Trees*, a similar story plays out, but with a living Tomomori.

3. 「川連法眼館」狐忠信の衣裳
── The Fox/Tadanobu's Costume in "The Kawatsura Hogen Residence"

藤色塩瀬の、秋草に流れ水の模様の着物に、白の長袴。袴の腰のあたりには紫の暈しに破れ片輪車の縫いが施されている。正体を見顕されてからは、真っ白な狐の衣裳に早替りする。

The Fox disguised as Tadanobu wears a light purple kimono with a pattern depicting flowing water and autumn flora. His white *hakama* trousers feature a white dragon pattern, and are shaded purple near the waist with a broken wheel pattern. When Tadanobu's true form is revealed, he quickly changes into sheer white robes to signify that he is a fox.

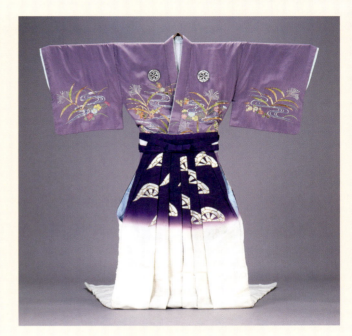

4. 六代の処刑
── Rokudai's Execution

すし屋では、三位中将維盛と御台所、そして子息六代君は身替わりのために助かるという結末になっている。史実の維盛は平家嫡流の身ながら行方知れずのままで家族と再び廻りあうことはなかった。息子六代は一度捕らえられて出家となり32歳まで生きたが、頼朝の死後、復讐を恐れる北條の意向で鎌倉に護送され斬られたと『平家物語』巻十二が伝えている。『義経千本桜』の作者は一家のつかの間の再会を、吉野山中のすし屋の中に描いた。

Koremori, his wife Naishi, and his son Rokudai are saved from capture and execution thanks to Gonta's family taking their place. Historically, Koremori, who was the eldest son of the Taira clan, never actually reunited with his family after the war. His son Rokudai was captured once but successfully entered the priesthood, allowing him to live to 32 years old. After Yoritomo's death, however, he was suspected of plotting revenge, escorted to Kamakura, and executed. All of this comes from the 10th book of *The Tale of the Heike*. In *Yoshitsune and the Thousand Cherry Trees*, the writers gave the family a touching reunion at the sushi shop on Mt. Yoshino.

5. 権太の息子は善太 —— Gonta and Zenta, Father and Son

関西で、やんちゃな子を「ごんた」と呼ぶのは、本作のいがみの権太からきているという。いがみは歪みと同じ。すし屋の息子だが素直に育たず、いがんだ不良になってしまった人物だ。権太はゆすりの常習犯。しかし茶屋女だった女房とのあいだにできた善太という子をおぶってやったりする子煩悩なところがある。そしていつか親孝行をしたいと思っている。「いがんだ俺が直（すぐ）な子を持ったは何の因果」は権太最期の嘆き。

"Gonta" is a name now given to rowdy children in the Kansai region, and it is originally a reference to Igami no Gonta in this play. "Igami" means "warped" or "distorted," a reference to the troublesome man Gonta became as an adult. Gonta is a serial conman who is always extorting people, but he also has a soft spot for his beloved son Zenta and hopes to be worthy of his love. In his final moments, Gonta asks sadly, "how is it that karma could give me such a good son?"

6. 弁慶の足がしびれる —— Benkei's Numb Legs

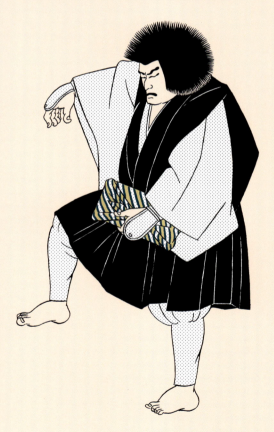

『義経千本桜』最大の創作は、壇ノ浦に沈んだ安徳帝は実は女子であったとしたこと。船宿の亭主になりすました知盛が安徳帝を娘お安として育てている。原作浄瑠璃には店先のひと間に寝かされているお安の上を、弁慶が跨ごうとして足がしびれる場面があり、お安がやんごとない生まれであることが示されている。知盛から安徳帝を預かった義経は本作の大詰で、安徳帝を母建礼門院のもとへ送り届け、その弟子にすると宣言している。

The greatest artistic liberty taken in *Yoshitsune and the Thousand Cherry Trees* is making Emperor Antoku (who historically died at Dan no Ura Bay) a girl. In the play, Tomomori hides with Emperor Antoku at a shipping house and raises her as his daughter, giving her the fake name Oyasu. When Yoshitsune and his men come to this boatyard, Benkei attempts to step over the young Oyasu only to have his legs go numb, indicating to him that she is actually a child of very high pedigree. Tomomori eventually leaves Emperor Antoku in Yoshitsune's care in the finale of the play. Yoshitsune promises to deliver the emperor to her mother Kenreimon'in so that she may be her student.

7. 狐ことば —— A Foxy Accent

佐藤忠信と、狐が化けた狐忠信を同じ演者が早替わりで演じるところが四段目の見どころ。違いは、衣裳髪型だけでなく言葉にもある。狐忠信は「つ」の音を発音せず、言葉の一部を伸ばす「狐ことば」を使う。たとえば「雌ぎ○ね、雄ぎ○ね」の○のところが子音は発音されず、音は鼻に抜ける。また手先なども狐に見えるように指を折り曲げる工夫がある。狐ことばで語られる、初音の鼓にされた親狐への思慕が、肉親の縁薄い義経の心を打つ。

The sudden transformation of Sato Tadanobu into his true fox form is a major highlight of Act IV. He not only changes his costume and hairstyle, but also his language. Tadanobu in fox form can't pronounce the "tsu" sound, for example, and extends certain syllables to create a unique "fox accent." Also, when in fox form the actor bends his fingers in a way that resembles a fox's paw. In the end, Yoshitsune is touched by the fox's plight, as he himself also lost his parents at an early age.

8. 小金吾の見せ場 —— Kokingo's Moment

六代君と御台所を守護する主馬の小金吾の討ち死は、絵画のような場面で見逃せない。暗闇の中、大勢の捕手が縄を放射状に掛け渡して浮き上がらせた円形の縄目の中に、肌脱ぎになって髪を振り乱した小金吾が乗る。立師だった坂東八重之助の工夫したものとして知られる。敵を蹴散らした小金吾も手負いとなり、御台所と六代君に最期の別れの言葉をかける。手負いとは深い傷を負ってしまうことで、この場面も大切な見せ場。

The scene depicting Kokingo's death while fending off Wakaba no Naishi and Rokudai's pursuers is staged like a gorgeous painting, a highlight of the show not to be missed. A disheveled Kokingo removes his coat and gallantly jumps onto the net cast by the enemies in a scene that was created by the great fight choreographer Bando Yaenosuke. Kokingo successfully fends of the pursuers but is severely wounded. He bids farewell to Naishi and Rokudai before expiring at the end of this truly magnificent scene.

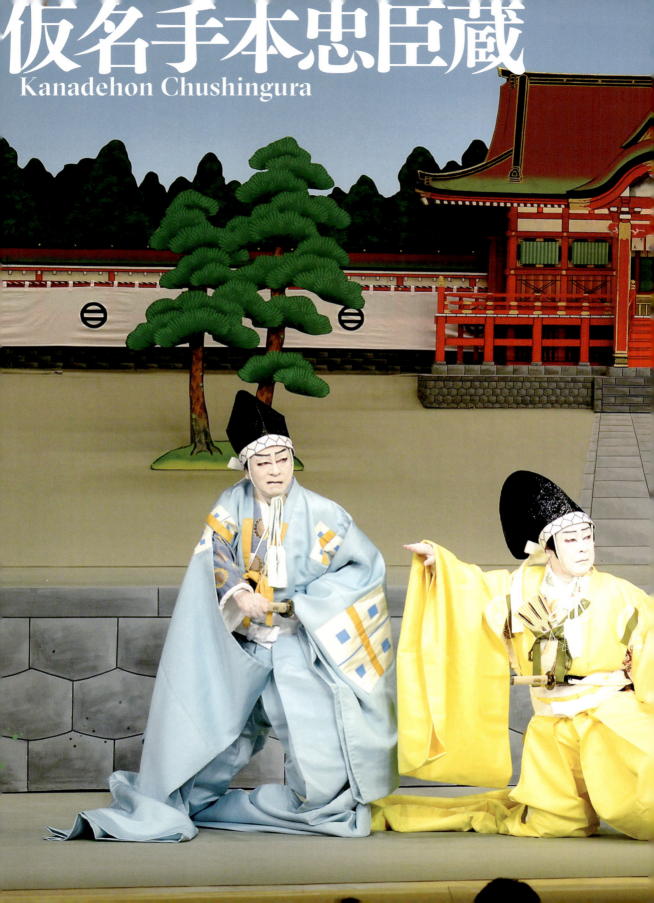

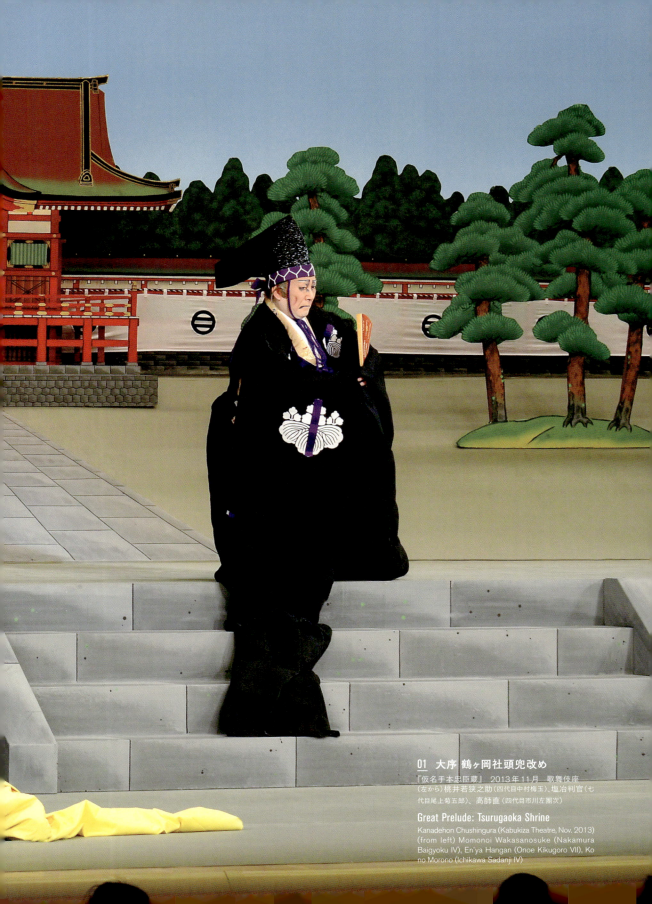

01 大序 鶴ヶ岡社頭兜改め
『仮名手本忠臣蔵』 2013年11月 歌舞伎座
(左から) 桃井若狭之助 (四代目中村梅玉)、塩冶判官 (七代目尾上菊五郎)、高師直 (四代目市川左團次)

Great Prelude: Tsurugaoka Shrine
Kanadehon Chushingura (Kabukiza Theatre, Nov. 2013)
(from left) Momonoi Wakasanosuke (Nakamura Baigyoku IV), En'ya Hangan (Onoe Kikugoro VII), Ko no Morono (Ichikawa Sadanji IV)

あらすじ / Synopsis

権力者から庶民まで、今も変わらぬ人間たち。
恋、金、死、様々な思いが交差する

270年の長きにわたり愛され、
あまたの後続作品を生み出す源となった不朽の名作。
代々の名優たちが心血をそそいで作り上げた演技演出が伝承されている、
歌舞伎の魅力がすべて詰まった名作。

A story of the human spirit, from rulers to peasants. Love, money, life, death…a prism of intersecting emotions reflected back upon us.

A masterpiece of the kabuki theater for over 270 years. The great actors of each generation poured their heart and soul into their roles, and their tradition has been kept alive in this magnificent play that features all of the trademarks of kabuki.

01　大序 鶴ヶ岡社頭兜改め

鎌倉の鶴岡八幡宮では、将軍足利尊氏の弟の直義が代参に来ており、執権の高師直、供応役の塩冶判官、桃井若狭之助が出迎えている。

先ごろ討ち死にした敵将新田義貞の兜を奉納することになり、兜の鑑定役として、かつて宮中に仕えていた判官の妻顔世御前が呼び出される。以前から顔世に邪恋を抱いていた師直は、顔世に文を渡し、さらに、夫の共応役の成否は自分の一存にかかっている、無事に勤められるかどうかは顔世の返事ひとつ、と言い寄る。

その時通りかかった若狭之助が機転を利かして助けに入り顔世を帰す。不機嫌になった師直は若狭之助を罵倒。思わず刀に手を掛ける若狭之助。そこへ割って入った塩冶判官が若狭之助をなだめ、その場を収める。

02　三段目 足利館門前の場

桃井家家老の加古川本蔵は、師直を斬ると息巻く主君若狭

01　Great Prelude: Tsurugaoka Shrine

Tadayoshi, brother of the shogun Ashikaga Takauji, arrives at Tsurugaoka Hachimangu Shrine, and is to be welcomed by the Kamakura Governor Morono, Momoi Wakasanosuke, and En'ya Hangan.

It has been decided that the helmet of the enemy general Yoshisada will be offered at this shrine. En'ya's wife Kaoyo Gozen, who used to serve at the imperial palace, is called to verify the helmet. Morono, who has fallen in love with Kaoyo, offers her a love letter and tells her that her husband's performance at this meeting may depend on her answer.

Just then Wakasanosuke comes by and helps Kaoyo out of this uncomfortable situation. The incensed Morono, however, curses Wakasanosuke, causing Wakasanosuke to reach for his sword. En'ya Hangan appears and calms Wakasanosuke down, putting an end to the scuffle.

02　Act III: Before the Ashikaga Residence

Kakogawa Honzo, chief retainer to Wakanosuke, finds out his master plans to kill Morono, but secretly goes to bribe Morono, thinking that he can soften Morono's feelings toward Wakasanosuke. This way, his master may rethink his

之助を案じ、主君に黙って師直に賄賂を贈る。師直の態度が軟化すれば、若狭之助の身に過ちもないとの思案だった。

03　三段目 足利館松の間刃傷

多額の付け届けを受け取った師直の態度は一変。師直を斬るべく足利館へやって来た若狭之助は、師直から平身低頭され、拍子抜けしてその場を立ち去る。その様子を本蔵が祈るような思いで陰からうかがっていた。

そこへ判官が到着。さらに、顔世から師直へ短冊が届く。短冊に認められたのは邪恋を戒める古歌。先ほど、意に反して若狭之助に頭を下げた鬱憤に加えて、顔世に拒絶された師直の恨みの矛先は判官に向かい、判官の付け届けの少ないことなどを様々にあてこすり、なじる。

最初はじっと堪えていた判官も、陰湿な仕打ちに耐えかね、師直に斬りかかるが、本蔵をはじめ駆けつけた大名たちに取り押さえられてしまう。

04　四段目 扇ヶ谷塩冶判官切腹

足利館での刃傷により、扇ヶ谷の自らの屋敷に閉門蟄居を命じられた塩冶判官。そこへ、幕府上使の石堂右馬之丞と薬師寺次郎左衛門が訪れ、判官の切腹と御家断絶、所領没収の上意を伝える。国家老・大星由良之助の到着を待ちわびつつ、待ちかねた判官が腹を刀で突いたところへ、由良之助が駆け付ける。判官は由良之助に切腹に用いた刀を形見に与え、無念と仇討ちの悲願を託し息絶える。

05　四段目 扇ヶ谷塩冶表門城明渡し

ここで合戦と逸る若侍たちを制し、館を幕府に明け渡した由良之助は、ひとり形見の刀に仇討ちを誓うのだった。

06　道行旅路の花聟

塩冶判官の家臣・早野勘平は、刃傷の当日判官の供をして足利館にいた。しかし、刃傷のその時、かねて恋仲の顔世の腰元お軽と逢引きのために場を外していた。騒動に気が付き戻った時は、すでに判官が自らの屋敷に帰された後。そのまま屋敷に戻ることもできず、申し訳なさに腹を切ろうとする勘平を必死で押し留めるお軽。

師直の怒りのもととなった顔世の短冊は、顔世の腰元お軽が運んだもの。それというのもお軽は勘平に会いたいばかりに、顔世のためらいをものとせず、その足利館へ出向く使いの役を買って出たのであった。

二人はお軽の実家のある山城国山崎に向かう。

assassination attempt.

03　Act III: Blood Spilled at the Ashikaga Residence

Morono's attitude toward Wakasanosuke has completely changed. He apologizes profusely, causing Wakasanosuke to abandon his attempt on Morono's life. Meanwhile, Honzo watches from the shadows as things pan out exactly as he'd hoped.

En'ya Hangan then appears and sees a note from Kaoyo to Morono containing a poem admonishing an illicit affair. Already disgruntled from prostrating himself to Wakasanosuke whom he meant to murder, Morono's anger wells up again at this fresh rejection from Kaoyo. In his anger he confronts En'ya Hangan, heaping insults at him.
Patiently enduring this abuse at first, finally En'ya Hangan can take no more. Drawing his sword, En'ya nearly kills Morono but is stopped by Honzo and the other Daimyo present.

04　Act IV: Judge En'ya's Seppuku

En'ya Hangan has been put on house arrest at his residence in Ogigayatsu. Ishido Umanojo and Yakushiji Jirozaemon, envoys from the Bakufu, come and give En'ya his sentence: Seppuku, severance of his house, and confiscation of his estate. En'ya waits some time for his chief retainer Oboshi Yuranosuke, but he is taking too long. Yuranosuke appears just as En'ya commits seppuku, and En'ya gives him the very blade he killed himself with as a memento. With his dying breath, En'ya charges Yuranosuke with avenging him.

05　Act IV: The En'ya Residence Forfeited

Yuranosuke takes command of the remaining samurai who are eager to fight and hands the residence over to the shogun, swearing to avenge his master with the blade he received as a memento.

06　Michiyuki (The Groom)

Retainer Hayano Kanpei had been with En'ya Hangan on the day of his death, but had chosen to abandon his duties to be with his lover Okaru, Kaoyo's chambermaid. Deeply ashamed at having abandoned his master at such a time, Kanpei attempts seppuku himself but is stopped by Okaru.

It turns out that Okaru was the messenger who delivered Kaoyo's letter to Morono, thus angering him. Thus, Okaru, too, played a hand in the events of that fateful day.

Kanpei returns with Okaru to her family's home in Yamazaki, Yamashiro Province.

07　Act V: The Gun in Yamazaki

Kanpei, who is now a hunter in Yamazaki, comes upon a former colleague from his days working under En'ya, Senzaki Yagoro. Yagoro reveals that he and others who were in En'ya's service are collecting funds to help avenge their

03 三段目 足利館松の間刃傷

『仮名手本忠臣蔵』 2001年3月 新橋演舞場
(左から)塩冶判官(七代目尾上菊五郎)、高師直(四代目市川左團次)

Act III: Blood Spilled at the Ashikaga Residence
Kanadehon Chushingura (Shinbashi Enbujo Theatre, Mar. 2001)
(from left) En'ya Hangan (Onoe Kikugoro VII), Ko no Morono (Ichikawa Sadanji IV)

04 四段目 扇ヶ谷塩冶判官切腹

『仮名手本忠臣蔵』 2013年12月 歌舞伎座
(左から)大星由良之助(九代目松本幸四郎)、塩冶判官(五代目尾上菊之助)

Act IV: En'ya Hangan's Seppuku
Kanadehon Chushingura (Kabukiza Theatre, Dec. 2013)
(from left) Oboshi Yuranosuke (Matsumoto Koshiro IX), En'ya Hangan (Onoe Kikunosuke V)

06 道行旅路の花聟

『仮名手本忠臣蔵』 2013年11月 歌舞伎座
（左から）腰元お軽（五代目中村時蔵）、早野勘平（四代目中村梅玉）

Michiyuki (The Groom)
Kanadehon Chushingura (Kabukiza Theatre, Nov. 2013)
(from left) Chambermaid Okaru (Nakamura Tokizo V),
Hayano Kanpei (Nakamura Baigyoku IV)

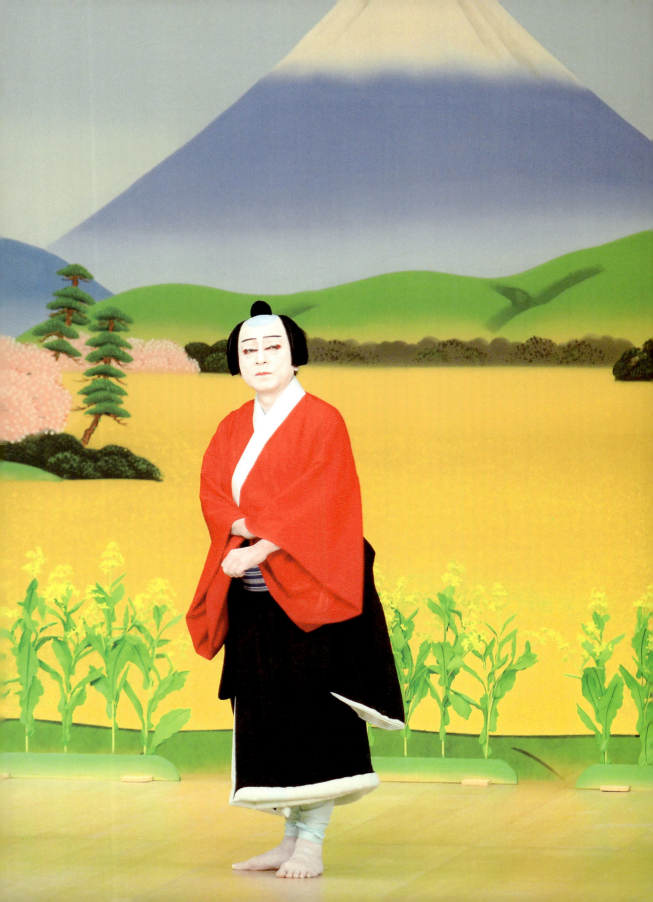

07　五段目　山崎街道鉄砲渡し

お軽の実家で猟師となった勘平は、狩りに出た山崎街道で塩冶家の同僚千崎弥五郎と出会う。仇討ちの資金調達をしていると打ち明けられた勘平は、金を調える約束をする。そして自らのあやまちを詫び、侍に戻って仇討ちの連判状に加わるよう由良之助への取り成しを頼む。

08　五段目　山崎街道二つ玉

お軽は、夫をもとの侍に戻すために身を売ることを決めた。相談されたお軽の父与市兵衛は、祇園に出向いて話を決め、身売りの代金の半額の五十両を受け取り、夜道を急いでいたが、何者かに殺され懐の金を財布ごと奪われてしまった。殺したのは、斧定九郎。判官の家老・斧九太夫の息子だが、放蕩のあまり親に勘当されている身だった。

折しも闇の中、定九郎は、猪を狙って発砲した勘平の銃弾にあたり、もがき苦しんで絶命。猪を撃ったつもりの勘平が暗闇を探ると、そこに倒れていたのは猪ではなく、人。薬を探そうと定九郎の懐をさぐる勘平の手に、金の入った財布が触れる。仇討ちの連判に加わりたい一心の勘平は、その財布を抜き取り、その場から逃げ去る。

09　六段目　与市兵衛内勘平腹切

翌日の与市兵衛の家。お軽と母親のおかやのところへ、祇園の一文字屋の女房お才と判人の源六がやってきている。父親がまだ戻ってきていないからというのも聞かず、身売りの代金の残金を渡しお軽を連れて行こうともめているところに勘平が戻ってくる。

勘平は昨夜の金を弥五郎に届け、意気揚々と戻ってきたのである。おかやからお軽の志を初めて聞いて深く感謝する一方、勘平はお才から昨夜の次第を聞く。これと同じ財布に五十両を入れ与市兵衛に渡した、と財布を見せるお才。その柄は昨夜夜道で奪った財布と同じ柄。勘平は昨夜殺したのは舅だったのか、と驚きうなだれる。

お軽は祇園に連れていかれ、あとに残った勘平とおかや。そこへ与市兵衛の死骸が運ばれてくる。おかやは勘平の様子から、勘平が与市兵衛を殺したと思い込み、勘平をきびしくなじる。

そこへ現れた原郷右衛門*と千崎弥五郎。由良之助から昨夜の金を拒絶され戻しに来たのだ。さらにおかやの訴えから、原・千崎からも舅を殺したことを詰問され、進退窮まった勘平、申し訳のために腹に刀を突き刺す。苦しい息の下の述懐から弥五郎が与市兵衛の死骸を改めると、死因は鉄砲でなく刃、かつ、殺したのは定九郎と知れる。

疑いの晴れた勘平は、仇討ちの連判に名を連ねることを許

former master. Kanpei decides to return to being a samurai, promises to raise money, and asks Yagoro to convince Yuranosuke to let him join the movement.

08　Act V: On a Road in Yamazaki

Okaru decides to sell herself so that her husband can become a samurai again. She consults her father Yoichibe, who leaves for Gion Shrine to negotiate, eventually receiving a down payment of 50 ryo. On his way back, however, Yoichibe is murdered by Ono Sadakuro, the disowned son of Kudayu, the judge's retainer.

Sadakuro is subsequently shot by Kanpei who is out hunting. Kanpei can't see well in the dark, but realizes he shot a man instead of a boar as he had intended. Searching the man's person for medicine, Kanpei finds the money Sadakuro had just stolen. He takes the money, thinking he can use it to become a samurai again and join the movement to avenge En'ya.

09　Act VI: Kanpei's Harakiri

Ichimonjiya's wife and Genroku arrive at Okaru and her mother Okaya's house. They are from the brothel and have come to take Okaru away in exchange for the remainder of their payment. Kanpei arrives as Okaru and Okaya argue that Yoichibe hasn't yet come home.

Kanpei is elated at his luck in finding the money. He hears of Okaru's sacrifice and is deeply touched at first, but soon hears about what had happened the previous night. Osai from Gion shows Kanpei a wallet, explaining that she had given 50 ryo to Yoichibe in a similar wallet the night before. Kanpei is shocked to see it is the same as the wallet he took off of the poor soul he shot the night before, thinking it must have been Yoichibe.
Okaru is taken away and Yoichibe's body brought in. Okaya is livid at Kanpei, who she believes murdered Yoichibe.

Hara Goemon* and Senzaki Yagoro arrive, their money having been rejected by Yuranosuke. They subsequently hear Okaya's story about the previous night and proceed to question Kanpei. Deeply ashamed of what he has done, he commits harakiri, but afterward Yagoro examines Yoichibe's body and finds that he was killed not by a gun, but by a blade.

As he dies, Kanpei is consoled to hear that his name will be noted as part of the movement to avenge En'ya Hangan.
* This character is also sometimes played with the name "Fuwa Kazuemon."

10　Act VII: Ichiriki Teahouse

Yuranosuke is enjoying himself at Ichiriki Teahouse in the pleasure district of Gion. Seeing his wanton ways, many of his fellow warriors wonder if he really intends to avenge his master. Teraoka Heiemon has come to see Yuranosuke

され、安堵して息絶える。
＊「不破数右衛門」として上演されることもある。

10 　七段目　祇園一力茶屋

　祇園の一力茶屋で、大星由良之助は遊興にふけっている。あまりの放埒ぶりに一味の武士も由良之助の本心を図りかね、血気に逸る者もいる。そうした若侍に連れられてやって来たのは足軽の寺岡平右衛門。平右衛門は低い身分ながら何とか仇討ちに加わりたいと願うが、由良之助は相手にもしない。

　そこへ由良之助の息子の力弥が、ひそかに顔世御前からの急ぎの書状を届ける。由良之助が書状をひろげて読むところ、床下にひそんでいた斧九太夫がこれを盗み読む。九太夫は、夙に師直方に寝返り、由良之助の本心を探って師直方に伝えるべく努めていた。また、祇園に身を売り、遊女となったお軽が、二階から鏡を使って書状を読んでしまう。

　お軽に手紙を読まれたことに気づいた由良之助は、彼女に身請けしようと言い出す。身請けにことよせ、口封じのため殺そうと考えたのだ。

　お軽の兄でもある平右衛門は、お軽の話から由良之助の心を察し、秘密を知った妹お軽の首を持参すればそれを手柄に連判に加われるかもしれないと、自ら妹を手にかける覚悟を決める。勘平の死を聞かされたお軽も死ぬ覚悟を固めるが、様子をうかがっていた由良之助にとどめられる。由良之助は連判に加わりながら死んでしまった勘平の代わりにと、お軽に手を添えて、床下の九太夫を討ち取らせるとともに、平右衛門を連判に加え、仇討ちの供を許す。

11 　八段目　道行旅路の嫁入

　加古川本蔵の妻戸無瀬と娘の小浪が鎌倉から京まで東海道を旅をしている。小浪は由良之助の息子の力弥の許婚だったのだが、刃傷事件この方、一連の騒動で嫁入りの話も立ち消えになっていた。力弥に恋い焦がれる娘の気持ちを思い、戸無瀬は小浪を伴い、山科に住む由良之助方を訪ねることにしたのだ。

12 　九段目　山科閑居

　山科の閑居を訪れた母娘を、由良之助の妻お石が出迎える。娘を嫁にと言い出す戸無瀬に、お石は、師直に媚びへつらった本蔵の娘を嫁に迎えることはできない、許嫁も解消すると言い放つ。

　このまま鎌倉へも帰れない二人は、ここで死ぬ覚悟を決める。小浪を討とうと戸無瀬が刀を振り上げたその時、お石が二人を止める。力弥との祝言を許すというのである。ただし、引き出物として本蔵の首を差し出せと言う。刃傷の折、本蔵が判官を抱きとめたために判官は師直を斬りそこねた。本蔵

and asks to be a part of the movement, but Yuranosuke ignores him.

Just then, Yuranosuke's son Rikiya delivers an urgent letter from Kaoyo. Kudayu, who is working for Morono, is hiding in the floor and secretly reads the letter. Okaru, also, happens to be in this brothel, and uses a mirror to read the letter from the second floor.

Yuranosuke sees Okaru read the letter and decides to buy her out of her bondage in order to kill her and keep his secrets safe.

Heiemon, who is also Okaru's brother, hears from his sister about Yuranosuke's plan and determines to kill her himself. By doing so, he hopes to earn Yuranosuke's trust and be allowed into the movement. Okaru is prepared to die after hearing of Kanpei's death, but Yuranosuke puts an end to this.

Yuranosuke decides to let Okaru into the movement in Kanpei's stead, and, after killing the hidden Kudayu, also allows Heiemon to help.

11　Act VIII: Michiyuki (The Bride)

Kakogawa Honzo's wife Tonase and daughter Konami are on their way to Kyoto from Kamakura. Konami had been promised to Rikiya (Yuranosuke's son), but their wedding had been put off ever since En'ya attacked Morono. Tonase, worried about her daughter who is in love with Rikiya, decides to visit Yuranosuke in Yamashina.

12　Act IX: The Yamashina Recluse

The mother and daughter arrive at Yuranosuke's house in Yamashina. Met by Yuranosuke's wife Oishi, Tonase asks that her daughter be allowed to marry Rikiya. Oishi refuses, however, saying that she couldn't possibly allow the daughter of Honzo, who had bribed Morono, to marry her son.

The two, who can no longer return to Kamakura, decide to commit suicide. Tonase draws a blade to cut Konami with, but Oishi stops them, saying she will permit the marriage after all, but only if they bring Honzo's head to her. Since it was Honzo who stopped En'ya Hangan from killing Morono, he had a part to play in the events of that fateful day.

Tonase hesitates, but Honzo himself appears just then. He had been watching from afar, disguised as a hooded monk. He angers Oishi by insulting her family, causing Oishi to attack him with a spear. Honzo disarms Oishi and pins her down but is subsequently stabbed by Rikiya. Yuranosuke appears then, stopping Rikiya from striking the finishing blow, and commenting that Honzo intended for Rikiya to kill him from the beginning. It turns out that Honzo had planned to die for his daughter's sake all along.

Honzo reflects that if things had been just a little different, he may have been in Yuranosuke's position. It was his actions that led En'ya to attack Morono, and though he had meant to save En'ya from severe punishment by stopping him from murdering Morono, his efforts were utterly in vain. On top of this, he had ruined his daughter's betrothal.

07 五段目 山崎街道鉄砲渡し
『仮名手本忠臣蔵』 2007年2月 歌舞伎座
早野勘平(七代目尾上菊五郎)

Act V: The Gun in Yamazaki
Kanadehon Chushingura (Kabukiza Theatre, Feb. 2007)
Hayano Kanpei (Onoe Kikugoro VII)

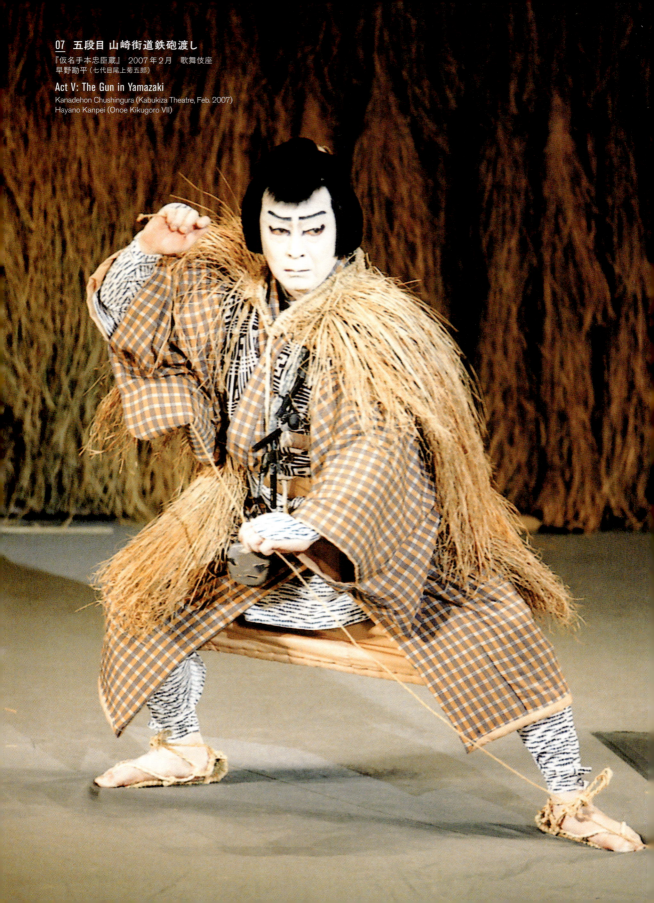

09 六段目 与市兵衛内勘平腹切
『仮名手本忠臣蔵』 2013年11月 歌舞伎座
（左から）千崎弥五郎（三代目中村又五郎）、早野勘平（七代目尾上菊五郎）、不破数右衛門（四代目市川左團次）

Act VI: Kanpei's Harakiri
Kanadehon Chushingura (Kabukiza Theatre, Nov. 2013)
(from left) Senzaki Yagoro (Nakamura Matagoro III), Hayano Kanpei (Onoe Kikugoro VII), Fuwa Kazuemon (Ichikawa Sadanji IV)

10 七段目 祇園一力茶屋
『仮名手本忠臣蔵』 2013年11月 歌舞伎座
（左から）遊女お軽（七代目中村芝雀）、大星由良之助（二代目中村吉右衛門）、寺岡平右衛門（四代目中村梅玉）他

Act VII: Ichiriki Teahouse
Kanadehon Chushingura (Kabukiza Theatre, Nov. 2013)
(from left) Prostitute Okaru (Nakamura Shibajaku VII), Oboshi Yuranosuke (Nakamura Kichiemon II), Teraoka Heiemon (Nakamura Baigyoku IV), others

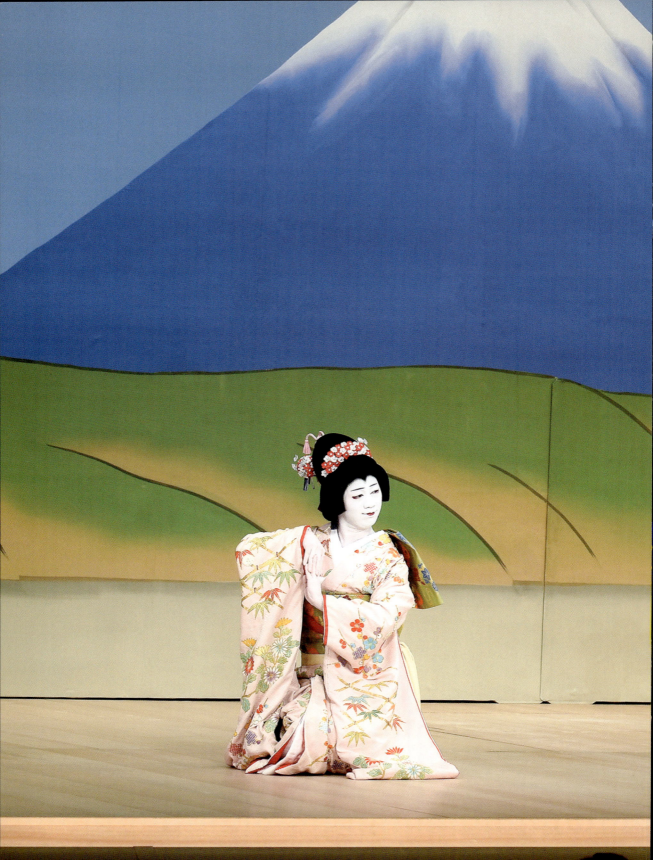

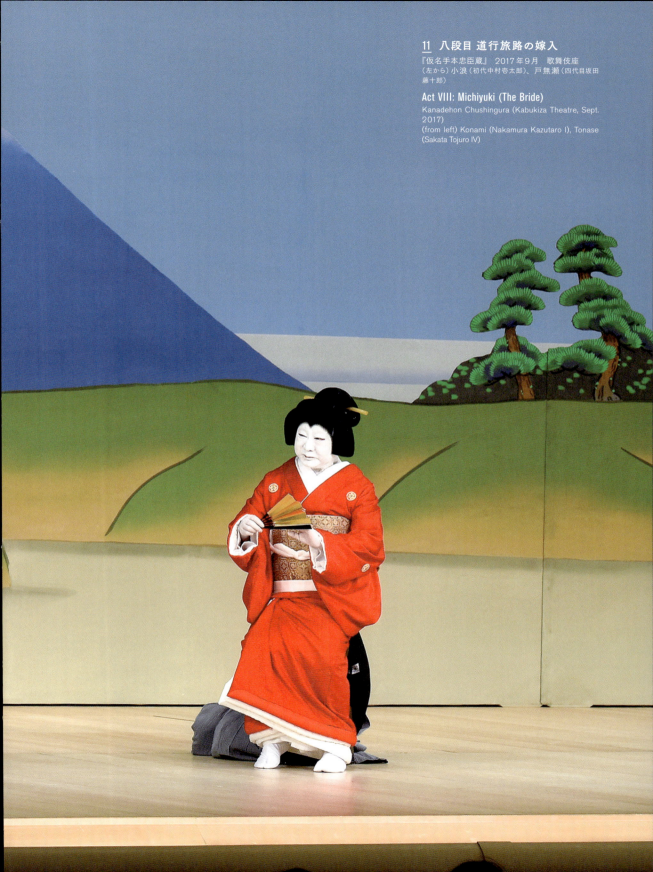

11 八段目 道行旅路の嫁入

『仮名手本忠臣蔵』 2017年9月　歌舞伎座
（左から）小浪（初代中村壱太郎）、戸無瀬（四代目坂田藤十郎）

Act VIII: Michiyuki (The Bride)
Kanadehon Chushingura (Kabukiza Theatre, Sept. 2017)
(from left) Konami (Nakamura Kazutaro I), Tonase (Sakata Tojuro IV)

に判官の憎しみがかからないわけがない。その本蔵の娘をただ嫁にする力弥ではない、というのである。

　母子が困惑していると、そこに本蔵が現れる。虚無僧に姿を変え、すべてを窺っていたのだ。本蔵はお石に罵詈雑言を浴びせかけ、お石を怒らせる。槍を手にしたお石を組み敷くと、飛び出してきた力弥の槍にわき腹を突き刺される。とどめを刺そうとする力弥を制し由良之助が現れ、狙い通り婿の力弥の手にかかって死ぬのは本望だろうと声をかける。実は本蔵は娘のために死ぬ気であった。

　今の由良之助の苦労は、ひとつちがえば自分の身の上にあったものかもしれない。主人を思い独断で師直に進物を贈ったことが、ひいては塩冶判官に師直の矛先が向くきっかけとなった。また、判官を抱きとめたのも師直に怪我がなければ判官も厳しく咎められまいと思ってのことだったが、身は切腹で家は取り潰しという結果になった。そうして娘の嫁入りも難しくなった。この上は申し訳に命を差し出す。忠義以外に命は捨てるものではないが、子のために捨てる親心を推量してほしい、と苦しい息の下、語った本蔵は、さらに引き出物として、師直の屋敷の絵図面を渡す。

　由良之助は本蔵の着ていた虚無僧の装束を借り受け、姿を変えると討入りの支度のため堺に出立していく。

13　十段目　天川屋義平内

　堺の商人天川屋義平は大星由良之助らの討入りのための武器の調達輸送を請け負っていたが、ある時大勢の捕手が店に乗り込んできた。長持の中に武器が入っているだろうと、長持を開けようとする捕手。長持の上に座して拒絶する義平。我が子を人質に脅されても、「天川屋義平は男でござる」と一歩も退かない。実はその捕手たちは塩冶の家臣で、由良之助の指示で町人天川屋の心を試そうとしたものであった。

　また、義平の女房お園は、父親が九太夫に通じているため、義平から縁を切られたのだが、由良之助の返礼としての心遣いで、再び夫婦親子で暮らせるようになる。

　由良之助は、夜討ちの合言葉を、天川屋にちなみ、「天」「川」とすることにする。

14　十一段目　高家表門討入

　師直館の表門では、由良之助以下、塩冶の浪士が勢ぞろいをし、主君判官の仇を討つべく、いよいよ討入りが始まる。

15　十一段目　高家柴部屋本懐

　激しい戦いが繰り広げられ、師直を追い詰めた浪士たちは、遂にその首を取り本懐を遂げるのだった。

Wishing to atone for all he had done, both for his daughter's sake and for the hand he played in En'ya's death, Honzo hands over the floor plans to Morono's residence with his dying breath.

Yuranosuke takes the monk's garb that Honzo had been wearing, prepares for the assassination, and heads to Sakai.

13　Act X: Amakawaya Gihei

The merchant Amakawaya Gihei in Sakai is preparing to ship weapons to Yuranosuke and his cohorts, but is suddenly accosted by officials who accuse him of having illegal weapons on his ship. Gihei boldly defies the officials, refusing to budge even when they threaten to take his son. It turns out that the officials are actually En'ya's retainers sent by Yuranosuke to test Gihei's loyalty.

Because Gihei's father-in-law had been an informer to Kudayu, he had been separated from his wife Osono. As thanks for Gihei's loyalty, however, Yuranosuke reunites them and allows them to live together again.

Yuranosuke decides to use the words "ama" and "kawa" as passwords, further honoring Gihei, whose shop is called Amakawaya.

14　Act XI: Attack on Morono's House

Standing before Morono's house, Yuranosuke and the other samurai who had served En'ya make ready to attack.

15　Act XI: Vengence Achieved

After a fierce battle, Yuranosuke and the other samurai succeed in taking Morono's head and avenging their late master En'ya.

作品の概要 / Overview

演目名 / **Title**

仮名手本忠臣蔵

Kanadehon Chushingura

作者 / **Writers**

竹田出雲・三好松洛・並木千柳

Takeda Izumo, Miyoshi Shoraku, and Namiki Senryû

概要 / **Overview**

　寛延元（1748）年8月　大坂・竹本座で初演された人形浄瑠璃の作品を歌舞伎に移したもの。原作浄瑠璃の作者は竹田出雲・三好松洛・並木千柳。歌舞伎では浄瑠璃初演の年、寛延元（1748）年12月　大坂・嵐座で上演されている。

　義太夫狂言の三大名作のひとつに数えられる。代々の歌舞伎俳優の工夫が積み重ねられ、様々な型が伝えられている。

　原作浄瑠璃は全十一段で、十一段目は早くから原作を離れ、別の台本で演じるのが通例となったが、それ以外のほぼ全場面が上演され、国立劇場が上演したときは3か月がかりであった。一日で通し狂言とする場合は、東京では「大序」「三段目」「四段目」に、原作にはない「道行旅路の花聟」を加え、「五・六段目」「七段目」「十一段目」の場割で上演されることが多く、「八段目」「九段目」は主に単独で上演される。関西では「道行旅路の花聟」のかわりに「裏門」を出し、さらに「九段目」や時に「十段目」を入れることがある。見取りでの上演も多い。「十一段目」は立廻り主体の場であり、場割は時により変わり、最後に「引揚の場」をつけることもある。

　あらすじは、東京での通し上演の場割に、「八段目」「九段目」「十段目」を加えたものである。

　Kanadehon Chushingura was first performed as a Bunraku play in August 1748 at Takemotoza Theater in Osaka. It was written by Takeda Izumo, Miyoshi Shoraku, and Namiki Senryu, and was later adapted to the kabuki theater, debuting in December 1748 at the Arashiza Theater in Osaka.

　One of the three *gidayu-kyogen* masterpieces, Kanadehon has been played in a number of forms by countless skilled actors over the years.

　Originally consisting of 11 acts, the eleventh act was cut early on and came to be performed separately. Other than this change, however, the play is still performed in its original format, and used to take three months to perform in its entirety at national theaters. When performed in a single day, acts I, III, and IV are played, followed by "Michiyuki: The Bride" (not part of the original play) and acts V, VI, VII, and XI are often performed. Acts VIII and XI are normally performed separately. "Michiyuki: The Bride" is often replace with a scene called "Rear Gate" in Osaka, and acts IX and X are also sometimes added to the performance there. The play may also be interpreted in other unique ways depending on the venue. For example, Act XI, which mainly deals with the battle, is sometimes amended to include the withdrawal of En'ya's samurai.

　The synopsis above is based on the version often played in Tokyo, with Acts VIII, IX, and X added.

初演 / **Premiere**

人形浄瑠璃―寛延元（1748）年8月　大坂・竹本座
歌舞伎―寛延元（1748）年12月　大坂・嵐座

Bunraku: August 1748, Takemoto-za Theatre, Osaka
Kabuki: December 1748, Arashi-za Theatre, Kyoto

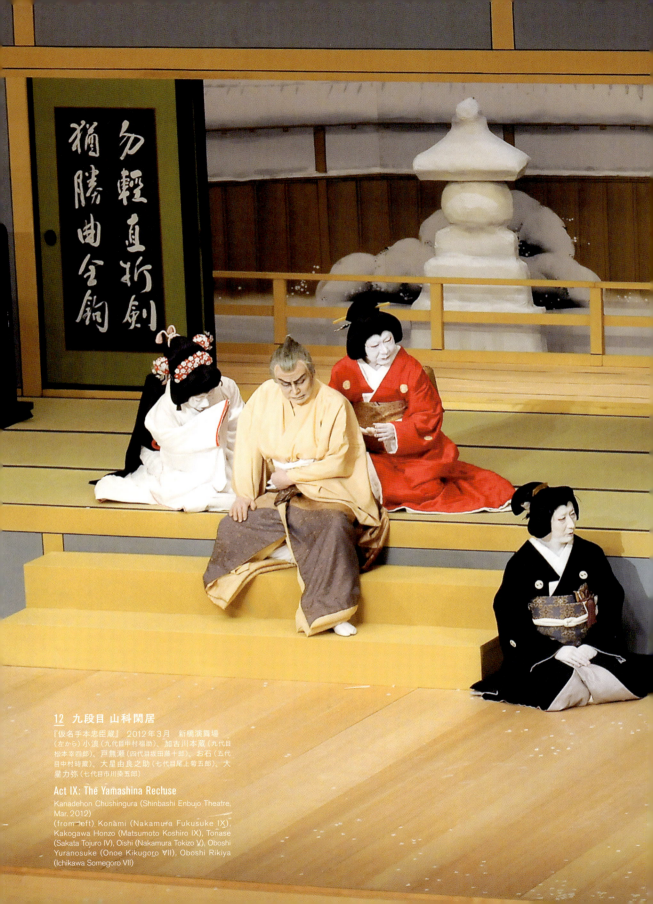

12 九段目 山科閑居

『仮名手本忠臣蔵』 2012年3月 新橋演舞場
(左から) 小浪 (九代目中村福助)、加古川本蔵 (九代目松本幸四郎)、戸無瀬 (四代目坂田藤十郎)、お石 (五代目中村時蔵)、大星由良之助 (七代目尾上菊五郎)、大星力弥 (七代目市川染五郎)

Act IX: The Yamashina Recluse
Kanadehon Chushingura (Shinbashi Enbujo Theatre, Mar. 2012)
(from left) Konāmi (Nakamura Fukusuke IX), Kakogawa Honzo (Matsumoto Koshiro IX), Tonase (Sakata Tojuro IV), Oishi (Nakamura Tokizo V), Oboshi Yuranosuke (Onoe Kikugoro VII), Oboshi Rikiya (Ichikawa Somegoro VII)

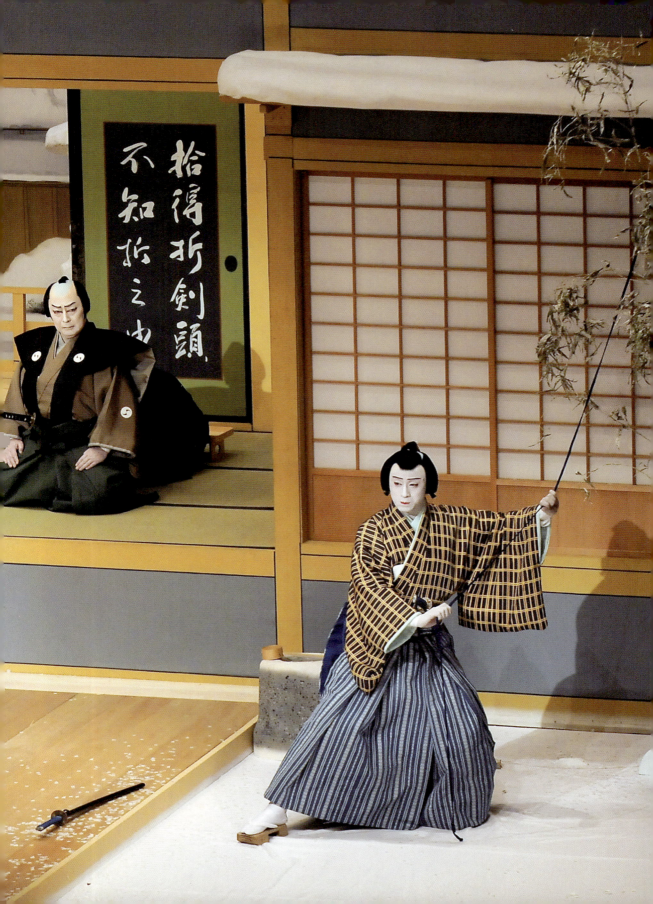

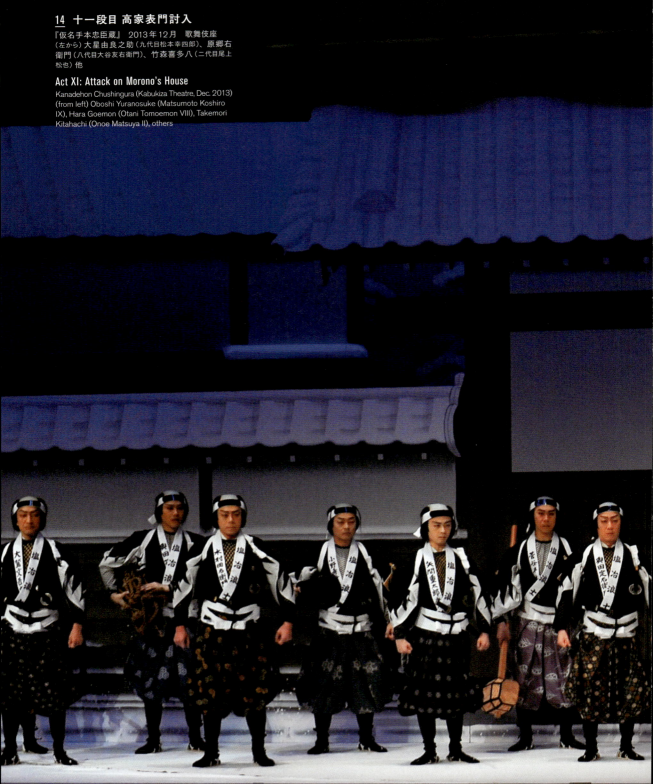

14 十一段目 高家表門討入

『仮名手本忠臣蔵』 2013年12月　歌舞伎座
(左から) 大星由良之助 (九代目松本幸四郎)、原郷右衛門 (八代目大谷友右衛門)、竹森喜多八 (二代目尾上松也) 他

Act XI: Attack on Morono's House

Kanadehon Chushingura (Kabukiza Theatre, Dec. 2013)
(from left) Oboshi Yuranosuke (Matsumoto Koshiro IX), Hara Goemon (Otani Tomoemon VIII), Takemori Kitahachi (Onoe Matsuya II), others

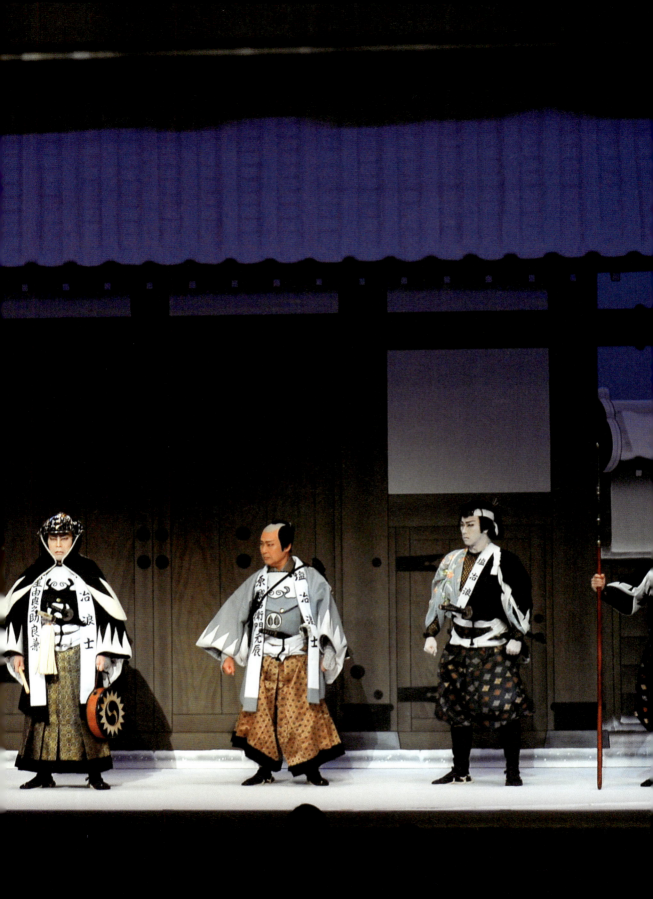

登場人物 / Characters

足利直義
あしかがただよし

将軍足利尊氏の弟で、名代として鎌倉鶴岡八幡宮へ参詣し新田義貞着用の兜を八幡宮へ奉納することの是非を問う。高師直は反対し桃井若狭之助が異を唱えるなか、鑑定役として元宮中の女官で今は塩冶判官の妻となっている顔世御前を呼び出す。数多い登場人物の中で最も気品と位取りが高く、「大序」の最初のせりふを発する重要な役。古くは若太夫（興行権を持つ座元の子息）が勤める決まりがあった。

Ashikaga Tadayoshi
Tadayoshi is the younger brother of Ashikaga Takauji. As his brother's proxy, he attends the meeting at Tsuruoka Hachimangu Shrine to determine the validity of the helmet of Nitta Yoshisada which is to be dedicated there. Ko no Morono objects to the dedication while Momonoi Wakasanosuke supports it. Judge En'ya's wife Kaoyo Gozen, meanwhile, is called upon to confirm the helmet's validity, having been present when it was originally presented to Yoshisada. Tadayoshi is the highest-ranked character in Kanadehon, and fulfils the important role of delivering the "great preface." His role is traditionally performed by the *wakadayu*, or the son of the producer who holds promotional and production rights to the play.

高師直
こうのもろのう

史実の吉良上野介、すなわちこの物語における敵役。鎌倉の執権職という権威・権力を持った人物で、「大序」における黒の衣裳がその強さと傲慢さを端的に象徴している。桃井若狭之助、塩冶判官といった大名を力で圧すると同時に顔世御前に横恋慕するという、色と欲にまみれた人物として描かれる。しかし役の大きさや格も大切で、これを演じる俳優は憎々しさを表現する演技に加え高い芸格が求められる。

Ko no Morono
Based on the historical Kira Yoshinaka, Morono is the villain of Kanadehon. As regent to the shogun, Morono commands great authority and power, and his black robes in the Great Preface are a bold representation of his strength and arrogance. He is depicted as a greedy and lustful character, as shown in his intimidation of Wakasanosuke and En'ya, as well as his attempted seduction of Kaoyo Gozen. This role requires a superb actor who can command not only the presence of such a high-ranking personage, but also the deep malice and evil of Morono.

桃井若狭之助
もものいわかさのすけ

塩冶判官と同様若き大名の一人、清廉実直で正義感が強くやや血気盛んな人物でもある。「大序」における浅葱色（あさぎいろ）の衣裳にもその性格が象徴されている。新田義貞の兜を巡って高師直と意見が対立し、また困惑する顔世御前を救うなど当初は師直の執拗な攻撃対象となるが、家老である加古川本蔵が師直へ相応の贈答をしたことにより決定的な衝突を免れる。史実には登場しない人物。

Momonoi Wakasanosuke
A young daimyo lord like En'ya Hangan, Wakasanosuke is an elegant, honest, and vigorous young man with a strong sense of justice. The light blue color (*asagi-iro*) of his costume in the Great Preface perfectly represents his personality. Wakasanosuke opposes Ko no Morono regarding the dedication of Nitta Yoshisada's helmet, and after saves Kaoyo from his persistent advances. Because of this, Morono becomes enraged, but a secret gift sent by Wakasanosuke's retainer smooths the situation over. Wakasanosuke is not based on any historical figure.

塩冶判官
えんやはんがん

史実の浅野内匠頭に当たる。誠実で温厚、思慮分別にも富んだ若き大名で、その優しい人物像は「大序」における玉子色の衣裳にも表れている。妻である顔世御前が高師直から恋慕され、また若狭之助に向けられていた矛先が急転換するなど、重なる事情からいわれなき師直の標的となりついに殿中で刀を抜いてしまう。覚悟を決めて臨んだ切腹の場、待ちかねた大星由良之助に無念を伝え暗に仇討ちを託す。

En'ya Hangan
Based on the historical Asano Naganori, En'ya Hangan is an honest and kind man also blessed with keen insight and wisdom. He appears in yellow robes during the Great Preface. Ko no Morono falls in love with his wife Kaoyo Gozen, and though initially bearing a grudge toward Wakasanosuke, he eventually confronts En'ya, who draws his sword in retaliation. En'ya commits seppuku in shame over his actions, but expresses his regrets to his servant Oboshi Yuranosuke before dying, indirectly asking him to avenge him.

顔世御前
かおよごぜん

塩冶判官の奥方で、女方の登場人物の中でもとりわけ高貴な役である。元は宮中に仕える女官で、新田義貞が後醍醐天皇から兜を賜った折、その取次の役目をしていたことから鎌倉鶴岡八幡宮での兜改めの場に呼び出され、見定めの役割を務める。しかしこの場で高師直から恋文を渡され、それを返歌に託して断ったため、ちょうどそこへ登城してきた塩冶判官が俄かに師直の憎しみの対象となった。

Kaoyo Gozen
En'ya Hangan's wife, Kaoyo Gozen is a very high-ranking role among other onnagata characters. Having served in the imperial palace, she was involved in the presentation of Yoshisada's helmet and is thus called upon to verify the validity of the helmet to be dedicated at the Hachimangu Shrine. She receives a love letter from Ko no Morono, but quickly rejects him, inadvertently causing Morono's animosity toward En'ya Hangan.

大星由良之助
おおぼしゆらのすけ

塩冶家の国家老で、史実における赤穂藩の大石内蔵助に当たるのはいうまでもない。『仮名手本忠臣蔵』の大星由良之助は正義感と思慮分別に富み、歌舞伎における「実事」という役柄の最も典型的な役とされる。「四段目」ではその後の責任を一身に背負った家老職、「七段目」では仇討ちの本心を見せず色街での放蕩三昧を続ける鷹揚さと男の色気、そして「討入」ではついに本懐を遂げた凛々しい姿を見せる。

Oboshi Yuranosuke

An elder retainer of the En'ya family, Yuranosuke's character is based on the historical Oishi Kuranosuke. In Kanadehon, Yuranosuke is blessed with a strong sense of justice and discernment, and is a representative example of the jitsugoto role in kabuki. Yuranosuke takes responsibility for his master's estate after he dies in Act IV, and is seen in the pleasure quarters in Act VII with no apparent intention of avenging En'ya. In the "Raid" scene, however, he shows his true gallant character when he finally avenges his master.

加古川本蔵
かこがわほんぞう

桃井若狭之助の家老で、高師直に相応の賄賂を贈ることにより、師直に斬りかからんと決心した若狭之助を寸前で食い止め主人を救う。また松の間で塩冶判官が師直に刃傷に及んだ際に後ろから判官を抱きとめ、それにより師直の傷は浅手となった。そのとき判官は本蔵の顔をしっかりと見極めているが、これが本蔵の心にのしかかり、「山科閑居」で娘の許嫁・大星力弥に潔く討たれる決意へと繋がる。

Kakogawa Honzo

Honzo is Momonoi Wakasanosuke's chief retainer. He bribes Ko no Morono to help ease the animosity between the two in hopes that his master will rethink murdering Morono. In the fateful scene where En'ya Hangan attempts to kill Morono, Honzo holds En'ya back and Morono survives with only a flesh wound. At this moment, the judge gives Honzo a piercing look that stays with him long after, eventually motivating him to help avenge En'ya together with his daughter's fiancé, Oboshi Rikiya.

早野勘平
はやのかんぺい

塩冶家の家臣で、判官の供を全うすべきところ顔世御前の遣いでやってきた腰元のお軽と逢瀬のため殿の大事に居合わさず取り返しのつかぬ負い目となる。足利館へ戻ることも叶わずお軽の故郷へ二人で落ち延び夫婦となるが、元の武士に戻るために女房は身売り、その後様々な行き違いから自ら腹を切る。史実で討入りに加わることなく自害した萱野三平がこの役のモデルとされる。

Hayano Kanpei

Kanpei is one of En'ya Hangan's retainers and is Okaru's lover. The fateful events culminating in En'ya's death occur while Kanpei and Okaru are seeing one another in secret, a fact that Kanpei continues to regret long after. Unable to return to the Ashikaga residence, he and Okaru return to her hometown and marry. However, Kanpei determines to join the plot to avenge En'ya, and Okaru agrees to sell herself to a brothel in order to gain the necessary funds for him to become a samurai again. In the end, however, Kanpei commits seppuku in a misguided act of penance after a series of unfortunately circumstances.

大星力弥
おおぼしりきや

大星由良之助の長男、史実の大石主税であることはまさしくその名の通り。「四段目　判官切腹の場」と「七段目　祇園一力茶屋の場」ではまだあどけなさの残る若衆姿を見せるが、「九段目　山科閑居の場」では許嫁の小浪とその父・加古川本蔵の苦悩に直面し、討入りの策を練って成長ぶりを見せる。大詰の「討入」では、史実に伝えられる通り裏門組のリーダーを務め颯爽たる振る舞いを見せる。

Oboshi Rikiya

The eldest son of Oboshi Yuranosuke, Oboshi Rikiya is based on the historical Oishi Chikara. Rikiya still seems boyish in Act IV ("En'ya's Seppuku") and Act VII ("Ichiriki Teahouse"), but has matured greatly by Act IX ("Yamashina Recluse"). In this act, Rikiya helps his fiancée Konami and her father, and plans the final raid to avenge En'ya. In the final raid scene, he leads the raid through the back gate in a gallant show that is true to history.

鷺坂伴内
さぎさかばんない

高師直に仕え、いかにも師直に媚びへつらう家来。「三段目　進物の場」では加古川本蔵と乗物の中にいる師直との間を軽妙に取り持ち、自らの袖の下にもニンマリ。お軽に岡惚れし「道行旅路の花聟」では大勢の花四天を従えて「お軽勘平」を追ってくるが、勘平に軽くあしらわれて降参する。コミカルなキャラクターで、半分道化の敵役すなわち「半道敵（はんどうがたき）」という役柄の典型。

Sagisaka Bannai

Sagisaka Bannai is the obsequious retainer of Ko no Morono. "The Gift" scene in Act III shows Bannai cleverly entertaining Kakogawa Honzo and Morono. He falls in love with Okaru, but her lover is Kanpei. In the Bridal Journey michiyuki scene he chases after Okaru and Kanpei, but gives up when Kanpei confronts him. Bannai is a comical villain, a role called "*hando-gataki*" in kabuki.

お軽
おかる

塩冶家の腰元で顔世御前から師直への文箱を届けに来るが、勘平と逢う間に殿の刃傷事件。勘平とともに里へと帰るが、勘平を仇討ちに加わらせるため自ら祇園へ身売りする。一人の女性が物語進行の中で「腰元お軽」「女房お軽」「遊女お軽」と役名を変え、あわせて役柄も変わってゆく。「七段目　祇園一力茶屋」で由良之助の秘密を知り、兄の平右衛門に覚悟を迫られるがやがて由良之助に救われる。

Okaru

A chamber maid of the En'ya house, Okaru comes to deliver a letter to Morono from Kaoyo Gozen, and while she meets with Kanpei the fateful confrontation between En'ya and Morono occurs. After this, she to her hometown with Kanpei, but sells herself into bondage to allow Kanpei to help avenge En'ya Hangan. Thus, the title of her character changes throughout the play, from "chambermaid Okaru" to "wife Okaru," and finally to "prostitute Okaru." Act VII's "Ichiriki Teahouse" scene shows Okaru and her brother Heiemon saved by Yuranosuke after she finds out about Yuranosuke's plot.

石堂右馬之丞
いしどううまのじょう

「四段目 判官切腹の場」で、幕府からの上意を伝えるべく遣わされた二人の上使のうちの一人。懐に差した御書を取り出し「切腹申しつくるものなり」と読み上げる。判官は由良之助の到着を待ちかねるが、刻限を迎え刃（やいば）を突き立てた時ようやく由良之助が到着、石堂は「苦しゅうない、近う近う」と温情を見せる。歌舞伎の立役の中で「捌（さば）き役」と呼ばれる颯爽とした正義感の役柄。

Ishido Umanojo

Ishido is one of two officials who come from Kamakura to give En'ya Hangan's sentence in Act IV. His sentence dictates that he must commit seppuku, but En'ya waits for his loyal retainer Yuranosuke. Eventually, En'ya runs out of time, however, and must kill himself without Yuranosuke. Just as he starts to cut into his stomach, however, Yuranosuke appears, and Ishido offers En'ya kind words in his last moments: "Suffer not. He is close by. Close by." Ishido's role is called *sabaki-yaku* ("judge role") and is played by a tateyaku leading man. He is characterized by a gallant and upright demeanor.

斧九太夫
おのくだゆう

塩冶家において大星由良之助と並ぶもう一方の家老職。由良之助が御用金配分を足軽小者に至るまで頭割り配分とするところ九太夫は知行高による分配を主張し、欲の深さを見せる。後には高師直に寝返り、「七段目 祇園一力茶屋の場」では鷺坂伴内と共に由良之助の仇討ちへの本心を探ろうと腐心するが、茶屋に潜んでいるところを由良之助によって成敗される。史実の大野九郎兵衛がこのモデル。

Ono Kudayu

Like Yuranosuke, Kudayu is a high-ranking retainer in the service of the En'ya house. He is an avaricious character who shows his colors in the dispute over how to distribute the estate. Yuranosuke insists on distributing money among lowly footmen, while Kudayu disagrees, wanting the money to be distributed only among the high-ranking servants. He eventually becomes a spy for Morono along with Sagisaka Bannai to seek out the truth of Yuranosuke's plot. Kudayu is based on the historical Ono Kurobe.

おかや
おかや

お軽の母親。夫の百姓与市兵衛がお軽身売りの半金・五十両を受け取ったあと何者かに殺されるが、勘平の様子と縞の財布に気付き、勘平が殺して金を奪ったと確信する。震える勘平をさんざんに責めるが、訪ねてきた侍の検分で与市兵衛を殺したのは定九郎、その定九郎を撃ったのが勘平と知れるが時すでに遅し、悲観した勘平は自害、年老いた老母は家族を次々と失い一人きりとなってしまう。

Okaya

Okaya is Okaru's mother. Her husband Yoichibe accepts 50 ryo, half of the price agreed upon to purchase Okaru. On his way home from the transaction, he is killed by Sadakuro, but Kanpei is mistakenly blamed. When the truth comes to light that Kanpei had actually killed Sadakuro, Kanpei has already committed suicide in penance. Okaya, therefore, loses her family one after another, and is eventually the only member left.

薬師寺次郎左衛門
やくしじじろうざえもん

石堂と共に塩冶判官の館にやって来る上使だが、高師直とは昵懇（じっこん）の間柄で石堂とは対照的な敵役として登場、判官や家臣たちにひたすら心ない態度を取り続ける。切腹の後も「早々屋敷を明け渡せ」と迫り、さらに後の見分とあたりを鋭く見まわして奥へと入ってゆく。現行は麻裃でやや写実に近い拵えだが、古くは黒ビロードの衣裳に顔は赤っ面と、典型的な敵役の扮装が用いられた。

Yakushiji Jirozaemon

Yakushiji is the other agent of the bakufu government who arrives with Ishido. Aligned with Ko no Morono, he is a villain in complete contrast to Ishido. As such, he is utterly unsympathetic to the judge and his retainers. After En'ya's seppuku, he immediately demands the forfeiture of the judge's mansion and inspects the inner rooms personally. In modern performances, he is seen wearing relatively modern kamishimo robes and realistic accoutrements, but traditionally he wore black velvet robes and red *akattsura* makeup which are traditional to tekiyaku (villain) roles.

斧定九郎
おのさだくろう

斧九太夫の息子だが親からも勘当を受け、山賊となって山崎街道あたりに出没する。与市兵衛がお軽身売りの金の半金・五十両を持って山崎街道に来かかると殺して奪うが、勘平が撃った鉄砲の弾に当たって果てる。古くは褞袍（どてら）を着込んだむくつけき山賊の拵えだったが、初代中村仲蔵の工夫により黒羽二重の衣裳に白塗りのニヒルな二枚目風が定着、人気のある役のひとつとなった。

Ono Sadakuro

Sadakuro is the disowned son of Ono Kudayu. He has become a bandit who robs people along a certain road in Yamazaki. On of his victims is Yoichibe, who is returning home on this road with half of the money offered in exchange for Okaru. Right after Sadakuro kills and robs Yoichibe, he is killed by a bullet from Kanpei's gun. Sadakuro's character traditionally wore a course padded kimono appropriate for a bandit, but his character has become more popular since his costume was changed to a black *habutae* robe with a second layer of white robes worn over it. This costume change was introduced by the first Nakamura Chuzo.

一文字屋お才
いちもんじやおさい

祇園の女将で、身売りしたお軽の引受人。百両の身代金の半金・五十両を縞の財布に入れて与市兵衛に渡し、残りの五十両でお軽を迎えに来る。そのとき同じ柄の財布を見せるが、同じものを勘平が持ち、母のおかやもそれに気づく。元は置屋亭主の才兵衛とされていたが明治以降は女方の役として定着、女方の登場が少ないこの芝居の中で一種の風格と色街の味わいを見せる貴重な役となった。

Ichimonjiya Osai

Osai is proprietress of the Gion Brothel, and is thus in charge of the transaction to buy Okaru. She gives 50 *ryo* (half of the money agreed upon) to Yoichibe in a striped wallet, promising to bring the other half when she picks Okaru up. When she appears at Okaya's house and procures a wallet with the other half of the money, Okayu notices it is identical to the wallet Kanpei has. Osai's character was originally male, but ever since the Meiji period it is commonly played as an *onnagata* character. As a welcome addition to a play with surprisingly few *onnagata* roles, Osai plays an important role and adds a certain sense of variety to *Kanadehon*.

寺岡平右衛門
てらおかへいえもん

お軽の兄で塩冶家の足軽。律儀で仇討ちの人数に加わりたい一心から、一力茶屋で放蕩三昧の由良之助に嘆願するが相手にされず。妹お軽の姿を探し求めるうちにふと出会い、由良之助に身請けされるという話から由良之助の本心とお軽の運命を悟る。やがて由良之助の許しを得て東へのお供すなわち討入りへの参加が認められる。史実の寺坂吉右衛門から作り上げられた個性あふれる登場人物。

Teraoka Heiemon

Heiemon is Okaru's older brother and a low-ranking servant of the En'ya house. He wishes to help in the plot to avenge En'ya, but is ignored when he approaches Yuranosuke at Ichiriki Teahouse. When he searches for his sister Okaru, he finds that Yuranosuke has saved her and is still planning to avenge En'ya. In the end, Yuranosuke accepts his help in the plot. Heiemon is an idiosyncratic character based on the historical Terasaka Kichiemon.

小浪
こなみ

大星力弥の許嫁でありながら、父は塩冶家と大星家にとって極めて深い因縁を背負った加古川本蔵。それでもひたすら嫁入りを願って長い旅を続け、一面雪に包まれた山科閑居で真っ白な無垢の花嫁姿に身を包む。やがて虚無僧姿となって現れた父・本蔵の命と引き換えに嫁入りを許される小浪だが、力弥も遂げるべき本懐のある身ゆえわずか一夜限りの契り。小浪はこの作品中最も可憐な女方の役。

Konami

Konami is Oboshi Rikiya's fiancée, but also daughter to the man who is partly responsible for En'ya Hangan's death. Despite this, she embarks on a long journey to the Yamashina residence to beg for Rikiya's hand. Eventually Rikiya's mother agrees to allow them to marry in exchange for Honzo's head, but the two only have a single night together as Rikiya has a responsibility to the plot for En'ya Hangan's vengeance.

お石
おいし

「九段目 山科閑居」で登場する大星由良之助の妻。実説の大石りくに当たる。力弥に嫁入りを願う小浪とその母・戸無瀬に向かって、「金銀をもって媚びへつらい、追従（ついしょう）武士の禄を取る本蔵殿」とののしり、あくまでも武家の女房として毅然と振る舞う。やがて嫁入りを許す代わりに加古川本蔵の首を渡せと迫る強さは、ある意味優しさとの表裏一体、妻として母として姿勢が貫かれる。

Oishi

Oishi is Yuranosuke's wife, first appearing in the "Yamanashi Recluse" scene in Act IX. She is based on the historical Oishi Riku, and in the play she berates Tonase and her daughter Konami who come requesting her son Rikiya's hand in marriage. She claims that Honzo, Tonase's husband, is a servile warrior who sneaks around giving bribes, a reference to the events leading to En'ya's death. As the wife of a samurai family, she shows great fortitude in her actions when she offers her son's hand in exchange for Honzo's head. This ultimatum is actually an act of kindness that allows her to hold true both to her position as wife of Yuranosuke, whose master died, and mother of Rikiya, who is in love with Konami.

戸無瀬
となせ

加古川本蔵の妻だが、後妻のため娘の小浪にとっては継母。大星力弥の許嫁である小浪と、女二人のほのぼのとした旅をして由良之助が住まう山科閑居へとやってくる。しかし判官の無念を招いた桃井家の家老までや刃傷の際のとめ立てをした本蔵の妻と娘とあっては迎えてくれるわけもなく、戸無瀬は娘とともに覚悟を見せる。武家の凛とした女性像である「片はずし」と呼ばれる役柄のひとつ。

Tonase

Kakogawa Honzo's second wife and stepmother to Konami, Tonase travels with her daughter to Yamashina where Yuranosuke lives in order to receive the family's blessing for Konami to marry Oboshi Rikiya. However, since Tonase's husband is largely blamed for the events that led to En'ya Hangan's death, she and her daughter are less than welcome among the rest of En'ya's former retainers. Despite this, the two are determined to convince the family. Tonase is a *katahazushi* role, the dignified female servant of a warrior family.

みどころ
Highlights

1. 形見の刃の血の跡を
—— A Bloody Keepsake

最期の時、判官は大星に九寸五分を形見として渡す。形見というその響きに「かたき」の意味がこめられていることは大星由良之助と客席にしかわからない。緊迫のみどころである。大星は主君亡き後の家臣の面倒を見、城を明け渡したあと、ひとり城外に歩き去る。大星がひそかに、形見の刃についた血を舐め仇討ちの覚悟を決める場面も見逃せない。このあと廻り舞台を静かにまわし、大道具の建物を徐々に後ろに引いて遠ざかる城を表現する。

En'ya Hangan gives Yuranosuke the dagger he used to commit seppuku as a keepsake. Using a play on words on the Japanese words for "keepsake" and "vengeance," he secretly charges Yuranosuke with avenging him. This touching moment is a highlight of the show. Yuranosuke takes charge of En'ya's retainers and leaves the castle. The *mawari-butai* ("rotating stage") slowly moves the castle into the background to spectacular effect. From the hanamichi, Yuranosuke dramatically licks the blood from the dagger and determines to avenge his master in a scene you can't miss.

2. 幕開きは眠りから醒めた人形のように
—— Like a Puppet Waking from Sleep

人形浄瑠璃から歌舞伎にアレンジされた作品を義太夫狂言と呼ぶ。ストーリーの面白さ巧みさから今でも人気が高い。『仮名手本忠臣蔵』はその代表的な作品。この作品にだけ、人形劇だった名残の特別な演出がある。開演前に、幕の外に口上人形が出て、エヘンエヘンと咳払いしながら、役人替名（配役）をながなが読み上げる。開幕後も、まず登場人物たちは皆人形のようにじっとうつむいており、しだいに魂が入ったように動き始める。

Kabuki plays that have been adapted from bunraku puppet plays are called *gidayu-kyogen*. These plays have riveting stories that are popular even today. *Kanadehon Chushingura* is a representative example of *gidayu-kyogen*. It is unique, however, in that the kabuki version pays homage to the puppet theater in a number of ways. Before the curtain rises, a puppet appears and introduces the cast. After the curtain rises, the actors are completely motionless, and for a moment it seems like they actually are puppets before they come to life.

3. 湯上がりの顔世
—— Kaoyo After her Bath

『仮名手本忠臣蔵』初演は刃傷事件47年後。幕府を批判していると思われないよう、事件を『太平記』の時代に置き換えた。『太平記』には好色な高師直が、塩冶判官（えんやはんがん）の妻で絶世の美女顔世（かおよ）の湯上がり姿を偶然のぞき見て兼好法師にラブレターを代筆させた話が載っている。顔世がこのラブレターを師直に突き返したせいで、師直は怒り狂う。この挿話を利用して『仮名手本忠臣蔵』は創作されている。

Kanadehon was first performed 47 years after an incident of violence similar to that shown in the play. To hide the fact that the play was criticizing the government, the writers changed the period to the "Taiheiki" era. During this period, the historical Kaoyo was seen by a lascivious Morono, who then had a proxy write a love letter to her. Kaoyo's rejection of Morono led to the violent incident that was then used as the basis for *Kanadehon*.

4. 切腹と腹切り
—— Seppuku and Harakiri

前半四段目の見どころは、塩冶判官の正確な武士の作法に則った切腹。上使が切腹を命じる書状を読み上げる時、覚悟をしていた判官は着物の下にすでに白装束を着込んでいる。肩衣を外し、柄のない九寸五分の刃に紙を巻いて握り切腹。駆けつけた家老の大星に遺言を伝えると、自らの手で頸動脈を切るとがっくりと息絶える。後半の六段目で、面目を失っていきなり腹に刀を突き立てる早野勘平のあわれな腹切りとの、対照がすさまじい。

En'ya's ritual seppuku in Act IV, accurately portrayed in the traditional way, is a great highlight of the play. En'ya has already prepared white robes under his kimono when he receives the official order to commit seppuku. He proceeds to remove the shoulders of his robes and draws a handle-less dagger that he wraps in paper. When his retainer Yuranosuke comes to his side, En'ya leaves his last words before cutting his own carotid artery. This scene contrasts greatly with the scene in Act VI wherein Hayano Kanpei suddenly kills himself with a sword after losing face.

5. 七段目祇園一力茶屋の舞台面 —— Gion Ichiriki Teahouse (Act VII)

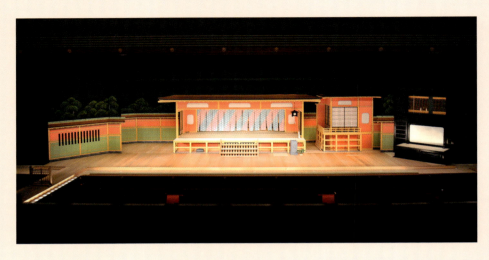

七段目は華やかな場面。つややかな壁色、派手な暖簾、軒先には釣灯籠に手水鉢、上手には二階座敷、花道には庭の枝折門が置かれる。本物の大石内蔵助も討入りの噂を打ち消すように遊郭で遊び、浮き大尽(うきだいじん)と仇名された。七段目の由良之助も粋な着物でここで遊び、戯れに仲居や太鼓持ちと鬼ごっこに興じ、浪士たちをいらだたせる。敵のスパイは縁の下に隠れ由良之助の本心を窺う。

A spectacular set in Act VII based on of the actual Ichiriki Teahouse in Gion. The set features bright walls, flashy *noren* curtains, steel lanterns hanging from the eaves, a two-floor section on the right hand of the stage, and a garden gate on the hanamichi. Oishi Kuranosuke, like Yuranosuke, tries to dispel rumors of the plot on Morono to avenge En'ya by indulging in the pleasure quarters and earning the nickname Ukidaijin ("debauched millionaire"). Yuranosuke and Kuranosuke's debauched show angers the other samurai who had served En'ya, but a spy eventually sounds out their true intentions.

6. 定九郎の工夫 —— Sadakuro's Character

五段目の定九郎はせりふが一言。殺した与市兵衛の財布の中を確かめて、ニヤついて言う「五十両」だけ。塩冶家家老の斧九太夫の息子だが不行跡で山賊になりはてた男なのだ。この後すぐ勘平の鉄砲に撃たれて死んでしまう。もともと、どてら姿で与市兵衛を追いかけて殺す地味な役だった。初代中村仲蔵が、白塗り黒紋付で出る工夫をしてから、定九郎は格好の良い役になった。

Sadakuro has a single line in Act V: "50 ryo," he says with a grin after killing Yoichibe and finding his wallet. He is Ono Kudayu's son but has become a bandit. After his single line, Sadakuro is immediately shot and killed by Kanpei. Originally, he wore a rough padded kimono and was a simple role, but gained popularity after the first Nakamura Chuzo played him in striking black robes after seeing a ronin in similar soaking black robes.

7. 十一段目高家奥庭泉水の場の舞台面
—— The Inner Courtyard Fountain (Act XI)

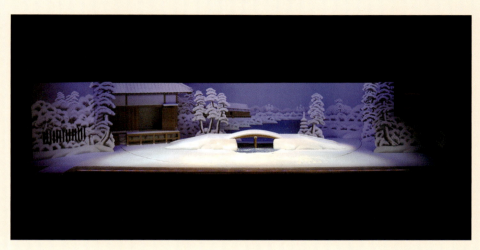

原作は討ち取った首に主君の位牌を供え、浪士たちが焼香する場面で終わる。これが歌舞伎に移されたころ、討入りは荒事で演じられた記録がある。現在の十一段目はリアルな立廻りが見せ場になっている。これは明治35年初演の『二十四刻忠臣蔵』などの趣向を取り入れたもので、柔術や拳闘なども流行した明治ならではの迫力ある動きが特色。雪景色の中の凄まじい立廻りは必見。しずかに響く太鼓の「雪音」も歌舞伎独特の効果音だ。

Kanadehon originally ended with En'ya's former samurai burning incense and offering Morono's head at their master's grave. The raid scene is not shown in the original play and was only added to the kabuki version as a scene played in the rough aragoto style. The current version depicts the raid as the climax of the play in Act XI and incorporates aspects of traditional martial arts from the Meiji period play *Nijushikoku Chushingura*. The snowy fight scene on the stone bridge above the fountain is a must-see. The soft taiko drum beat that mimics the sound of snowfall is a sound effect unique to kabuki.

8. 赤穂浪士討入事件
—— Raid of the 47 Ronin

赤穂浪士討入り事件は、元禄14（1701）年3月赤穂の領主浅野内匠頭が江戸城内で、有職故実を伝える高家の吉良上野介に斬りつけ、即日切腹・藩取潰しの憂き目に遭ったことが発端。翌年暮、赤穂の国家老大石内蔵助を筆頭に47人が吉良邸に討入り、吉良の首を取った。大石は「君父の仇は共に天を戴かず」（君の仇と同じ空の下にいるつもりはない）との書状を掲げ討入った。前代未聞の義挙ともてはやされたが、浪士らは幕府により切腹を命じられた。

The Ako Incident occurred in 1701, originating in Asano Naganori's attempt to kill Kira Kozukenosuke and subsequent seppuku. The year after, the Ako House's chief retainer Oishi Kuranosuke led 47 ronin on a raid of the Kira residence and killed Kira Kozukenosuke. He and his men raided the residence with a written statement that read, "I will not share this world with my master's murderer." Though the raid was praised as a deed of great heroism, but the ronin were ordered by the government to commit seppuku.

伽羅先代萩
Meiboku Sendaihagi

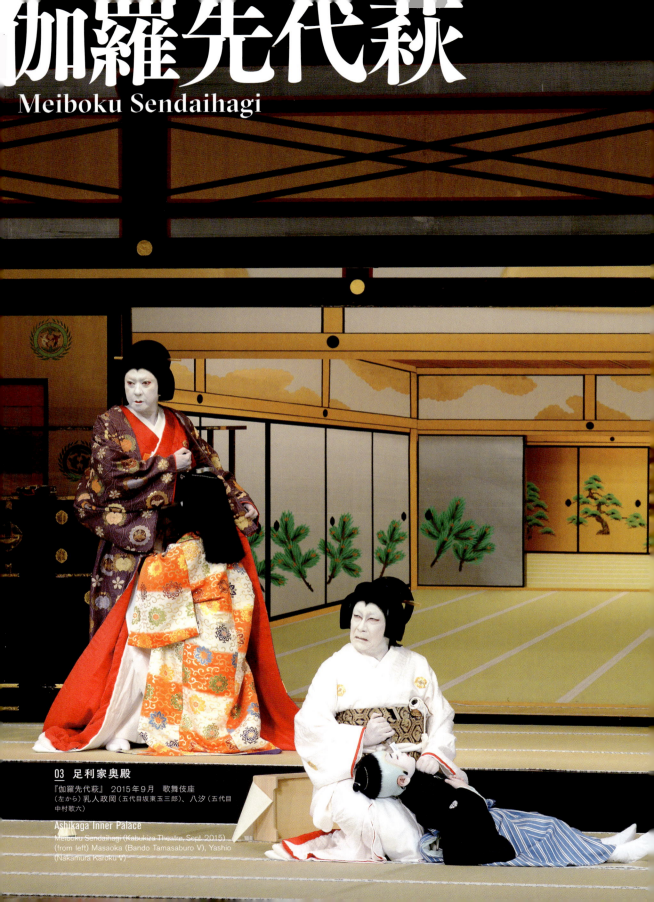

03 足利家奥殿
『伽羅先代萩』 2015年9月　歌舞伎座
(左から) 乳人政岡 (五代目坂東玉三郎)、八汐 (五代目中村歌六)

Ashikaga Inner Palace
Meiboku Sendaihagi (Kabukiza Theatre, Sept. 2015)
(from left) Masaoka (Bando Tamasaburo V), Yashio (Nakamura Karoku V)

あらすじ / Synopsis

武家のお家乗っ取りの顚末を描く「お家騒動物」の代表作

三千世界に子を持った親の心はみな一つ……。
武士の胤(たね)に生まれたは果報か因果か……。
音と動きと激情とが一体化する義太夫狂言の面白さを味わえる一幕。

── An age-old story of the struggles of succession and the family discord created when another tries to take power.

The universal love of a parent…
The karmic burden of succession in a warrior family…
Sound, movement, and passion become one in this masterpiece of *gidayu-kyogen*.

01　鎌倉花水橋

　奥州の太守足利頼兼はお家乗っ取りを企む一味の計略にのせられ、夜ごとに遊興にふけっている。ことに高価な香木である伽羅を履物にして廓通いに用いるなど、そのぜいたくはとどまるところをしらない。大磯の廓からの帰途、鎌倉花水橋で待ち伏せをしていた悪人たちにおそわれるが、駆け付けた抱え力士の絹川谷蔵に助けられる。

02　足利家竹の間

　足利頼兼は隠居を命じられ、家督を相続したのは幼い鶴千代。鶴千代の命を狙い、お家乗っ取りを企む悪人がいるので、乳人(めのと＝乳母)政岡は鶴千代が男を嫌う病気になったと言い立て、鶴千代と同年代の我が子・千松以外の男を遠ざけ、食事も毒を警戒して、自ら用意するなど厳戒態勢である。

　御殿の竹の間に、お家乗っ取りの首謀者仁木弾正の妹八汐、家臣の奥方沖の井、松島が見舞いに訪れる。鶴千代殺害をもくろむ八汐は、女医者・小槇や忍び入らせた鳶の嘉藤太らとはかって政岡に鶴千代暗殺の濡れ衣を着せようとするが、沖の井の働きや聡明な鶴千代の言葉によって退けられる。

03　足利家奥殿

　一連の騒動で食事ができなかった鶴千代と千松のために、政岡は茶道具を使って飯を炊く。大名でありながら食事も自

01　Hanamizu Bridge

The extravagant Ashikaga Yorikane plots to seize power and take over as head of the family. Each night he spends in the pleasure quarters, wearing sandals made from a rare fragrant wood. He is attacked on Hanamizu Bridge one night on his way back from the pleasure quarters but is saved by Kinugawa Tanizo.

02　Take no Ma

Yorikane is forced into seclusion while his young brother Tsuruchiyo is made head of the family. Fearing an assassination attempt, the wet-nurse Masaoka is wary of poison and keeps Tsuruchiyo and her own son Senmatsu hidden, claiming they have a strange illness that causes an aversion to men.

Yashio, sister of the head conspirator Nikki Danjo, suspects Tsuruchiyo's illness is a ruse. She takes Lady Okinoi and lady Matsushima to check up on Tsuruchiyo in the Bamboo Room (*take no ma*). Yashio has secretly planted a man named Katota near Tsuruchiyo's room and makes it seem as though Masaoka has hired him to murder Tsuruchiyo. However, Lady Okinoi and Tsuruchiyo himself make it clear that this is false.

03　Ashikaga Inner Palace

Though she only has tea utensils available to her, Masaoka cooks for Tsuruchiyo and Senmatsu, who have not been able to take their meal due to the disturbance. Masaoka is deeply touched by Tsuruchiyo's plight, not being able to

由に取れない鶴千代の境遇に心を痛め、幼い二人が空腹に耐え辛抱する健気な姿に涙する政岡。そこへ逆臣方に加担する室町幕府の管領・山名宗全の奥方・栄御前が見舞いに来るとの知らせがあり、鶴千代はじめ政岡、八汐など一同が出迎える。

　栄は菓子を持参し、鶴千代に勧める。毒を恐れる政岡は手を出す鶴千代をとどめるが、それを栄に見とがめられてしまう。管領家からの下され物を疑うのかと言われ窮地に陥っていると、千松が駆け寄って菓子をほおばり、箱を足蹴にする。菓子はやはり毒で、千松はにわかにもだえ苦しむ。八汐はすぐさま懐剣で千松を刺し、悪事を隠滅しようとはかる。

　政岡は鶴千代守護が大事と、我が子が眼前でなぶり殺しにあっても涙も見せなかった。栄御前はその様子から鶴千代と千松は取り替え子であると思い込み、お家横領一味の連判状を預ける。栄御前を見送った後、母親に返った政岡は、若君の身替わりとなった千松を褒めつつ、武士の子に生まれたゆえの不憫を嘆く。

　そこへ襲いかかってきた八汐を討ち、政岡は千松の仇を取る。その時大きな鼠が、政岡が預かった連判状をくわえると、いずこかに走り去った。

04　足利家床下

　御殿の床下では讒言（ざんげん）によって主君から遠ざけられた荒獅子男之助が、ひそかに鶴千代の警護を行っている。男之助は巻物をくわえた怪しい大鼠をとらえるが取り逃がしてしまう。鼠は実は仁木弾正が化けたもので、もとの弾正の姿に戻ると、連判を懐に悠々と去っていくのだった。

05　問註所対決

　幕府の問註所では、鶴千代側の老臣・渡辺外記左衛門、その子渡辺民部、山中鹿之介、笹野才蔵らと、お家乗っ取りを企む仁木弾正、大江鬼貫、黒沢官蔵らが対峙し、取り調べが行われている。裁いている山名宗全は弾正方で、外記の提出する証拠はことごとく退けられ、外記方の敗訴が確定しかかる。

　あわやというその時に、宗全の相役・細川勝元がやってくる。弾正の悪を暴く密書の断片を手に入れていた勝元は、さわやかな弁舌で弾正を追及し、外記方を勝利に導く。

06　問註所詰所刃傷

　仁木弾正は、渡辺外記に近づき、隠し持った短刀で刺す。外記は扇子一つで弾正の刃に抗い、民部らの援護を受けて弾正を倒す。細川勝元は外記らの働きをねぎらい、鶴千代の家督を保証する墨付を与えるのだった。

eat freely even though he is a mighty Daimyo. Sakae Gozen, wife of the high-ranking Daimyo Yamana Sozen, arrives to visit the sick Tsuruchiyo, though she is also on the side of the conspirators.

　Sakae has brought a dessert for Tsuruchiyo, who reaches out to accept it. He is, however, stopped by Masaoka, who fears it may be poisoned. Masaoka is put in a difficult position when Sakae asks why she doesn't trust the house of a high-ranking noble. Just then, Senmatsu rushes over and eats the dessert, which is in fact poisoned. Senmatsu immediately begins to groan, but Yashio comes forward and stabs him immediately to conceal the fact that the dessert was poisoned.

　Masaoka, only thinking of protecting Tsuruchiyo, suppresses her grief over the loss of her son. Sakae sees this and mistakenly believes that Senmatsu was actually Tsuruchiyo in disguise. Thinking Masaoka is on her side, Sakae gives her a secret scroll about the conspirators and leaves. After seeing Sakae off, Masaoka goes to her son, praising his bravery and lamenting that he was born to be a warrior.

　Suddenly Yashio reappears and attacks Masaoka, but the mother is able to avenge herself upon the woman who killed her son. Just as Masaoka kills Yashio, a giant rat appears and steals the scroll before running off.

04　Under the Floor

　Arajishi Otokonosuke, one of Tsuruchiyo's retainers who has been separated from his master on false accusations, is secretly watching Tsuruchiyo from under the floor. He sees the rat, which is actually Nikki Danjo in disguise, and attempts to capture it. The rat escapes and returns to his original human form as Danjo, with the scroll in hand.

05　The Confrontation at Monchujo

　A trial is conducted at the court. On Tsuruchiyo's side are chief retainer Watanabe Gekisaemon, his son Minbu, Yamanaka Shikanosuke, and Sasano Saizo. On the side of the conspirators are Nikki Danjo, Oe Onitsura, and Kurosawa Kanzo. The judge, Yamana Sozen, is an ally of Danjo's and rejects the evidence brought forth by Geki, nearly allowing Danjo to win the trial.

　Just as the trial is about to end, however, Sozen's colleague Hosokawa Katsumoto appears with a fragment of a document incriminating Danjo. After a series of pointed questions, Danjo is shown to be guilty, and Geki's side wins the trial.

06　Bloodshed at the Trial

　Danjo approaches Geki and stabs him with a knife he had concealed in his robes. Geki uses a fan to defend himself, and Danjo is eventually captured by Minbu and the others. Katsumoto praises Geki and his comrades, and signs a document certifying Tsuruchiyo's position as head of the house.

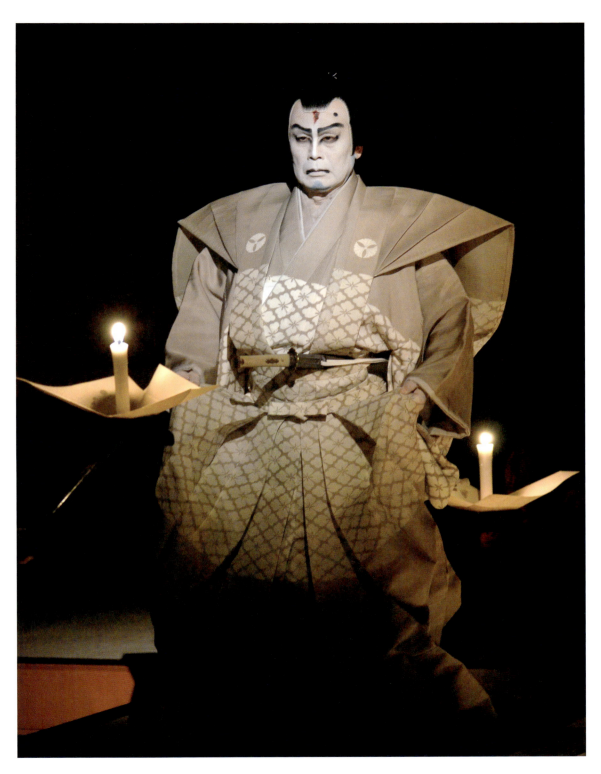

04 足利家床下
『伽羅先代萩』 2013年5月 歌舞伎座 仁木弾正（九代目松本幸四郎）
Meiboku Sendaihagi (Kabukiza Theatre, May 2013) Nikki Danjo (Matsumoto Koshiro IX)

作品の概要 / Overview

Title
伽羅先代萩

Meiboku Sendaihagi

Writers
奈河亀輔

Nagawa Kamesuke

概要

　仙台藩のお家騒動「伊達騒動」を脚色した演目。伊達騒動は様々に脚色され、本作はその中でも最もよく知られているものだが、成立過程は複雑である。

　まず、安永 6（1777）年 4 月　大坂・中の芝居で奈河亀輔ら合作の歌舞伎『伽羅先代萩』が初演された。これは時代を鎌倉時代に置き換えた作品である。

　翌安永 7（1778）年 7 月には累の怪異伝説と伊達騒動を結び付けた桜田治助・笠森専助合作の歌舞伎『伊達競阿国戯場』が江戸・中村座で初演。これは時代を足利時代にとっている。

　さらに、天明 5（1785）年 1 月には、江戸の結城座で人形浄瑠璃『伽羅先代萩』が上演されている。松貫四・高橋武兵衛・吉田角丸合作の本作は、奈河亀輔らの『伽羅先代萩』に、『伊達競阿国戯場』を取り入れて浄瑠璃化したもので、時代は鎌倉である。

　現行の『伽羅先代萩』はこれらの諸作品を折衷して確立されたもので、「御殿」「床下」は浄瑠璃『伽羅先代萩』を基にしながら、登場人物名などは『伊達競阿国戯場』により足利時代に統一されている。こうした台本が定着したのは明治半ばからといわれる。

　そのため、たとえば義太夫狂言の魅力をたたえた「御殿」に対し、「竹の間」「対決」「刃傷」は義太夫抜きでセリフ中心。「床下」では荒事の男之助が登場するなど、各場面で舞台の雰囲気が変わり、それもまた魅力の一つになっている。

Overview

　Meiboku Sendaihagi is a dramatization of the historical "Date Disturbance" (date sodo), a famous dispute over succession among the Date clan. An often-fictionalized story, Meiboku is well-known by the name of "Date Disturbance," but was developed under rather complicated circumstances.

　The first kabuki play entitled Meiboku Sendaihagi was a play co-written by Nagawa Kamesuke and performed in April 1777. This version changes the era to the Kamakura era.

　In July of the following year, another play based on the Date Disturbance debuted, this time mixing in elements from an old ghost story. Entitled Date Kurabe Okuni Kabuki and co-written by Sakurada Jisuke, this version debuted at the Nakamura-za Theater in Osaka. The era this time is the Ashikaga era.

　Once again, in January, 1785, a new bunraku play entitled Meiboku Sendaihagi debuted at the Yoki-za in Edo (modern-day Tokyo). Written by Matsu Kanshi, Takahashi Buhei, and Yoshida Kadomaru, this bunraku adaptation is based on Kamesuke's Meiboku but adds elements of Date Kurabe. It is set in the Kamakura era.

　The current kabuki version of Meiboku Sendaihagi is a blending of all three of these previous plays, basing scenes like "The Inner Palace" and "Under the Floor" on the bunraku adaptation while setting the drama in the Ashikaga era and taking its character names from Date Kurabe. This version of the play is said to have originated in the Meiji Era.

　It is because of this complicated history that you see so much variety in Meiboku. The impressive palace scene in the gidayu-kyogen style is contrasted by "Take no ma," "The Trial," and "Bloodshed," which focus more on the character's words, and the aragoto-style "Under the Floor" which features the impressive Otokonosuke. Such changes in mood from scene to scene are part of what make Meiboku such a fascinating play.

初演

安永 6（1777）年 4 月　大坂

Premiere

April 1777, Osaka

登場人物 — Characters

足利頼兼
あしかがよりかね

足利家の殿様で、お家乗っ取りを企む一味の計略に乗せられて廓通いに明け暮れ、高尾太夫という傾城に入れ上げている。実説では伊達家の三代藩主・伊達綱宗、あまりの放蕩ぶりから藩主の座を追われ伊達騒動の発端となっている。その綱宗が伽羅（きゃら）という銘木（めいぼく）で作られた下駄を履いて廓通いをしたという巷説が伝えられ、これが『伽羅先代萩』という外題の元となっている。

Ashikaga Yorikane
An extravagant lord of the Ashikaga clan, Yorikane plans to seize power from the current head of the family but spends each night in the pleasure quarters with the courtesan Takao Dayu. Yorikane is based on the historical figure Date Tsunamune, who was removed from his position as clan head due to his debauchery. Tsunamune was known for wearing sandals made of a very valuable wood (*meiboku*) called *kyara*, which is indicated in the title.

仁木弾正
にっきだんじょう

足利家の家老で、お家乗っ取りを企む一味の中でも中心人物。妖術で鼠に化けるという突飛な発想も登場する。「床下」の場で鼠の姿から本性を顕し、無言で不敵な笑みを浮かべ悠然と花道を入る姿は芝居全体のなかでも観客を引き付ける重要な場面。「対決」「刃傷」ではずる賢く、最後まで刀を抜いて抵抗を見せるがついに討ち取られる。歌舞伎における「実悪」という役柄の代表的な役。

Nikki Danjo
Chief Retainer of the Ashikaga House, Danjo is the key player in Yorikane's plot to seize power. He is shown to have the extraordinary ability to transform himself into a rat. In the scene "Under the Floor" (*Yukashita*), he reveals his power by returning to his human form. This is a riveting scene in which Danjo flashes a sinister smile and moves boldly off stage and into the isles where the audience sits. He maintains this sinister character through the many scenes up until the very end when he is finally vanquished after a fierce fight. Danjo is an example of the "*Jitsu-aku*" (real evil) role in kabuki.

千松
せんまつ

政岡の子。鶴千代のそばに仕え、幼いながら懸命に主君に尽くしている。母・政岡の言いつけを守り、空腹に耐えながらも武家の子としての信念を通し、「腹が減ってもひもじゅうない」のせりふは心を打つ。持ち込まれた菓子を毒入りと知りながら口にし、それによって鶴千代の窮地を救うが、もしもの時は主君に代わって毒でも口にするという、日頃からの母の教えを忠実に実行した。

Senmatsu
Senmatsu is Masaoka's son. Despite his youth, he faithfully serves his master, Tsuruchiyo. Proud of his samurai heritage, he listens faithfully to his mother's words and endures his hunger, courageously saying "My stomach may be empty, but I don't feel hunger." He eventually sacrifices himself by eating food he knows is poisoned, faithfully carrying out the teachings his mother taught him.

乳人政岡
めのと まさおか

幼くして藩主となった鶴千代の乳母。鶴千代が御家乗っ取りを企む者たちに命を狙われているので病気と偽って奥殿に匿い、食事も毒を警戒して出された膳には手を付けさせず自らが周到に用意している。主君への忠義には自分の子に犠牲を強いるという辛い選択を全うするが、独りになった時に初めて母の嘆き悲しみを見せる。気丈な武家の女性の「片はずし」と呼ばれる役柄の代表格。

Menoto Masaoka
Wet-nurse to the young clan head, Tsuruchiyo. Fearing attempts on the young lord's life, Masaoka claims Tsuruchiyo is sick in order to hide him away and refuses to let him eat anything she hasn't personally prepared. When her own son is sacrificed for Tsuruchiyo's sake, she keeps her composure in order to protect the young lord, but cries bitterly when the danger has passed. Her character is an example of a "*Kata-hazushi*" role, the clever woman in the service of a samurai.

鶴千代
つるちよ

足利頼兼の嫡男で、頼兼が隠居させられた後に幼くして藩主となった。なおも命を狙われているので、男性が近づくのを嫌う病気と称して奥殿に籠り、政岡の子の千松だけを相手に日々を送っている。運ばれた膳には手を付けずいつも腹を空かせているが、あくまでも若殿の威厳を見せ決して弱音は吐かない。史実では伊達家の亀千代だが、この演目ではその名が鶴千代と改められている。

Tsuruchiyo
The eldest son of Ashikaga Yorikane, Tsuruchiyo was made clan head after Yorikane was removed from the position. The young and vulnerable lord is shut up in the inner palace for fear of assassination with only Masaoka's son Senmatsu to keep him company. He often goes hungry because he is not allowed to eat much of the food that is brought to him, but he remains brave and refuses to show weakness despite his tender age. The historical figure Tsuruchiyo is based on is actually named Kamechiyo.

八汐
やしお

仁木弾正の妹で、お家乗っ取りを企む一味の一人。天井に隠れていた曲者を捕らえて詮議し、政岡に頼まれたと白状させて政岡を牢に入れようと企むが、鶴千代の毅然とした防御に阻まれる。しかし、毒菓子を口にして俄かに苦しむ千松に容赦なく懐剣を突き立て、証拠隠滅を図るなど実行役として存在を見せつける。凄みのある女性なので、女方ではなく立役の俳優が勤めることも多い。

Yashio
Nikki Danjo's sister, Yashio is an ally to the conspirators. She conspires to frame Masaoka with a fake kidnapping attempt but is thwarted by Tsuruchiyo, who boldly protects Masaoka. However, she does not hesitate to murder Senmatsu when he eats poisoned food meant for Tsuruchiyo, thus burying the evidence. She is a merciless and fearsome villain, and is not often played by onnagata actors, but rather *tachiyaku* leading men.

栄御前
さかえごぜん

山名宗全の妻で、乗っ取り一味の中でも身分の高い一人。将軍家からの下され物として毒入り菓子を持参し、鶴千代に食べるようしきりと促す。それをとどめる政岡を窮地に追い込むが、そこを千松が小さな命を懸けて救った。政岡が千松のなぶり殺しを目前にしながら動揺や悲しみを一向に見せない様子を冷静に観察、取り替え子と悟り、政岡も一味と思い込んで秘密の連判状を渡してしまう。

Sakae Gozen
Yamana Sozen's wife, Sakae is one of the highest ranking of the conspirators. She brings poisoned food from the shogun and insists that Tsuruchiyo eat it. Because of the potential rudeness toward such a high-ranking noble, Masaoka is in a difficult position, but Senmatsu saves her at the cost of his life. Seeing Masaoka's level-headedness at witnessing her son's death, Sakae believes Senmatsu was actually Tsuruchiyo in disguise and that Masaoka is on her side. She leaves a secret scroll about the plot with Masaoka.

小槙
こまき

大場道益という医者の妻で自らも医者である。「竹の間」と「御殿」では、鶴千代の病状により男性の立ち入りが一切成らず、栄御前、八汐をはじめすべてその妻などが名代として登場してくる。小槙は鶴千代の診察と称して脈を取るが、御殿の間では死を予告する危険な脈、廊下で測り直してみれば不思議なことに平脈と告げ、部屋の中を捜索して天井に隠れた曲者を誘き出すという八汐計画に加担する。

Komaki
Wife of the doctor Oba Doeki. Komaki is one of the many female characters who appear before Tsuruchiyo due to his illness prohibiting male visitors. Conspiring with Yashio, Komaki comes on the pretense of diagnosing Tsuruchiyo. During her examination of Tsuruchiyo, she claims that she can feel a deadly presence through his pulse. She determines that it is in the very room they are in, and eventually discovers the fake kidnapper in the ceiling.

渡辺外記左衛門
わたなべげきざえもん

足利家の忠義深い老臣で、お家乗っ取りを懸命に阻止する。裁きの場で仁木弾正と対決するが、裁決をする山名宗全が乗っ取り側なので外記左衛門の申し立てや証拠はことごとく退けられる。やがて現れた細川勝元の名裁きで弾正らの不正が暴かれ、ようやく勝利を収めるが、その後も悪あがきを続ける仁木弾正に斬り付けられ致命的な深手を負う。勝元の介抱を受けお家の無事を喜ぶ。

Watanabe Gekizaemon
An elder retainer of deep loyalty to the Ashikaga House, Watanabe Gekizaemon helps stop Yorikane's plot to seize power. He defies Danjo at the trial, but Judge Yamana Sozen, who is complicit in Danjo's plot, repudiates all evidence brought forth. Hosokawa Katsumoto finally appears and shows Danjo to be guilty, but in his anger Danjo stabs Geki. He is tended to by Katsumoto, but the wound is fatal. In his weakened state Geki rejoices that the Ashikaga House is safe.

沖の井 と 松島
おきのい と まつしま

沖の井は田村右京の妻、松島は渡辺主水の妻、八汐と共にいずれも夫の名代として鶴千代の病気見舞いにやってくる。鶴千代がお膳の食事に一切手を付けず絶食状態なのを危惧し、病気快癒のためにもと懸命にすすめるが、決して悪巧みの側ではなく忠臣の心から。そして八汐が天井に忍んだ曲者や手紙を巧みに使って政岡に罪を着せようとするが、松島、沖の井がそれぞれに理を通して正す。

Okinoi and Matsushima
Okinoi and Matsushima go to visit the supposedly ill Tsuruchiyo on behalf of their husbands. The two see that Tsuruchiyo is not eating any food and try to convince the young lord to eat something to regain his strength. They are sincerely concerned, however, and not part of the plot. Yashio uses this opportunity to stage a fake kidnapping and frame Masaoka for hiring the kidnapper, but Okinoi and Matsushima, both upright characters, are able to see through the act and prove Masaoka innocent.

荒獅子男之助
あらじしおとこのすけ

足利家の中でも武勇に優れた忠臣だが悪人たちによって遠ざけられ、奥殿の床下に閉じこめられている。そこに迷いこんできた怪しい鼠を捕らえ、足で踏みつけた上に派手な立廻りを演じるが、残念ながら取り逃がしてしまう。その鼠は妖術を使った仁木弾正。この場の男之助は甲高いせりふと力強い見得で華やかに演じ、この瞬間だけ江戸歌舞伎色の強い典型的な荒事の様式美が舞台を飾る。

Arajishi Otokonosuke
An Ashikaga retainer renowned for his military prowess, Arajishi has been confined to the basement of the palace by the conspirators. When he sees a suspicious-looking rat scurry by, he tries stepping on it, resulting in an entertaining scuffle on stage. Unfortunately, however, the rat escapes, and is revealed to have been Danjo in rat form, transformed by his mysterious powers. Otokonosuke's grandiose words and powerful postures in this scene are truly reminiscent of the *aragoto* style kabuki of the Edo era.

山名宗全
やまなそうぜん

裁判官の役割も持つ管領（かんれい）だがそもそもお家乗っ取りに加担する人物で、毒菓子を持参した栄御前はその妻。もう一人の管領である細川勝元を同席させずに単独で裁きを進め、重要な証拠の書状を勝手に燃やしてしまうなど、一方的に外記左衛門など忠臣側の言い立てを退ける。やがて現れた細川勝元に裁定のことごとくを覆され、次第にその正体が浮き彫りになってゆく。

Yamana Sozen
Yamana Sozen, a high-ranking official, serves as judge at the trial, but is actually one of the conspirators. His wife is Sakae Gozen, who took the poisoned dessert to Tsuruchiyo. He starts the trial without his colleague Hosokawa Katsumoto and proceeds to burn the evidence brought forth and completely refute Gekizaemon's case. When Katsumoto finally appears, he turns the tide of the trial, eventually bringing the truth to light.

大江鬼貫
おおえのおにつら

足利頼兼の叔父で、まさしく乗っ取りを企む首謀格の人物。歌舞伎におけるお家騒動にはこういった親戚筋の黒幕が絡むというのがいわばお約束で、この役も「叔父敵（おじがたき）」と呼ばれる役柄の典型的な例。「対決」の場では仁木弾正と連座し、山名宗全も加えた一味同士で見え透いた芝居を演じ一時は乗っ取り側の一方的な勝利と見えるが、後に現れた細川勝元によりすべてが露見してしまう。

Oe Onitsura

Oe Onitsura is Yorikane's uncle and one of the masterminds behind the plot to seize power. His character is that of the "*ojigataki*," the middle-aged villain who supports his kin's evil plots. He joins Danjo during the trial, and with Sozen in their corner it seems certain that the villains will win. However, Hosokawa Katsumoto appears in the nick of time to save the day.

細川勝元
ほそかわかつもと

任務としては山名宗全と同じ裁判官役。裁きの場に居合わさぬ羽目になりそうなところ、遅ればせながらその場の空気を一変させて登場する。すでに裁定は済んでいると告げられ、当初はそれを肯定しつつも、ひとつひとつ解きほぐして次第に正しい裁定に導いてゆく。「捌き役（さばきやく）」と称する役柄の典型で、颯爽と現れ見事に解決してみせる気持ちの良い役である。

Hosokawa Katsumoto

Hosokawa Katsumoto is to serve as judge at the trial, the same position of Yamana Sozen, but he almost misses the whole affair. Arriving at the last moment, he completely turns the tide of the trial. Told that the trial has already been determined, he calmly reexamines the facts and disproves every claim, slowly revealing the truth of the whole affair. Katsumoto's role is called "*sabakiyaku*" a gallant and wholesome judge who appears just in time and astonishingly resolves the conflict.

みどころ
Highlights

1. 乳人政岡の衣裳 —— Menoto Masaoka's Costume

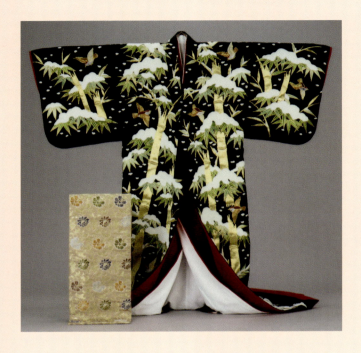

幼い藩主を必死に守る乳人が着る黒繻子の裲襠（うちかけ）。しんしんと降る雪を積もらせた笹のあいだを雀が飛び交う柄は「雪持笹」と呼び、政岡のトレードマークになっている。「竹に雀」は仙台藩主伊達家の紋章の意匠でもある。

A long black satin overgarment worn by the nanny Masaoka, who desperately tries to protect her young lord. The pattern wherein sparrows flutter between bamboo grass sticking up through the fallen snow is called Yukimochizasa, and is a trademark of Masaoka. Sparrows among bamboo trees is also a design used in the coat of arms of the Sendai Domain Date (pronounced da-teh) family.

2. 伊達な殿様の御家騒動 —— A Family Disturbance Among Stylish Lords

伊達男と言えば、お洒落な男性のこと。伊達政宗に始まる伊達藩主のなかに、派手好みで伽羅の下駄を履いて吉原通いしたと伝わる殿様がいて隠居させられ伊達騒動が起こった。舞台化にあたって題名に伽羅の字を入れ「めいぼく（銘木）」と読ませ、さらに先代萩の字で、仙台と宮城野の萩を連想させた。御家騒動は、庶民の好奇心を大いに刺激した。一生垣間見ることもできない豪華絢爛の大名屋敷で起きるドロドロ騒動を、庶民は芝居で楽しんだのだ。

The term "*date-otoko*" refers to a stylish man but derives from the Date clan. The clan leader Date Masamune was notorious for his penchant for extravagance, wearing sandals made of a rare wood called kyara and frequenting the pleasure quarters. Because of his indiscretion, he was put on house arrest, which began of the Date Disturbance. When dramatized, the Chinese characters for the rare wood *kyara* were used but read as *meiboku*, or "precious wood." Furthermore, the characters used for Sendaihagi are meant to suggest both the region of Sendai and the bush clovers of Miyagino. This family feud was a tantalizing topic for the commoners of the time. The dramatization of this episode allowed common folk to have a peak into the dripping melodrama of the higher classes of society.

3. 手強い悪女は立役が演じる
── The Tough *Akujo* Characters Played by *Tateyaku* Actors

歌舞伎の女方は優美な美しさ、心根のやさしさが持ち味。だが時には人を殺すのもいとわないような悪女も登場する。『先代萩』に登場する八汐は仁木弾正の妹で、兄と一緒に御家乗っ取りを企む悪女。毒が入った菓子をわざと食べた千松の首に刃を刺しつけ、ぐりぐりと苦しませて殺してしまう。このような手強い悪女は、通常は立役(男性の役)を専門にしている俳優が演じる。その独特の線の太い悪女ぶりも、みどころのひとつ。

Onnagata characters are graceful, beautiful, and kind. But there are also *akujo* (female villains) who are more than willing to hurt or murder others. In *Sendaihagi*, Yashio helps her brother Nikki Danjo in the plot to seize power of the Date house. She immediately kills Senmatsu after he purposely eats the poisoned dessert that was meant for Tsuruchiyo. Evil female characters like this are played by *tateyaku* (leading men) actors. The striking and unique lines drawn by the *akujo* character Yashio are another big highlight of *Sendaihagi*.

4. 腹が減ってもひもじゅうない
── "My Stomach May be Empty, But I don't Feel Hunger."

むかし貴人は乳母を雇って子女を育てさせた。乳兄弟とは、その子女と乳母の子供のこと。幼い時から、若君の側近くでともに育つこともあったが、幼くとも主従の関係である。本作では、若君鶴千代と乳人政岡の子千松が乳兄弟。鶴千代を毒殺の危険から守るため、政岡は自ら炊く飯以外二人に食べさせない。腹ぺこで待つ二人は武士の子らしく、「腹が減ってもひもじゅうない」とやせ我慢。転じて、「千松」は空腹の隠語になった。

In the past, nobles would hire wet-nurses to raise their children. The term *chikyodai*, or "milk siblings," refers to a wet-nurse's ward and actual child, who are often raised together, though their social relationship is one of master and servant. In *Meiboku Sendaihagi*, Tsuruchiyo and Senmatsu (the wet-nurse Masaoka's son) are therefore milk brothers. To protect the two boys from assassination attempts, Masaoka only allows them to eat food she has personally prepared. The two boys live up to their warrior status by bearing their hunger pains gallantly, saying "my stomach may be empty, but I don't feel hunger." Because of this, the word "senmatsu" has become synonymous with hunger in the theater.

5. 変身した時に受けた傷
── Wounded When Transformed

歌舞伎の悪人は時に妖術を使う。御家乗っ取りを企む仁木弾正(にっきだんじょう)はネズミに化けて、大事な巻物を善人の手から奪い、口にくわえて逃げ去る。しかし、ひそかに床下で守護していた若武者に、鉄扇でぴしりと傷つけられた。人間に戻って不敵な笑いを浮かべるその額に、赤い傷跡があるのが凄い。スッポン(付録)と呼ばれる花道の穴からネズミ色の裃姿で出て、傷もそのまま悠然と花道を去りゆく様は一番のみどころ。

Villains in kabuki sometimes use magic. In *Meiboku*, plot leader Nikki Danjo transforms into a rat to steal a scroll from one of the protagonists. A young warrior hiding under the floor, however, spots and wounds him with a steel fan. The crimson wound on his forehead as he transforms back into a human and laughs triumphantly adds a ghastly mood to the stage. The greatest highlight of the show is watching Danjo appear from a trapdoor in the *suppon* (a type of *hanamichi*) and calmly exit the stage despite his wound.

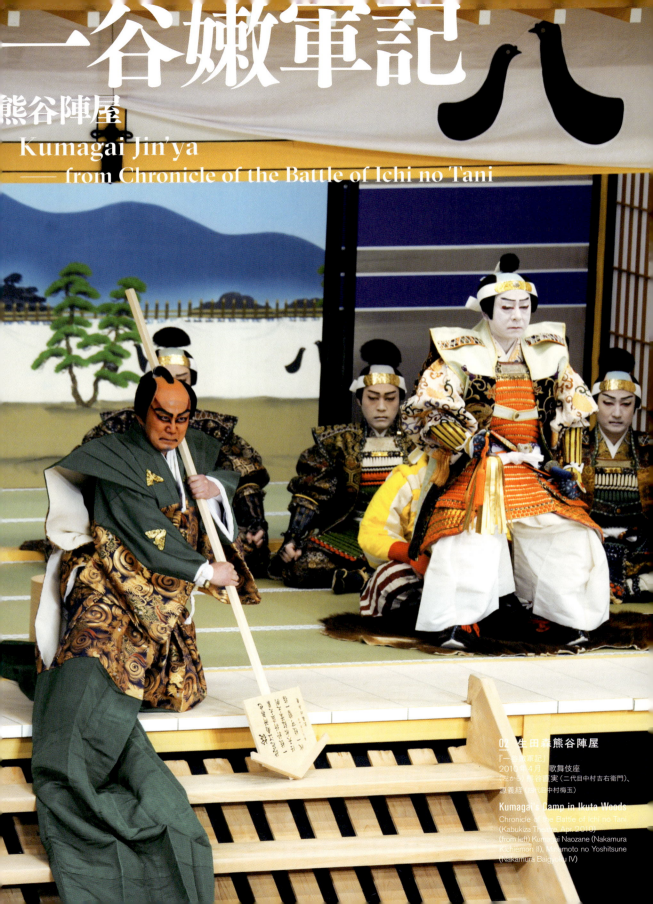

一谷嫩軍記
熊谷陣屋
Kumagai Jin'ya
—— from Chronicle of the Battle of Ichi no Tani

02 生田森熊谷陣屋
『一谷嫩軍記』
2010年4月 歌舞伎座
(左から) 熊谷直実 (二代目中村吉右衛門)、
源義経 (四代目中村梅玉)

Kumagai's Camp in Ikuta Woods
Chronicle of the Battle of Ichi no Tani
(Kabukiza Theatre, Apr. 2010)
(from left) Kumagai Naozane (Nakamura
Kichiemon II), Minamoto no Yoshitsune
(Nakamura Baigyoku IV)

あらすじ

江戸時代のフィクションが、今我々の心を打つ。
これぞ古典の力、歌舞伎の力

熊谷直実に渡された制札。そこに込められた非情の命令とは。
軍人熊谷に下されたのは我が子を身替わりにする軍命。
政治と個人、命令と人情、軍人と父親。
様々な板挟みのなかで決断を下した熊谷、そして……。熊谷の慟哭が胸に突き刺さる演目。

Synopsis

Fiction of the distant past that resonates in our hearts today. This is the power of the classics, the power of kabuki.

The warrior Kumagai Naozane is given a sign board with a cruel secret message. His son is to take the place of another in battle, creating a profound internal conflict. Politician and individual, duty and humanity, warrior and father —Kumagai finds himself torn within, but keeps his resolve and bears profound loss that touches audiences to the core.

01　この場にいたるまで

　源平の戦いのなか、源氏の武将熊谷次郎直実は、大将の源義経から、一ノ谷の戦場に向かえ、という命令とともに、一枚の制札を渡された。弁慶が書いたというその制札には「一枝（いっし）を伐（き）らば一指（いっし）を剪（き）るべし」との文言があった。

　また、直実は、須磨の浦で、平敦盛を一騎打ちの末討ち取った。

02　生田森熊谷陣屋

　生田の森にある直実の陣屋。そこに直実の妻相模が我が子小次郎の初陣を案じてやってくる。ついでそこに逃げ込んできた藤の方。藤の方は平経盛の妻で、平敦盛の母。今は敵味方であるが、二人は知り合い。直実と相模は、その昔御所で恋愛関係にあり、不義として牢に入れられるところを、院の籠愛深い藤の方のとりなしで助かったことがあった。その折、相模も藤の方も懐胎しており、相模が直実の故郷で産んだのが小次郎であり、懐胎のまま経盛に嫁した藤の方が産んだの

01　The Story So Far...

　As the Genpei War rages on, Genji commander Kumagai Jiro Naozane went to the battle at Ichi no Tani on General Yoshitsune's orders. He carried a sign board with a warning written by Benkei: "He who cuts a branch must also cut his finger."

　During an altercation at Suma no Ura, Naozane defeated the young Taira no Atsumori.

02　Kumagai's Camp in Ikuta Woods

　The setting is Kumagai's Camp located in the Ikuta Woods. His wife Sagami has arrived to express her worry over their son Kojiro who is away on his first battle. Fuji no Kata, Tsunemori's wife and Atsumori's mother (and thus on the side of the Taira), has also fled to this camp. Though they are enemies now, the two women are well acquainted. Fuji no Kata had helped Kumagai and Sagami in the past when they had been put in jail on charges of infidelity. At that time, Sagami had been pregnant with Kojiro and Fuji no Kata with Atsumori.

　Kajiwara Kagetoki, a Genji, has also come to question the stone mason.

一
谷
嫩
軍
記

熊
谷
陣
屋

あ
ら
す
じ

が敦盛であった。

さらに、源氏方の梶原景高が、石屋の白毫(びゃくごう)の弥陀六を詮議のために連行してくる。(※ここまでは上演されないことが多い)

外出から戻った熊谷は、相模を見て驚く。また、敦盛の仇と討ちかかってきた藤の方と相模に、敦盛討ち死にの様子をつぶさに語って聞かせるのだった。

悲しみに暮れる相模と藤の方は、敦盛が所持していた青葉の笛を吹き、敦盛を弔う。すると障子に敦盛の影。しかし障子をあけると中にあるのは鎧櫃(よろいびつ)に飾られた鎧であった。

やがて直実が敦盛の首を義経の実検に備えると持ち出す。とそこに義経の声。義経も熊谷の陣屋にやってきていたのである。

直実は制札を義経に差し出し、首桶の蓋を取った。その中に入っていたのは敦盛ではなく、熊谷の子小次郎の首。我が子と気づいた相模と、立ち騒ぐ藤の方を制し、熊谷は首桶を義経に差し出す。義経はその首を検分し、敦盛の首に違いないと断じるのだった。

「一枝(いっし)を伐(き)らば一指(いっし)を剪(き)るべし」という制札の言葉には、実は「一枝」「一指」に同じ読みの「一子」を重ね、実は院の子敦盛ではなく、熊谷に我が子小次郎を身替わりに斬り、敦盛を助けよ、という意味が込められていた。それを読み解いた熊谷は、我が子を犠牲にしたのだった。

石屋の詮議にかこつけ、陰で様子を窺っていた梶原景高は、義経が敦盛を助けたことを、鎌倉の頼朝に注進しようと走り出すが、弥陀六に石鑿(いしのみ)を投げつけられ殺されてしまう。

弥陀六は実はその昔、少年だった頼朝や幼い義経の命を助けた弥平兵衛宗清(やへいびょうえむねきよ)という平家の侍だった。弥陀六は自分の温情が平家を滅ぼす遠因となったことを悔やむ。義経はその時の恩に報いるように、藤の方と鎧櫃に隠した本物の敦盛を弥陀六に託す。

子を失った熊谷は、髪を剃り落として出家の意思を明らかにする。主君義経に暇乞いして許され、小次郎が生まれてからの十六年の月日を夢だったと歎じながら、悄然と立ち去っていくのだった。

* The scene is often abbreviated by cutting everything up until this point.

Kumagai returns and is surprised to see Sagami there. Fuji no Kata attempts to avenge her son Atsumori, but Kumagai makes her and Sagami listen as he recounts his battle with Atsumori in great detail.

Deeply saddened at Kumagai's story, Sagami and Fuji no Kata play a flute that had belonged to Atsumori in his memory. Just then, Atsumori's shadow appears behind a shoji sliding door. Opening the door, however, they find that it was merely Atsumori's armor.

Kumagai retrieves the head he had taken from the battle for Yoshitsune to inspect, prompting Yoshitsune himself to call out. He had already arrived at the camp.

Kumagai produces the sign board he had been given and removes the lid from a container he had brought. The head inside is not Atsumori's, but his own son, Kojiro's. Sagami realizes the head is her son's. She and Fuji no Kata begin to protest, but are stopped. When Kumagai shows the head to Yoshitsune, he inspects it carefully and states that it is indeed the head of Taira no Atsumori.

The message on the signboard, "He who cuts a branch must also cut his finger," had actually been an encrypted message asking Kumagai to save Atsumori by killing his own son Kojiro instead. Understanding this message, Kumagai executed his master's wishes, sacrificing his own son.

Kajiwara Kagetoki, who had only pretended to have business with the stone mason, had been listening from a distance. He suddenly begins to flee, saying he will report the betrayal of saving Atsumori to the Genji leader Yoritomo in Kamakura. Midaroku, however, kills him with a chisel before he can escape.

Midaroku, it turns out, is actually the Taira warrior Munekiyo who had saved Yoritomo and Yoshitsune when they were very young. Midaroku expresses regret at his actions, saying that they led to the fall of the Taira clan. In gratitude, Yoshitsune offers Atsumori's armor case to Midaroku. In fact, Atsumori himself is hiding within this case.

Kumagai, who has lost his son, shaves his head and says that he will enter the priesthood. He asks leave of his master which Yoshitsune grants. The scene ends with a dejected Kumagai lamenting Kojiro's short life of 16 years, which passed like a dream.

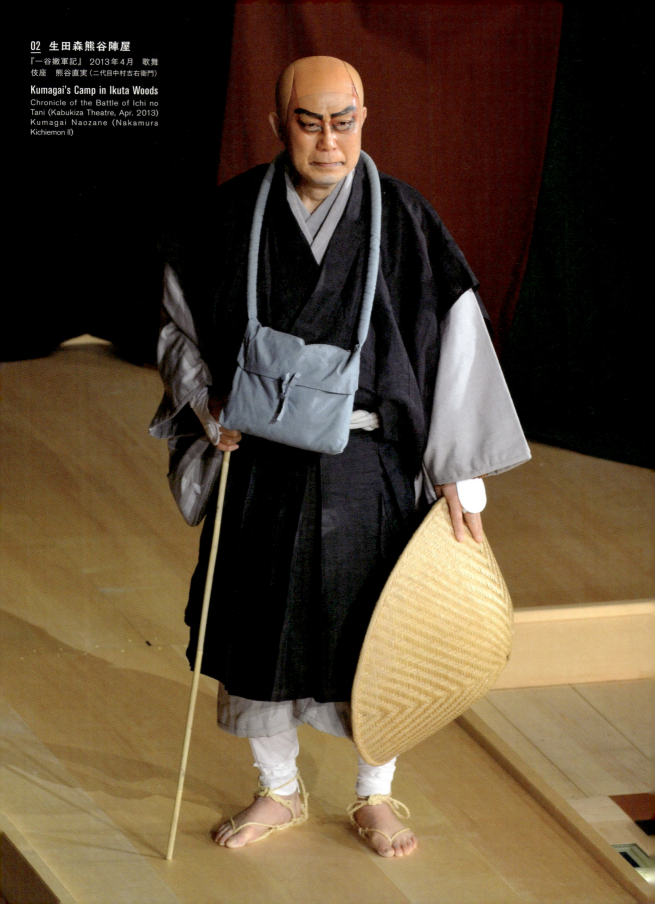

02 生田森熊谷陣屋
『一谷嫩軍記』 2013年4月 歌舞伎座 熊谷直実（二代目中村吉右衛門）

Kumagai's Camp in Ikuta Woods
Chronicle of the Battle of Ichi no Tani (Kabukiza Theatre, Apr. 2013)
Kumagai Naozane (Nakamura Kichiemon II)

作品の概要

演目名

一谷嫩軍記―熊谷陣屋

作者

並木宗輔ほか
（宗輔が三段目まで書いて病没したため、
四段目以降を浅田一鳥らが合作）

概要

宝暦元（1751）年12月　大坂・豊竹座で初演された人形浄瑠璃の作品を歌舞伎に移したもの。原作浄瑠璃の作者は並木宗輔ほか。宗輔が三段目まで書いて病没したため、四段目以降を浅田一鳥らが合作したと伝えられる。歌舞伎では浄瑠璃初演の翌年、宝暦2（1752）年5月に江戸の中村座、森田座の二座で上演されている。

『一谷嫩軍記』全五段のうち、熊谷陣屋は三段目の切に当たる。熊谷次郎が平家の若き公達平敦盛を討ち、無常を感じて出家した挿話はよく知られており、その知られざる裏側をフィクションで描いた。

「熊谷陣屋」に先立つ二段目は、「陣門」「組討」と通称され、歌舞伎でも上演される。

ここでは熊谷が、敦盛（とみせかけた小次郎）を討つ場面である。敦盛が実は小次郎であることは明かされず、続く「熊谷陣屋」で、すべてが明らかになる構成になっている。また、熊谷陣屋の前半は割愛されることが多い。

初演

人形浄瑠璃 ― 宝暦元（1751）年12月　大坂・豊竹座
歌舞伎 ― 宝暦2（1752）年5月　江戸・中村座、江戸・森田座

Overview

Title

Kumagai Jin'ya
— from *Chronicle of the Battle of Ichi no Tani*

Writers

Namiki Sôsuke
(Acts I-III prior to his death,
completed by Asada Iccho and others)

Overview

Originally written for the bunraku puppet theater, this work debuted at the Toyotake-za Theater in Osaka in the December of 1751 and was adapted to kabuki later. The original bunraku play was co-written by Namiki Sosuke. Sosuke wrote the play up to the third act but passed away before finishing. The remaining acts were written by Asada Iccho and others.

Chronicle of the Battle of Ichi no Tani consists of five acts, and the scene "Kumagai Jin'ya" is part of the third act. The historical fact of Kumagai's entering the priesthood in his sadness over killing the young noble Atsumori is well-known, and this scene is a fictional retelling of that story.

Act II, which precedes "Kumagai Jin'ya," contains the two popular scenes called "Jinmon" (the camp gate) and "Kumiuchi" (the dual) which show Atsumori's death at Kumagai's hand. It is not revealed that the man who dies in these scenes is actually Kojiro until the following scene, "Kumagai Jin'ya." The beginning of this scene is often cut when performed.

Premiere

Bunraku: December 1751, Toyotake-za Theatre, Osaka
Kabuki: May 1752, Nakamura-za and Morita-za Theatres, Edo

| 登場人物 | Characters |

熊谷次郎直実
くまがいじろうなおざね

源氏の武将で、史実において若き平敦盛を討った人物としてよく知られている。その史実通り須磨浦で敦盛と一騎打ちで戦い首を討ち取るが、実は身替わりとなった同い年の我が子・小次郎であるという、この作品ならではの飛躍したトリックである。実説の熊谷直実も仏門への思いを強めて出家するが、ここに登場する熊谷も敦盛の命を救いのち仏の道へ入り、自ら手を掛けた我が子を終生弔う。

Kumagai Jiro Naozane
The Minamoto general Kumagai Naozane is a historical figure well-known for killing Taira no Atsumori. In this play, the scene where Kumagai battles with Atsumori and cuts him down is faithfully depicted, but in this fictional retelling it is later shown that the man Kumagai killed was actually his own son. The historical fact that Kumagai enters the Buddhist priesthood is also depicted. However, in this retelling, he has saved Atsumori's life and killed his own son, and it is to mourn that fallen son that he enters the priesthood.

小次郎
こじろう

熊谷次郎直実の子で熊谷小次郎直家、平敦盛も同い年という設定。平家の陣門に一番乗りして初陣を飾るが、間もなく深い疵を負い熊谷に抱えられて逃げてゆく。続いて白馬にまたがった平敦盛が颯爽と現れ駆け抜けてゆく。この敦盛と熊谷が戦い、敦盛は討たれるが実は入れ替わった小次郎、先ほど怪我で逃れた小次郎こそ実は敦盛であるが、そのことは「熊谷陣屋」で明かされる。

Kojiro
Kojiro is the son of Kumagai Jiro Naozane and is the same age as Taira no Atsumori in this play. He proudly rides forth from the Taira camp to his first battle, but is wounded badly and escapes with the help of his father. Soon after, the gallant Taira no Atsumori appears, engages Kumagai in battle, and is killed. However, this Atsumori is actually the previously wounded Kojiro in disguise, a fact only revealed at the end of the "Kumagaya Jin'ya" scene.

藤の方
ふじのかた

宮中で後白河法皇の寵愛を受け、身籠りながらも平経盛に嫁入りし、やがて生まれた子がすなわち平敦盛。その敦盛が熊谷に討たれたと知り、陣屋へやって来て熊谷に斬りかかるが、首実検で義経の前に差し出された首を見れば我が子にあらず。聞けば相模と熊谷が東へ下りその時の子が「(首となった)この敦盛」すなわち小次郎、それまでの相模と藤の方の立場はまさに逆転する。

Fuji no Kata
When she worked in the imperial palace, Fuji no Kata had an illegitimate affair with Emperor Goshirakawa and married Taira no Tsunemori when she became pregnant with Atsumori. When she hears of his death at Kumagai's hand, Fuji no Kata comes to Kumagai's camp to avenge her son, but soon finds that the one who was killed was not actually her son. The moment it is revealed that Kojiro, not Atsumori, has been killed, the positions of Sagami and Fuji no Kata are completely reversed.

平敦盛
たいらのあつもり

平家の若き武将で、熊谷直実との一騎打ちで討ち取られた逸話はよく知られるが、若く美しい姿で潔く、「実は生きていた」という願望の混じった巷説も数多く存在する。本作もそのひとつで、後白河法皇の落胤とされる敦盛を救うべく、熊谷直実の子を身替わりにと義経が暗に命じる。舞台上に登場するのはすべて身替わりの敦盛だが、あくまでも敦盛その人として演じるべきで、見る側も同様である。

Taira no Atsumori
The young Taira General Atsumori is historically known for his death at Kumagai's hand, and there have always been hopeful rumors that the handsome young man had actually survived after the war. This play is a depiction of just such a scenario, showing Yoshitsune secretly instructing Kumagai to kill his own son instead of Atsumori, who is the illegitimate child of ex-Emperor Goshirakawa. The Atsumori who appears throughout this play is actually the imposter Atsumori, but the actor who plays this role is expected to play it as though he is really Atsumori, and the audience should also read his performance as such.

相模
さがみ

熊谷直実の妻。元は宮中に勤め藤の方に仕えていたが、佐竹次郎のちの熊谷直実と恋仲になり、藤の方の恩で落ち延びた過去がある。熊谷の陣屋へは、息子・小次郎の初陣以来心配が募り、訪ね歩くうち来てはならぬと知りながらたどり着いてしまった。ここで初めて熊谷が敦盛を討ったと知るが、討ち取った首を見れば敦盛ではなくまさかの我が子。うろたえるところを熊谷に制される。

Sagami
Sagami is Kumagai Naozane's wife. She previously worked at the palace for Fuji no Kata, who once saved her when she fell in love with Kumagai. When her son Kojiro goes off to his first battled, the deeply worried Sagami makes her way to Kumagai's camp where she finds out about Atsumori's death. When she sees the head Kumagai took is actually their son, she nearly cries out but is stopped by her husband.

源義経
みなもとのよしつね

この物語では源氏の大将・源義経が平敦盛の命を助けるという飛躍した展開になっているが、それは敦盛の母・藤の方が後白河法皇の子を宿し、後に平経盛に嫁いだという経緯による。天皇の血を引く敦盛を助けるため、義経は「一枝を伐らば、一指を剪るべし」という制札の文言で熊谷に「一子」すなわち我が子を斬れと暗に命じる。救った敦盛を、義経は旧恩ある平宗清に託す。

Minamoto no Yoshitsune
In this depiction, Minamoto general Yoshitsune saves Taira no Atsumori's life, knowing that his true father is the former Emperor Goshirakawa. To save Atsumori, who carries imperial blood, Yoshitsune uses a signboard with the words, "He who cuts a branch must also cut his finger." In this message is a double entendre that secretly instructs Kumagai to kill his own son, thus saving Atsumori. Atsumori is left in the hands of Taira no Munekiyo, who saved Yoshitsune and his brother when they were young.

梶原平次景高
かじわらへいじかげたか

源氏方の武将として名高い梶原平三景時の息子。親の梶原平三ともども、芝居にはしばしば登場するが、頼朝の腹心として概ね敵役として登場する場合が多い。「熊谷陣屋」の場では、義経が平家方である敦盛を救うという極めて意外な事実を知り、さっそく鎌倉殿すなわち頼朝の元へ知らせようと勇んで駆けてゆくが、石屋の弥陀六（実は平宗清）が放った石鑿（いしのみ）で殺されてしまう。

Kajiwara Heiji Kagetaka
Son to Kajiwara Heizo Kagetoki, Kagetaka is a well-known Minamoto General. He appears in this play with his father frequently, but as Yoritomo's confidante he is primarily an antagonist. When he hears of the plot to save Atsumori in the "Kumagai Jin'ya scene, he immediately rushes to inform Kamakura and Yoritomo. However, he is killed by a chisel thrown by the stonemason Midaroku (actually Taira no Munekiyo).

弥陀六 実は 弥平兵衛宗清
みだろく じつは やへいびょうえむねきよ

飄々とした石屋の親父・弥陀六は鎌倉に注進する梶原平次を仕留めるが、義経に呼び止められる。義経は眉間のほくろからこの人物が平家の弥平兵衛宗清であることを見破っていた。その昔義経が母の常盤御前に抱かれ、雪の中で凍えていたのを親子四人救ってくれたその恩が懐かしい。しかし宗清は、あの時あの子を助けていなければ今なお平家は滅ぼされず栄えていたものを、と思いを巡らす。

Midaroku / Yahei Hyoe Munekiyo
The son of an easy-going stonemason, Midaroku kills Kajiwara Kagetaka as he rushes to Kamakura. He is then called out by Yoshitsune, who has realized that he is actually Munekiyo of the Taira clan. Munekiyo had saved Yoshitsune and his family when they were young and stranded in the freezing snow. Yoshitsune is still deeply indebted to Munekiyo, but Munekiyo laments the fact that he saved them, realizing that if he had not, the Taira clan may not have fallen.

みどころ
Highlights

1. 熊谷次郎直実の衣裳
—— Kumagai Jiro Naozane's Costume

熊谷が陣屋に戻ってくる、最初の出の衣裳。茶地織物の着物に、紺木綿に亀甲を刺繍した袴姿である。團十郎型の熊谷は一幕で三度衣裳を替える。次は首実検に臨む長裃、最後は鎧の下に墨染めの衣を着て出る。

This is the first costume Kumagai wears when he brings a bucket containing the head of Atsumori back to his encampment. The kimono is brown, and the ceremonial *kamishimo* robes are made of navy cotton adorned with embroidered turtle shells. Kumagai changes costumes three times in the first act. After this costume, Kumagai wears a long ceremonial *kamishimo* when surveying the decapitated head, and finally he changes into black robes worn under his armor.

2. 桜を切るな！の謎かけ
—— The Hidden Message

須磨寺に見事な桜の木があった。義経は傍に「一枝を伐らば、一指を剪るべし」という立て札を立てたという。桜を一枝伐る者は、指一本切り落とすぞという戒めだ。幕開きにはこれを読んで怖がる人々が出てくる。しかし、これには実は、義経から熊谷に向けた謎かけが隠されている。一枝＝一子、一指＝一子。音の同じ「一子」と読めば、「一子を斬るなら、一子を斬れ」となる。これを読んだ熊谷がどうしたか、それが重要ポイントだ。

Yoshitsune is said to have erected a signboard next to the beautiful cherry tree in Kuma-dera Temple. The sign read, "He who cuts a branch must also cut his finger," a warning to anyone who would dare to cut a branch from this splendid tree. As the curtain is drawn, you see a number of people cowering as the warning is read, but there is actually a hidden meaning behind this message that is meant for Kumagai. Yoshitsune uses a play on the words "branch," "child," and "finger" to send this hidden message: "If a child is to be killed, you must kill a child." Kumagai's response to this cryptic message is vital to the plot of "Kumagai Jin'ya."

3. 並木宗輔の絶筆 —— Namiki Sosuke's Final Work

「実は生きていた」という設定には身替わりの悲劇がほぼセットになっている。名高い物語の世界を借り、江戸時代の作者たちは「実は〜」の趣向を使って、古い英雄の悲劇を庶民の胸に迫るドラマに置き換えた。それらは現在の観客にも見応えがあり、歌舞伎の人気作品としてたびたび上演されている。作者並木宗輔は歌舞伎三大名作すべてに作者として名を連ねているが、この「熊谷陣屋」を書いた直後に世を去った。即ち、これが絶筆である。

It is very common in Kabuki plays for historical characters to actually be alive past their supposed death. Such plays always end in an alternate tragedy that is just as moving to audiences. Playwrights of the Edo period were particularly fond of these "what if?" stories, giving the heroes of yesterday a new stage on which to move audiences. Namiki Sosuke is one such playwright who is known to have helped write the three greatest works of kabuki, but he passed away after writing "Kumagai Jin'ya," his final work.

4. 『平家物語』の敦盛最期 —— Atsumori's Death in Tale of the Heike

『平家物語』敦盛最期の記述によれば、平敦盛は笛の名手であったという。義経に追い立てられた平家軍が船で沖へ退却するが、無官太夫敦盛は乗り遅れて渚に駒を走らせていたところ、熊谷次郎直実に組み敷かれる。だが熊谷は、敦盛の顔を見て自分の子と同年輩の美しい若者なのを見てはげしく動揺する。「疾く疾く首を取れ」との敦盛の言葉に、遂にその首を切り落としたが、熊谷は無常を感じて発心し戦場を離脱してしまう。

According to *The Tale of the Heike*, Taira no Atsumori was a talented flutist. When Yoshitsune drove the Taira army to the sea, Atsumori was too late to board his clan's ship and was eventually caught by Kumagai. Kumagai, however, was hesitant kill him since Atsumori was the same age as his own son. Atsumori is said to have met his death bravely with the words, "hurry and kill me." Kumagai killed Atsumori, but left the battlefield after this deeply disturbing battle.

5. 鎧櫃のひみつ —— The Secret of the Armor Case

「熊谷陣屋」の舞台に敦盛は登場しない。母藤の方が形見の笛を吹くと、障子に敦盛の幻が浮かぶのみ。敦盛として桶に収まったのは小次郎の首。義経が、平家の供養塔を建てるという石屋の弥陀六に鎧櫃を預け、中に敦盛がいることを示唆するが、鎧櫃の中は客席からは見えない。助けられた敦盛はどうなるのか、ミステリアスなまま幕は閉じられ、「熊谷陣屋」の後の敦盛は描かれない。敦盛は歴史と創作をつなぐカギの役割である。

Atsumori himself does not appear in "Kumagai Jin'ya." Only his shadow is shown behind the shoji doors when his mother Fuji no Kata plays his flute. As is later revealed, Atsumori was saved and Kojiro killed in his place. Yoshitsune gives the armor case in which he has hidden Atsumori to Midaroku, who is erecting a memorial to the fallen Taira clan. The audience is unable to see inside the case, however, and the curtain falls before we can know what happens to Atsumori. He is a key piece of history and a role that unifies the plot, yet what happens to him after this fateful scene is unknown.

6. 團十郎型と芝翫型 —— Danjuro-gata and Shikan-gata

熊谷の演出には、團十郎型と芝翫（しかん）型がある。團十郎型は七代目團十郎と九代目團十郎の工夫が伝えられたもので、幕外での花道の引っ込みが大きな特徴である。僧になった熊谷が、悲しみ無常を際立たせる演出である。芝翫型は、幕末から明治にかけての名優四世中村芝翫が創意工夫した型で、原作の人形浄瑠璃に近い古風な味わいが特徴。衣裳から見得の形や演出、また、幕外の引っ込みがないなどの違いがある。両方の型を見比べ、味わうのも歌舞伎の楽しみの一つ。

"Kumagai Jin'ya" has two styles of performance: Danjuro-gata and Shikan-gata. Danjuro-gata refers to the tradition of Danjuro VII and IX, and features a dramatic exit on the hanamachi at the end of the play—that of Kumagai, now a Buddhist monk lamenting the fleeting nature of this world. Shikan-gata is an older style of performance closer to the original bunraku puppet play. Some key differences from the danjuro-gata version are changes to costumes and mie poses as well as performance styles. Furthermore, the dramatic exit at the end of the play is notably missing. These different styles of production and performance allow theater-goers to see and compare the different versions of kabuki plays.

7. 首実検 —— Inspection of the Head

いくさで討ち取った敵の首が本物か、顔を実際に見て確認すること。味方の大将に見せ、恩賞を得る。大将は軍扇をかざし、すきまから実検するのが作法だった。歌舞伎では、これが山場になることが多い。熊谷直実が主君義経に向け、敦盛の首実検を願う。しかしそれは敦盛ではなく、熊谷の子小次郎の首。義経はそれを見て微笑み、敦盛の母はおどろき、熊谷の妻相模は呆然とする。その一瞬に悲劇の当事者が入れ替わるのである。

It was common practice for officials to take the heads of high-ranking enemies and inspect the face to make sure of their identities. Showing an enemy head to your general would often earn you a reward. It was common practice for the general to spread out his official fan and inspect the head through the crevices between the fan blades. This inspection is often an important turning point in kabuki plays. In "Kumagai Jin'ya," for example, Kumagai shows Atsumori's head to his master Yoshitsune in a scene that reveals that he sacrificed his own son Kojiro to save Atsumori. In this moment, the victims of the tragedy are completely reversed. Yoshitsune smiles in approval, Atsumori's mother is pleasantly surprised, and Kumgai's wife is shocked.

8. 同い年の敦盛と小次郎 —— Atsumori and Kojiro

『一谷嫩軍記』の熊谷は義経の命を受けて敦盛を殺さず、身替わりに同い年の息子の首を取って出家する道を選んだ。たったひとりの息子を亡くせば、家名は途絶える。職務を果たしたが、熊谷にとっては、もはや家を伝える意味がなくなってしまっていたのだ。敦盛も小次郎も同い年の16歳。しかも母親たちはその昔の主従。「嫩軍記」は、芳しい嫩（ふたば）のように芽吹いたばかりの16歳の二人のうち、片方が欠ける物語である。

In *Chronicle of the Battle of Ichi no Tani*, Kumagai kills his own son in place of Atsumori under Yoshitsune's orders. With the death of his only son, Kumagai's house thus ends with him. He executes his duty, but loses purpose in life due to the end of his family. Atsumori and Kojiro are both 16 in this play, and their mothers were once master and servant. This is the tragic story of two budding young men, one of whom must die so that the other can live.

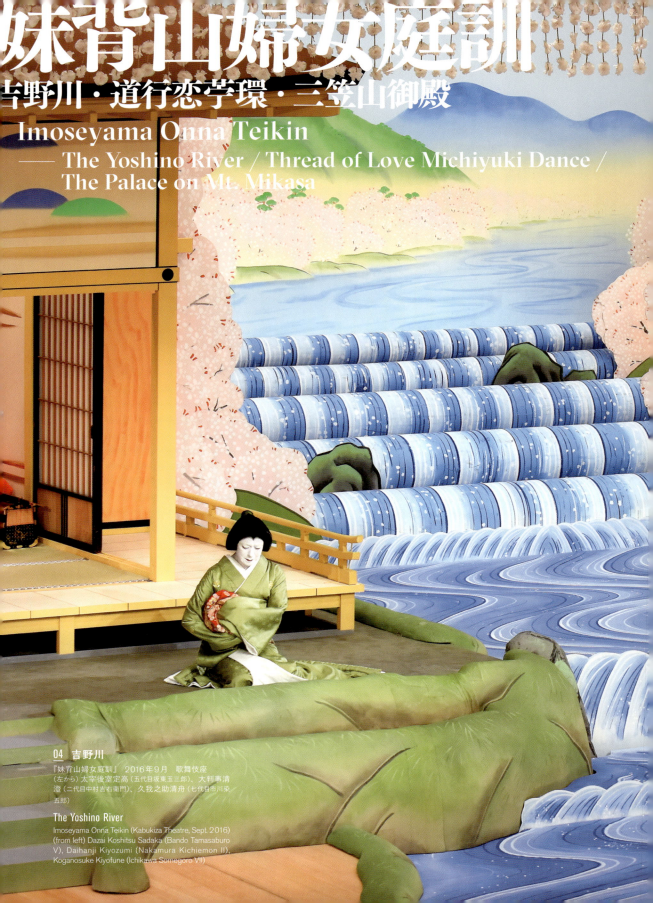

妹背山婦女庭訓
吉野川・道行恋苧環・三笠山御殿

Imoseyama Onna Teikin
—— The Yoshino River / Thread of Love Michiyuki Dance / The Palace on Mt. Mikasa

04　吉野川

『妹背山婦女庭訓』　2016年9月　歌舞伎座
(左から) 太宰後室定高 (五代目坂東玉三郎)、大判事清澄 (二代目中村吉右衛門)、久我之助清舟 (七代目市川染五郎)

The Yoshino River
Imoseyama Onna Teikin (Kabukiza Theatre, Sept. 2016)
(from left) Dazai Koshitsu Sadaka (Bando Tamasaburo V), Daihanji Kiyozumi (Nakamura Kichiemon II), Koganosuke Kiyofune (Ichikawa Somegoro VII)

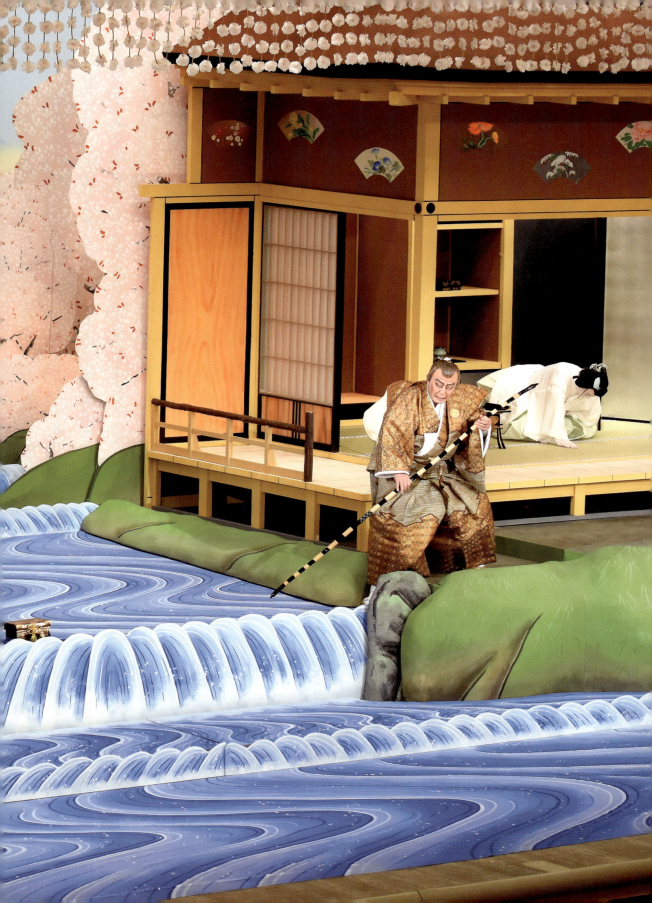

あらすじ　　　　　　　　　　　　Synopsis

翻弄され踏みにじられても恋を貫く女たち。
古代を舞台にした、ファンタジック巨編

親同士が不仲の二人が恋をした……。
その二人を押しつぶそうとする謀反人入鹿。親たちが下した決断と恋の結末。（吉野川）
超人的な謀反人入鹿に対抗するために必要な二つのアイテム。
その一つは嫉妬に燃える女の生血……。（三笠山御殿）

── The undying love of a woman trampled and ridiculed. A truly fantastic tale set in ancient Japan.

A man and woman from feuding families who fall in love, and the man who tries to destroy them… Their parents face a painful decision that may spell the end of this romance. ("Yoshino River")

Two things are necessary to defy the superhuman Iruka who plots against the lovers. The first is the blood of a woman consumed by jealousy… ("The Palace on Mt. Mikasa")

01　この場にいたるまで

　蘇我入鹿は、盲目の天智天皇の隙をうかがい宮中に乗り込み、みずから帝と名乗っている。
　入鹿は父蝦夷が白い牡鹿の血を妻に飲ませて産ませたので超人的な力を持っていた。しかし「爪黒の鹿の血汐」と「疑着の相（ぎちゃくのそう＝嫉妬の形相）の女の生血」を注ぎかけた横笛の音を聞くと、正体をなくし力が弱まる。それゆえ、入鹿に対抗する藤原鎌足と淡海の親子はその二つを探し、「爪黒の鹿の血」を手にいれることができた。

吉野川を中心としたあらすじ

02　春日野小松原

　紀伊国の領主大判事清澄と大和国の太宰少弐の家は領地争いで対立し、長いこと敵同然の家柄であった。

　奈良の小松原で太宰の娘雛鳥と、大判事の息子久我之助清舟が恋仲となる。入鹿の家臣宮越玄蕃に見つけられ、その

01　The Story So Far…

　Soga no Iruka has seized control from the blind Emperor Tenchi. Iruka possesses superhuman strength, having been born when his father Emiji forced his wife to drink the blood of a white buck. However, the blood of a sacred deer and that of a jealous woman can help weaken him. Fujiwara Kamatari and Tankai search for these two substances and eventually succeed in obtaining the deer's blood.

Synopsis of the "Yoshinogawa River" section

02　Komatsubara Plain

　Daihanji Kiyozumi and Dazai Shoni are lords of the Kii Province and the Yamato Province, respectively, and their families have feuded over land for many years.

　One day on the Komatsubara Plain in Nara, Dazai's daughter Hinadori and Daihanji's son Koganosuke meet and fall in love. Iruka's retainer happens to have witnessed their meeting and tells the two that they are from feuding families, causing the two lovers to lament their misfortune.

言葉からお互いが不和の家の子と知り、嘆き悲しむ。

　また、久我之助は帝の寵愛を受ける采女の局が身を守るため宮中から脱出するのを手伝う。

03　太宰館花渡し

　大和の太宰少弐の館。さきごろ少弐が亡くなり、家は妻の定高が守っている。そこに入鹿が訪れ、大判事も呼び出された。

　入鹿は横恋慕する采女の行方を捜しており、付け人であった久我之助が知っているだろうと詰問する。さらに、久我之助と雛鳥が恋仲なのは、実は手を結び、反旗を翻そうとしているのではないかと疑う。

　入鹿は定高に娘の雛鳥を妃に差し出すように命じ、大判事には久我之助を臣下として仕えさせよと命じる。拒否した時は二人の命はない。大判事・定高が各々の子を容赦すれば家を取り潰し、一族を絶やすと脅す。

04　吉野川

　紀伊国の背山と、大和国の妹山は、吉野川を挟んで並びそびえている。季節は春。全山が桜に覆われている。

　妹山には太宰の下館(別荘)があり、雛鳥が養生に来ている。吉野川を挟んだ対岸の背山には久我之助が謹慎している。雛鳥は久我之助が背山にいると聞きつけ、母に頼んで妹山に養生に来ているのだ。桃の節句とて、妹山には雛人形が美しく飾られている。

　雛鳥は久我之助の姿を認めるが、当初久我之助は気づかない。やがて二人は川を隔てて対面をする。お互いに手を差し伸べ、心ばかりで抱きあう二人。そこへそれぞれの親の来訪が告げられる。

　吉野川の堤では、大判事と後室定高が川越しに言葉を交わす。入鹿の命に従わなければ子の命はない。それぞれの子が入鹿の命令に従う場合は、手にした桜の花を散らさずに川に流し、従わぬ時は花を散らせ、枝ばかり流すことを申し合わせる。

　館についた定高は、雛鳥に入鹿へ嫁入りするよう説得する。久我之助と縁を切り、入鹿に従えば久我之助の命が助かる、それがまことの貞女。久我之助を助けるために、という定高の言葉に雛鳥は入内を承知する。

　一方、背山の大判事は久我之助の切腹を許す。臣下として仕えよとは入鹿の甘言で、采女詮議のために拷問にかけられ

Afterward, The Emperor's mistress Uneme appears, whom Koganosuke helps escape the palace.

03　Flowers at the Dazai Residence

　At the Dazai Residence, the master Shoni has just passed away, leaving his wife Sadaka to protect the house. Iruka visits the house and summons Daihanji there as well.

　Iruka is actually searching for the Emperor's mistress Uneme, and has come to question Koganosuke who is thought to have assisted her. He also claims that Koganosuke and Hinadori's affair may be part of an attempt to seize power.

　Iruka demands that Sadaka to send Hinadori to the palace to be his wife, and that Daihanji hand Koganosuke over to be his servant. If they refuse, he says he will have the young lovers executed, and that he will go as far as to crush both houses completely should they allow the two to continue with their affair.

04　The Yoshino River

　The Yoshino River runs between Mt. Se in Kii Province and Mt. Imo in Yamato Province. It is spring, and the mountains are covered in stunning cherry blossoms.

　Daihanji has a villa on Mt. Se by the river where Koganosuke has been confined. Hearing of this, Hinadori has asked her mother to let her take rest at the Dazai Villa on Mt. Imo, just across the river from the Dazai Villa. Mt. Imo is decorated with beautiful dolls for Girl's Day.

　Hinadori sees Koganosuke, but he does not notice her at first. When he does, the two stand on either side of the river, reaching their hands out, unable to embrace each other. At this time, it is announced that Daihanji and Sadaka have arrived at their respective villas.

　Daihanji and Sadaka speak to each other across the river. The discuss how their children will die if they do not obey Iruka's order. They agree on a sign to indicate their respective choices: send a branch with cherry blossoms still attached if they choose to obey, and a barren branch should they choose to disobey.

　Sadaka urges Hinadori to marry Iruka, saying that it is the right thing to do since cutting her ties to Koganosuke will save his life. Finally, Hinadori agrees to wed Iruka in order to save Koganosuke's life.

　On the other side of the river, Daihanji agrees to let Koganosuke commit seppuku, knowing that Iruka only intends to torture him for information on Uneme. Although he says that his son's life is a small price to pay for the sake of the country (since they will be saving Uneme, the Emperor's consort), he is deeply pained to have to assist in his own son's suicide.

　Meanwhile on Mt. Imo, Sadaka realizes that Hinadori

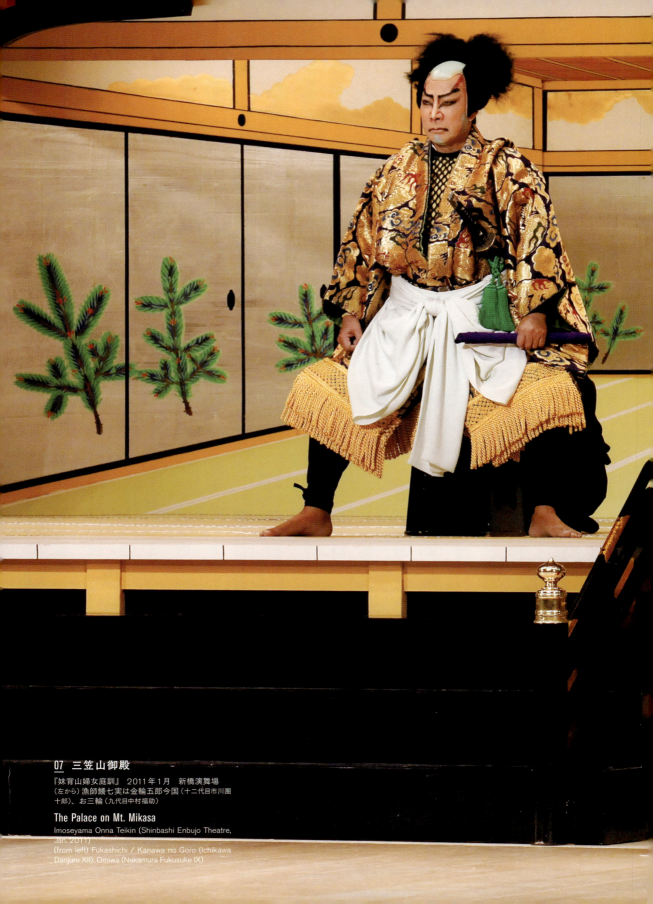

07 三笠山御殿
『妹背山婦女庭訓』 2011年1月 新橋演舞場
（左から）漁師鱶七実は金輪五郎今国（十二代目市川團十郎）、お三輪（九代目中村福助）

The Palace on Mt. Mikasa
Imoseyama Onna Teikin (Shinbashi Enbujo Theatre, Jan. 2011)
(from left) Fukashichi / Kanawa no Goro (Ichikawa Danjuro XII), Omiwa (Nakamura Fukusuke IX)

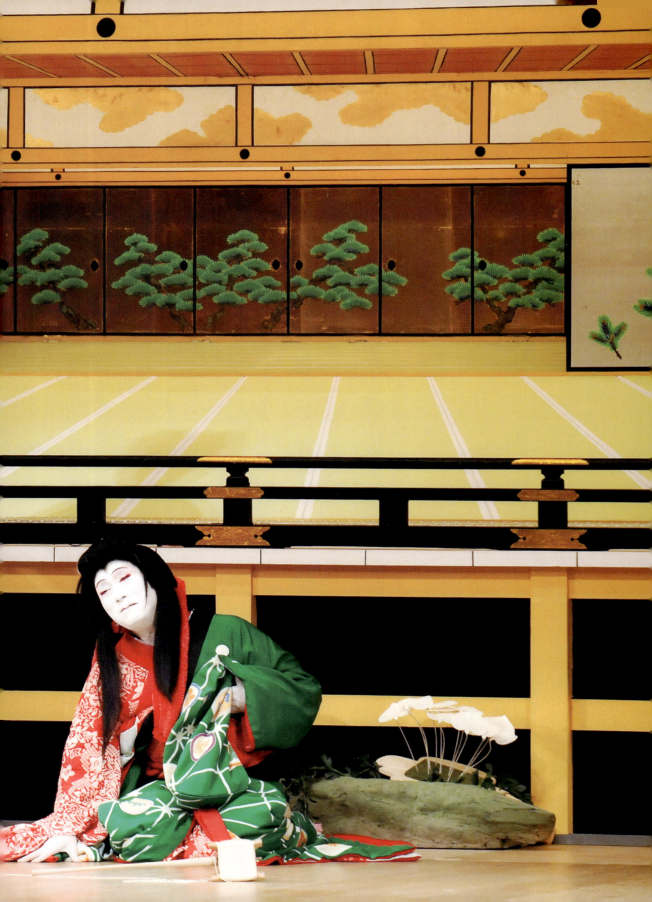

るのは必定。それならばここで切腹したほうが天下のためになる。天下のためには我が子の命など惜しくはない、と口では言いながらも、我が刀で我が子の介錯を行うことになるとは、と苦衷を吐露する大判事であった。

妹山では、雛鳥が久我之助と添い遂げられぬ思いを女雛に打ち付ける。人形の首が落ちたのを見た定高は、実はこのように首を切るつもりだったと本心を明かす。

刀を身に突き立てた久我之助は、雛鳥が後を追わぬように、大判事に花のついた枝を流すように頼む。流れる花を見た雛鳥は久我之助が生きていることを喜び、母の前に首を差し出す。定高も花の枝を川へ投げ入れ、刀を振りおろす。

大判事と久我之助も、妹山から桜が流れるのを見て安心するが、谷に響く定高の嘆きの声に、雛鳥が死んだことを悟る。定高も瀬死の久我之助の姿を見つける。せめて相手の子ども一人は助けたいと願ったが、それも叶わなかった。

悲しみのなか、定高は久我之助の生きているうちに娘の首を送り対面させたい、それがせめての嫁入りと大判事に声を掛ける。そして雛道具に雛鳥の首を乗せ川に浮かべる。首を受け取る大判事。いまや両家のわだかまりは解けた。大判事は雛鳥の首と久我之助を対面させ、忠義に死した久我之助と、恋を貫いた雛鳥の操をたたえるのであった。

道行恋苧環・三笠山御殿を中心としたあらすじ

05　杉酒屋

大和国にある三輪の里。杉酒屋の娘お三輪は隣家へ越してきた烏帽子折の園原求女と恋仲になった。七夕の夜、お三輪は星に供えた紅白の苧環（おだまき）の、赤い糸の苧環を求女に渡し、白い糸の苧環を自ら持ち、いつまでも変わらぬ思いを誓った。ところがその求女のもとに姫が通ってきており、姫の後を追う求女の後をお三輪も追っていく。

06　道行恋苧環

布留の社で二人に追いつき、姫とお三輪の恋する女同士の口争いがはじまる。夜明も近くなり帰宅を急ぐ姫の袖に、求女は苧環の赤い糸の端をつける。それを見たお三輪は求女の裾に白い糸をつける。

07　三笠山御殿

入鹿が三笠山に新たに建てた壮麗な御殿。入鹿が家臣たちと酒宴を催していると、藤原鎌足の使いとして、無骨で言

intends to end her own life when she knocks the head off a doll in anger at not being able to marry Koganosuke.

Before he dies, Koganosuke asks Daihanji to send a branch with cherry blossoms on it down the river to keep Hinadori from taking her life too, since this would signify that he is still alive. Hinadori, who is resolved to die anyway, is nonetheless happy to hear that Koganosuke is alive. Sadaka also sends a branch with flowers down the river, and proceeds to cut off Hinadori's head.

Daihanji and Koganosuke are also relieved to see the cherry blossoms flowing down the river, but realize Hinadori is actually dead when they hear Sadaka's anguished voice echoing through the canyon. Sadaka also sees Koganosuke on the brink of death, and realizes that neither house's children could be saved in the end.

Deeply anguished, Sadaka decides to send Hinadori's head to Koganosuke while he is still alive. Saying this can be a type of wedding before Koganosuke dies, she sends Hinadori's head across the river on a doll display stand. Daihanji receives the head and says that the enmity between the two houses has dissipated. Allowing Hinadori and Koganosuke to meet one last time, he praises Koganosuke's loyalty and Hinadori's undying love.

Thread of Love Michiyuki Dance / The Palace on Mt. Mikasa

05　Sugizakaya

Omiwa, daughter of Sugizakaya proprietor, has fallen in love with Sonohara Motome, who has moved to a neighboring house. On the night of Tanabata, Omiwa gives Motome a spool of red thread, keeping the white spool that is its compliment and swearing undying love. However, a princess dances onto the stage and comes to Motome. When the princess leaves, Motome follows after her, and Omiwa follows Motome. ("Sugizakaya")

06　Thread of Love Michiyuki Dance

The two women vying for Motome's love arrive at Furu Shrine, where they begin to argue. Soon the sun sets and the princess must rush home. As she leaves, Motome attaches the red thread from his spool to her. Seeing this, Omiwa attaches her own white thread to the hem of Motome's trousers.

07　The Palace on Mt. Mikasa

As Iruka is holding a banquet at his newly-built palace on Mt. Mikasa, a boorish fisherman named Fukashichi arrives. He is Fujiwara Kamatari's messenger who has brought *sake* as a gift from Kamatari. The bold Fukashichi ends up arguing with Iruka and drinking the *sake* that was supposed to be a gift. Off-put by this, Iruka retreats to a back

葉遣いも荒々しい鱶七という漁師がやってくる。鱶七は臆することなく入鹿に対峙し、鎌足から入鹿への手土産だったはずの酒を飲み干すなど、傍若無人にふるまう。気分を害した入鹿は奥へ引っ込むとともに、鱶七をひそかに討つよう命ずる。しかし、様々な暗殺の手をかわした鱶七は、豪胆にも床から突き出された槍の穂先を枕に寝入ってしまう。

御殿に先ほどの姫が戻ってくる。実は彼女は入鹿の妹橘姫。次いで求女も糸をたどってやってくる。求女も実は藤原淡海。淡海は、橘姫に入鹿が盗み取った宝剣の奪還を依頼し、姫は恋と天下のためにそれを承諾する。

やがて御殿にお三輪がたどりついた。お三輪を見かけた官女たちは、姫の恋敵と勘づき、大勢でお三輪を取り囲む。求女に会わせると親切ごかしに言いながら、馬子歌を歌わせたりして散々にいじめぬく。

だまされたと知ったお三輪が帰ろうとした時に、奥から求女と橘姫の祝言を祝う声がする。嫉妬に燃え上がったお三輪は、姿も荒々しく奥へ駆け入ろうとする。そのお三輪に鱶七が刃を突き立てた。彼は実は鎌足の家来金輪五郎。入鹿を倒すために必要な、疑着の相の女の生血を探していたのだ。

恋しい求女が実は藤原淡海であり、お三輪の犠牲は求女（淡海）のためになると聞かされ、お三輪は未来で結ばれることを願い、苧環を抱きしめながら息絶える。

room, instructing his servants to kill Fukashichi secretly. Fukashichi, who has seen his fair share of assassination attempts, pays no mind to the spears that strike through the floor beneath him and falls asleep.

The princess has just returned to the palace, and it is revealed that she is in fact Iruka's sister, Princess Tachibana. Motome is also revealed to be none other than Fujiwara Tankai, who has asked the princess to steal back the sacred sword which Iruka has stolen. For the sake of love and country, Princess Tachibana has agreed to do this.

Omiwa finally arrives at the palace, only to be confronted by Tachibana's servants. Knowing Omiwa is Tachibana's rival, these women torment Omiwa, saying they will let her meet with Motome if she sings songs for them.

Omiwa is about to leave, realizing the court ladies have tricked her, but she suddenly hears the voices of Motome and Tachibana who have just been wed. Filled with jealousy, Omiwa violently tries to force her way into the inner palace. Fukashichi appears then and stabs Omiwa. He is actually Kamatari's retainer Kanawa Goro in disguise, who has been searching for the blood of a jealous woman to defeat Iruka with.

Her death being in the service of the man she loves (Tankai/Motome), Omiwa dies clinging to her spool and praying that they may be together in a future life.

作品の概要 / Overview

演目名 / Title

妹背山婦女庭訓
――吉野川・道行恋苧環・三笠山御殿

Imoseyama Onna Teikin
― The Yoshino River / Thread of Love Michiyuki Dance / The Palace on Mt. Mikasa

作者 / Writers

近松半二、松田ばく、栄善平、
近松東南、三好松洛（後見）

Chikamatsu Hanji, Matsuda Baku, Sakai Zenpei, Chikamatsu Tonan, Miyoshi Shoraku

概要 / Overview

明和 8（1771）年 1 月　大坂・竹本座で初演された人形浄瑠璃の作品を歌舞伎に移したもの。原作浄瑠璃の作者は近松半二、松田ばく、栄善平、近松東南、三好松洛（後見）。歌舞伎では浄瑠璃初演の年、明和 8（1771）年 8 月　大坂・中の芝居で上演されている。

大化の改新を題材としているが、役名やあらすじをみてもわかる通り、史実からはかなり離れた脚色をしている。

原作は全五段。国立劇場の試みを除き、近年歌舞伎での通し上演はほとんどない。原作の三段目にあたる「吉野川」、四段目にあたる「道行恋苧環」「三笠山御殿」が独立して上演されている。「吉野川」にいたるまでの、「小松原」「花渡し」は国立劇場での復活後、時折上演されることがある。また、「道行恋苧環」「三笠山御殿」の前に、あまり上演されない「杉酒屋」と呼ばれる場面がある。あらすじではこれらの内容も含んでいる。

「吉野川」は歌舞伎でも大曲中の大曲として知られている。舞台装置も仮花道を設置し、吉野川の堤に見立て、客席を挟んで大判事と定高が言葉を交わす場面などは歌舞伎ならではの名場面である。

Imoseyama Onna Teikin was first performed for the puppet theater in January of 1771 at Takemoto-za Theater, Osaka. The original bunraku play was written by Chikamatsu Hanji, Matsuda Baku, Ei Zenbei, Chikamatsu Tonan, and Miyoshi Shoraku. The play made its kabuki debut in August of 1771 at the Naka no Shibai Theater in Osaka.

Though based on the Taika Reforms, this fictionalized account takes many liberties, as you may be able to tell from the synopsis.

Originally a five-act play, *Imoseyama* is rarely performed in its entirety. "Yoshino River" from Act III and the two scenes "Thread of Love Michiyuki" and "The Palace on Mt. Mikasa" from Act IV are usually played together. The scenes "Komatsu Plain" and "Flowers" which lead up to "Yoshino River" were revived at the national theater and are now performed once in a while. The "Sugi Sake Shop" scene leading up to the "Michiyuki" scene is not often played, but we included it in the synopsis.

"The Yoshino River" is a hugely popular scene that is widely known in the kabuki community. The special hanamichi constructed for this piece allow Daihanji and Sadaka to speak to each other over the audience, drawing the audience into the performance as the Yoshino River. It's an experience truly unique to the kabuki theater.

初演 / Premiere

人形浄瑠璃 ― 明和 8（1771）年 1 月　大坂・竹本座
歌舞伎 ― 明和 8（1771）年 8 月　大坂・中の芝居

Bunraku: January 1771, Takemoto-za Theatre, Osaka
Kabuki: August 1771, Naka no Shibai Theatrre, Osaka

登場人物 / Characters

蘇我入鹿
そがのいるか

史実において飛鳥時代の最高権力者だが、歌舞伎の作品上でも身分の高い巨悪で「公家悪」と呼ばれる役柄が常套である。父の蘇我蝦夷（そがのえみし）を切腹に追いやってまで天下を取ろうと企んだ悪人だが、その出生の秘密から「爪黒の鹿の血汐」と「疑着（ぎちゃく）の相の女の生血」を混ぜて鹿笛を吹くと成敗されてしまうという。藤原鎌足はそれを手に入れて入鹿を討とうとする。

Soga no Iruka
The historical Soga no Iruka was the ruler during the Asuka period of Japan, and in this dramatization is also a very high-ranking statesman. His role as the supreme villain is an example of the *kugeaku* (aristocratic villain) role in kabuki. Having led his father to commit seppuku to gain power, he is a formidable villain, but the secret of his birth gives hint to how to defeat him. The blood of a sacred deer and that of a jealous woman must be mixed together and a special flute played to weaken him.

大判事清澄
だいはんじきよずみ

吉野川を望む紀伊国背山を所領としている大判事家は、川を挟んだ向かい側の大和国妹山の太宰家とその境界を巡って争いを続けている。しかしその息子と娘が恋仲となり、やがて悲劇へとつながる。蘇我入鹿は横恋慕する采女（うねめ）の局の行方を大判事が知っていると疑い、そうでないなら証しとして息子の久我之助を自分に仕えさせよと命じるが表向き、その命は危ない。

Daihanji Kiyozumi
Daihanji Kiyozumi is the ruler of Kii Province who desires control of Yoshino River. Since the river is on the border between Kii and Yamato, there is an ongoing border dispute between the Daihanji and Dazai families. His son falls in love with the daughter of the Dazai leader, a romance that ends in tragedy. Iruka, suspecting that Daihanji knows about Imperial Consort Uneme's whereabouts, manipulates the situation to force Koganosuke into his service. This, of course, is a trap that puts Koganosuke's very life in danger.

雛鳥
ひなどり

定高の娘・雛鳥はある日、凛々しい久我之助と出会い恋仲となるが、互いの家は向かい合わせながら親同士が永年争いを続けている不和の間柄、逢うことも叶わず苦悩している。ある日、母の定高が雛鳥を入鹿の元へ入内という厳命を受けたが、いっそのこと死んで久我之助に添おうと母娘ともども決断する。そしてせめて久我之助には無事に生きてもらおうと願うのである。

Hinadori
Sadaka's daughter, Hinadori falls in love with the dashing Koganosuke. Despite their houses being so close, the dispute of their parents prevents the two from meeting. When Iruka demands Hinadori's hand in marriage, mother and daughter both determine that Hinadori should commit suicide, allowing for Koganosuke to be saved.

藤原鎌足
ふじわらのかまたり

歴史上でも大化の改新で名高く、権力を誇っていた蘇我入鹿を討った事実もよく知られている。蘇我入鹿を討ち取るため腹心の家来に命じて二様の血を探し求めるが、猟師芝六実は玄上太郎、もう一人は漁師鱶七実は金輪五郎、ここで山と海を対比させているのも作品の趣向である。現在上演される劇中に登場することは少なく、舞台上には主に息子の藤原淡海が登場する。

Fujiwara no Kamatari
Fujiwara no Kamatari actually played an important role in the historical Taika Reforms: he is the one who killed Soga no Iruka. In the play he commands two servants to search for the blood needed to defeat Iruka. One disguises himself as a hunter and the other as a fisherman, playing into the symbolism of land and sea which is a special feature of the play. Katamari is not often portrayed in modern performances, but his son Fujiwara no Tankai often appears on stage.

太宰後室定高
だざいこうしつ さだか

大判事家と吉野川を挟んだ妹山には定高が住んでいるが、亡き夫・太宰少弐（だざいのしょうに）の後を継いでこの地を守っている。蘇我入鹿は大判事家と太宰家が表向き不和と見せかけて、実は馴れ合って采女の局を隠しているのではないかと疑い、太宰家にはその疑いを晴らす証しとして娘の雛鳥を入鹿の元へ入内させよという難題を突き付けている。両家の親は沈痛である。

Dazai Koshitsu Sadaka
Dazai Sadaka lives on Mt. Imo on the opposite side of the river from the Daihanji villa, and is charged with the protection of their domain after her husband's death. Accusing her family of conspiring with Daihanji to hide Uneme, Iruka claims that their feud is a fraud and demands that Sadaka give her daughter Hinadori to him to wed as proof that his suspicions false.

久我之助清舟
こがのすけきよふね

大判事清澄の息子。恋しい人と川を挟んで逢うことの叶わぬ辛さは雛鳥と同様。親の不和ばかりでなく蘇我入鹿の勢いは凄まじく、近隣といえども徒党の企てと疑われると嘆き、挟んだ川は互いの関所。大判事が久我之助の出仕という入鹿の厳命を受けてくるが、おそらくそれは表向きで厳しい詮議の上殺されるのも必定。すでに自害の覚悟はできているが恋しい雛鳥を気遣い、やがて二人はあの世で結ばれる。

Koganosuke
Daihanji Kiyozumi's son, Koganosuke is kept from meeting his love, Hanadori, by the river which symbolizes the feud between their families. This is the least of their worries, however, as Iruka accuses their families of conspiring together under the guise of a feud. When Iruka demands that Koganosuke serve him, both father and son realize that this is a trick to extract information from him. He will likely die at Iruka's hand anyway, so Koganosuke determined to kill himself, but longs for his love. In the end, Koganosuke and Hanadori are brought together in death.

杉酒屋お三輪
すぎざかや おみわ

杉酒屋の娘・お三輪は可憐な田舎娘。烏帽子折求女という見目麗しい男に恋をするが、その姿を追ってやってきたのは立派な御殿、実は蘇我入鹿の館である。求女の行方を尋ねれば、姫の許婚で今日はここで祝言と聞かされ、激しい嫉妬心が燃え上がる。そこに現れた鱶七にお三輪は刺されてしまうが、嫉妬心が高じた疑着の相の女の生血が入鹿成敗に役立ち、恋しい求女（実は藤原淡海）を助ける。

Sugizakaya Omiwa
Omiwa, a charming country girl, is the daughter of Sugi Sake Shop's proprieter. She falls in love with the handsome Eboshiori Motome, but he is whisked off to Iruka's palace. When he hears that she is to marry the princess of that palace, Omiwa is consumed by jealousy. Fukashichi, who needs the blood of a jealous woman to fight Iruka, kills her, which eventually saves Motome (who is actually Fujiwara Tankai).

橘姫
たちばなひめ

蘇我入鹿の妹。烏帽子折求女（実は藤原淡海）とはつい素性を知らぬまま恋仲となる。お三輪と恋の火花を散らした末入鹿の館へと帰ってくる。やがて糸に引かれるように求女がやってくるが、次第にその素性に気づいてゆく。求女と夫婦になれないならば殺してと願うが、入鹿が盗んだ三種の神器の宝剣を見事奪い取るなら望みを叶えようという求女の言葉に思いを託す。

Princess Tachibana
Princess Tachibana is the younger sister of Soga no Iruka. She falls in love with the disguised Fujiwara Tankai without realizing who he is. She argues with Omiwa along the way, but after an otherwise uneventful journey, she returns to Iruka's palace. Following the thread he has attached to her, Motome arrives at the palace and the two realize each other's identity. Tachibana wishes to die if she cannot marry Tankai, but he says that he will marry her if she can steal back the sacred sword which Iruka had stolen.

豆腐買おむら
とうふがい おむら

ストーリーとはほぼ関係ないが、重苦しく展開する中にあって一服の清涼剤として場を和ませる、これも貴重な役である。右も左もわからぬお三輪に呼び止められ、豆腐を買いに行くあわただしさのなか、今日これから淡海と橘姫が祝言を挙げるという情報をうまくまた軽妙に伝える役割は重要である。芝居の隙間をさらってゆく役なので、登場は短いながら人気俳優がご馳走で勤めることが多い。

Tofugai Omura
Omura has little to do with the story but offers comic relief in an otherwise very dark play. He nonetheless plays a very important role: in his rush to prepare he lets slip to Omiwa that Princess Tachibana and Tankai are to be wed. The character comes at a slight lull in the scene and is gone again in a moment, adding flavor to the scene. This is why Omura is often played by a popular actor.

烏帽子折求女 実は 藤原淡海
えぼしおりもとめ じつは ふじわらのたんかい

史実では藤原不比等。藤原鎌足の息子で、父と同様蘇我入鹿の征伐に奔走している。逆に入鹿からは賞金付きのお尋ね者となっている。烏帽子折に身をやつしお三輪の杉酒屋の隣家にいるが、そこへ互いの素性を知らぬまま恋仲となった橘姫がやってくる。しかしお三輪も求女にぞっこん、一男二女の恋の鞘当てとなる。三人三様の思いを秘めた道行の後、入鹿の館へやって来て橘姫と祝言、ついに入鹿を討つ時が迫ってくる。

Eboshiori Motome / Fujiwara Tankai
Fujiwara Kamatari's son, Tankai goes to great lengths to overthrow Iruka, and Iruka himself has put a bounty on his head. In his disguise he lives next door to the Omiwa, who falls in love with him. Princess Tachibana appears before Motome and the two, not knowing each other's true identity, fall in love. The resulting love triangle is depicted in the michiyuki dance which precedes Tachibana and Motome's wedding and Iruka's downfall at the palace.

鱶七 実は 金輪五郎今国
ふかしち じつは かなわのごろういまくに

三笠山の蘇我入鹿の館に、藤原鎌足の使いとしてやってきた漁師の鱶七、実は鎌足の家臣・金輪五郎という侍である。もてなされた酒に毒が仕込んであったり、槍が突き出されたりという難もうまく逃れ館にしばし逗留する。その後にやってきたお三輪が嫉妬のあまり疑着の相となったのを狙いすまし、お三輪を刺してその生血を得る。入鹿討伐の準備がこのようにして着々と進められる。

Fukashichi / Kanawa no Goro
The samurai Kanawa no Goro goes to Iruka's palace disguised as the fisherman Fukashichi and claiming to be a messenger sent by Kamatari. He manages to stay in the palace for quite some time despite many attempts at his life. When the jealous Omiwa arrives, he stabs her to obtain her blood and defeat Iruka.

いじめの官女
いじめのかんじょ

「御殿」の場のひとつの特徴ともなっている道化的な役。館に勤める大勢の官女たちだが、うぶで田舎娘のお三輪をさんざんにいたぶる役なので、通常女方ではなく屈強な立役をあえてこの役に当てる。恐る恐る館の中を行くお三輪に「誰じゃ！」と図太い声で威嚇し、酒を注がせたり踊らせたりと様々な手練手管で苛め抜く。その哀れさがまたお三輪という女性の悲劇を演出してゆく。

Ijime no kanjo ("bullying ladies")
A rather comical role, the "bullying ladies" are court ladies who appear in the palace scene to torment Omiwa whom they see as a country bumpkin. The cruel ladies are usually played by burly leading actors rather than onnagata actors. They torment poor Omiwa as she wanders the palace, forcing her to pour their *sake* and dance for them. This torment adds to the tragedy that awaits the pitiful Omiwa.

みどころ
Highlights

1. 杉酒屋お三輪の衣裳 —— Omiwa's Costume

萌葱色（もえぎいろ）の縮緬、十六むさし裾模様の振袖。萌葱は黄味がかった緑で田舎娘の役柄を表す。十六むさしは斜線入りの碁盤目に親石、子石を置いて競う卓上ゲームをデザイン化したもの。黒繻子の襟付き。

In the Scenes "Sugi Sake Shop," "Michiyuki," and "The Palace on Mount Mikasa," Omiwa wears a silk crepe costume adorned with a pattern called "*juroku musashi*." The color of her costume is "*moegi-iro*," a yellowish green that indicates Omiwa's status as a girl from the country. The *juroku musashi* pattern is based on a traditional board game which uses a diagonal go board and involves using "parent stones" and "child stones" to defeat your opponent. Omiwa's costume also features a black satin collar.

2. 吉野川の流れる舞台装置 —— A River Flowing Through the Audience

作者近松半二はシンメトリカルな舞台構成を好んだ。『妹背山婦女庭訓』「吉野川」では、舞台の上手に大判事清澄の家、下手に太宰の家があり、舞台中央奥から客席へ向かって吉野川が流れている。川の流れをからくりで見せる大道具のワザは必見。客席上手側にも花道（仮花道）が設けられる。二つの花道は土手に見立てられ、両家の親たちは土手に立って川越しに対話する。客席は川の流れにいながら、両岸で起こる悲劇を観る気分になる。

Author Chikamatsu Hanji was fond of symmetrical stages, which is why the "Yoshino River" scene of *Imoseyama Onna Teikin* consists of the Daihanji and Dazai houses on opposite sides of the stage, separated by a river that seemingly flows down the center of the stage and into the audience. You'll want to pay attention to the large prop that simulates the flow of a river, and the special *hanamichi* erected on the right side of the audience seating. On each of the two *hanamichi* (the "banks" of the river) stand Daihanji and Dazai talking to one another over the audience. This gives the audience the unique sensation of watching the tragedy unfold from the neutral position of the river that flows between the two protagonists.

3. 大化の改新前夜
── The Night Before the Taika Reforms

西暦645年の蘇我入鹿暗殺に始まる「大化の改新」が題材。改新の立役者は中大兄皇子（なかのおおえのおうじ）と中臣鎌足。権勢のあった蘇我入鹿を暗殺し、皇子はのちに即位して天智天皇となったと教科書で誰もが習ったことだろう。鎌足が大織冠という地位を賜ったので、歌舞伎ではこの時代を扱った芝居を「大織冠物」と呼ぶ。だが『妹背山婦女庭訓』では入鹿暗殺前に天智天皇が登場するなどエピソードの前後がひっくり返っている。江戸時代の歴史感覚はかなり大胆だった。

The Taika Reforms of 645. If you're familiar with Japanese history, you may know that the leaders of the reforms were crown prince Naka no Oe and Nakatomi Kamatari, who assasinate the previous leader Soga no Iruka and instate Naka no Oe as Emperor Tenji. Although period pieces set in this time are often called "*daishokukan-mono*," *Imoseyama* has a much more modern, Edo-period quality to it. For example, Emperor Tenji appears before the assasination of Iruka, a reversal of the historical events.

4. 恋の苧環（おだまき）
── Spool of Love

苧環とは糸をくるくると輪に巻く糸巻のこと。七夕には機織りの上達を願って苧環を祀る風習があった。また「赤い糸」は男女の縁の喩えでもある。恋のもめ事を「糸のもつれ」に喩えると実にわかりやすい。勝ち気な娘お三輪と、優柔不断な恋人求女と、求女に恋する謎めいた橘姫の恋の鞘当てに、白糸赤糸の苧環が大活躍する。逃げる橘姫に求女が付けた赤糸と、お三輪が求女に付けた白糸をくるくるたどる苧環は恋の夜道を照らす灯のようだ。

An "*odamaki*" refers to a round spool of thread. At Tanabata (the star festival) it was common to pray to an *odamaki* for improvements in weaving, and the "red thread" is a common symbol of the connection between a man and a woman. It is common to refer to a fight between lovers as a "tangling of threads" (*ito no motsure*). The spools of thread play an important role in this play, helping connect the determined Omiwa, the indecisive Motome, and the mysterious Princess Tachibana. The white thread Omiwa attaches to Motome and the red thread Motome attaches to Tachibana act as beacons leading the way on the dark night road they travel.

5. 「女庭訓、しつけ方よう見やしゃんせ」
—— *Onna Teikin* and the Rules of Etiquette

庭訓（ていきん）とは教訓やしつけのこと。「女庭訓」は女性のため教訓集だ。だがこの作品に登場する女性たちは庭訓に従うような性格ではない。優男の求女に恋した酒屋のお三輪は勝ち気な娘。恋敵の橘姫を追いかけていって、「人の恋人を盗むなんて、ひどい。女庭訓を見なさいよ」と激しく詰め寄る。橘姫は「恋はしたもん勝ち！ そなただって親の許しも得てないくせに」と強気。三角関係の対処法は女庭訓にはないだろう。

"*Teikin*" refers to education and upbringing. Therefore, an "*onna teikin*" is a strict set of teachings specifically for women. However, the women who appear in this piece are not the ideal type who follow such rules strictly. Omiwa, whom Motome falls in love with, is a determined and unyielding young woman. She chases after her rival Princess Tachibana and reprimands her for stealing another's love. But the princess shoots back, claiming that Omiwa hasn't even received her parents blessing. How to deal with such a love triangle is not likely to be in an actual *onna teikin*.

6. 古都奈良の伝説が彩る
—— The Legends of Ancient Nara

原作浄瑠璃には古都奈良の題材が全編にちりばめられている。まず二段目には猿沢池に身投げした采女の哀話や鹿殺しの言伝えが取り入れられている。三段目は吉野川の両岸にある背山と妹山が舞台。四段目は三輪山伝説。毎夜娘のもとを訪れる男の素性を知ろうと、父親が明け方帰っていく男の衣服に糸を縫い付けてたどったところ、男が三輪の神様と気付いたという話だ。それらを織り交ぜ、作者近松半二は、叶わぬ恋というテーマをロマンチックに紡いだ。

Themes related to the ancient city of Nara can be seen everywhere in this play. First, in Act II we are shown Sarusawa Pond where lady Uneme committed suicide, and told of the deer that must be killed. We see Mt. Se and Mt. Imo on the bank of the Yoshino River in Act III, and the legend of Mt. Miwa in act IV. This legend tells of a man who goes to see a young girl every night. The girl's father attaches a thread to the man to learn who he is, only to find that the man is The god of Mt. Miwa. The author Chikamatsu Hanji thus interweaves themes of unrequited love into this romantic play.

祇園祭礼信仰記
金閣寺
Kinkakuji —— from Gion Sairei Shinkoki

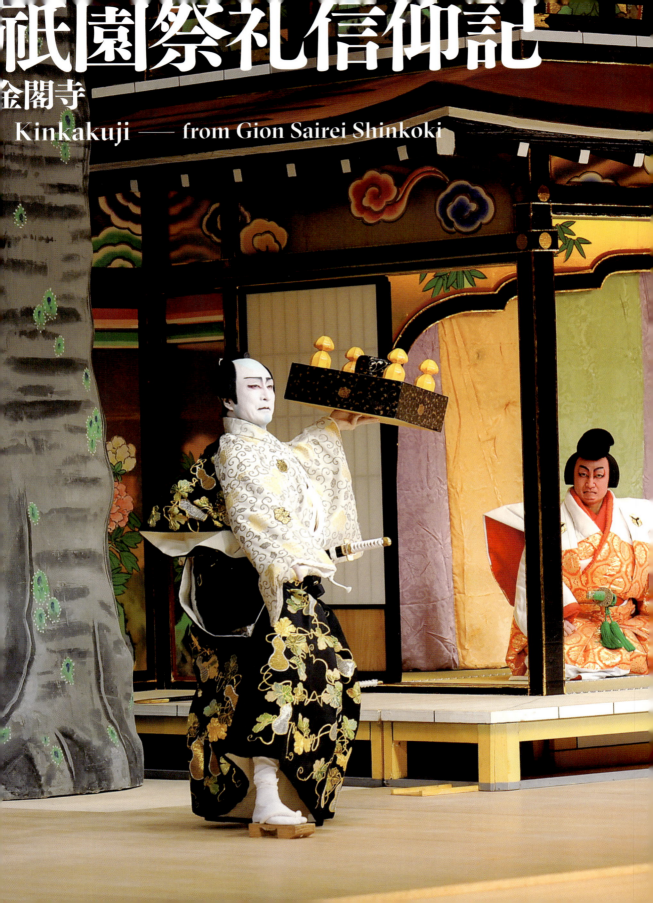

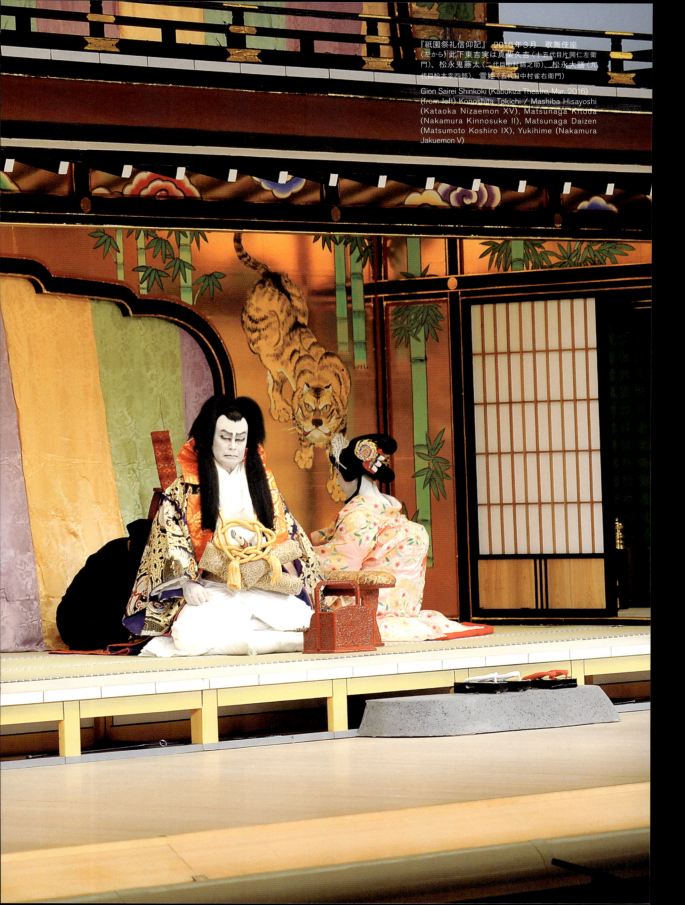

『祇園祭礼信仰記』 2016年3月 歌舞伎座
(左から) 此下東吉実は真柴久吉(十五代目片岡仁左衛門)、松永鬼藤太(二代目中村錦之助)、松永大膳(九代目松本幸四郎)、雪姫(五代目中村雀右衛門)

Gion Sairei Shinkoki (Kabukiza Theatre, Mar. 2016)
(from left) Konoshita Tokichi / Mashiba Hisayoshi (Kataoka Nizaemon XV), Matsunaga Kitoda (Nakamura Kinnosuke II), Matsunaga Daizen (Matsumoto Koshiro IX), Yukihime (Nakamura Jakuemon V)

あらすじ / Synopsis

息を継ぐ間もなく繰り広げられる
極彩色の歌舞伎絵巻

爛漫たる桜花、絢爛たる金閣寺を舞台に、登場するのは国家を狙う謀反人、人質奪回をもくろむ爽やかな智将、囚われの美女。
加えて龍を映す不思議な刀に、絵が奇跡を起こすファンタジックな展開、さらに大道具のスペクタクル。随所に見どころがちりばめられた演目。

A colorful piece that keeps you on the edge of your seat.

A truly stunning piece set among the cherry blossoms of Kinkakuji temple. An imposing villain who plots to take over the country is set against the gallant hero who saves the hostage and a beautiful woman who has been captured. Add to this a mysterious sword, a miraculous feat by the confined princess, and a spectacular set piece that raises up from beneath the floor… Every moment is filled with excitement in this magnificent play!

　松永大膳は主君である将軍足利義輝に謀反を起こし暗殺、さらに義輝の母慶寿院を人質として金閣寺の上層に幽閉し、自らも金閣寺に立てこもっている。

　弟鬼藤太と碁を打っている大膳のもとに、配下の十河軍平が、敵方の小田春永に仕えている此下東吉を連れてくる。大膳に仕えたいという東吉の智恵を試そうと、大膳は井戸に碁笥（碁石を入れる器）を投げ込み、手をぬらさずに碁笥を取りあげろと命じる。東吉は樋を使って近くの滝から水を井戸に引き入れ、井戸水に浮かび上がった碁笥を取り上げて、差し出す。感心した大膳は東吉を召し抱えることにする。

　また、金閣寺の天井に龍の絵を描かせるため、名高い絵師の夫婦狩野直信と雪姫が呼ばれているが、直信は命に従わず牢に入れられてしまい、雪姫は、さらに大膳の邪な思いに従うよう口説かれ、拒否したために金閣寺に幽閉されている。

　龍の絵を描くには、祖父雪舟から家に伝わる手本が必要という雪姫に、大膳は自らの刀を夕日にかざす。すると滝に龍の姿が現れる。実はこれこそ狩野家に伝わる重宝倶利伽羅丸。朝日にかざすと不動の姿を映し、夕日にかざすと龍の絵

Matsunaga Daizen has plotted against the shogun Ashikaga Yoshiteru. After assassinating him, Daizen imprisons Yoshiteru's mother Keijuin in Kinkakuji Temple where he hides.

While Daizen is playing a game of go with his brother Kitoda, Sogo Gunpei brings a man named Konoshita Tokichi, who serves their enemy Oda Harunaga. Daizen tests Tokichi, who wishes to enter his service, by throwing his go box into a well and telling him to retrieve it without wetting his hands. Tokichi uses a bamboo pipe to funnel water from the waterfall into the well, causing the box to rise with the water. Daizen is impressed when Tokichi successfully retrieves the box and decides to hire him.

Meanwhile, artist Kano no Naonobu and his wife Yukihime have been asked to paint a dragon on the ceiling of Kinkakuji. Naonobu, however, has been thrown in prison for refusing, while Yukihime has been locked away in Kinkakuji after Daizen tried to persuade her once more to paint the ceiling for him.

Yukihime claims that she will need her grandfather Sesshu's painting as a model to paint the dragon for Daizen. Daizen responds by drawing his sword which casts the reflection of a dragon onto the nearby waterfall.

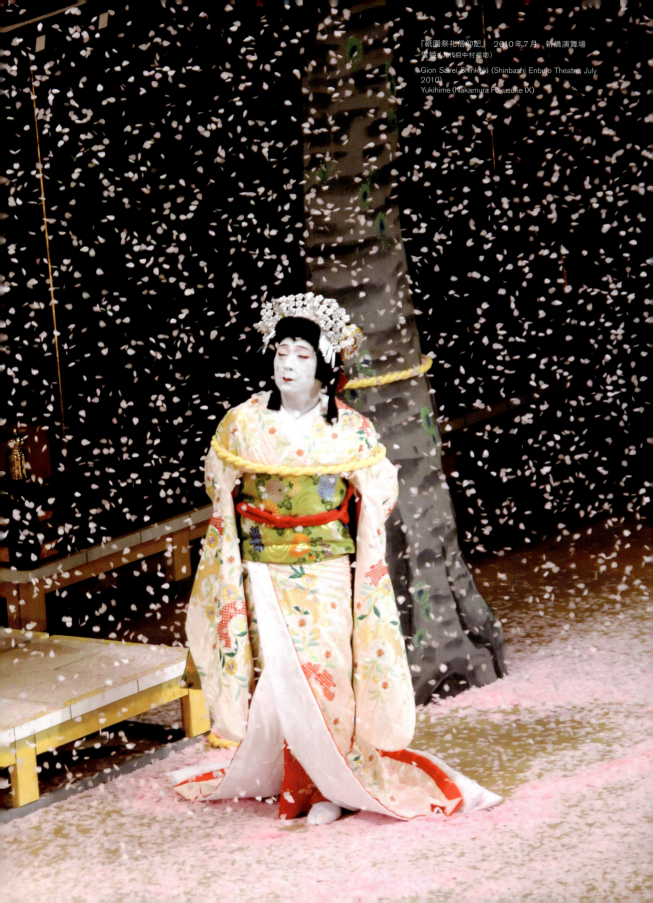

『祇園祭礼信仰記』 2010年7月 新橋演舞場
雪姫(九代目中村福助)
Gion Sairei Shinkoki (Shinbashi Enbujo Theatre, July 2010)
Yukihime (Nakamura Fukusuke IX)

が現れる宝刀だが、雪姫の父雪村が殺された時に紛失したもの。刀を持っているから父の仇と、雪姫は大膳に討ちかかるが、縛りあげられて桜の木につながれてしまう。雪姫は縛られながらも足元の桜の花を集め、つま先で鼠の絵を描く。涙で鼠を描いた祖父の故事を思い出したものだが、思いが通じて絵は白鼠となって現れ、姫を縛っている縄を食い切る。

　大膳の配下となった東吉は、実は慶寿院奪還のために春永が送り込んだ武将真柴久吉であった。久吉は身軽に上層に登り、慶寿院を見事救出する。また、十河軍平も実は春永方の佐藤正清で、早くから大膳方に入り込み、隙をうかがっていたのだ。

　取り囲まれた大膳は、久吉、正清と後日の戦いを約して別れるのだった。

Yukihime now knows that this sword is actually the sacred Kurikaramaru sword which belonged to her father. Yukihime attacks Daizen, who she now knows killed her father, but she is stopped and tied to a cherry tree. Thinking of her late father, Yukihime uses her feet to form the fallen cherry blossoms into the shape of a rat. The cherry blossoms magically transform into a real rat that frees Yukihime by gnawing at the ropes binding her.

　Tokichi, it turns out, is actually Commander Mashiba Hisayoshi, who has been sent by Harunaga to retrieve Keijuin from Daizen. Having fooled Daizen, Hisayoshi makes his way easily into the upper floors of Kinkakuji and frees Keijuin. Sogo Gunpei, too, is actually an agent of Harunaga's named Sato Masakiyo, who had infiltrated Daizen's ranks long before, waiting for his chance to strike.

　Daizen, who has been completely surrounded, swears to do battle with Hisayoshi and Masakiyo in the future.

作品の概要

演目名

祇園祭礼信仰記―金閣寺

作者

中邑阿契・豊竹応律・黒蔵主・
三津飲子・浅田一鳥（合作）

概要

宝暦7（1757）年12月　大坂・豊竹座で初演された人形浄瑠璃の作品を歌舞伎に移したもの。原作浄瑠璃の作者は中邑阿契・豊竹応律・黒蔵主・三津飲子・浅田一鳥ら。歌舞伎では浄瑠璃初演の翌月、宝暦8（1758）年1月に京都にある南側芝居と北側芝居の二座で上演されている。

『祇園祭礼信仰記』全五段のうち、現在の歌舞伎では四段目の「金閣寺」の場が頻繁に上演され、その他の場面はほとんど上演されない。

敵役のなかでも色気と華を必要とされる、「国崩し」の役柄の大膳、颯爽たる二枚目の東吉など、多彩な登場人物が舞台を彩る。なかでも雪姫は、数ある姫役の中でも特に難しいとされる「三姫」のひとつに数えられている。

雪姫の最大の見せ場は「爪先鼠」と呼ばれる場面。満開の桜の木に縛られた雪姫が足を使い、桜の花びらで鼠を描くと、それが実体化して縄を食いちぎるというファンタジックな場面があり、このほか朝日にかざすと不動の姿を映し、夕日にかざすと龍の絵が現れる宝刀倶利伽羅丸など、他に類を見ない発想の面白さがある。

さらに絢爛豪華な金閣寺の屋台が、大ゼリで上下するなどのスペクタクル演出も見どころであるが、これは人形浄瑠璃初演からの趣向で、これらの工夫で人形浄瑠璃では3年のロングランヒットになったと伝えられる。

初演

人形浄瑠璃 ― 宝暦7（1757）年12月　大坂・豊竹座
歌舞伎 ― 宝暦8（1758）年1月　京都・南側芝居（沢村染松座）
　　　　　　　　　　　　　　　京都・北側芝居（中村粂太郎座）

Overview

Title

Kinkakuji
— from Gion Sairei Shinkoki

Writers

Nakamura Akei, Toyotake Oritsu, Kokuzosu, Mitsu Inshi and Asada Iccho

Overview

Gion Sairei Shinkoki debuted for the bunraku puppet theater December of 1757 at the Toyotake-za Theater in Osaka, and was written by Nakamura Akei, Toyotake Oritsu, Kokuzosu, Mitsu Inshi, and Asada Iccho. It was later adapted for the kabuki theater and debuted in January of 1758 at the Minamigawa Shibai theater in Kyoto.

Of the original five acts of *Gion*, only "Kinkakuji" from Act IV is played popularly played now. You rarely ever see other parts of the play performed.

Gion features a colorful cast. The villain Daizen is a kuni-kuzushi role that requires passion and vibrance to perform, contrasting the gallant hero Tokichi. And of course, Yukihime is another great role that is counted among the *sanhime*, the three great princesses of kabuki.

Yukihime's greatest scene is the rat scene. Tied to a cherry tree, Yukihime gathers cherry blossoms into the form of a rat with only her feet. The blossoms then magically transform into an actual rat which saves her from her bindings. The sacred sword Kurikaramaru that reflects different forms depending on the type of day is another unique charm of *Gion Sairei Shinkoki*.

The massive *ozeri* (large lift) used to raise and lower the magnificent Kinkakuji Temple is another stunning feature which takes its cue from the bunraku puppet theater.

Premiere

Bunraku: December 1757, Toyotake-za Theatre, Osaka
Kabuki: January 1758, Minamigawa Shibai Theatre and Kitagawa Shibai Theatre, Kyoto

登場人物 / Characters

雪姫
ゆきひめ

絵師として名高い雪舟（せっしゅう）の孫で、父も雪村（せっそん）という絵師。しかし父は何者かに殺されお家の名刀・倶利伽羅丸（くりからまる）も奪われている。美しい雪姫には狩野之介直信という夫がいるが、大膳は雪姫を我が物にしようと企んでいる。雪姫は大膳の刀を倶利伽羅丸と見抜き父の仇と斬りかかるが桜の木に縛られてしまい、やがて雪姫の不思議な絵の力が発揮される。

Yukihime
Yukihime is the daughter of the painter Sesson, and granddaughter of the famous painter Sesshu. The sacred sword Kurikaramaru was stolen by Daizen, the man who killed her father. Though she loves Kanonosuke Naonobu, Daizen tries to make Yukihime his own. She realizes Daizen is her father's murderer and tries to kill him, but is captured and tied to a cherry tree. She eventually escapes using a mysterious power.

此下東吉
このしたとうきち

小田春永の家臣だが本人が松永大膳に仕えたいと望み、大膳との碁の対戦や難問の鮮やかな解決で智勇が認められ大膳によって抱えられる。しかしそれは計略で、危機に瀕した雪姫を救い、さらに捕らわれている慶寿院を無事に助け出して、真柴久吉として政敵である松永大膳を討ち取るべく対決する。小田春永はすなわち織田信長、此下東吉は木下藤吉郎、真柴久吉は羽柴秀吉である。

Konoshita Tokichi
Tokichi works for Oda Harunaga but asks to serve Daizen. After playing go together and being tested by Daizen, he is acknowledged and allowed to work for him. This, however, is part of Harunaga's plan. Tokichi's true identity is Mashiba Hisayoshi, and he is there to save Yukihime, release Keijuin, and take down Daizen. Each character's names are all very similar to their historical counterparts, merely using different kanji that sound similar.

慶寿院
けいじゅいん

足利義輝の母で、今は松永大膳により金閣寺の高楼へ幽閉されている。大膳は、もし小田春永が押し寄せてきたならばこの慶寿院を楯の板にくくりつけ、剣を喉に突きつける所存、文字通りの人質である。やがて大膳の家来となっていた此下東吉がやって来て「小田春永が家臣、真柴筑前守久吉、お迎えに参上せり」と名乗り、慶寿院も安堵するものの、すでに覚悟はできているので目を閉じ合掌する。

Keijuin
Mother of Ashikaga Yoshiteru, Keijuin is captured and locked away in Kinkakuji Temple. She is a hostage in the most literal sense of the word. Daizen threatens to take her and cut her throat should Harunaga dare come near the temple. Though Tokichi, who is supposedly serving Daizen, comes to Keijuin stating his true identity as Harunaga's man, she is nonetheless prepared to die and clasps her hands together in prayer.

松永大膳
まつながだいぜん

将軍・足利義輝を殺し母の慶寿院を人質として幽閉している大悪人。歌舞伎で一国一城を揺るがす巨悪の敵役「国崩し」という役柄の典型で、「大膳」という役名や長い髪を肩まで伸ばした「王子（おうじ）」という鬘（かつら）など、まさに敵役のお決まりである。天下を狙うと同時に美しい雪姫を手に入れようと躍起になっているが、身内と思われた者たちから追い詰められる。

Matsunaga Daizen
Daizen is the main villain who kills shogun Ashikaga Yoshiteru and takes his wife Keijuin hostage. He is a prime example of the *kunikuzushi* role, the great villain who threatens to take over the country. His name and oji-style hair that falls to the shoulders are all hallmarks of the *kunikuzushi* role. He tries both to take over the country and steal away the beautiful Yukihime, but is ultimately thwarted by men he thought were his allies.

狩野之介直信
かのうのすけなおのぶ

狩野派の絵師で、雪姫の父・狩野雪村の弟子。雪姫とは夫婦であるが、雪姫ともども松永大膳に捕らえられ、慶寿院の望みで金閣寺の天井に墨絵の龍を描くよう強要されている。しかし墨絵の龍はお家の秘密と拒絶する直信は牢に繋がれ、雪姫も夫ある身ゆえ不義はせぬというので直信に対する大膳の恨みは募り処刑寸前となる。しかし縄をつかんで引っ立てた十河軍平により救われる。

Kanonosuke Naonobu
A painter of the Kano style, Kanonosuke Naonobu is a student of Yukihime's father Kano Sesson. He is married to Yukihime but is captured by Daizen who demands he paint a dragon on the ceiling of Kinkakuji Temple. He refuses, saying he cannot share the secret of the family's dragon painting, and is thrown in prison. Yukihime also refuses and says that she cannot be unfaithful to her husband. This enrages Daizen, who almost kills Yukihime, but Sogo Gunpei stops him.

松永鬼藤太
まつながきとうだ

松永大膳の弟。兄の大膳が顔を白塗にしつつも不気味な様子を浮かべる巨悪であるのと対照的に、「赤っ面」と呼ばれる、いかにも憎々しく、荒々しい若者の敵役である。幕開きで兄と碁を打ち、負けが込んでいるが、後に此下東吉が碁で大膳を打ち負かすのを際立たせる役割もする。兄から大事な倶利伽羅丸を預かるが、十河軍平に討ち取られ、その名刀も軍平の手に渡る。

Matsunaga Kitoda
Kitoda is Daizen's younger brother. His rowdy *akattsura* (red face) contrasts with his brother's ghastly white makeup, indicating his role as a minor villain. He is losing his game of go with Daizen when Tokichi arrives, adding weight to the fact that Tokichi subsequently beats Daizen at the same game. He is entrusted with guarding the sacred Kurikaramaru sword, but Sogo Gunpei defeats him and takes the sword.

十河軍平 実は 佐藤正清
そごうぐんぺい じつは さとうまさきよ

松永大膳の側近で腕も立ち、厚い信頼を受ける家来。あくまでも大膳に忠誠を尽くす敵役として演じるがその正体は最後に見顕され、真柴久吉の家臣・佐藤正清（すなわち加藤清正）である。此下東吉を松永大膳の前に導いて家来とすることを促し、また直信の縄を持って引っ立ててゆく役割を演じるなど大膳の右腕として積極的に働くが、実は刑を受ける寸前の直信を無事に助け出す。

Sogo Gunpei / Sato Masakiyo

An able and trusted man in Daizen's service, he plays the villain loyal to Daizen until his true identity (Sato Masakiyo, Mashiba Hisayoshi's retainer) is revealed at the end. He is the one who recommends Tokichi into Daizen's service, and though he plays his role as Daizen's right hand well, dragging Naonobu around by the ropes that bind him, he heroically saves him just before he can be killed.

みどころ
Highlights

1. 雪姫の衣裳
—— Yukihime's Robes in *Gion Sairei Shinkoki*

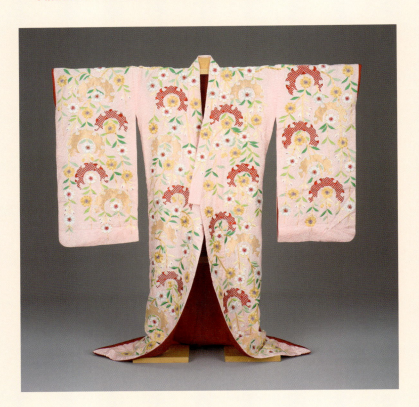

雪姫の着物は鴇（とき）色綸子の振袖で、雪輪に枝垂桜の柄が刺繍されている。鴇は日本の国鳥朱鷺のこと。これを着て桜木にくくりつけられた姫の姿を、大膳は「雨を帯びたる海棠桃李（かいどうとうり）」に喩える。

Yukihime wears a pink *furisode* kimono with a *shidare-zakura* (weeping cherry) pattern. The shade of pink is called "*toki-iro*" in Japanese, after the crested ibis (*toki*) that is Japan's national bird. After Daizen has tied her to the cherry tree, he likens her to a precious fruit ruined by the rain.

2. 国崩しとは巨悪のこと
—— Kunikuzushi, the Ultimate Villain

日本の宝である金閣寺を占有し、雪姫を我が物にしようとする松永大膳は天下を狙う巨悪である。歌舞伎の役柄のなかで、天下を狙う人物を「国崩し」と呼んでいる。大膳はその典型的な役柄である。国の秩序を崩してしまいそうなスケールの大きさがある。悪役ながら白塗りで髪は総髪、ゆったりした装いながら、ただならぬ豪儀な気配を漂わせる。悪の華の魅力である。大膳が大きくなくては、この芝居は面白くならない。

Matsunaga Daizen seizes control of the national treasure Kinkakuji Temple and steals away Yukihime for his own. He is a typical example of the "*kunikuzushi*" role, the great villain who attempts to take contorl of the country. As such, his character is powerful enough to crush the current world order. Although he is a villain, he wears white makeup, keeps his hair in the *sohatsu* style (knotted in the back), and wears somewhat easy-going robes. Even so, he commands great power. Without a truly grand and commanding Daizen, this play would be quite boring indeed.

3. 三姫は皆恋に殉じる
—— The Three Princesses who Die for Love

『祇園祭礼信仰記』の雪姫、『鎌倉三代記』の時姫、『本朝廿四孝』の八重垣姫を、歌舞伎の「三姫」と呼ぶ。どれも大役で、歴代の名女方が演じてきた。いずれも深窓の令嬢なのだが、恋しい男のため命がけの大胆な行動に出る。時姫も八重垣姫も、許嫁のために実の親を裏切る。雪姫の場合は、夫の命を救うため大膳に身を任せようかとも迷うが、自分の力で奇跡を起こし、倶利伽羅丸を手に入れ夫のもとに走ってゆく。

Yukihime from *Gion Saireki Shinkoki*, Tokihime from *Kamakura Sandaiki*, and Yaegakihime from *Honcho Nijushiko* are known as the "sanhime," or three princesses of kabuki. All three are big roles in their respective plays, and have been played by the greatest of *onnagata* actors over the years. Each of these roles is that of a reclusive princess who steps forth for the man she loves. Tokihime and Yaegakihime both betray their parents when their lovers turn out to be enemies. In Yukihime's case, she considers giving herself over to Daizen to save her husband, but miraculously escapes and runs to the side of her husband who has obtained the sacred sword Kurikaramaru.

4. 雪舟の孫娘
—— The Granddaughter of Sesshu

雪姫は雪舟の孫娘という設定である。雪舟は室町時代に活躍した日本を代表する水墨画家。応永27（1420）年生まれで、幼いころ近くの寺に入って禅の修行を積んだ。成人したのち明国に渡って彼の国の絵画を学んだが、帰国後独自の画風を確立した。子供のころ、絵ばかり描いて御経を読まず、師の僧に寺の柱に縛りつけられてしまい、流した涙で鼠の絵を描いたところ、生きているかのような出来映えだったという逸話が有名。

Yukihime is granddaughter to the famous *sumi-e* painter Sesshu who was active during the Muromachi period. He was born in 1420 and studied zen buddhism from an early age. He went to Ming China and studied painting there as an adult, but established his own style of painting upon returning to Japan. Even as a child, he would paint all day rather than read his sutras, and it is said that he himself was tied to a post by his teacher, much like Yukihime in this play. Also like Yukihime, he drew a very realistic rat on the ground at his feet using his tears.

5. 名刀倶利伽羅丸の奇瑞
—— The Auspicious Power of the Sword Kurikaramaru

歌舞伎には、家宝の名刀が大切な役割を果たす場面が多い。『祇園祭礼信仰記』に登場するのは、その昔雪舟が明帝から賜ったという名刀倶利伽羅丸（くりからまる）。鞘を払って夕日に映すと、龍が浮き出て、朝日に映せば不動の尊体が浮かぶという奇瑞を起こす。クリカラはもともとインドの龍王の名を表す言葉で、龍王は仏法を護る存在であった。炎の黒龍を巻き付かせた剣のかたちでイメージされ、不動明王の化身とされる。

Family heirloom swords play an important role in many kabuki plays. In *Gion Sairei Shinkoki*, for example, the sword Kurikaramaru appears. This sword was brought from Ming China by Sesshu. When unsheathed before a waterfall, it is said to reflect the image of a dragon that brings rain. When the morning sun shines upon it, it is supposed to show an omen of good health. "Kurikara" is the name of an Indian dragon that is said to protect buddhism. Made in the image of a fiery black dragon, the sword is said to be the incarnation of Acala, god of fire.

6. 描いた鼠が縄を噛み切る
—— A Mouse Drawn from Flowers Cuts the Ropes

雪姫には絵の名人の血が流れている。自由を奪われても祖父雪舟の鼠の逸話を思い出し、足先で桜の花びらをかき寄せ一心不乱に鼠を描く。と、鼠が動き出す。積もる桜の花びらの中から、小道具の真白い鼠がカサコソと動き出すくだりは、絵画美あふれるクライマックス。鼠は縄を噛み切ると消えてしまう。この場の作り物の桜の花びらが軽やかな音を立てるが、本物の桜の花びらも足でかき分けると同じような音がする。

Yukihime, who has the blood of the great painter Sesshu running through her veins, is captured, but, remembering the story of her grandfather drawing a rat when tied to a post, she too draws a rat from the cherry blossoms at her feet. Miraculously, this rat comes to life. The climactic moment when the pure white rat rustles up from the blossoms is a moment you won't want to miss. It proceeds to gnaw at the ropes binding Yukihime, freeing her before disappearing. The fake blossoms in this scene make a soft rustling sound when touched, which mimics the actual sound of stepping on cherry petals.

7. 金閣寺の究竟頂
—— The Highest Tower of Kinkakuji Temple

足利義満の山荘だった北山第が、その遺言により禅寺鹿苑寺となったのは、ちょうど雪舟が生まれた応永27年である。金箔の舎利殿金閣があるので寺は金閣寺と呼ばれ、都の観光名所となった。『祇園祭礼信仰記』では、松永大膳が金閣寺の最上階である究竟頂（くきょうちょう）に、足利義輝の母慶寿院を人質に取って立てこもる。究竟頂を見せるため、セリを使って金閣そのものを上下させる。豪華な舞台転換である。

It is said that the former villa of Ashikaga Yoshimitsu was reconstructed as the zen temple Rokuon-ji in 1420, the same year that Sesshu was born. Due to it's guilded gold exterior, the temple came to be known as "Kinkaku-ji" (temple of the golden pavilion) and eventually became a famous sightseeing spot.
In *Gion Sairei Shinkoki*, Matsunaga Daizen confines Ashikaga Yoshiteru's mother, Keijuin, in the uppermost level of the temple. In order to show this level, a *seri* lift is used to raise and lower the entire temple, offering a uniquely opulant experience only found in kabuki.

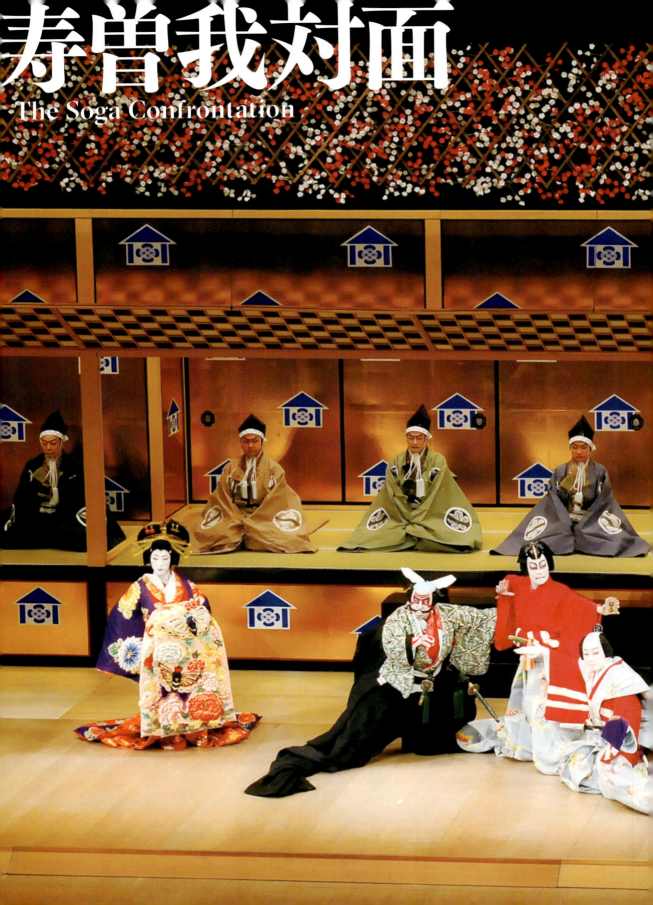

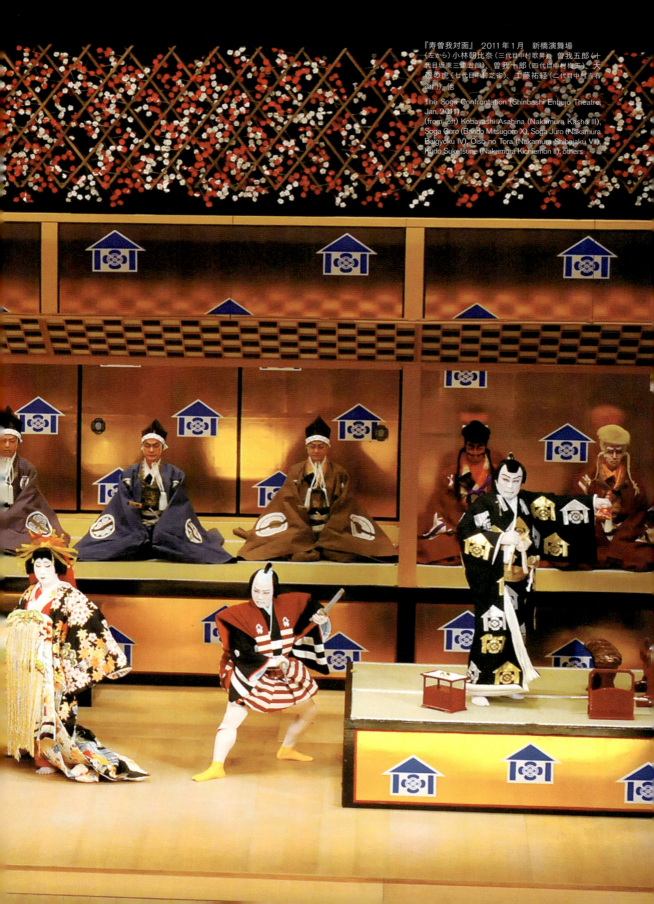

『寿曽我対面』 2011年1月 新橋演舞場
（左から）小林朝比奈（三代目中村歌昇）、曽我五郎（十代目坂東三津五郎）、曽我十郎（四代目中村梅玉）、大磯の虎（七代目中村芝雀）、工藤祐経（二代目中村吉右衛門）他

The Soga Confrontation (Shinbashi Enbujo Theatre, Jan. 2011)
(from left) Kobayashi Asahina (Nakamura Kasho III), Soga Goro (Bando Mitsugoro X), Soga Juro (Nakamura Baigyoku IV), Oiso no Tora (Nakamura Shibajaku VII), Kudo Suketsune (Nakamura Kichiemon II), others

様々な役柄が一堂に会する、歌舞伎ならではの一幕

音楽や衣裳の隅々まで磨き上げられた様式美。視覚でも聴覚でも楽しめる演目。

A colorful cast of characters meet in this one act that shows off the unique character of kabuki.

Treat both eyes and ears with this opulent piece which features magnificent costumes and music from start to finish.

源頼朝の信頼の厚い工藤祐経の館。このたび祐経が、一﨟職という重職と、頼朝が催す巻狩の総奉行職に任命された祝宴が催されている。梶原景時・景高親子、小林朝比奈（舞鶴）が居並び、さらに多くの大名たちが祝いのために集まっている。大磯の虎や化粧坂の少将ら傾城たちも招かれて花を添えている。

やがて朝比奈が工藤に会わせたい若者がいると申し出て、ふたりの若者を呼び入れる。現れたのは、曽我十郎と曽我五郎の兄弟。ふたりの顔を見た工藤は、兄弟が河津三郎に似ていることに気づく。十八年前、工藤によって非業の死を遂げた河津の遺児が十郎と五郎。兄弟は父を闇討ちにした工藤を討ちたいと願っていたが、今日初めて仇に対面することができた。

血気に逸る五郎は、無念さを抑えきれず、工藤に討ちかかろうとするが、工藤は自分を討ち取ることなどかなわぬことだと言い放つ。さらに、曽我家が頼朝から預かった源氏の重宝友切丸を紛失したことを咎め、友切丸が見つかるまでは、兄弟の大願は叶わないと語る。

そこへ曽我家の家臣の鬼王新左衛門が紛失した友切丸を持参して駆けつける。刀を手に入れた兄弟は、工藤に改めて仇と名乗り出るようにと迫る。しかし、富士の巻狩の総奉行の仕事を控えている工藤は、その役目が終わるまでは討たれることはできないと言い、袱紗（ふくさ）包みを投げ与える。その中には狩場の通行に必要な「切手」が入っていた。役目を遂げた後ならば、敢えて討たれてやろうとの肚を、工藤は暗に示したのである。双方、狩場での再会を約して別れるのであった。

Kudo Suketsune, a trusted official under the shogun Minamoto Yoritomo, has just been promoted and given an important role in the shogun's ritual hunt. He is currently hosting a banquet in celebration. Kajiwara Kagetoki (accompanied by his son) and Kobayashi Asahina (with his sister) are in attendance along with a number of Daimyo lords. Many beautiful women have also been brought as entertainment.

Asahina declares that he wishes to introduce two young men to Suketsune, and proceeds to call in the Soga brothers, Juro and Goro. Suketsune sees them and realizes they resemble the Kawazu Sukeyasu whom he killed 18 years ago. Suketsune realizes Juro and Goro are Sukeyasu's children. The brothers wish to avenge their father by killing Suketsune, but this is their first time meeting him.

The impatient Goro cannot hold back his rage and attempts to cut Suketsune, but Suketsune speaks down to the brothers, saying that their wish for revenge will never be fulfilled. He continues to state that the sacred sword Tomokirimaru has been stolen from him. If the brothers can find the sword, they may have a chance of revenge.

Suddenly a retainer of the Soga family, Onio Shinzaemon appears with the very sword in question. The Soga brothers once again attempt to take on Suketsune, but he stops them by explaining that he cannot be killed until after his duties have been fulfilled at the upcoming hunt on Mt. Fuji. Suketsune gives them two tickets to this very hunt so that they may have their chance at revenge then. Swearing to meet again, the brothers take their leave.

作品の概要

演目名

寿曽我対面

作者

不明

概要

曽我兄弟が初めて仇工藤と会う、「対面」の場は、延宝4 (1676) 年2月、江戸・中村座で初めて上演されたとされる。享保 (1716～36) 以後の江戸歌舞伎では、毎年正月は曽我兄弟の仇討ちを脚色した「曽我狂言」を上演するのが習わしになり、「対面」は欠かせぬ場面として様々な「対面」が創作された。

現在上演されているものは、明治36 (1903) 年3月　東京・歌舞伎座で上演される際に河竹黙阿弥が整理した台本と演出を受け継いだものである。この公演は九代目團十郎が前年亡くなった盟友五代目菊五郎の遺児、六代目尾上菊五郎と六代目尾上梅幸、六代目坂東彦三郎の襲名披露で、それぞれ五郎、十郎、八幡を演じさせ、自らは工藤を演じた舞台であった。

歌舞伎の役柄がほとんど勢ぞろいし、視覚的にも音楽的にも、歌舞伎らしい様式美にあふれた一幕である。

初演

延宝4 (1676) 年2月　江戸・中村座

Overview

Title

The Soga Confrontation

Writers

Unknown

Overview

The "Confrontation" scene in which the Soga brothers first meet Suketsune was first performed in February 1676 at the Nakamura-za Theater in Edo (present-day Tokyo). From the early 1700's, *"Soga Kyogen,"* which is also based on the Soga brothers' revenge, became a standard performance at the Edo New Year festivities, and as a result many different fictional accounts of the "Confrontation" were created.

The version popular now is based on the script written by Kawatake Mokuami, which debuted in March 1903 at the Kabuki-za Theater in Tokyo. This performance was produced by Danjiro IX who played Suketsune, and featured the debuts of Onoe Kikugoro VI, Onoe Baiko VI, and Bando Hikosaburo as Goro, Juro, and Yawata no Saburo, respectively.

This single act is astonishing in that it features nearly every kabuki role type, as well as fantastic visuals and music from start to finish.

Premiere

February 1676, Nakamura-za Theatre, Edo

登場人物 / Characters

工藤左衛門祐経
くどうさえもんすけつね

有名な曽我兄弟の仇討ち、その親の仇として歴史的にも知られる人物。工藤祐経は源頼朝の下で信任の厚い大名で、富士の裾野で行われる巻狩の総奉行を務め、館では宴が催されている。そこへやって来た曽我五郎・十郎の兄弟は18年前に工藤が討った河津三郎の子で、当時はまだ幼児。工藤は狩の通行切手を二人に与え、後日堂々と再会することを約束する。敵ではあるが座頭（ざがしら）が勤める重要な役。

Kudo Saemon Suketsune

Suketsune is a prominent historical figure known for killing the Soga brothers' father and inciting the brothers' revenge. Suketsune is a trusted Daimyo lord under the shogun, Minamoto Yoritomo, and has been given the honor of serving as marshal at the shogun's ritual hunt. He holds a banquet at his palace in celebration, but it is interrupted by the Soga brothers Goro and Juro, who have come to avenge their father whom Suketsune killed 18 years before. Suketsune gives the brothers invitations to the hunt, vowing to meet them again then. He is the villain of the story, but played by the very important *zagashira*, the lead actor of the kabuki troupe.

曽我五郎時致
そがのごろうときむね

工藤祐経に暗殺された河津三郎の子で、成長して曽我五郎と名乗り、兄の十郎と共に富士の裾野で見事親の仇を討つ。歴史的ヒーローとして名高く、この演目のみならず『助六』『矢の根』など多くの歌舞伎作品に主人公として登場する。五郎は勇壮で血気盛ん、舞台上で荒事として演じるのが常で、この演目でも工藤祐経を前に今にも飛びかからんと心もはやるが、兄の十郎に制される。

Soga no Goro Tokimune

The son of Kawazu Sukeyasu who was assassinated by Suketsune. Choosing to go by the name Soga Goro, he and his brother Juro eventually succeed in exacting their vengeance at the hunt on Mt. Fuji. Historically known for his heroism, Goro also appears as the protagonist in many other kabuki plays such as *Sukeroku* and *Ya no Ne*. Heroic and passionate, Goro is played in the *aragoto* style, and "The Soga Confrontation" is no exception. He is raring to cut Suketsune down but is stopped by the cool-headed Juro.

小林朝比奈
こばやしのあさひな

奴の扮装で道化の役柄、顔の拵えもコミカルで、台詞には「もさ言葉」と呼ばれる朴訥な言葉が使われる。曽我兄弟を工藤祐経に引き合わせる役目を負う。

Kobayashi no Asahina

Asahina is a *doke* (comical) role which manifests both in his physical appearance and his unsophisticated speech. In "Confrontation" his ultimate role is to allow the Soga brothers audience with Suketsune.

曽我十郎祐成
そがのじゅうろうすけなり

曽我五郎の兄で、兄弟力を合わせて父の仇・工藤祐経を討ち、歴史に残る仇討ちのヒーローとして名を残している。史実では工藤を討った後、五郎は最後まで戦って捕らえられるが、十郎はその場で討ち死にしている。歌舞伎では五郎が荒事で演じられる一方、十郎は優しく温厚な人柄を表し和事で演じるのがお決まりである。この演目でも血気に逸る五郎を制しながら美しく形を極める。

Soga no Juro Sukenari

Juro is Goro's brother. The two are actual historical figures known for their heroism in avenging their father and killing Kudo Suketsune. Historically, Goro continues fighting after Suketsune is killed, and is eventually captured. Juro, however, dies in the fight. Traditionally, Goro is played as a hot-headed character in the *aragoto* style, while Juro is played as a kind and gentle man. As such, in "Confrontation" Juro calmly stops his hot-headed brother from rushing in to fight Suketsune.

朝比奈妹舞鶴
あさひないもうと まいづる

朝比奈の妹。演出によっては朝比奈にかわって「対面」に登場する。並々ならぬ強さを持ちながら女性らしさもそなえる「女武道（おんなぶどう）」の役柄。ちなみに朝比奈三郎の大力の逸話を女性版にした『和田合戦女舞鶴（わだかっせんおんなまいづる）』にも、夫のために門を押し破ってしまう板額（はんがく）御前という女性が登場する。

Maizuru (Asahina's sister)

This character is Asahina's sister, but sometimes is played as a female version of Asahina in his stead. In this case, she plays the same role of helping the Soga brothers meet Suketsune.

大磯の虎
おおいそのとら

工藤の館には大磯の廊から多くの遊女たちも来て花を添えている。大磯の虎は格の高い太夫で、女方の中でも立女方が演じる。曽我十郎の恋人というところもお約束である。

Oiso no Tora

A prostitute brought from the pleasure quarters to entertain at Suketsune's banquet. Her role is an important one that is generally played by a leading *onnagata* actor (*tate-oyama*). She is also played as Juro's lover.

喜瀬川亀鶴
きせがわかめづる

この演目は上演ごとに登場人物が変わることも多く、大磯の虎、化粧坂の少将のほか、喜瀬川亀鶴が加わることがある。こちらも若女方の役どころ。

Kisegawa Kamezuru

A *waka-onnagata* like Kewaizaka no Shosho, Kisegawa Kamezuru's character may be included with the other prostitutes or omitted depending on the production.

八幡三郎
やわたのさぶろう

工藤祐経の家臣で、近江小藤太と共に河津三郎暗殺の実行役とされる。小藤太と共にこの演目には必ず登場する敵役。

Yawata no Saburo

Saburo is Suketsune's retainer who assassinated Kawazu Sukeyasu together with Kotota. Saburo's character always appears together with Kotota in productions of "The Soga Confrontation."

化粧坂少将
けわいざかのしょうしょう

大磯の虎と同じく工藤に招かれて来ている遊女。若女方の役どころで、曽我五郎とは恋仲である。

Kewaizaka no Shosho

A prostitute like Oise no Tora. Her role is considered a *waka-onnagata* (young female) and she is also Goro's lover.

近江小藤太
おうみのことうだ

工藤祐経の家臣で、この舞台面では八幡三郎と対の形で控えている。役柄としては敵役、史実では河津三郎を討った実行役とされる。

Omi no Kotoda

Kotota is one of Suketsune's retainers and is meant to be a foil to Yawata no Saburo. He plays a villain, and historically was the one ordered to kill Kawazu Sukeyasu.

梶原平三景時
かじわらへいぞうかげとき

源頼朝に重用される家臣として名高く、この演目のみならず多くの歌舞伎演目にその名が登場する。ここでは並び大名の筆頭格で息子の梶原平次と並び、祐経を祝い曽我兄弟を威嚇する。親子がよく似た風貌で並ぶので俗に「親梶原」とも呼ばれる。

Kajiwara Heizo Kagetoki

Well-known as a top retainer of Minamoto Yoritomo, Kagetoki appears in a number of other kabuki plays as well. He is the head of the Daimyo lords attending Suketsune's banquet and brings his son Kagetaka with him. He supports Suketsune and threatens the Soga brothers when they make their appearance. Since he is portrayed to closely resemble his son, Kagetoki is often called *oya-kajiwara* (father Kajiwara).

梶原平次景高
かじわらへいじかげたか

梶原平三の子、親子で工藤祐経の祝いの席にやってくる。親梶原に対し「子梶原」と通称される。

Kajiwara Heiji Kagetaka
Kagetaka is Kagetoki's son, and attends Suketsune's banquet together with his father. He is popularly called *ko-kajiwara* (son Kajiwara).

大名
だいみょう

工藤の館の宴席には多くの大名が祝いに訪れている。俗に「並び大名」と呼ばれ、いずれも烏帽子（えぼし）、素襖（すおう）の正装で居並んでいる。祐経に祝いの言葉を述べるが、曽我兄弟が現れると口々にののしる。

Daimyo
The many Daimyo lords who attend Suketsune's banquet, commonly called *narabi-daimyo*. They each wear formal eboshi headdresses and suo robes. They toast Suketsune, speaking highly of him, but when the Soga brothers appears they are seen to ridicule him.

鬼王新左衛門
おにおうしんざえもん

曽我兄弟の忠実な家臣。この演目では、兄弟が探し求める源氏の重宝・名刀友切丸を見つけ出したと報告し、手に携えてくる。

Onio Shinzaemon
Shinzaemon is the Soga brother's loyal retainer who brings forth the sacred sword Tomokirimaru which the brothers had been searching for.

みどころ
Highlights

1. 絵面に役柄が揃う
—— Every Role Comes Together for the Spectacular *Emen no Mie* Pose

この作品は、歌舞伎の主な役柄が揃うことでも知られる。五郎の荒事、十郎の和事、小林朝比奈の道化、大磯の虎が立女方、化粧坂の少将が若女方、鬼王新左衛門が実事、そして工藤が座頭の立役である。最後の場面はそれぞれが決まりのかたちを見せ、その全体が一枚の絵のような構図になるので、これを「絵面（えめん）の見得」とも呼んでいる。親の仇に対面する切迫性よりも、儀式的な場面の様式美に鑑賞のポイントがある。

This scene is known widely for the fact that every role type is needed to perform it. Goro is an *aragoto* role while Juro is a *wagoto*. Kobayashi Asahina is an example of the comical *doke*, Oiso no Tora the *tachi-onnagata*, Kewaizaka no Shosho the *waka-onnagata*, Onio Shinzaemon the *jitsu-goto*, and finally, Suketsune is the leading *tachiyaku* played by the troupe leader. The final scene, meant to give the impression of a completed painting, ends with the "*emen no mie*" pose. The scene is meant to give the impression of the beauty of a formal ceremony rather than the tension of vengeance.

2. 大磯の虎の衣裳
—— Oiso no Tora's Costume

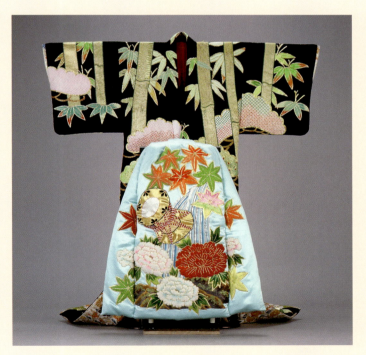

大磯廓の傾城虎は立女方の役どころで、化粧坂の少将とともに舞台を華やかに彩る。黒繻子地に竹林を刺繍した豪華な裲襠（りょうとう）を羽織り、浅葱繻子の俎板帯を前に結ぶ。帯には紅葉、牡丹、鼓の鮮やかな刺繍がほどこされている。

Oiso district's courtesan Tora is a *tate-onnagata* (top female role), who livens the stage with Keiwaizaka no Shosho (another courtesan). This costume consists of a gorgeous long overgarment made of black satin with a bamboo grove embroidered on it. It is adorned with a light green satin *mana-ita obi* (literally "cutting board belt") that's tied in front. The obi is vividly embroidered with autumn leaves, peonies and drums.

3. 父河津三郎の暗殺 —— The Assasination of Kawazu Saburo, the Soga Brother's Father

安元2(1176)年のこと。伊豆の伊東祐親の館に幽閉されていた頼朝を慰めようと、近隣の武将たちが伊東で狩を催した。祐親の嫡子祐泰は、河津を所領として河津三郎祐泰を名乗っていたが、力自慢で相撲の名手として知られ、「河津掛け」という相撲の決まり手に名を残している。領地争いから祐親祐泰を怨んでいた工藤祐経は、卑怯にも狩場から帰る祐泰を毒矢で暗殺させた。祐泰は妻子を案じながら絶命したという。

The year is 1176. Neighboring military officials host a hunt in the Province of Ito for Yoritomo, who had previously been confined in Ito Sukechika's palace. Sukechika's son, Sukeyasu, governs the Kawazu region and has taken on the name Kawazu Saburo Sukeyasu. He also made a name for himself as an adept sumo wrestler, and created the "*kawazu-gake*" move in sumo. Kudo Suketsune holds a grudge against Sukeyasu over territory disputes, and murders him with a poisoned arrow as he makes his way back from the hunt. Sukeyasu dies thinking of his beloved wife and children.

4. 曽我兄弟の仇討ち —— Revenge of the Soga Brothers'

18年後の建久4(1193)年5月、鎌倉将軍となった頼朝が富士の裾野で大規模な巻狩を催す。頼朝の重臣であった工藤祐経は巻狩の奉行に任じられた。同月28日祐泰の遺児十郎と五郎は狩場に忍び込み、みごと父の仇工藤を討ち果たした。十郎は討ち取られ、五郎は捕らえられ頼朝の面前に引き出される。頼朝は兄弟の武勇を賞賛したが、五郎は斬首された。兄弟の仇討ちは日本三大仇討ちの一つとして、後の世まで称えられる。

18 years later in May, 1193, Yoritomo has become shogun and plans a great hunt on Mt. Fuji, assigning his trusted retainer Kudo Suketsune as marshal. On the 28th of that same month, Sukeyasu's sons Juro and Goro sneak into the hunting party and heroically avenge their father. Juro is killed in combat, but Goro is captured and taken away. Yoritomo praised the two brothers' heroism, but eventually had Goro beheaded. Juro and Goro's story is one of three great revenge stories touted as the greatest in Japan.

5. 曽我物語の人気 —— The Popularity of *Soga Monogatari*

兄弟が曽我姓を名乗るのは、母満江御前が相模の曽我祐信に再嫁したため。養父のもとで18年の苦節に耐え仇討ちを成し遂げ、短い生涯を閉じた曽我兄弟を民衆はひいきにした。二人の活躍を描いた『曽我物語』は大いに親しまれ、能や歌舞伎の恰好の題材となった。河津の八幡神社には兄弟像と、力石を持ち上げる河津三郎の像がある。小田原下曽我では、毎年5月に二人の霊を慰める「曽我の傘焼きまつり」が開催され、歌舞伎俳優も参加する。

The reason the brothers take on the surname Soga is that their mother married Soga Sukenobu of Sagami region. The boys lived with their step-father for 18 years, after which they were finally able to avenge their father. Their story of vengeance and of lives cut short is a very popular one. The story *Soga Monogatari* is beloved by many, and the story is the basis for noh and kabuki plays as well. At the Kawazu Hachiman Shrine you can find a statue of the Soga brothers and of Kawazu Saburo lifting a boulder. The Soga Umbrella-burning Festival is held every May in Shimo-soga, Odawara city to calm the spirits of the brothers.

6. 二股膏薬 —— Futamata-koyaku (Two-Faced)

工藤の館ではまず大名たちが皆うち揃って、頼朝の覚えめでたい工藤にこびへつらう様が描かれる。大名たちのせりふにあるのが「二股膏薬」。内股に貼った膏薬は足の動きにつれて右足に付いたり、左足に付いたりすることから、自分の信念を持たずに、権力のある人物のほうに味方する大名たちが自らの処世術をうそぶいて言うのだ。信念を曲げず仇討ちを期す兄弟を、信念を持たない連中が取り囲んで囃し、二人をさらに際立たせている。

At the Suketsune palace, the daimyo lords gather and Yoritomo is shown to be rather obsequious toward Suketsune. As the daimyo are talking a word meaning two-faced (*futamata-koyaku*) comes up. This reflects upon the daimyo, who are all men who blindly side with whoever happens to be in power with no real convictions of their own. When these men surround the Soga brothers, they only serve to illuminate their deep conviction.

7. 親の仇は座頭が演じる —— The Villain Played by the Kabuki Troupe Leader

兄弟が工藤祐経の館の宴席に入り込み、仇工藤と対面する場面が『寿曽我対面』である。仇を目前にした兄弟の逸る胸の内と、二人を兄弟と知った工藤の心の対比が見どころだ。仇と狙われる工藤は、物語の上からは敵役であるはずだが、歌舞伎では一座の要である座頭の演じる役に変えた。頼朝から命ぜられた、富士のすそ野の巻狩の総奉行の大役を果たしたら、潔く二人に討たれようという心を示す、格のある役である。

The scene in which the Soga brothers confront Suketsune during a banquet at his palace to avenge their father is called "Kotobuki Soga no Taimen." It is a deeply impactful scene which beautifully depicts both the brothers' unbearable anticipation at the thought of achieving their revenge, and Suketsune's bold and knowing rise to the challenge. Though Suketsune is the villain of this story, his role is played by the kabuki troupe leader. He is a character of principle who graciously gives the brothers the opportunity of vengeance after he has fulfilled his duties at the ritual hunt that he is to martial under Yoritomo's orders.

8. 大願成就の芝居は正月に —— Plays of Great Ambition Performed at the New Year

曽我兄弟の仇討ちは、歌舞伎でも様々に脚色され、それらを「曽我物(曽我狂言)」と総称する。仇討ちの大願成就の物語はめでたいこととして受け止められ、江戸時代のある年、正月に「曽我物」の芝居を出したところ大当たりしたので、それ以後正月には「曽我物」が上演される習わしとなった。そのため、おびただしい数の「曽我物」があり、様々な趣向の対面が創作された。現在『寿曽我対面』として上演されているのは明治に整理された台本演出によっている。

The story of the Soga brothers' revenge is commonly called "Soga-mono" or "Soga-kyogen." Such stories of successful revenge are considered auspicious, and Soga-mono gained great popularity in new year celebrations after a particular performance during the Edo period (1603–1868). Soga-mono became a staple of new year celebrations, and as a result, various versions of the story were created over the years. The modern version of "Soga" is based on the script that was established in the Meiji period (1868–1912).

Appendix

付録

Historical Period Dramas ── 時代物

歌舞伎の歴史

日本の伝統芸能と歌舞伎の特徴

日本には伝統的な音楽・舞踊・演劇などが数多く伝承されています。

成立した順に挙げると、まず雅楽があります。現在伝わる形が整ったのが、10世紀頃。1000年以上の歴史がある音楽と舞で、宮廷音楽として、また寺社で受け継がれました。貴族たちの芸能といっていいでしょう。

次が能楽。能と狂言を合わせた呼び名で、室町時代に大成し、650年近い歴史があります。江戸時代は武家式楽、武士の儀に使われる音楽となりました。いわば武士たちの芸能。

そして、歌舞伎。

それから、人形浄瑠璃、文楽。浄瑠璃という音曲の語りに合わせ人形が動く人形浄瑠璃の内、現在、義太夫節を使用する「文楽」が代表的です。義太夫節の成立は300年ほど前。

また、沖縄には、宮廷の音楽として作られ、300年近い歴史を有する「くみおどり」が伝わっています。

今上げた五つの芸能は、ユネスコの無形文化遺産にも登録され、日本を代表する古典芸能です。さらに、落語や講談などの大衆芸能、琴や三味線を使った音楽、舞などの古典舞踊などもあります。これらは、国も専用の劇場を設け保護育成に力を入れている音楽・舞踊・演劇であり、それぞれ専門の実演家、プロフェッショナルがいる芸能、いわゆる人間国宝が出るジャンルともいえます。

実はこれほど古い芸能が数多く残っているのは世界的にも珍しいのです。

西欧では、新しい芸術が起きると、先行するものは淘汰されてしまうことが多い。それは芸能も同じで、先行の芸能は衰退してしまうのがほとんどです。ところが日本では、先行する芸能も大事に伝承してきました。いくつものジャンルがあって、それぞれ歴史が古い、これが日本の古典芸能の大きな特徴です。

さらにもう少し大きく見ていくと、民俗芸能といわれるものがあります。地域の祭りや行事などの際、普段は別の仕事をしている人たちにより演奏され、演じられます。この中にもアイヌの民俗音楽など、無形文化遺産に登録されている芸能があります。

また、声明などに代表される宗教音楽、さらに、民謡、盆踊り、太鼓、また、津軽三味線、沖縄の三線など、地方独自の音楽もあります。

少し周りを見渡してみると、現代でも伝統的な音楽や舞踊は意外と身近にあるのです。

そして、明治から取り入れた西洋の音楽や舞踊、これもまた、当たり前のように身近にある。どころか、世界中で活躍している音楽家やダンサーも輩出しています。

つまり、日本には伝統的な音楽や舞踊も、西洋的な音楽や舞踊も身近にあり、我々はその中で生活している。なかなか気が付かないことですが、これは日本の文化の大きな特徴なのです。

宮中や寺社で継承された雅楽、武家に庇護された能楽、宮廷音楽として発生した組踊と違い、人形浄瑠璃と歌舞伎は庶民が支持した芸能です。歴史をみても権力者による庇護はおろか、むしろ弾圧をうける方が多く、その網の目をかいくぐってきました。

次からはその歴史を見てみましょう。

歌舞伎の歴史①──野郎歌舞伎まで

慶長8(1603)年、京都でお国(出雲阿国)という女性が始めた「歌舞伎踊り」が歌舞伎の発祥とされます。

これは歴史の教科書にも載っていることなので、ご存知の方も多いでしょう。

では、なぜ女性の始めた芸能が、現在は男性だけによって演じられているのでしょう。実は現在の歌舞伎に至るまで、様々な紆余曲折があったのです。ここでは現在の歌舞伎の直接的な始まり「野郎歌舞伎」までの道のりをたどります。

さて、お国の「歌舞伎踊り」は男女混交の一座により、歌と踊りを中心に、時に滑稽な寸劇が上演されました。お国は当時流行していた「かぶき者」の男に扮し、茶屋の女に扮した男性のもとに通う、茶屋遊びの踊りを見せたと言われています。この芸能は「お国歌舞伎」とも呼ばれ大流行。そのスタイルはすぐ全国に追随者を生み出しました。

類似の集団に加え、人気に目を付けた遊女屋が抱えている遊女を舞台に上げ、歌や踊りを見せ始めました。遊女も含めた女性が登場する「女歌舞伎」は人気を博しましたが、風紀を乱すという理由で幕府は女性芸能を禁止してしまいます。

かわりに台頭してきたのが、若い少年たちが歌舞を見せる「若衆歌舞伎」。これは「女歌舞伎」全盛時代から並行して行われてきていましたが、「女歌舞伎」衰退により一世を風靡しました。しかしこれも風紀を乱すという理由で禁止されます。

一旦消えかけた歌舞伎の火は、関係者の熱意により、若衆

たちの若さと色気のシンボルである前髪を剃り落とし、野郎頭で演じる「野郎歌舞伎」として再興しました。

この「野郎歌舞伎」が現在の歌舞伎につながります。前髪を剃り落とされ、容色だけで売ることができなくなったこと、また、「狂言尽くし」として、歌舞でなく、演劇を主体とするように制限されたことが、現在の歌舞伎への道を切り拓いたのです。

お国が演じたレビュー的な「歌舞伎踊り」は、度重なる禁令と圧力を巧みにかわし、やがて男性のみで演じる演劇として姿を変えたのです。

「歌舞伎」と「傾（かぶ）き」

現在用いられる「歌舞伎」の表記は、音楽的（歌）で、舞踊の要素（舞）、芝居の要素（伎）もある演劇という特徴をよく表していますが、これは、後世の当て字。「かぶき」という言葉は、並外れたもの、常軌を逸するものという意味の「傾く（かぶく）」という動詞から来ています。

お国が歌舞伎踊りを始めた当時、「かぶき者」と呼ばれる一団がいました。わざと珍しい、人の目を驚かせるような奇抜な扮装や髪型をしたり、わざわざ目立つような行動を取ったりする若者たちでした。お国はかぶき者の男性に扮して、かぶき者たちの行動を舞台に取り入れました。

発生がかぶき者たちの姿を取り入れてできた芸能ゆえか、歌舞伎には常に同時代の流行を取り入れたいという傾向があるのです。

歌舞伎の歴史②──野郎歌舞伎から現在まで

野郎歌舞伎として再出発した歌舞伎は、江戸から現在にいたるまで様々に発展してきました。長い期間にわたる話なので、駆け足になりますが、後の「歌舞伎の言葉」で説明する用語を中心にざっと見ていきましょう。

元禄時代、江戸で「荒事」、上方で「和事」という対照的な芸が生まれました。また、この時代の作者としては近松門左衛門が知られています。やがて、人形浄瑠璃（現在の文楽）が、ドラマ性の優れる数多くの作品を生み出し人気を博したので、それらの作品を取り入れ上演するようになります。これらの作品を「義太夫狂言」と呼び、レパートリーの大きな位置を占めています。

文化文政期には、江戸で四世鶴屋南北が作者として活躍。南北が得意としたのは、それまでの「世話物」をさらにリアルにした、後に「生世話」と呼ばれるジャンルでした。

江戸の終わりには「歌舞伎十八番」が制定されました。天保の改革では当時辺鄙であった浅草猿若町に劇場移転を命じられたり、人気俳優の追放などの弾圧をうけました。また、明治にかけては作者の河竹黙阿弥が活躍しました。

一方、舞踊も「三味線音楽」とともに目覚ましく発達を遂げました。天明期の舞踊や、江戸中期以降に流行した「変化舞踊」。江戸の終わりに端を発し、明治以降多く作られた「松羽目舞踊」など、様々な演目が今に伝えられています。

そのほか、舞台機構も発達。「花道」「廻り舞台」「セリ」など現在でも多用される機構が発達しました。

やがて明治維新を迎えると、歌舞伎も大きな転機を迎えます。高尚な作品を上演するようにという明治新政府の意向を受け、歴史に忠実であることを目指した、後に「活歴物」と呼ばれる作品群や、新たな時代の風俗をそのまま取り入れた「散切物」などの作品が生まれました。その後、外部の劇作家による、西洋戯曲に倣った「新歌舞伎」が新たなレパートリーに加わりました。

その後も軍部の統制、空襲による劇場の焼失、占領軍による封建的演目の上演禁止などの危機を乗り越えましたが、生活の急激な変化などにより、一時は公演数も少なくなります。しかし関係者の不断の努力もあり現在は隆盛が続いています。

また、海外公演を積極的に行い、日本だけでなく、広く世界の歌舞伎として認知されています。

以上駆け足で概要を紹介しましたが、歌舞伎の歴史は決していつでも順調だったわけではありません。激動する時代に適応し、たくましく歴史を重ねていることがおわかりいただけたのではないかと思います。

歌舞伎のように発生当時から今に至るまでショウビジネスとして成り立っている芸能というのは、ユネスコの無形文化遺産に登録されている世界の芸能の中で類を見ないことなのです。

The History of Kabuki

Traditional Japanese Performance Arts and the Characteristics of Kabuki

In Japan, there are many a great number of traditional styles of music, dance, and drama, each of which has been carefully passed down from generation to generation.

Gagaku music is the very first of these art forms to develop, the style as we know it today having been established in the 10th century. This thousand-year-old tradition of court music was passed down directly from the court and through temples and shrines. It is a high form of music originally meant for the aristocracy.

The next performance art to develop in Japan is *nogaku*. A general term that includes both noh and *kyogen* dramatic forms, *nogaku* was popular during the Muromachi Period of Japan (1336–1573) and has a history of over 650 years. In the Edo Period (1603–1868), samurai started using this style of music for ceremonies. It thus became very closely associated with the warrior class.

And finally, we come to kabuki and the puppet theater, *bunraku*.

The puppet theater involves the use of puppets which are skillfully manipulated in sync with the music and actors' spoken word. "*Bunraku*" which uses *gidayu-bushi* music is the most commonly known form of puppet theater and was established about 300 years ago. There is also a style of puppet theater music used by the royal court in Okinawa that has close to 300 years of history. This tradition is called "*kumi-odori*."

The above five performing arts are inscribed by UNESCO as intangible cultural heritage elements, and as such are the most representative of Japan's classical performing arts. There are, of course, many other performance arts, such as *rakugo* and *kodan* storytelling, *koto* and *shamisen* music, and traditional dances like *buyo*. These all fall under the categories of music, dance, or drama. The Japanese government has erected specialized theaters and supports the training of professionals in each field. These arts forms require specially trained professionals, and often produce living national treasures.

The number of ancient arts that have been preserved in Japan is actually quite high when compared to countries around the world. In western Europe it is common for new technologies to supersede the old, and the same goes for performance arts: when a new performance art is born, the previous one inevitably goes into decline. In Japan, however, the older traditions are passed on just as diligently as newer art forms. The most unique characteristic of Japanese arts is that there are so many genres, each with its own rich history.

There are also a number of folk art forms that have not been mentioned yet. These include the music played during regional festivals, often by locals who have normal day jobs. Another prime example is the folk music of the Ainu (native people of northern Japan), which has been inscribed as an intangible cultural heritage element.

Another example is Buddhist chants called "*shomyo*," a type of religious music. *Min'yo* folk songs, *bon-odori* dance, taiko drums, *Tsugaru-shamisen* and Okinawan *sanshin* music are just a few examples of Japan's rich tradition of unique regional arts.

Look around Japan and you'll find traditional art forms all around you. Our country has also absorbed a great number of Western art forms, and they, too, can be found everywhere in Japan. What's more, Japan boasts a great number of musicians and dancers who enjoy international acclaim.

The Japanese live amongst this rich intermingling of traditional Japanese and modern Western arts. Easy to overlook, this is one of the unique characteristics of Japanese culture.

Gagaku was preserved by shrines and temples, nogaku by samurai, and *kumi-odori* by the court. The puppet theater and kabuki, however, were popular arts supported by the public. Historically, these arts received no support from the government. In fact, they were often suppressed. Despite this, however, these dramatic art forms persevered.

Let's take a closer look at the history of the puppet and kabuki theaters.

History of Kabuki 1 —Beginnings to *Yaro-kabuki*

As commonly noted in history books, kabuki originated as a style of dance called *kabuki-odori*, which was developed in Kyoto in 1603 by a woman named Izumo no Okuni.

Now, how did this art created by a woman turn into a dramatic form performed exclusively by men? Well, there were a lot of twists and turns along the way before kabuki became what it is today. First, let's look at the early history leading up to *yaro-kabuki*, a form which more closely resembles modern kabuki.

Okuni's *kabuki-odori* featured a mix of both women and men depicting often comical sketches through song and dance. Okuni herself would dress as a male "*kabuki-mono*" and a male actor would dress as a female tea-shop worker. The two would perform a dance called "*chaya-asobi*," or "tea-house fun." Also called "*Okuni-kabuki*," *kabuki-odori* gained incredible popularity all around the country.

Soon rival troupes were formed, and brothels also began having their prostitutes perform songs and dance in this new style. "*Onna-kabuki*," for which prostitutes were used, gained enormous popularity, but was soon banned by the shogun because of its

negative effect on public morality.

With the decline of onna-kabuki came the rise of "*wakashu-kabuki*," which had young boys perform instead of women. Despite its popularity, however, wakashu-kabuki was likewise prohibited due to its negative effects on public morality.

In response to these prohibitions, a new form of kabuki was developed which eliminated boy actors and the sexually suggestive bangs that female roles often called for. This new form of kabuki was called "*yaro-kabuki*."

Modern kabuki is derived from *yaro-kabuki*. With this new form of kabuki, actors who could no longer wear bangs were forced to rely on more than physical features to charm audiences. Furthermore, instead of song and dance, performers were made to use their dramatic skills in a form called "*kyogen-tsukushi*." These developments are what paved the road for modern-day kabuki.

Okuni's kabuki-odori evolved in response to the numerous prohibitions which threatened to stifle it, and thus it became a dramatic art performed exclusively by men.

Etymology of "Kabuki"

The modern-day word "kabuki" uses three Chinese characters meaning "song," "dance," and "skill," but these do not indicate kabuki's original meaning. The word "kabuki" derives from a verb meaning "to slant," and used to referred to an off-beat or eccentric person.

In Okuni's time, there were people known as "*kabuki-mono*," who donned strange clothes and hair styles, and conducted themselves in a strange fashion deliberately to shock other people. Okuni herself chose to dress as these *kabuki-mono* and incorporate their ways into her *kabuki-odori*.

It may be because kabuki originally sought to incorporate eccentricity that it continued to integrate modern fads into its performances through the ages.

History of Kabuki 2
— From *Yaro* to modern-day kabuki

The reborn *yaro-kabuki* underwent many changes from the Edo period (1603–1868) to the modern day. Since we will now cover a long period of history, this will be an abridged explanation. We recommend referring to the "Kabuki Glossary" for more detailed information about kabuki terms.

During the Genroku years (1688–1704), two contrasting performance styles developed: "*aragoto*" in Edo (Tokyo) and "*wagoto*" in Kyoto. The renowned writer Chikamatsu Monzaemon is also from this period. He and his contemporaries wrote a great number of masterful dramatic works for the puppet theater (*bunraku*), making it the premier dramatic form of the time. These plays are commonly called "*gidayu-kyogen*" and constitute a large part of the repertoire.

The Bunka-Bunsei years (1688–1704) saw the works of Nanboku Tsuruya IV, who developed the "*nama-sewamono*" which brought a deeper realistic element to the everyday genre of "*sewamono*."

The Eighteen Great Kabuki Plays was established at the end of the Edo Period. The Tenpo years (1830–1844) saw various reforms resulting in the banishment of many actors from Edo and the relocation of theaters to Asakusa on the outskirts of the city. The dramatist Kawatake Mokuami was active during these final years of Edo and well into the Meiji Period (1868–1912).

While the dramatic arts were dampened, buyo dance thrived alongside *shamisen* music. The *buyo* style of dance from the Tenmei years (1781–1789) developed into the henka-buyo dance popular from the mid-Edo period, and the *hatsubame* style of dance was born at the end of the Edo period, continuing to thrive during the subsequent Meiji period.

Great developments were also made in staging and mechanics during this period, including the *hanamichi* platforms, the *mawari-butai* (rotating stage), and the *seri* lift.

With the Meiji Restoration, kabuki once again saw a great shift. Under orders from the Meiji Government to produce plays of high artistic value, writers now focused on plays that were historically accurate, now called "*katsureki-mono*." Another new form, called "*zangimono*," were meant to integrate aspects of modern thought and ways. Furthermore, a new style of kabuki that attempted to imitate Western theater was developed by non-kabuki writers. This new form was called "*shin-kabuki*" (new kabuki).

Later during the war, a number of playhouses were burned down in air raids, and during the occupation all feudalistic plays were prohibited. Kabuki persevered through this, but even after the occupation, due to the aftershock of the war kabuki plays were scarce for a time. Despite this, the art form was faithfully preserved and now enjoys great popularity again.

Nowadays kabuki is not only performed in Japan, but in countries all around the world.

This ends our abridged overview of kabuki's history. As you can see, kabuki did not always enjoy the popularity it has now but evolved with the violent changes of history to become what it is today. We hope that our readers have gained an appreciation for this rich history.

Kabuki started and developed until the modern day as a show business that exhibited great innovation and adaptability to survive to the modern day. We believe it is a performance art unlike any other inscribed as a UNESCO intangible cultural heritage element.

付録　歌舞伎の見方

　もとより歌舞伎に「正しい」見方や作法、堅苦しいルールなどはありません。それぞれの心のままに見て楽しんでもらえればそれで十分であり、観客の数だけ見方があるともいえます。

　しかし中には、心のままに、と言われても不安が残る方もいるようです。難しいのではないか、勉強しないと理解できないのではないか、などと見ない前から思い込んでいる方もいます。見たことがない方ほどその傾向は強く、堅苦しいものと決めつけてしまう人も多い。こうした思い込み、不安が先に立ち、歌舞伎の魅力に触れることができないとしたら、これは大変にもったいないことです。

歌舞伎は「商業演劇」

　歌舞伎は400年を超す歴史を持ち、日本を代表する古典芸能の一つとして、ユネスコの無形文化遺産にも登録されていることはご承知の通り。それと同時に、発生から現在に至るまで、観客の入場料ですべてを賄う「商業演劇」でもあり続けています。これは大きな特徴です。

　観客の支持なくしては立ち行かないのですから、観客の喜ぶものは何でも取り入れてきました。その集積が現在の歌舞伎です。400年以上お客様を喜ばせ続けてきた芸能、とも言えましょう。

　現在隆盛の歌舞伎ですが、世間でよく言われるように、難しく退屈なだけの芸能だったら、果たしてこれほど多くの観客を集められるでしょうか。400年にもわたり続くでしょうか。

　しかも、一度でも劇場に足を運んでいただけばわかるのですが、多くの観客が舞台を見ながら、笑ったり、涙を流したり、と舞台を楽しんでいます。現代においても十分「楽しめる」演劇なのです。「古典」や「伝統」と肩書がつくと、まるで博物館に展示されている骨董品であるかのように思えますが、現代の俳優が演じ、現代の観客が見て楽しんでいる、現代のエンターテインメントなのです。

　もちろん長い時間をかけ磨き抜かれ、古典というにふさわしい大きさと深さを持つ戯曲や役も数多くあります。古典ならではの豊かな世界に身を任せ、深い感銘を抱く、これも楽しみの一つであることはいうまでもありません。

歌舞伎といってもいろいろある

　歌舞伎を初めて観劇した人から、思っていたよりも「〇〇」だった、という声を聞くことがあります。「〇〇」の内容は様々ですが、いずれも観劇前に抱いていた印象——綺麗だとか華やかなどのプラスの印象もあれば、退屈そうだとか寝てしまいそうだというマイナスの印象もある——とは違っていた、といいます。

　観客の喜ぶものを取り入れ成長した歌舞伎は、実は大変に幅が広く、バラエティーに富んでいます。ひと口に歌舞伎といってもいろいろとあるのです。

　一般によく言われる歌舞伎のイメージがあります。例えば顔や体に色の線を描く独特の化粧「隈取」や、男性が女性の役も演じる「女方」、大きくポーズを決める「見得」、独特の発声と台詞まわし、などです。誇張されたものではありますが、これらは確かに歌舞伎の一部。しかしすべてではありません。

　隈取は歌舞伎を特徴づけるものですが、歌舞伎の演目に必ず隈取の化粧をした人物が登場するわけではなく、隈取の人物が一人も登場しない演目も数多くあります。劇場に行くと隈取が見られるだろうと思っている人がそうした演目を見ると、これは私が想像していた歌舞伎とは違う、となるかもしれません。

　『勧進帳』という演目はよく知られていますが、この演目には女性の役はありません。普段女性を演じている女方の俳優が、源義経の役で出演することはありますが、これは男性の役。『鈴ヶ森』と呼ばれる演目も登場人物は男ばかり。つまり、女方といえども、すべての演目に登場するわけではありません。

　独特の発声と台詞まわしも、実は様々な演技様式のうちの一つであり、様式が違えば台詞の印象も大きく違います。また、難しいと思われがちな言葉にしても、平易な現代語による脚本も数多くあります。

　なかには、見終わって、これ《が》歌舞伎なの、と驚かれる作品もありますが、それ《も》歌舞伎。最初にこうしたもの、と思い込んでくると、大概そのイメージは覆される、それほど歌舞伎のレパートリーは広くて深いのです。

　歌舞伎の幅広さを理解するには、「映画」に置き換えるとわかり易いかもしれません。ひと口に映画といっても様々です。ハリウッドの超大作、単館で上映される小品。ミュージカル、ホラー、スプラッタ。恋愛もの、アクション。アニメ、コメディー、ドキュメンタリー。歌舞伎も同じで、様々なジャンルの演目が揃っています。

　幅広いレパートリーを持っていますので、華やかな世界を期待していったら、たまたまその月は渋い演目だった、とか、古典を期待していったら、新作歌舞伎の月だったなど、ミスマッチも起こります。ただそれで歌舞伎＝（イコール）つまらな

い、ということになってしまうのは残念、もったいない。

　映画であれば、たまたまミュージカル映画を最初に見たからといって、映画には必ず歌や踊りがあるものとは思わないはず。たまたま見た映画が面白くなかったからといって、映画というジャンル自体をつまらないものと決めつけはしないでしょう。

　ところが、歌舞伎は、最初に見たものが気に入らないと、歌舞伎そのものがつまらないと思われてしまう。いろいろとある中の一部分でしかないものをそれだけで判断されてしまうのです。

　初めて歌舞伎を見たら、想像していた通りだったということもあるけれど、思っていたのと違うこともある。その時、思っていたのと違うけれど、これはこれで面白い、となる方もいるし、思っていたのと違うからダメだとなる方もいる。

　もし、見たものが「私の考える歌舞伎」と違っても、ぜひ演目を選んで再挑戦してみてください。必ず「あなたの考える歌舞伎」が見つかるはず。逆に言えば何かしらお気に召す歌舞伎はあるはずです。

　そしてそこから様々な歌舞伎に触れてみてください。あなたの考えていた歌舞伎以外にもきっと面白い歌舞伎が見つかるはずです。

歌舞伎の見方

　「歌舞伎は商業演劇であり、今を生きているエンターテインメントである」ということと、「歌舞伎といってもいろいろある」この二点を覚えておいて、肩に力を入れず、気持ちを楽に持って、生の歌舞伎に触れてみてください。

　歌舞伎には一言では言い尽くせないほどの魅力が詰まっています。

　とにかく一遍実際に歌舞伎を「体験」してみてください。400年間エンターテインメントであり続けた歌舞伎は、様々な魅力や特徴を備えています。俳優の姿や演技、衣裳の華やかさ、音楽の楽しさ、お芝居の内容。きっとどこかで何かしら感じるところがあるはず。どこをどう面白いと思うか、素敵だと思うかはご覧になった方次第。そこを入り口にして、歌舞伎の世界を覗いてみてください。間口が広くて奥が深い、すばらしい世界が目の前に広がります。

　同じ時間と空間を共有するのが、歌舞伎に限らずライブパフォーマンスの醍醐味です。その時、その場所で起こることを楽しむこと、歌舞伎の見方、というものがあるとしたらこの一言に尽きるだろうと思います。

　ざっくりまとめると、歌舞伎の「多様性」と「商業性」の話で、あまり堅く考えすぎないで、ライブを楽しみに来てくださいね、というのが大意です。

　ところでこの多様性、歌舞伎の特徴の一つでもあります。

　歌舞伎に携わる人々には常にこの多様な演目とそれらの様式を身につけること、また、継承と創造との両方に精進することが課せられているともいえましょう。

　一方で古典であり堅苦しく、敷居が高いと思われ、もう一方で、様々な新しい試みがマスコミで大きく報道されています。ややともすると現代的な試みばかりもてはやされがちですが、これらの試みも古典あってのこと。歌舞伎の俳優やスタッフは、そのことをよく知っています。どちらも歌舞伎であって、どちらも必要なことなのです。

　「商業性」については、これが舞台の原動力であることは言うまでもありません。

　ただし注意していただきたいのは、しばしば商業性と芸術性が対立しているかのように考えられることです。商業的になりすぎると芸術性が失われてしまう、むしろ芸術とは商業的であってはならないという考えすら見受けられます。確かに相反することもありますが、決して両立しないものではありません。商業的であることが芸術的ではないということは決してないのです。

　歌舞伎を見たことがない人でも歌舞伎俳優の名前や顔を知っています。それは歌舞伎の俳優は映画やテレビにも出ているからです。時代劇はもちろん、現代を舞台にしたドラマなどにも出演しています。では、歌舞伎以外の伝統芸能の関係者で、ドラマに出演する人は何人ぐらいいるでしょうか。数人はいらっしゃいますが、歌舞伎ほど多くはいません。

　歌舞伎の俳優は、舞台のみならず映画やテレビにも出演しており、歌舞伎を知らない人にも知られている。歌舞伎の俳優は、伝統の担い手であると同時に、現在でも一般的な知名度が高く、人気がある。これはほかの伝統芸能にはない、大きな特徴です。

　また東京の歌舞伎座を国の施設だと勘違いしている人もいますが、歌舞伎座は松竹が経営しています。伝統芸能でもありながら、現代でも民間企業が公演する商業演劇でもあるのが現在の歌舞伎なのです。

How to Watch Kabuki

There is no such thing as a "proper" way to watch kabuki, nor are there any strict rules. The only thing a viewer has to do is watch and enjoy in his or her own way. You could say that there are as many ways to watch kabuki as there are audience members.

That being said, many still feel uneasy about watching kabuki, thinking that it will be too difficult to understand without studying beforehand. This is especially true of those who have never seen a kabuki play before. However, it would be a terrible shame if such preconceptions kept potential viewers from ever enjoying the many charms of kabuki.

Kabuki is Commercial!

One of Japan's representative classical art forms, kabuki boasts a history of over 400 years and is inscribed by UNESCO as an intangible cultural heritage element. At the same time, kabuki developed over the years funded entirely by its viewers who paid for entrance at theaters. This commercial element is a unique characteristic of kabuki. Since it couldn't survive without the support of its viewers, kabuki has constantly added new elements to please its audiences, and modern kabuki is the accumulation of that 400-year history of happy audiences.

Modern kabuki, too, is incredibly popular, and it is often argued that a boring, archaic art form couldn't possibly garner the audience that kabuki has, let alone survive off proceedings alone for 400 years. If you ever make your way to a performance, you'll see that kabuki audiences are incredibly engaged, laughing and crying throughout the program. When we use heavy terms like "classic" and "traditional" to describe kabuki, it may feel like an antique displayed at a museum. But in reality, contemporary actors stand on the stage and people just like you and me are in the audience watching. Kabuki really is a very modern form of entertainment.

Of course, many kabuki plays are old classics that have stood the test of time. Being able to enjoy these rich pieces of classical literature that have been polished over hundreds of years is naturally one of the many joys of the kabuki theater.

Kabuki is Multi-faceted

Many first-time viewers of kabuki say that it wasn't what they expected. Now, what they expected and how it was different varies greatly from person to person—some people expect brilliant stages and costumes, while others expect to be bored to death. This is because kabuki, which evolved by constantly incorporating new elements to bring joy to audiences, has an incredibly varied repertoire. The word "kabuki" itself, therefore, cannot be summed up by any single image or expectation.

There are many well-known characteristics of kabuki, such as the bold kumadori makeup that is applied to the face and body of actors. Other characteristics of kabuki include *onnagata* (male actors who play female roles), bold poses called *mie*, and unique cadences and speech styles used by actors. These are indeed a part of kabuki, but it would be a mistake to think that any one of these applies to all of kabuki.

Kumadori is considered a staple of kabuki, but in fact kabuki plays do not all necessarily feature this unique makeup style. In fact, there are entire plays in which not a single actor wears *kumadori*. If you went to kabuki expecting *kumadori*, but happened to choose a play such as this, undoubtedly you will be surprised and even disappointed when the play ends.

Kanjincho is a very well-known play that features absolutely no *onnagata* parts. Sometimes an *onnagata* actor will play Minamoto no Yoshitsune, but the role is still that of a man. The play Suzu ga Mori is another play featuring all male characters. As you can see, kabuki does not necessarily imply the presence of *onnagata*.

The same goes for the unique cadences of kabuki. There are actually a number of different styles that can be used, and which is used may greatly affect the ultimate impression left on the audience. Furthermore, some old plays which originally used very antiquated and difficult language have been rewritten to be easier to understand.

It is very easy to see why some viewers get to the end of a play and think, is this really kabuki? The answer is yes, this too is kabuki. If you are convinced that kabuki must be this or that way, your entire view of it may be turned upside down by the time you get to the end of a play. That is just how deep and varied the kabuki repertoire is.

An easy way to think of this may be to compare kabuki to movies. The word "movie" encapsulates an unbelievable variety of genres, from big Hollywood blockbusters to independent films only shown at small local theaters, from musicals to horror films. Even within the horror genre there are subgenres such as splatter films. There are romantic, action, animated, comedy, documentary, and various other genres. Now, just think of kabuki the same way, with the same rich variety of genres.

It is because of this great variety that viewers are sometimes surprised at the plays they see. Some expect an opulent piece only to find they went to the theater during the run of a very dark play, while others may expect a classic piece only to find that the theater was producing a *shinsaku-kabuki* (contemporary kabuki) program that month.

However, it would be a shame for those viewers to think that all kabuki is uninteresting from just one such experience. If the first movie you saw was a musical, you probably wouldn't assume that all movies include singing and dancing. Neither would you assume all movies are boring just because of a bad movie you happened to watch.

When it comes to kabuki, however, this is exactly what some viewers do. Often times, viewers see a single play that only showcases a fragment of kabuki's variety, yet they proceed to cast judgement on the entire field. Some viewers may find that the play they watched was exactly what they expected, while others find it completely different. Some find kabuki interesting from the start, while others are displeased by their experience.

If you happen to see a kabuki production that didn't live up to your expectations, then try picking a different program next time. There are definitely plays that will live up to those expectations. To put it another way, I'm confident that, among the vast repertoire of kabuki, there is a play out there for you. Once you've found that, I encourage you to branch out from there. If you do, you are bound to find that some of the plays that don't quite match those initial expectations are quite enjoyable.

How to Watch Kabuki

Kabuki is commercial—a constantly changing, living form of entertainment. It also encapsulates an incredible depth of variety. From now on I ask that you approach kabuki with these two points in mind, and when you get to the theater, just relax and enjoy the story that unfolds before your eyes.

The many charms of kabuki defy attempts to define it in a single word, but I encourage everyone to go and see one live. It is a 400-year-old form of entertainment that has evolved and grown with audiences over the ages. The actors' stances and performance styles, the gorgeous costumes, the unique music, and the stories themselves—every aspect of kabuki is the product of years of tradition and evolution, and there is bound to be something that moves you. What it is that you find funny, stunning, or deeply moving, is entirely up to you. Whatever it is, use that as your gateway to the world of kabuki. An incredibly vast and deep world is just waiting for you to explore.

When watching kabuki, there is an incredible sensation of sharing in this moment, in this space. This isn't unique to kabuki; it is exactly what makes any live performance exciting. If I had to explain what the proper way to watch kabuki is, it would be simply that: experiencing the events unfolding before you, here and now.

In other words, as a multi-layered form of commercial entertainment, don't think too hard about what kabuki is. Rather, just sit back and enjoy the live performance.

The variety of experience is again another important aspect of kabuki. In the past, many have tried expounding on kabuki as though it could be expressed in so many sentences. But kabuki is something that defies such simple explanations. After all, by saying "kabuki must be thus," you run the risk of missing out on all the forms of kabuki that do not fit that description.

Those involved in the kabuki industry are constantly honing their skills to tackle the many different styles and forms that make up the industry. They are also charged two-fold with honoring long-standing traditions and creating new ones.

On the one hand, kabuki can be archaic, formal, and unapproachable, but on the other hand it can be an incredible cutting-edge experiment that spreads like fire through the media. Though we are prone to get caught up in these exciting new experiments, they are only possible because of the classics. Kabuki actors and crew members all know this, as should everyone. Both the classical and the modern are vital aspects of kabuki.

At this point it hardly warrants saying that the commercial aspect of kabuki is a driving force of the field. However, we must be careful when talking about this. It is often said that business and art are opposed to one another. Indeed, many believe that the more commercial art is, the less valuable it is as art. Some even believe that art must not be commercialized at all. I recognize that the two are at time opposed, but that does not mean that they cannot coexist. Just because art is commercialized does not take away its artistic value.

Have you ever wondered why it is that some people who have never watched kabuki nonetheless know the names of kabuki actors? The answer is simple: those actors also appear in movies and on TV. They often play in period pieces, and even in dramas set in modern times. Though there are a few artists from other traditional performance arts who appear in dramas like this, no other art boasts the number that kabuki does.

This is another important characteristic of kabuki—that many of its actors are popular figures who appear in other productions such as TV programs and movies.

Kabuki actors shoulder the heavy burden of a rich tradition but are at the same time highly popular figures widely known to the public. There are no other artists from other fields who appear on variety and quiz shows like kabuki actors do.

There are also some who come to the Kabuki-za Theatre in Tokyo and mistakenly assume it is a government-run establishment. It is in fact the Shochiku Company that runs Kabuki-za, making kabuki a truly unique hybrid—a traditional performance art and commercial show run as a private business.

歌舞伎の言葉

演目に関する言葉

【狂言】
能とともに上演される狂言。その狂言と全く同じ文字、同じ発音だが、歌舞伎関係者が狂言という時は、大概「演目」と同じような意味になる。「襲名披露狂言」「追善狂言」「狂言作者」など様々に使われる。

【みどり狂言】【通し狂言】
一日の内に数種類の演目を並べて上演する興行方法を、「みどり」「みどり狂言」という。見せ場を抜きだし並べることで、歌舞伎の持つ多彩な魅力が味わえる。漢字をあてれば「見取」で、より取り見取りのみどりだと言われている。これに対し、最初から最後まで、ストーリーを通して上演することを「通し狂言」「通し上演」という。

【純歌舞伎狂言】【義太夫狂言】【舞踊】
歌舞伎の狂言は、成立によって「純歌舞伎狂言」「義太夫狂言」「舞踊」に大別される。「舞踊」は「所作事」ともいい三味線音楽とともに発達した。また、人形浄瑠璃から移入した作品群を「義太夫狂言」や「丸本歌舞伎」などと総称する。「純歌舞伎狂言」というのは、歌舞伎のために書きおろされた演目のことである。

【和事】【荒事】
演技の様式。元禄期、京・大坂を中心とした上方と、江戸とで、それぞれ異なる芸が生まれた。上方では、後に「和事」と呼ばれる演技術が生まれた。優雅でやわらかい身のこなしが特徴。「荒事」は江戸で発達した芸で、「隈取」をはじめとする扮装や、「六方」などの演技により表現される豪快で力強い芸。

【活歴物】【散切物】
明治維新以降、時代の流れに乗り、それまでの荒唐無稽な作劇法ではなく、時代考証を重視し、史実に忠実な作品、「活歴物」が作られた。また、髷を切った散切り頭の人物が登場する「散切物」も創出された。どちらも明治の新時代に合わせ、従来の歌舞伎にはない新たな活動であった。

【新歌舞伎】【新作歌舞伎】【スーパー歌舞伎】
明治中期以降、外部の文学者・作家によって書かれた戯曲作品のことを「新歌舞伎」という。欧米の演劇や小説の影響を受けた作品が、近代的な演出で上演された。また戦後に新たに書かれた作品は、「新作歌舞伎」として区別されるのが一般的。さらに現代でも「スーパー歌舞伎」をはじめ様々な新しい試みがされている。

【時代物】
公家や武家の社会で起こった事件を題材にした演目をいう。狭義には平安中期から戦国期までの武将を主人公にした演目を指すが、平安以前の貴族社会を題材にした「王代(朝)物」、江戸時代の武家のお家騒動を題材にした「お家物」も含むことがある。
時に史実に大胆な虚構を加え、正史でない、歴史の裏側を描き出す。いわば江戸時代の庶民から見た歴史フィクション。登場人物は、名前こそ歴史上の人物だが、姿も行動もすべて徳川時代の人間の投影である。
豪華な衣裳、誇張された台詞など、いわゆる歌舞伎らしい演出が見られる。

【世話物】
「世話」とは、「世」間の「話」というほどの意味であり、世上に起こることは善悪を問わず題材となる。盗賊が主人公になる「白浪物」や、落語や講談の人情話を脚色した作品など様々な演目が含まれ、登場人物もアウトローや名もなき市井の人々といった同時代人。いわば江戸時代の現代劇である。江戸と上方で地域色あふれる演目が生まれ、今に伝承されている。
衣裳や台詞、演技も誇張の少ないものとなり、演者には、リアルな味わいが求められる。今や失われてしまった江戸時代の風俗習慣が舞台上で再現されることも楽しみの一つ。

【舞踊】
「歌舞伎踊り」から現在に至るまで、舞踊はレパートリーの大きな位置を占め、俳優は踊りの修業が欠かせない。もとは女方の専門領域であったが、やがて立役も踊るようになり、伴奏音楽の発展とともにレパートリーが広がった。音楽にのせ躍動的な動きを見せる舞踊の魅力に溢れる作品に加え、演劇的な構成と内容を持ち、かつ音楽的舞踊的な見せ場もある「舞踊劇」ともいうべき演目もある。長さも小品から大作まで多彩である。一人の踊り手が様々な役を次々踊り分ける「変化舞踊」、能狂言の様式を取り入れた「松羽目舞踊」などがある。

【新作歌舞伎】
古典の継承と新作の創造は現代の歌舞伎の大きなテーマである。一見相反するように見えるが、どちらも歌舞伎の発展には欠かせない両輪である。新作は内容や表現に新たな地平を拓くとともに、新たな客層を開拓する役目をはたし、現代においても様々な新作が試みられている。古典様式に則った擬古典的な作品、現代の作家・演出家と組んだ作品、原作をマンガなどに求めた作品もある。埋もれた過去の作品を現代に合わせ再創造することも大きな意味での新作である。優れた新作は再演を重ね、やがて新たな古典となっていくのである。

俳優に関する言葉

【名跡】【襲名】【追善】
代々継がれていく名前を「名跡」という。名優の「名跡」はことに大切にされ、継いだ俳優も、名前にふさわしい名優にならなければならないとされる。名を名乗ることを「襲名」という。襲名披露の公演はことに華やかである。また亡くなった名優を偲ぶことを「追善」とよび、追善狂言もまた華やかである。みどりのうちの一本を追善狂言として上演することもある。襲名や追善は歌舞伎の活性化につながっている。

【屋号】【俳名】
歌舞伎の俳優はそれぞれ屋号を持っている。市川家の「成田屋」が始まりといわれ、初代團十郎が成田山を信仰したことに由来するといわれる。
また「俳名」を持つ俳優もいる。俳名とは俳句の号。俳句の趣味はなくても俳名を持つ俳優もあり、名跡同様継承されることもある。また、俳名を芸名として襲名することも多い。

【女方】【立役】【敵役】
女性の役、またはその役を演じる俳優を「女方」という。対して、男性役全体、または善人の役を主に演じる俳優、またはその役を「立役」という。本来は「敵役」に対する、善方の役を指す言葉だが、後に男性の役全般を表す言葉になった。

【家の芸】
俳優の家に代々伝えられた得意芸や演目を集めたもの。市川團十郎家の「歌舞伎十八番」「新歌舞伎十八番」が知られている。他に尾上

菊五郎家の「新古演劇十種」などがある。また、俳優一代の当たり役を集めることもあり、初代中村鴈治郎の当たり役を集めた「玩辞楼十二曲」、初代中村吉右衛門の「秀山十種」などがある。最も新しいものは平成22年に選定された「三代猿之助四十八撰」である。

演技に関する言葉

【見得】
演技のクライマックスで、一瞬動きを止め、その演技を誇張する手法。多くにらみを伴う。形により「元禄見得」「柱巻の見得」などの名前がある。

【立廻り】【立師】【とんぼ】【所作立】
劇中の戦いの場面を「立廻り」、立廻りを考案する担当者を「立師」と呼ぶ。立廻りの途中、切られたり投げられたりした者が空中で回転する動きを「とんぼ」、また、舞踊の中で、曲に合わせ演じる立廻りを特に「所作立」という。

【だんまり】
登場人物が暗闇の中で探り合う動きを様式的に表した場面。暗闇の場面であるが、照明は暗くせず、明るい中で演技される。

扮装に関する言葉

【隈取】
顔の筋肉を誇張したものとも血管を表したものともいわれる。役柄により色や形が異なり、主に赤（紅色）、青（藍色）、茶（代赭色—たいしゃいろ）の三色が用いられる。赤い隈は、若さや正義、力、激しい怒りなど発散する陽の力を表し、青い隈は邪悪や怨霊など陰の力を表現。茶色の隈は、人間に化けた妖怪変化などに使用される。隈取は、筆や指で直接顔に描く。これを「隈を取る」、という。

【ぶっかえり】【引き抜き】
「引き抜き」は、衣裳を一瞬にして変える仕掛け。舞踊で曲調の変わり目に、場の雰囲気を一変させたい時などに使われる。「ぶっかえり」は隠していた正体を現したり、性格が一変する際などに使われる技法。衣裳はその役の性格や境遇を表しているので、性格が変わったり、本名を名乗るなど境遇が変わると、当然衣裳も変わるというのが歌舞伎の考え方。その大胆なデザインや色遣いで、世界的にも評価されている歌舞伎の衣裳は劇的効果を高める役割も果たしている。歌舞伎では衣裳も芝居の一部なのだ。

【黒衣】
全身黒ずくめの着衣、またはそれを着ている人を「黒衣」という。歌舞伎では、黒で無を表すので、黒く塗られている、また、黒布で覆われたり、隠されているものは、ないもの、見えないものとする、という約束がある。ゆえに黒衣姿で舞台に登場しても、その人物はいない、見えないということになる。なお、通常「くろご」と濁って発音される。

音に関する言葉

【三味線音楽】
歌舞伎には三味線音楽が欠かせない。舞台に溢れる音のほとんどは、三味線の音色だ。戦国時代に琉球から伝来したというが、「お国歌舞伎」の後に取り入れられた。当時最先端の楽器だったのだ。やがて江戸時代の音楽は三味線抜きでは語れないくらいに広がりをみせる。ひと口にいっても、様々な流派があり、音域や表現方法、用いる楽器の大きさなども違う。歌舞伎では、「長唄」「義太夫節」「常磐津節」「清元節」などが多く用いられる。

【黒御簾音楽】
舞台に向かって左手、下手にある黒御簾と呼ばれる場所で演奏される音楽。中には、長唄と囃子の担当者がいて、舞台に合わせて音楽を演奏している。ここで演奏される音楽を黒御簾音楽といい、芝居を盛り上げるバックミュージックや、雨の音や雪の音などの効果音を演奏している。水、雨、雪、幽霊の出現などを太鼓で打ち分け表現するなど優れた工夫が伝承されている。

【柝（き）】
幕開きなどに鳴る拍子木。この拍子木は「き」と呼ばれ、舞台進行の合図である。開幕、閉幕、道具の転換などはこの「柝」の合図で行われる。ゆえに、舞台進行を担当する「狂言作者」が打つことになっている。

【ツケ】
上手、舞台に向かって右側で、拍子木のような棒を板に打ち付けてバタバタという音を出すのがツケ。立廻りや見得を引き立てる、一種の効果音。

【掛け声（大向こう）】
演技の途中に客席から掛かる声。観客が演者をほめる掛け声で、大向こうと通称されるが、本来大向こうというのは客席の一部を指す言葉である。掛け声は屋号のほか、代数などを掛ける。観客も一体となって芝居を作り上げているのだ。

舞台機構の言葉

【花道】
歌舞伎に欠かせない舞台機構の一つ。舞台の一部が客席を貫いて張り出し、主要な役の登退場に使われる。観客のすぐ近くを俳優が通ることで、客席と舞台に一体感が生まれる。時にはこの花道での演技が大きな見せ場になることもある。

【セリ】
舞台を四角に切り、昇降するようにした機構。上に人物や大道具を乗せて上げ下げする。花道のセリを特別に「スッポン」と呼ぶ。「セリ」「スッポン」を使用する演出も多い。

【廻り舞台】
舞台を円形に切り、回転するようにした機構。今では外国のミュージカルなどでも使われるが、発祥は日本。現在のような大掛かりな機構は250年ほど前の大坂で、世界に先駆けてつくられた。

【揚幕】
花道の突き当たりに吊ってある幕。この幕を開け閉めして、人物が登退場する。劇場の座紋などが染め抜かれていることが多い。

【定式幕】
黒色、柿色、萌葱色の三色の引幕。歌舞伎をイメージする色としてよく知られている。色の並びは劇場により異なる。江戸時代には幕府から認められた「大芝居」のシンボルであった。

Kabuki Glossary

Performance Terms

"kyogen"
Though "*kyogen*" originally refers to short skits performed together with noh plays, it is also often used in a kabuki context. In this case, "*kyogen*" simply refers to a program. *Shumeihiro-kyogen*, for example, refers to a program featuring an actor who is succeeding to another actor's stage name.

"toshi-kyogen" and "midori-kyogen"
A program which takes scenes from various plays to perform in a single day is called "*midori-kyogen*." The term "*midori*" refers to the action of selecting the best out of a pool of candidates, making a *midori-kyogen* program the perfect way to get a taste of the kabuki's great variety. "*Toshi-kyogen*," on the other hand, refers to a program that showcases scenes from a single play in a way that shows audiences the full story.

"jun-kabuki kyogen" / "gidayu-kyogen" / "buyo"
Kabuki plays can be classified into three broad categories: *jun-kabuki-kyogen*, *gidayu-kyogen*, and *buyo*.
"*Buyo*" is a type of dance-drama that developed in conjunction with shamisen music. Several sub-genres are included in the category of buyo. "*Henka-buyo*" is a variation in which a single actor performs multiple roles, while "*matsubame-mono*" are Noh plays that were adapted for kabuki. Kabuki plays that have been adapted from bunraku scripts are called "*gidayu-kyogen*" or "*maruhon-kabuki*"
"*Jun-kabuki*," or "pure kabuki," refers to plays originally written specifically for the kabuki theater.

"aragoto" / "wagoto"
These are contrasting acting styles that developed during the Genroku Period (1688–1704) in Kyoto/Osaka and Edo (Tokyo). The graceful *wagoto* style was developed in Kyoto and Osaka, while the rough *aragoto* style was developed in Edo. The wild *kumadori* makeup and dramatic *roppo* exit are characteristics of the vigorous *aragoto* style.

"katsureki-mono" / "zangiri-mono"
During the Meiji Restoration, the writing of *bunraku* and kabuki plays shifted from the absurd and comical to the historical, and these plays were called "*katsureki-mono*." Plays featuring characters sporting the *zangiri-atama* ("cropped head") hairstyle also appeared. These were called *zangi-mono*. Both forms were innovations to kabuki that had never been seen before the Meiji Period.

"shin-kabuki" / "shinsaku-kabuki" / "super kabuki"
"*Shin-kabuki*" (new kabuki) refers to plays written by non-kabuki writers from the mid-Meiji Period onward. These pieces were influenced greatly by western theater and novels and strived for a modern performance style. Plays written after the war are commonly called "*shinsaku-kabuki*" (contemporary kabuki) while "super kabuki" refers to experimental plays written very recently.

"jidai-mono"
Broadly defined as a play featuring historical events involving nobles or warriors, a "*jidai-mono*" is narrowly defined as a piece featuring a warrior hero from the Heian through the Warring States period. Pieces featuring nobles from before the Heian Period are called "*odai-mono*" or "*ocho-mono*," and those involving family disputes of warriors from the Edo period are called "*oie-mono*."
A feature of some *jidai-mono* is the inclusion of elements that are not true to history. This historical fiction of the people often features historical names whose appearance and actions are made to reflect those of the Tokugawa Period.

"sewa-mono"
"*Sewa*" refers both to "taking care of" someone and "worldly talk." Thus "*sewa-mono*" plays depict real-life events in the world without drawing conclusions about good and evil. Including "*shiranami-mono*" in which the knave is the hero, and dramatizations of heartwarming *rakugo / kodan* stories, sewa-mono feature casts of common folk and outlaws. *Sewa-mono* were created during the Edo Period and have been passed down to the modern day.

"buyo"
"*Buyo*" dance constitutes a large part of the kabuki repertoire and has been a feature of kabuki since the original *kabuki-odori*. Therefore any aspiring kabuki actor must practice dance. Originally only required of onnagata actors, eventually leading roles came to require dancing, expanding the repertoire together with developments in music. Over time more dramatic elements were added to kabuki along with the lively movements of the buyo dance. Still, there are "*buyo-geki*" which feature striking scenes in the *buyo* style. The length of a *buyo-geki* can vary from a short sketch to an epic, from the "*henka-buyo*" featuring a single actor playing multiple parts to the "*matsubame-buyo*" which take their cue from noh plays.

"shinsaku-kabuki" (contemporary kabuki)
A major issue in modern kabuki is the balance between traditional methods and the creation of something novel. Although these two may seem contradictory at first glance, they are both vital to the development of kabuki. The creation of new works paves the way for kabuki in the modern world and attracts new audiences. Some modern dramatists conform to classical formats, while others experiment by working together with other writers and actors. There are even cases of kabuki plays based on manga! Reproductions of forgotten plays is yet another form of *shinsaku* ("new production"). The best of these *shinsaku-kabuki* plays, after all, will eventually become the classics of tomorrow.

Terms Relating to Actors

"myoseki" / "shumei" / "tsuizen"
A name that is passed down from generation to generation is called "*myoseki*." Myoseki of great actors are particularly important, and their successors are under a lot of pressure to live up to that name. "*Shumei*" refers to the act of succeeding to another's stage name. Performances honoring such a succession are often particularly lavish to denote the occasion. "*Tsuizen*" refers to the memorial of a great actor who has passed away. Tsuizen performances are also very lavish, and occasionally portions of a *midori-kyogen* will be dedicated as a *tsuizen* performance. As such, *shumei* and *tsuizen* are often important catalysts for kabuki performances.

"yago" / "haimyo"
All kabuki actors have a *yago*, or stage name. The Ichikawa family, for example, used the name "Narita-ya" presumably because the first Danjuro believed in the faith of Mt. Narita.
There are also actors who possess a *haimyo*. Originally meaning a pen name for haiku poets, some actors also have a *haimyo*, which is sometimes passed on to a successor like *myoseki*.

"onnagata" / "tachiyaku" / "katakiyaku"
Both female roles and the actors who play them are referred to as "*onnagata*." Male roles in general and the actors who play them are called "*tachiyaku*." In a narrow sense, "*tachiyaku*" can also refer specifically to male protagonists. *Tachiyaku* was originally meant to contrast the term "*tekiyaku*" (villain) but is more often used to refer to male actors in general now.

"ie-no-gei"
Specialized arts and roles passed down within an acting family are called *ie-no-gei*. The *Eighteen Great Kabuki Plays* and *New Eighteen Great*

Kabuki Plays of the Ichikawa Danjuro family, and Onoe Kikugoro's Ten New and Old Plays are just a few examples. In some cases ie-no-gei can be the a compilation of roles played by a single generation, as with the first Nakamura Ganjiro's collection, Ganjiro's Twelve Selections. The most recent example of this is Forty-eight Selections of Ennosuke III, which was compiled in 2010.

Performance Features

"Mie"
"Mie" refers to the dramatic pose taken by an actor at the climax of a play, often accompanied by a sharp glare. There are many varieties of mie, including genroku mie and hashiramaki no mie.

"tachimawari" / "tateshi" / "tonbo" / "shosa-date"
"Tatemawari" refers to fight scenes in kabuki plays, and "tateshi" refers to the actor who specializes in staging such scenes. When an actor is cut or thrown in a fight scene, the "tonbo" (flip) movement is used, and tachimawari scenes that are staged in sync with music are a type of buyo called "shosa-date."

"danmari"
"Danmari" refers to a scene in which characters are supposed to be in darkness. Though the stage lights are lit for the audience to see, the actors use a formal technique to seem as though they are groping in the dark.

Costumes and Cosmetics

"kumadori"
"Kumadori" makeup is meant to exaggerate facial muscles and/or blood vessels in the face. The color of kumadori can be red, blue, or green depending on the role. Red kumadori suggests youth, justice, power, and anger, and is used for righteous roles. Blue, on the other hand, is used to express vengeful spirits and evil. Green kumadori is used for spirits that have transformed into humans. Kumadori makeup is applied with brushes or directly with one's hand.

"bukkaeri" and "hikinuki"
"Hikinuki" refers to a dramatic, instantaneous costume change. A hikinuki occurs together with a musical shift to completely alter the mood of a scene. "Bukkaeri" also refers to a costume change in which a character reveals his/her true identity or undergoes a change in character. In kabuki, a costume is an expression of a character's personality, so it is common sense that a change in character or name would result in a costume change. This bold aspect of kabuki design serves an important role in productions and is widely acclaimed around the world. Costumes are thus an integral part of kabuki.

"kurogo"
"Kurogo" refers to an actor who wears all black or to the costume itself. Black represents nothingness in kabuki, and therefore any character or thing that is painted or clothed in black is meant to be invisible or nonexistent. Therefore, if you see a character wearing all black appear on stage, he is meant to be ignored as though he does not exist in the world of the play.

Musical / Audial Terms

"shamisen ongaku"
"Shamisen ongaku," or "shamisen music," is an integral part of kabuki that makes up most of the music in kabuki. This music which came from the Ryukyu Islands during the Warring States period, was incorporated after the original okuni-kabuki. It was the premier instrument of its time and had become completely inseparable from kabuki by the Edo period. There are several different styles of music and sizes of shamisen instruments, and kabuki uses a great number of these, including the "nagauta" and "gidayu-bushi."

"kuromisu-ongaku"
This refers to the music played in the pit ("kuromisu") located in a corner of the left-hand side of the stage. The conductor makes sure the music is in sync with the play, guiding both the dynamic background music and sound effects such as rain and snow. The orchestra uses a number of traditional techniques, such as the striking of the taiko drum when the weather changes or an apparition appears.

"ki"
"Ki" are simply wooden clappers used at the opening of the curtain and other pivotal moments during a play, such as the lowering of the curtain and changing of the set. The actor in charge of the "ki" is called the "kyogen-sakusha."

"tsuke"
"Tsuke" refers to the sound effect produced by striking wooden clappers against a board on the right-hand side of the stage. It is used to emphasize the tatemawari and mie.

"kakegoe" ("omuko")
"Kakegoe" refers to a shout by audience members in the middle of a performance. It is commonly called "omuko" (referring to a portion of the audience) and is meant as a form of praise to the actor. Calling an actor's yago or succession number is a common form of kakegoe. It is meant to include the audience as a participant in the production.

Stage Mechanisms

"hanamichi"
The "hanamachi" is an indispensable part of kabuki. It is a piece of staging that juts out into the isles between the audience's seats and is used for entrances and exits of important characters. By having the actors pass right through the audience, the hanamichi creates a sense of unity between the audience and the stage. Some plays even feature important scenes performed on the hanamichi.

"seri"
"Seri" simply refers to a rectangular lift used to raise and lower the stage or portions of the stage. A lift used for the hanamichi is called a "suppon," and many kabuki performances utilizes either one or both of these mechanics.

"mawari-butai"
"Mawari-butai" refers to a stage cut into a circular pattern to allow it to rotate. Many musicals around the world now use such a mechanism, but it originated in Japan. The first time a large-scale mawari-butai was ever used was in Osaka 250 years ago.

"agemaku"
The "agemaku" is the curtain that hangs down at the end of the hanamichi. It is opened and closed in conjunction with entrances and exits of important characters and often bears the theater's crest.

"joshiki-maku"
The "joshiki-maku" is a unique and well-known feature of kabuki. It is the main stage curtain and consists of 3 colors: black, reddish-brown (kaki-iro), and green (moegi-iro). The order of these colors differs depending on the theater. This style of curtain was officially recognized as a symbol of a major theater by the government of the Edo period.

隈取一覧　　　　　　　　　　　　Kumadori

筋隈 すじぐま / Sujiguma*

超人的な力強さを備え、激しいエネルギーを発する正義の側の人物にしばしば用いられる。梅王丸（『菅原伝授手習鑑 車引』）、曽我五郎（『矢の根』）など。赤い隈（紅隈）は、主に力強さ、若さ、血気などを表す。

This mask is often used for characters on the side of justice possessing superhuman power and energy. Used for Umeomaru ("Sugawara Denju Tenarai Kagami Kurumabiki") and Soga Goro ("Ya no Ne") etc. Red kuma (crimson kuma) mainly express power, youthfulness, and passion.

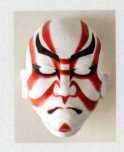

むきみ隈 むきみぐま / Mukimiguma

目元にのみ施す隈。血気、力強さなどとともに、二枚目の要素をもあわせもつ人物に用いられることが多い。桜丸（『菅原伝授手習鑑 車引』）、助六（『助六』）など。

Kuma are only found around the eyes on this mask. This kuma is used for characters who posess both passion and strength, such as Sakuramaru in Sugawara and the Secrets of Calligraphy.

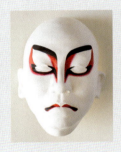

一本隈 いっぽんぐま / Ipponguma

血気、力強さを備えた若い荒武者の役に用いられることがある。梅王丸（『菅原伝授手習鑑 賀の祝』）など。

This mask is sometimes used for the role of a young warrior with passion and physical strength. Used for Umeomaru in Sugawara and the Secrets of Calligraphy.

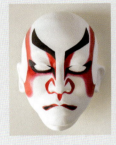

二本隈 にほんぐま / Nihonguma

比較的珍しい隈。松王丸（『菅原伝授手習鑑 車引』）に用いられる。

This mask is fairly unusual. It is used for Matsu Ohmaru ("Sugawara and the Secrets of Calligraphy").

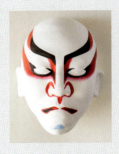

猿隈 さるぐま / Saruguma

額に複数の横筋を描いた隈。力強さとともに、おどけた人柄を表している。小林朝比奈（『寿曽我対面』など）に用いられる。

This mask features several horizontal kuma lines on the forehead. It indicates a strong and jocular character such as Kobayashi Asahina in "The Soga Confrontation."

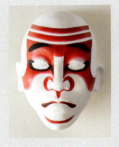

弁慶 べんけい / Benkei　*2 kinds (1and2)

源義経の豪勇無双の忠臣・武蔵坊弁慶の隈。『御所桜堀川夜討 弁慶上使』『義経千本桜 鳥居前』で用いられる（1）。また別の演目では、やや異なる形の隈がみられることもある（2）。あごや口のまわりの淡い青は、濃いひげを表したものと考えられ、勇猛で男性的な弁慶の人物像を感じとることができる。

Minamoto Yoshitsune's courageous and matchless loyal retainer Musashibo Benkei's kuma. Used for *Gosho Zakura Horikawa Youchi, Benkei Jou no Dan*" and "*Yoshitsune and the Thousand Cherry Trees*" (1). In other programs somewhat different forms of kuma can be seen (2). The pale blue around the chine and mouth is meant to be a dark beard, giving audiences the impression that Benkei is truly a brave and masculine character.

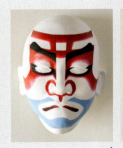 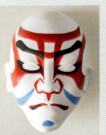

1　　　2

奴 やっこ / Yakko

武家の従僕である「奴」の役に見られる隈。左右へはね上げた「鎌ひげ」が特徴的。

The *kuma* for this mask is used for characters playing the role of an attendant or servant of a samurai. This mask is characterized by the sickle-shaped moustache turned up on the left and right.

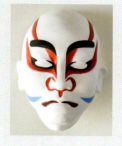

火焔隈 かえんぐま / Kaenguma

炎を思わせる曲線を描いた隈。精霊などに用いられる。源九郎狐（『義経千本桜 鳥居前』）が代表例。

Kuma drawn as curves reminiscent of a flame. It is used for spirits and the like. Genkurou Gitsune ("*Yoshitsune and the Thousand Cherry Trees*") is a typical example.

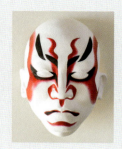

公家荒 くげあれ / Kugeare (2 varieties)

天皇の位を奪おうともくろむ、皇族や公家の極悪人に用いられる隈。「公家荒」の青（藍）は、冷酷さ、邪悪さ、さらには妖気を表す。役や俳優により、いくつものパターンがある（1：藤原時平『菅原伝授手習鑑』）（2：蘇我入鹿『妹背山婦女庭訓』）。

This *kuma* is used for villains that are from the royal family or court nobles that endeavor to usurp the Emperor. The blue (indigo) of *kugeare* represents coldness, evilness, and even spirited vibe. There are several patterns depending on roles and actors (1: Fujiwara Tokihira "*Sugawara and the Secrets of Calligraphy*") (2: Soga no Iruka "*Imoseyama Onna Teikin*").

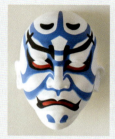 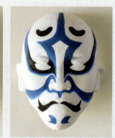

1 2

平知盛の霊 たいらのとももりのれい / Taira no Tomomori no Rei

『船弁慶』に登場する、平家随一の勇将・平知盛の霊に用いられる隈。平家一門の仇・源義経に、怨霊となって襲いかかる知盛の執念や妖気を表す。

Used for the spirit of the famous Heike warlord Taira no Tomomori (Funa Benkei). It evokes the otherworldly mood of the revengeful spirit that attacks Yoshitsune, the Taira clans enemy.

般若 はんにゃ / Hannya

鬼女と化した女性の、すさまじいねたみや復讐の念に燃えるさまを表した、能の面「般若」を思わせる。

This mask is reminiscent of the noh mask called "*Hannya*," which represents a woman turned into a devil, consumed by envy, and obsessed with revenge.

土蜘 つちぐも / Tsuchigumo

『土蜘』に登場する土蜘の精の隈。僧侶に化けていたところを見破られたのち、妖怪の本性を現した時に用いる。黛赭（たいしゃ・茶色）の隈は、主に妖怪変化に用いる。

This is the *kuma* of the ground spider that appears in *Tsuchigumo*. It is used to show the true nature of a phantom after its disguise as a monk is revealed. The mayuzumi (brown) *kuma* is mostly used when characters change into phantoms.

茨木 いばらき / Ibaraki

『茨木』に登場する妖怪・茨木童子の隈。切り落とされた腕を奪い返すため老婆に化けていた茨木童子が、本性を現した時に用いる。

This *kuma* is used for the phantom Ibaraki Doji that appears in "*Ibaraki*". This mask is used to show the true nature of Ibaraki Doji, who turns into an old woman to take back her arm that was severed.
* (the term "kuma" stands for the makeup seen on each mask)

歌舞伎名演目
時代物

監修　松竹株式会社
発行日　2018年12月31日　第1刷

デザイン	TAKAIYAMA inc.
イラスト	大津萌乃
執筆・原稿提供	松竹株式会社　演劇ライツ室 （概要・あらすじ・歌舞伎の言葉・隈取一覧） 金田栄一（登場人物） 関根和子（みどころ） 元禄鯨太（演目紹介・歌舞伎の歴史・歌舞伎の見方）
監修協力	松竹衣裳株式会社 歌舞伎座舞台株式会社
写真	松竹株式会社　演劇ライツ室
写真協力	公益社団法人　日本俳優協会
翻訳	クリストファー・E・ザンブラーノ
校正（日本語）	みね工房
校正（英語）	アーヴィン香苗
編集	碓井美樹（美術出版社）
印刷・製本	凸版印刷株式会社
発行人	遠山孝之、井上智治
発行	株式会社美術出版社 〒141-8203 東京都品川区上大崎3-1-1 目黒セントラルスクエア5階 Tel. 03-6809-0318（営業）、03-6809-0542（編集） 振替　00110-6-323989 http://www.bijutsu.press

禁無断転載
落丁、乱丁本、お取り替えいたします。

松竹株式会社
明治28（1895）年創業。映像事業、演劇事業、不動産・その他事業の3つを主体とする、総合エンターテインメント企業。

KABUKI GREATS
Historical Period Dramas

Supervised by SHOCHIKU
The First Edition Published on December 31, 2018

Designer	TAKAIYAMA inc.
Illustrator	Moeno Ootsu
Manuscript	SHOCHIKU Co., Ltd. / Play Rights Division (Overviews, Synopses, Kabuki Glossary / Kumadori explanation) Eiichi Kaneda (Characters) Kazuko Sekine (Highlights) Keita Genroku (Introductions, The History of Kabuki, How to Watch Kabuki)
Editorial Assistance	SHOCHIKU COSTUME KABUKIZA BUTAI
Photography	SHOCHIKU Co., Ltd. / Play Rights Division
Photography Assistance	Japan Actors Association
Translator	Christopher E. Zambrano
Proofreader (Japanese)	Mine Kobo
Proofreader (English)	Kanae Ervin
Editor	Miki Usui (BIJUTSU SHUPPAN-SHA CO.,LTD.)
Printing and Binding	TOPPAN PRINTING CO., LTD.
Publisher	Takayuki Toyama, Tomoharu Inoue

Published by BIJUTSU SHUPPAN-SHA CO.,LTD.
MEGURO CENTRAL SQUARE 5F, 3-1-1
Kamiosaki, Shinagawa-ku, Tokyo 141-8203 Japan
Tel. 03-6809-0318 (Sales), 03-6809-0542 (Editorial)
Transfer account 00110-6-323989
http://www.bijutsu.press

All Rights Reserved
We will happily replace any copy of this book that contains missing pages or pages bound out of order.

SHOCHIKU CO., LTD.
Est. 1895, Shochiku is a general entertainment enterprise consisting of the three primary divisions of Motion Picture, Theater, and Real Estate among other divisions.

ISBN978-4-568-43106-3 C0074
© Shochiku / BIJUTSU SHUPPAN-SHA CO., LTD. 2018
All rights reserved Printed in Japan